Praise for John Berger

'Electric with thought and energy . . . Berger's words and images, rendered serene by age and habit, provide an exhilarating and unflinching account of global devastation and ordinary life'

Colin MacCabe, *New Statesman*

'Berger is a writer one demands to know more about . . . an intriguing and powerful mind and talent'

New York Times

'John Berger throws a long shadow across the literary landscape; in that shade so many of us have taken refuge, encouraged by his work that you can be passionately, radically political and also concerned with the precise details of artistic production and everyday life, that the beautiful and the revolutionary belong together, that you can chart your own course and ignore the herd, that you can make words on the page sing and liberate minds that way. Like so many writers, I owe him boundless gratitude and regard news of a new book as encouragement that the most important things are still possible. The gifts are huge, and here's another one coming'

Rebecca Solnit

'A broad jumper of the intellect. He is always making links where no one else has. Between the famous photograph of a Bolivian colonel pointing to Che Guevara's dead body and the Rembrandt painting of a doctor in an identical pose pointing to a cadaver before a group of medical students. Between the struggle of Third against First World today and the tensions of city dweller against peasant as painted by Millet'

Adam Hochschild

'In this extraordinary new work, John Berger embarks on a process of rediscovery and refiguring of history through the visual narratives given to us by portraiture. Berger's ability for storytelling is both incisive and intriguing. He is one of the greatest writers of our time'

Hans Ulrich Obrist

PORTRAITS:
JOHN BERGER ON ARTISTS

by
John Berger

Edited by Tom Overton

VERSO

London • New York

This paperback edition first published by Verso 2017
First published by Verso 2015
© John Berger 2015, 2017
Introduction © Tom Overton 2015, 2017

1 3 5 7 9 10 8 6 4 2

Verso
UK: 6 Meard Street, London W1F 0EG
US: 20 Jay Street, Suite 1010, Brooklyn, NY 11201
versobooks.com

Verso is the imprint of New Left Books

ISBN-13: 978-1-78478-179-8
ISBN-13: 978-1-78478-177-4 (US-EBK)
ISBN-13: 978-1-78478-178-1 (UK-EBK)

British Library Cataloguing in Publication Data
A catalogue record for this book is available from the British Library

The Library of Congress Has Cataloged the Hardback Edition As Follows:

Berger, John, author.
[Essays. Selections]
Portraits : John Berger on artists / edited by Tom Overton.
pages cm
ISBN 978-1-78478-176-7 (hardback)
1. Art. I. Title. II. Title: John Berger on artists.
N7445.2.B466 2015
709.2ʹ2–dc23
2015030114

Typeset in Electra by Hewer Text UK Ltd, Edinburgh
Printed in the UK by CPI Mackeys

For Beverly and for Gareth Evans

Contents

Contents

Contents

Preface

I HAVE ALWAYS hated being called an art critic. It's true that for a decade or more I wrote regularly in the Press about artists, exhibitions, museum shows, and so the term is justified.

But in the milieu in which I grew up since I was a teenager, to call somebody an art critic was an insult. An art critic was somebody who judged and pontificated about things he knew a little or nothing about. He wasn't as bad as an art dealer, but he was a pain in the arse.

This was a milieu of painters, sculptors, graphic artists of all ages who struggled to survive and to create a life's work with a minimum of publicity, acclaim, or smart recognition. They were cunning, they had high standards, they were modest, the old masters were their companions, they were fraternally critical of one another, but they didn't give a fuck about the art market and its promoters. Many of them were political émigrés. And by nature they were outlaws. Such were the men and women who taught and inspired me.

Their inspiration has led me to write about art intermittently throughout my long life as a writer. Yet what happens when I write – or try to write – about art?

Having looked at a work of art, I leave the museum or gallery in which it is on display, and tentatively enter the studio in which it was made. And there I wait in the hope of learning something of the story

of its making. Of the hopes, of the choices, of the mistakes, of the discoveries implicit in that story. I talk to myself, I remember the world outside the studio, and I address the artist whom I maybe know, or who may have died centuries ago. Sometimes something he has done replies. There's never a conclusion. Occasionally there's a new space to puzzle both of us. Occasionally there's a vision which makes us both gasp – gasp as one does before a revelation.

What such an approach and practice yields, it is for the reader of my texts to judge. I myself can't say. I'm always in doubt. One thing, however, I'm sure about, and that is my gratitude to all the artists for their hospitality.

The illustrations in this book are all in black and white. This is because glossy colour reproductions in the consumerist world of today tend to reduce what they show to items in a luxury brochure for millionaires. Whereas black-and-white reproductions are simple memoranda.

John Berger
24 March 2015

Introduction: The Company of the Past

Tom Overton

'I OFTEN THINK now that even when I was writing about art', said John Berger in 1984, 'it was really a way of storytelling – storytellers lose their identities and are open to the lives of other people.'

Some of Berger's friends, Geoff Dyer and Susan Sontag included, were unconvinced. Wasn't this a story Berger was telling about himself? Isn't storytelling an oral form, and don't writers like Berger deal in the printed word? Nevertheless Berger stuck to it, partly because it covers the breadth of his work, from short fiction to plays, poems, novels, radio, films, installations, and essays to unclassifiable collaborative performances. As Marina Warner has pointed out, the way Berger addresses people in their own homes on the 1972 collaborative BBC TV series *Ways of Seeing* has all of the direct, spoken address of a much older form of engagement.

Berger proposes that he began to see himself as a storyteller during his military service in 1944, when he had written letters home for soldiers who couldn't. Often, he added embellishments to order, in return for their protection. This wasn't the splendid isolation of the stereotypical novelist or critic; rather, here Berger saw himself as equal, arguably even subservient, to the society around him.

In 1962 Berger left Britain, spending the years that followed moving around Europe. It was only once he settled in the French Alpine

village of Quincy in the mid-1970s that his wife Beverly could build a stable literary archive of the documents that had survived.[1] When it arrived in lightly edited form at the British Library in London in 2009, it was with the logic of storytelling: what interested Berger most about it, he said, were not the notes and the drafts he had made, but the letters or messages that had been sent to him.

Berger had been born in London, and his decision to donate the archive to the British Library rather than sell it to the highest bidder was significant in itself. He set the precedent for such a gesture in 1972, when he discovered that the Booker McConnell Prize he'd been awarded had connections to the slave trade, which his winning novel, G., was partly about. His response was to share the proceeds of the prize equally between the Black Panthers and his next project, A Seventh Man (1975), a collaboration with the photographer Jean Mohr which examined Europe's abuse of migrant labour. In 2009, as in 1972, Berger felt that the issue was not one of charity or philanthropy, but of what he called 'my continuing development as a writer: the issue is between me and the culture that formed me'.

The archive at the British Library is more text than image, and the drawings, where they occur, are generally marginal. But when I read through it between 2010 and 2013, cataloguing it and writing a PhD as I went along, I got an increasing sense of how often, even when Berger was telling a story, it had also been a way of writing about art.

The archive's earliest fragments come from Berger's first career as a painter, studying at the Chelsea and Central Schools of Art, exhibiting around London, and getting a painting into the Arts Council Collection. In 2010, he explained that

> it was a very conscious decision to stop painting – not stopping drawing – and write. A painter is like a violinist: you have to play every single day, you can't do it sporadically. For me, there were too many political urgencies to spend my life painting. Most urgent

1 On the official papers, he called it the Nuthatch Archive, after Beverly's nickname. Beverly died in 2013, before she could see it in its new home.

was the threat of nuclear war – the risk of course came from Washing, not Moscow.

He wrote talks on art for the BBC, then journalism for *Tribune* and the *New Statesman*, and by 1952, his art-school peers considered him to be a writer. His first book was a study of the Italian painter Renato Guttuso, published in 1957 in Dresden. The archive also shows him assembling *Permanent Red: Essays in Seeing* (1960), his first collection of writings, and a novel, *A Painter of Our Time* (1958), which finds a fictional form for many of the same arguments.

Then, as now, Berger considered himself 'amongst other things a Marxist', although he was never a member of a communist Party. His primary critical demand of art, developed from the writings of Frederick Antal, Max Raphael, and the émigré artists among whom he lived, was 'does this work help or encourage men to know and claim their social rights?' He took the line that though clichéd Socialist Realist paintings of Stakhanovite Soviet workers were obviously propaganda, so too was US Abstract Expressionism: freed from any other function, it merely represented capital itself.[2] He spent the decade advocating a type of painting and sculpture that was largely figurative, but built on the discoveries of modernist abstraction.

In 1959, Berger wrote an article called 'Staying Socialist', in which he conceded that he 'was wrong, for the most part, about the young painters in this country. They have not developed along the lines that I prophesied.' He did however see some hope in other areas, and added: 'what I prophesied in the field of painting has been proved absolutely right in the field of literature and the theatre'.

At this point, he was turning away from full-time exhibition reviewing, but visual art remained a vital presence in his fiction. The two main characters of *A Painter of Our Time* (1958) are brought together by the experience of looking at Goya's *Dona Isabel* in the National Gallery, and in *Corker's Freedom* (1964), the awkward discovery of a

2 If this seemed paranoid to many of his contemporaries, writers such as Frances Stonor Saunders have since explored the CIA's funding of cultural activity at the time, particularly through the Congress for Cultural Freedom.

reproduction of *The Maja Undressed* on a chocolate box serves as an index of Corker's Englishness; his repression and lack of fulfilment.

Perhaps inevitably for someone with his training, Berger has always looked to visual art not just for inspiration, but for practical guidance. Sticking to a 1956 declaration that 'if I am a political propagandist, I am proud of it. But my heart and eye have remained those of a painter', he sets out to learn from the experience of looking as an artist *and* as a storyteller. Writing for *New Society* in 1978, he approved of how the academics Linda Nochlin[3] and T. J. Clark[4] had recently explained 'the theory and programme of Courbet's realism' in social and historical terms. But the question remained, Berger thought, 'how did he practise it with his eyes and hands? What is the meaning of the unique way in which he rendered appearances? When he said: art is "the most complete expression of an existing thing", what did he understand by expression?' He went on to examine how, in *A Burial at Ornans* (1849–50), Courbet had

> painted a group of men and women as they might appear when attending a village funeral, and he had refused to organise (harmonise) these appearances into some false – or even true – higher meaning. He had refused the function of art as the moderator of appearances, as that which ennobles the visible. Instead, he had painted life-size, on 21 square metres of canvas, an assembly of figures at a graveside, which announced nothing except: This is how we appear.

At the time, Berger was working on the *Into Their Labours* trilogy (1979–91) – a collection of tightly linked stories about peasant life as a disappearing form of human dignity, drawn from Quincy and the mountains around it. In the archival drafts for the first book, *Pig Earth* (1979), *A Burial at Ornans* features in a list of 'Possible Illustrations'. The funeral in the painting is in the Jura, about three hours to the north of Quincy. It was made between 1849 and 1850, which means

3 *Realism* (1971).
4 *Image of the People: Gustave Courbet and the 1848 Revolution* (1973) and *The Absolute Bourgeois: Artists and Politics in France 1848–1851* (1973).

that the great-grandfather who loses his eye in 'The Wind Howls Too', one of the stories from *Pig Earth*, would then have been about the same age as the altar boy in the foreground. It seems to have served Berger as a means of imagining his neighbours' place in history.

This sense of living connections is central to Berger's idea of his storytelling vocation. It comes from Max Raphael, whom Berger thought had shown 'as no other writer has ever done the revolutionary meaning of the works inherited from the past – and of the works that will be eventually created in the future'. This sense – expressed in *Ways of Seeing* – that capitalism functions by cutting us off from history led Berger to develop his Social Realism of the 1950s into a kind of Magical Realism, in which the living and the dead coexist. So when he donated the archive in 2009, Berger gave an interview suggesting that archives were

> another way of people who lived in the past who perhaps are still living or perhaps are dead being present. This seems to me absolutely one of the quintessential things about the human condition. It's what actually distinguishes man from any other animal: living with those who have lived and the companionship of those who are no longer alive. Not necessarily the people that one knew personally, I mean the people perhaps whom one only knows by what they did, or what they left behind, this question of the company of the past, that's what interests me, and archives are a kind of site in the sense of like an archaeological site.

The experience of looking at visual art has continued to play a role in the development of Berger's storytelling; the collaborative correspondence in *Titian: Nymph and Shepherd* (2003) begins with Titian's ghost appearing to Berger's daughter in an exhibition in Venice. The 'John' character running through *Here Is Where We Meet* (2005) reminds us of the protagonist of *A Painter of Our Time*. There are reproductions of the Fayum portraits in the archival drafts, as well as the endpapers for the first edition of *From A to X* (2008). *Bento's Sketchbook* (2011) imagines the discovery of the drawings of Marx's favourite philosopher, Baruch Spinoza. But if so much of Berger's writing responds to art, how can it be usefully put into a collection such as this?

When Geoff Dyer wrote the introduction to his *Selected Essays of John Berger* (2001), he invited readers to use Berger's example to 'redraw the maps' of contemporary literary reputations, in particular the idea that novel-writing is more prestigious or important than non-fiction. As Picasso put it in 1923, 'Whenever I had something to say, I have said it in the manner in which I have felt it ought to be said. Different motives inevitably require different methods of expression.'[5]

This book tries to show the range of Berger's responses to art by including, but not limiting itself to, the essay. The most conventional are exhibition reviews; the least conventional is probably the elegy to the sculptor Juan Muñoz, written as a sequence of letters to the long-dead Turkish poet Nazim Hikmet. In between, there are poems, extracts from novels and dramas, and pieces written in dialogue which show Berger's commitment to collaboration from very early in his career. Each piece is a portrait in the sense that it attentively, empathetically responds to the complex mesh of an individual artist's life, work and times, or, in the case of the first two entries, to a group of artists brought together by their anonymity.[6] A couple – Lee Krasner and Jackson Pollock, for example – are, by the logic Berger pursues in the piece, inseparably double portraits.

Berger's 1967 essay 'No More Portraits' was a kind of autopsy for the tradition exemplified by the National Portrait Gallery. It identified three contributing factors, the first and most obvious of which was the advent of photography. The second was an increasing inability to believe in the social roles in which this sort of art was designed to confirm the people it depicted. Think, for example, of Hals's portraits of the wealthy burghers around him; even in this Berger imagines the portraitist's dissatisfaction with his task, his essential resentment of the regents and regentesses.

The third is that because of the technological, political, and artistic

5 Berger himself used the quotation in *The Success and Failure of Picasso*.

6 Outside of these parameters, Berger has produced a whole range of more theoretical texts which draw in the broader scope of historical periods: 'The Moment of Cubism', or 'The Clarity of the Renaissance', for example, and texts which demonstrate his under-recognised role in advocating writers such as Brecht, Benjamin, and Barthes to an English-speaking public. These will feature in a second volume, *Landscapes*.

changes associated with modernity, 'we can no longer accept that the identity of a man can be adequately established by preserving and fixing what he looks like from a single viewpoint in one place'. In this we see the seeds of a famous line from G. – 'never again will a single story be told as though it were the only one'.

This book is not trying to rehabilitate this tradition, but rather to point out the frequency with which Berger's writing reaches the intensity of focus and imaginative empathy of the exceptions: the Fayum portraitists, or – the comparison is irresistible given the variety, insight, and frequency with which Berger has written about him – Rembrandt. In the exchange of letters with Leon Kossoff, Berger sets out his vision of what happens in what he considers to be a true portrait:

> The romantic notion of the artist as creator eclipsed – and today the notion of the artist as star still eclipses – the role of receptivity, of openness in the artist. This is the pre-condition for any such collaboration.

This is the only sense in which it seems fair to look at this collection – as it is probably impossible *not* to do – as adding up to a self-portrait (Dyer called his *Selected Essays of John Berger* 'a kind of vicarious autobiography'). Berger is at some distance from the association of the essay and the self-portrait Montaigne made – 'it is for my own self I paint'. But a passage from Berger's 1978 essay 'The Storyteller' confirms that the analogy between portraiture and storytelling is not too wrenching:

> What distinguishes the life of a village is that it is also a *living portrait of itself*: a communal portrait, in that everybody is portrayed and everybody portrays; and this is only possible if everybody knows everybody. As with the carvings on the capitals in a Romanesque church, there is an identity of spirit between what is shown and how it is shown – as if the portrayed were also the carvers. A village's portrait of itself is constructed, not out of stone, but out of words, spoken and remembered: out of opinions, stories, eyewitness reports, legends, comments, and hearsay. And it is a continuous portrait; work on it never stops.

As the pieces in this book were not written to be read as they are presented here, the combined effect is something like the famous opening scene of *Ways of Seeing*, in which Berger cuts out what looks to be Venus's head from Botticelli's *Venus and Mars*, and announces a kind of Situationist *détournement*: 'Reproduction isolates a detail of a painting from the whole. The detail is transformed. An allegorical figure becomes a portrait of a girl.'

Having established the principles of selection, I was left with the issue of organisation. David Sylvester is one roughly contemporary example; when he edited his own *About Modern Art: Selected Essays 1948–2000*, he settled on a thematic structure, and compared it to a retrospective exhibition. In the preface, Sylvester remembered how he and Berger had sparred in the 1950s London press, and essentially attacked Berger for not having recognised and promoted the same artists – namely Francis Bacon and Alberto Giacometti – with the same energy.[7]

Even as early as 1959 Berger admitted, 'I have been writing art criticism long enough to be proven wrong.' One of the defining characteristics of Berger's long writing life is the habit – perhaps *necessity* – of reconsideration, and the key text for understanding it is the essay 'Between Two Colmars' (1976), which describes the experience of visiting Grünewald's Isenheim altarpiece either side of the revolutionary disappointments of 1968. 'On the occasion of both my visits to Colmar', Berger writes,

> it was winter, and the town was under the grip of a similar cold, the cold which comes off the plain and carries with it a reminder of hunger. In the same town, under similar physical conditions, I saw differently. It is a commonplace that the significance of a work of art changes as it survives. Usually, however, this knowledge is used to distinguish between 'them' (in the past) and 'us' (now). There is a tendency to picture *them* and their reactions to art as being embedded in history, and at the same time to credit *ourselves* with an over-view, looking across from what we treat as the summit of

7 James Hyman's *The Battle for Realism: Figurative Art in Britain During the Cold War, 1945–1960* (2001) is still the authority on the early part of Sylvester and Berger's relationship. In his later writing, Berger was often a respectful advocate of Sylvester's insights.

history. The surviving work of art then seems to confirm our superior position. The aim of its survival was us.

This is illusion. There is no exemption from history. The first time I saw the Grünewald I was anxious to place *it* historically. In terms of medieval religion, the plague, medicine, the Lazar house. Now I have been forced to place myself historically.

This is a view of history trying to shape itself around a view of a painting. Many of the other pieces around 'Between Two Colmars' trace repeated returns to the work of an artist, finding something different each time. The pieces on the entanglement of Henry Moore's work in Cold War cultural politics are one example; the lifetime's written response to Rembrandt's images of human ageing are another. The pieces which look at how Monet submitted himself to the discipline of painting the same cathedral again and again, 'each canvas seizing a different and new transformation as the light changed', offer a way of looking at what Berger himself is doing in his writing.

Berger's previous collaborators on image placement – they include Jean Mohr, Richard Hollis, and John Christie – have set the bar very high indeed, giving his books a sense that photographic reproductions can be a revolutionary language in their own right. There have been various attempts to update *Ways of Seeing* for the age of digital reproduction, which tend to suggest that though their delivery has aged, the essential theses still hold; the TV version cannot be issued on DVD precisely because of the issues of art and property it discusses. But these issues also mean that the reader can watch it for free online, and keep up with Berger's vast pictorial vocabulary with internet searches.

The illustrations used here try to avoid what Berger describes as a 'tautology' of word and image, and the atmosphere of the coffee-table book. Always black-and-white references, or 'memoranda' as Berger explains in his preface, these images take a different approach with every text. Sometimes they highlight a relevant feature of a work; sometimes they draw out Berger's talent for unexpected comparisons. More generally, they try to illustrate the essentially dialectical relationship between text and image in Berger's work: the pattern in which an image shapes a text, which then goes on to shape how we understand that image.

The broader structure of this book comes from the chronology of the vast historical range of artists Berger has written about. In this sense it represents Berger's history of art. But in allowing space for these repeated engagements to emerge within each chapter, in the order in which they were written, it becomes more fully a series of portraits, written with a storyteller's openness to the lives of others. Such structure is not without dangers; Berger himself argued in 1978 that 'to treat art history as if it were a relay race of geniuses is an individualist illusion, whose origins in the Renaissance corresponded with the phase of the primitive accumulation of private capital'.

He admitted that this attitude, incompatible with the whole ethos of the storyteller, was not properly dealt with in *Ways of Seeing*. But he also elsewhere reflected that 'not learning dates is disastrous; comparative dates are a stimulus to thought', and this structure instantly gives an impression of the historical range of the oeuvre, and makes it easily navigable. Dipping into the book offers snapshots of writing on particular artists. Reading it from start to finish draws out Berger's instinctive desire to historicise, as he notes to himself that one artist is the contemporary of another, who in this case features in the next chapter.

However it's read, from the paintings of the Chauvet caves, all the way to Randa Mdah's work about contemporary Palestine, this book constructs a history of art that is not about distinction, but about connection; not just between artists, but between artists and us. Perhaps, finally, this brings us to the only definition of genius which sits easily with Berger's work, a 1942 quotation from Simone Weil, which Berger uses in his piece on Géricault's portraits:

> Love for our neighbour, being made of creative attention, is analogous to genius.

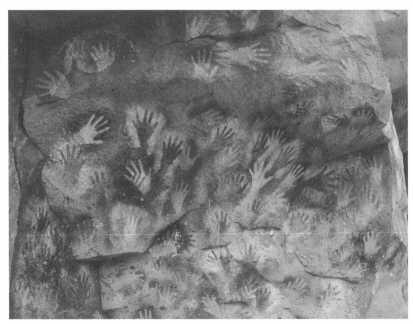

Cueva de las Manos (Cave of the Hands), 11,000–7,500 BC

1.

The Chauvet Cave Painters
(c. 30,000 years BC)

YOU, MARISA, WHO have painted so many creatures and turned over many stones and crouched for hours looking, perhaps you will follow me.

Today I went to the street market in a suburb south of Paris. You can buy everything there from boots to sea urchins. There's a woman who sells the best paprika I know. There's a fishmonger who shouts out to me whenever he has an unusual fish that he finds beautiful, because he thinks I may buy it in order to draw it. There's a lean man with a beard who sells honey and wine. Recently he has taken to writing poetry, and he hands out photocopies of his poems to his regular clients, looking even more surprised than they do.

One of the poems he handed me this morning went like this:

> Mais qui piqua ce triangle dans ma tête?
> Ce triangle né du clair de lune
> me traversa sans me toucher
> avec des bruits de libellule
> en pleine nuit dans le rocher.
> Who put this triangle in my head?

This triangle born of moonlight
went through me without touching me
making the noise of a dragonfly
deep in the rock at night.

After I read it, I wanted to talk to you about the first painted animals. What I want to say is obvious, something which everybody who has looked at paleolithic cave paintings must feel, but which is never (or seldom) said clearly. Maybe the difficulty is one of vocabulary; maybe we have to find new references.

The beginnings of art are being continually pushed back in time. Sculpted rocks just discovered at Kununurra in Australia may date back seventy-five thousand years. The paintings of horses, rhinoceros, ibex, mammoths, lions, bears, bison, panthers, reindeer, aurochs, and an owl, found in 1994 in the Chauvet Cave in the French Ardèche, are probably fifteen thousand years older than those found in the Lascaux caves! The time separating us from these artists is at least twelve times longer than the time separating us from the pre-Socratic philosophers.

What makes their age astounding is the sensitivity of perception they reveal. The thrust of an animal's neck or the set of its mouth or the energy of its haunches were observed and recreated with a nervousness and control comparable to what we find in the works of a Fra Lippo Lippi, a Velázquez, or a Brancusi. Apparently art did not begin clumsily. The eyes and hands of the first painters and engravers were as fine as any that came later. There was a grace from the start. This is the mystery, isn't it?

The difference between then and now concerns not finesse but space: the space in which their images exist as images and were imagined. It is here – because the difference is so great – that we have to find a new way of talking.

There are fortunately superb photographs of the Chauvet paintings. The cave has been closed up and no public visits will be allowed. This is a correct decision, for like this, the paintings can be preserved. The animals on the rocks are back in the darkness from which they came and in which they resided for so long.

We have no word for this darkness. It is not night and it is not ignorance. From time to time we all cross this darkness, seeing everything:

so much everything that we can distinguish nothing. You know it, Marisa, better than I. It's the interior from which everything came.

<div align="center">ଔ</div>

ONE JULY EVENING this summer, I went up the highest field, high above the farm, to fetch Louis's cows. During the haymaking season I often do this. By the time the last trailer has been unloaded in the barn, it's getting late and Louis has to deliver the evening milk by a certain hour, and anyway we are tired, so, while he prepares the milking machine, I go to bring in the herd. I climbed the track that follows the stream that never dries up. The path was shady and the air was still hot, but not heavy. There were no horseflies as there had been the previous evening. The path runs like a tunnel under the branches of the trees, and in parts it was muddy. In the mud I left my footprints among the countless footprints of cows.

To the right the ground drops very steeply to the stream. Beech trees and mountain ash prevent it being dangerous; they would stop a beast if it fell there. On the left grow bushes and the odd elder tree. I was walking slowly, so I saw a tuft of reddish cow hair caught on the twigs of one of the bushes.

Before I could see them, I began to call. Like this, they might already be at the corner of the field to join me when I appeared. Everyone has their own way of speaking with cows. Louis talks to them as if they were the children he never had: sweetly or furiously, murmuring or swearing. I don't know how I talk to them; but, by now, they know. They recognise the voice without seeing me.

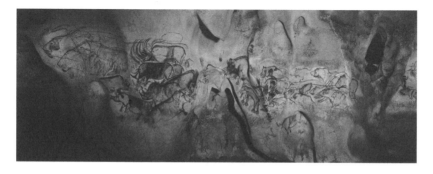

Painting in Chauvet Cave, c. 30,000 BC

When I arrived they were waiting. I undid the electric wire and cried: *Venez, mes belles, venez.* Cows are compliant, yet they refuse to be hurried. Cows live slowly – five days to our one. When we beat them, it's invariably out of impatience. Our own. Beaten, they look up with that long-suffering, which is a form (yes, they know it!) of impertinence, because it suggests, not five days, but five eons.

They ambled out of the field and took the path down. Every evening Delphine leads, and every evening Hirondelle is the last. Most of the others join the file in the same order, too. The regularity of this somehow suits their patience.

I pushed against the lame one's rump to get her moving, and I felt her massive warmth, as I did every evening, coming up to my shoulder under my singlet. *Allez,* I told her, *allez, Tulipe,* keeping my hand on her haunch, which jutted out like the corner of a table.

In the mud their steps made almost no noise. Cows are very delicate on their feet: they place them like models turning on high-heeled shoes at the end of their to-and-fro. I've even had the idea of training a cow to walk on a tightrope. Across the stream, for instance!

The running sound of the stream was always part of our evening descent, and when it faded the cows heard the toothless spit of the water pouring into the trough by the stable where they would quench their thirst. A cow can drink about thirty litres in two minutes.

Meanwhile, that evening we were making our slow way down. We were passing the same trees. Each tree nudged the path in its own way. Charlotte stopped where there was a patch of green grass. I tapped her. She went on. It happened every evening. Across the valley I could see the already mown fields.

Hirondelle was letting her head dip with each step, as a duck does. I rested my arm on her neck, and suddenly I saw the evening as from a thousand years away:

Louis's herd walking fastidiously down the path, the stream babbling beside us, the heat subsiding, the trees nudging us, the flies around their eyes, the valley and the pine trees on the far crest, the smell of piss as Delphine pissed, the buzzard hovering over the field called La Plaine Fin, the water pouring into the trough, me, the mud in the tunnel of trees, the immeasurable age of the mountain, suddenly everything there was indivisible, was one. Later each part would fall to

pieces at its own rate. Now they were all compacted together. As compact as an acrobat on a tightrope.

'Listening not to me but to the *logos*, it is wise to agree that all things are one,' said Heraclitus, twenty-nine thousand years after the Chauvet paintings were made. Only if we remember this unity and the darkness we spoke of, can we find our way into the space of those first paintings.

Nothing is framed in them; more important, nothing meets. Because the animals run and are seen in profile (which is essentially the view of a poorly armed hunter seeking a target) they sometimes give the impression that they're going to meet. But look more carefully: they cross without meeting.

Their space has absolutely nothing in common with that of a stage. When experts pretend that they can see here 'the beginnings of perspective', they are falling into a deep, anachronistic trap. Pictorial systems of perspective are architectural and urban – depending upon the window and the door. Nomadic 'perspective' is about coexistence, not about distance.

Deep in the cave, which meant deep in the earth, there was everything: wind, water, fire, faraway places, the dead, thunder, pain, paths, animals, light, the unborn . . . They were there in the rock to be called to. The famous imprints of life-size hands (when we look at them we say they are ours) – these hands are there, stencilled in ochre, to touch and mark the everything-present and the ultimate frontier of the space this presence inhabits.

The drawings came, one after another, sometimes to the same spot, with years or perhaps centuries between them, and the fingers of the drawing hand belonging to a different artist. All the drama that in later art becomes a scene painted *on* a surface with edges is compacted here into the apparition that has come *through* the rock to be seen. The limestone opens for it, lending it a bulge here, a hollow there, a deep scratch, an overhanging lip, a receding flank.

When an apparition came to an artist, it came almost invisibly, trailing a distant, unrecognisably vast sound, and he or she found it and traced where it nudged the surface, the facing surface, on which it would now stay visible even when it had withdrawn and gone back into the one.

Things happened that later millennia found it hard to understand. A head came without a body. Two heads arrived, one behind the other. A single hind leg chose its body, which already had four legs. Six antlers settled in a single skull.

It doesn't matter what size we are when we nudge the surface: we may be gigantic or small – all that matters is how far we have come through the rock.

The drama of these first painted creatures is neither to the side nor to the front, but always behind, in the rock. From where they came. As we did, too . . .

2.

The Fayum Portrait Painters
(1st–3rd century)

THEY ARE THE earliest painted portraits that have survived; they were painted whilst the Gospels of the New Testament were being written. Why then do they strike us today as being so immediate? Why does their individuality feel like our own? Why is their look more contemporary than any look to be found in the rest of the two millennia of traditional European art which followed them? The Fayum portraits touch us, as if they had been painted last month. Why? This is the riddle.

The short answer might be that they were a hybrid, totally bastard art-form, and that this heterogeneity corresponds with something in our present situation. Yet to make this answer comprehensible we have to proceed slowly.

They are painted on wood – often linden – and some are painted on linen. In scale the faces are a little smaller than life. A number are painted in tempera; the medium used for the majority is *encaustic*, that is to say, colours mixed with beeswax, applied hot if the wax is pure, and cold if it has been emulsified.

Today we can still follow the painter's brushstrokes or the marks of the blade he used for scraping on the pigment. The preliminary surface on which the portraits were done was dark. The Fayum painters worked from dark to light.

What no reproduction can show is how appetising the ancient pigment still is. The painters used four colours apart from gold: black, red, and two ochres. The flesh they painted with these pigments makes one think of the bread of life itself. The painters were Greek Egyptian. The Greeks had settled in Egypt since the conquest of Alexander the Great, four centuries earlier.

They are called the Fayum portraits because they were found at the end of the last century in the province of Fayum, a fertile land around a lake, a land called the Garden of Egypt, eighty kilometres west of the Nile, a little south of Memphis and Cairo. At that time a dealer claimed that portraits of the Ptolemies and Cleopatra had been found! Then the paintings were dismissed as fakes. In reality they are genuine portraits of a professional urban middle class – teachers, soldiers, athletes, Serapis priests, merchants, florists. Occasionally we know their names – Aline, Flavian, Isarous, Claudine . . .

They were found in necropolises, for they were painted to be attached to the mummy of the person portrayed, when he or she died. Probably they were painted from life (some must have been because of their uncanny vitality); others, following a sudden death, may have been done posthumously.

They served a double pictorial function: they were identity pictures – like passport photos – for the dead on their journey with Anubis, the god with the jackal's head, to the kingdom of Osiris; secondly and briefly, they served as mementoes of the departed for the bereaved family. The embalming of the body took seventy days, and sometimes after this, the mummy would be kept in the house, leaning against a wall, a member of the family circle, before being finally placed in the necropolis.

Stylistically, as I've said, the Fayum portraits are hybrid. Egypt by that time had become a Roman province governed by Roman prefects. Consequently the clothes, the hairstyles, the jewellery of the sitters followed the recent fashions in Rome. The Greeks, who made the portraits, used a naturalist technique which derived from the tradition established by Apelles, the great Greek master of the fourth century BC. And, finally, these portraits were sacred objects in a funerary ritual which was uniquely Egyptian. They come to us from a moment of historical transition.

And something of the precariousness of this moment is visible in the way the faces are painted, as distinct from the expression on the faces. In traditional Egyptian painting nobody was seen in full-face, because a frontal view opens the possibility to its opposite: the back view of somebody who has turned and is leaving. Every painted Egyptian figure was in eternal profile, and this accorded with the Egyptian preoccupation with the perfect continuity of life after death.

Yet the Fayum portraits, painted in the ancient Greek tradition, show men, women, and children seen full-face or three-quarters full-face. This format varies very little and all of them are as frontal as pictures from a photo-mat. Facing them, we still feel something of the unexpectedness of that frontality. It is as if they have just tentatively stepped towards us.

Among the several hundred known portraits, the difference of quality is considerable. There were great master-craftsmen and there were provincial hacks. There were those who summarily performed a routine, and there were others (surprisingly many in fact) who offered hospitality to the soul of their client. Yet the pictorial choices open to the painter were minute; the prescribed form very strict. This is paradoxically why, before the greatest of them, one is aware of enormous painterly energy.

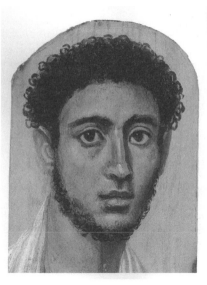

Fayum portrait of a young man

The stakes were high, the margin narrow. And in art these are conditions which make for energy.

I want now to consider just two actions. First, the act of a Fayum portrait being painted, and, second, the action of our looking at one today.

Neither those who ordered the portraits, nor those who painted them, ever imagined their being seen by posterity. They were images destined to be buried, without a visible future.

This meant that there was a special relationship between painter and sitter. The sitter had not yet become a *model*, and the painter had not yet become a broker for future glory. Instead, the two of them, living at that moment, collaborated in a preparation for death, a preparation which would ensure survival. To paint was to name, and to be named was a guarantee of this continuity.[1]

In other words, the Fayum painter was summoned not to make a portrait, as we have come to understand the term, but to register his client, a man or a woman, looking at him. It was the painter rather than the 'model' who submitted to being looked at. Each portrait he made began with this act of submission. We should consider these works not as portraits, but as paintings about the experience of being looked at by Aline, Flavian, Isarous, Claudine . . .

The address, the approach is different from anything we find later in the history of portraits. Later ones were painted for posterity, offering evidence of the once living to future generations. Whilst still being painted, they were imagined in the past tense, and the painter, painting, addressed his sitter in the third person – either singular or plural. *He, She, They as I observed them.* This is why so many of them look old even when they are not.

For the Fayum painter the situation was very different. He submitted to the look of the sitter, for whom he was Death's painter or, perhaps more precisely, Eternity's painter. And the sitter's look, to which he submitted, addressed him in the second person singular. So that his reply – which was the act of painting – used the same personal pronoun: *Toi, Tu, Esy, Ty . . . who is here.* This in part explains their immediacy.

Looking at these 'portraits', which were not destined for us, we find ourselves caught in the spell of a very special contractual intimacy. The contract may be hard for us to grasp, but the look speaks to us, particularly to us today.

If the Fayum portraits had been unearthed earlier, during, say, the eighteenth century, they would, I believe, have been considered as little more than a curiosity. To a confident, expansive culture these

1 A truly remarkable essay by Jean-Christoph Bailly on the Fayum portraits has just been published (1999) by Hazan, Paris, with the title *L'Apostrophe Muette*.

little paintings on linen or wood would probably have seemed diffident, clumsy, cursory, repetitive, uninspired.

The situation at the end of our century is different. The future has been, for the moment, downsized, and the past is being made redundant. Meanwhile the media surround people with an unprecedented number of images, many of which are faces. The faces harangue ceaselessly by provoking envy, new appetites, ambition, or, occasionally, pity combined with a sense of impotence. Further, the images of all these faces are processed and selected in order to harangue as noisily as possible, so that one appeal out-pleads and eliminates the next appeal. And people come to depend upon this impersonal noise as a proof of being alive!

Imagine then what happens when somebody comes upon the silence of the Fayum faces and stops short. Images of men and women making no appeal whatsoever, asking for nothing, yet declaring themselves, and anybody who is looking at them, alive! They incarnate, frail as they are, a forgotten self-respect. They confirm, despite everything, that life was and is a gift.

There is a second reason why the Fayum portraits speak today. This century, as has been pointed out many times, is *the* century of emigration, enforced and voluntary. That is to say, a century of partings without end, and a century haunted by the memories of those partings.

The sudden anguish of missing what is no longer there is like suddenly coming upon a jar which has fallen and broken into fragments. Alone you collect the pieces, discover how to fit them together, and then carefully stick them to one another, one by one. Eventually the jar is reassembled, but it is not the same as it was before. It has become both flawed and more precious. Something comparable happens to the image of a loved place or a loved person when kept in the memory after separation.

The Fayum portraits touch a similar wound in a similar way. The painted faces, too, are flawed, and more precious than the living one was, sitting there in the painter's workshop, where there was a smell of melting beeswax. Flawed because very evidently hand-made. More precious because the painted gaze is entirely concentrated on the life it knows it will one day lose.

And so they gaze on us, the Fayum portraits, like the missing of our own century.

3.

Piero della Francesca
(c. 1415–92)

AFTER READING BRECHT'S *Galileo* I was thinking about the scientist's social predicament. And it struck me then how different the artist's predicament is. The scientist can either reveal or hide the facts which, supporting his new hypothesis, take him nearer to the truth. If he has to fight, he can fight with his back to the evidence. But for the artist the truth is variable. He deals only with the particular version, the particular way of looking that he has selected. The artist has nothing to put his back against – except his own decisions.

It is this arbitrary and personal element in art which makes it so difficult for us to be certain that we are accurately following the artist's own calculations or fully understanding the sequence of his reasoning. Before most works of art, as with trees, we can see and assess only a section of the whole: the roots are invisible. Today this mysterious element is exploited and abused. Many contemporary works are almost entirely subterranean. And so it is refreshing and encouraging to look at the work of the man who probably hid less than any other artist ever: Piero della Francesca.

Berenson praises 'the ineloquence' of Piero's paintings:

In the long run, the most satisfactory creations are those which, like Piero's and Cézanne's, remain ineloquent, mute, with no

urgent communication to make, and no thought of rousing us with look or gesture.

This ineloquence is true so far as Piero's protagonists are concerned. But in inverse ratio to how little his paintings say in terms of drama, they say volumes about the working of his own mind. I don't mean they reveal his psychology. They reveal the processes of his conscious thought. They are open lessons in the logic of creating order. And possibly the inverse ratio exists because, just as the aim of the machine is economy of effort, the aim of systematic thought is economy of thought. Anyway it remains true that before a Piero you can be quite sure that any correspondence or coincidence which you discover is deliberate. Everything has been calculated. Interpretations have changed, and will change again. But the elements of the painting have been fixed for good and with comprehensive forethought.

If you study all Piero's major works, their internal evidence will lead you to this conclusion. But there is also external evidence. We know that Piero worked exceptionally slowly. We know he was a mathematician as well as a painter, and that at the end of his life, when he

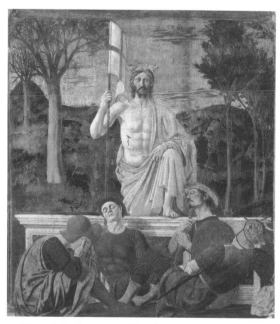

Piero della Francesca, *The Resurrection*, 1467–68

was too blind to paint, he published two mathematical treatises. We can also compare his works to those of his assistants: the works of the latter are equally undemonstrative, but this, instead of making them portentous, makes them lifeless. Life in Piero's art is born of his unique power of calculation.

This may at first sound coldly cerebral. However, let us look further – at the *Resurrection* in Piero's home town of San Sepolcro. When the door of the small, rather scruffy municipal hall is first opened and you see this fresco between two fictitious, painted pillars, opening out in front of you, your instinct is somehow to freeze. Your hush has nothing to do with any ostentatious reverence before art or Christ. It is because looking between the pillars you become aware of time and space being locked in a perfect equilibrium. You stay still for the same reason as you do when you are watching a tightrope walker – the equilibrium is that fine. Yet how? Why? Would a diagram of the structure of a crystal affect you in the same way? No. There is more here than abstract harmony. The images convincingly represent men, trees, hills, helmets, stones. And one knows that such things grow, develop, and have a life of their own, just as one knows that the acrobat can fall. Consequently, when here their forms are made to exist in perfect correspondence, you can only feel that all that has previously occurred to them, has occurred in preparation for this presented moment. Such a painting makes the present the apex of the whole past. Just as the very basic theme of poetry is that of time passing, the very basic theme of painting is that of the moment made permanent.

This is one of the reasons why Piero's calculations were not so cold, why – when we notice how the left soldier's helmet echoes the hill behind him, how the same irregular shield-shape occurs about ten times throughout the painting (count them), or how Christ's staff marks in ground plan the point of the angle formed by the two lines of trees – why we are not merely fascinated but profoundly moved. Yet it is not the only reason. Piero's patient and silent calculations went much further than the pure harmonies of design.

Look, for instance, at the overall composition of this work. Its centre, though not of course its true centre, is Christ's hand, holding his robe as he rises up. The hand furrows the material with emphatic force. This is no casual gesture. It appears to be central to Christ's

whole upward movement out of the tomb. The hand, resting on the knee, also rests on the brow of the first line of hills behind, and the folds of the robe flow down like streams. Downwards. Look now at the soldiers so mundanely, so convincingly asleep. Only the one on the extreme right appears somewhat awkward. His legs, his arm between them, his curved back are understandable. Yet how can he rest like that just on one arm? This apparent awkwardness gives a clue. He looks as though he were lying in an invisible hammock. Strung from where? Suddenly go back to the hand, and now see that all four soldiers

Piero, *The Resurrection* (detail)

lie in an invisible net, trawled by that hand. The emphatic grip makes perfect sense. The four heavy sleeping soldiers are the catch the resurrecting Christ has brought with him from the underworld, from Death. As I said, Piero went far beyond the pure harmonies of design.

There is in all his work an aim behind his calculations. This aim could be summed up in the same way as Henri Poincaré once described the aim of mathematics:

> Mathematics is the art of giving the same name to different things. . . . When language has been well chosen one is astonished to find that all demonstrations made for a known object apply immediately to many new objects.

Piero's language is visual, not mathematical. It is well chosen because it is based on the selection of superb drawing. Nevertheless, when he connects, by means of composition, a foot with the base of a tree, a foreshortened face with a foreshortened hill, or sleep with death, he does so in order to emphasise their common factors – or, more accurately still, to emphasise the extent to which they are subject to the same physical laws. His special concern with space and perspective is dependent on this aim. The necessity of existing in space is the first

common factor. And this is why perspective had so deep a *content* for Piero. For nearly all his contemporaries it remained a technique of painting.

His 'ineloquence', as already hinted, is also connected with the same aim. He paints everything in the same way so that the common laws which govern them may be more easily seen. The correspondences in Piero's works are endless. He did not have to invent them, he only had to find them. Cloth to flesh, hair to foliage, a finger to a leg, a tent to a womb, men to women, dress to architecture, folds to water – but somehow the list misses the point. Piero is not dealing in metaphors – although the poet in this respect is not so far removed from the scientist: he is dealing in common causes. He explains the world. All the past has led to this moment. And the laws of this convergence are the true content of his art.

Or so it seems. But in fact how could this be possible? A painting is not a treatise. The logic of its measuring is different. Science in the second half of the fifteenth century lacked many concepts and much information which we now find necessary. So how is it that Piero remained convincing, whilst his contemporary astronomers have not?

Look again at Piero's faces, the ones that watch us. Nothing corresponds to their eyes. Their eyes are separate and unique. It is as though everything around them, the landscape, their own faces, the nose between them, the hair above them, belonged to the explicable, indeed the already explained world: and as though these eyes were looking from the outside through two slits on to this world. And there is our last clue – in the unwavering, speculative eyes of Piero's watchers. What in fact he is painting is a state of mind. He paints what the world would be like if we could fully explain it, if we could be entirely at one with it. He is the supreme painter of *knowledge*. As acquired through the methods of science, or – and this makes more sense than seems likely – as acquired through happiness. During the centuries when science was considered the antithesis of art, and art the antithesis of well-being, Piero was ignored. Today we need him again.

4.

Antonello da Messina
(c. 1430–79)

I WAS IN London on Good Friday, 2008. And I decided, early in the morning, to go to the National Gallery and look at the Crucifixion by Antonello da Messina. It's the most solitary painting of the scene that I know. The least allegorical.

In Antonello's work – and there are fewer than forty paintings which are indisputably his – there's a special Sicilian sense of thereness which is without measure, which refuses moderation or self-protection. You can hear the same thing in these words spoken by a fisherman from the coast near Palermo, and recorded by Danilo Dolci a few decades ago in *Sicilian Lives* (1981):

> There's times I see the stars at night, especially when we're out for eels, and I get thinking in my brain. 'The world is it really real?' Me, I can't believe that. If I get calm, I can believe in Jesus. Badmouth Jesus Christ and I'll kill you. But there's times I won't believe, not even in God. 'If God really exists, why doesn't He give me a break and a job?'

In a Pietà painted by Antonello – it's now in the Prado – the dead Christ is held by one helpless angel, who rests his head against Christ's head. The most piteous angel in painting.

Sicily, island which admits passion and refuses illusions.

I took the bus to Trafalgar Square. I don't know how many hundred times I've climbed the steps from the square that lead up to the National Gallery and to a view, before you enter, of the fountains seen from above. The square, unlike many notorious city assembly points – such as the Bastille in Paris – is, despite its name, oddly indifferent to history. Neither memories nor hopes leave a trace there.

In 1942 I climbed the steps to go to piano recitals given in the gallery by Myra Hess. Most of the paintings had been evacuated because of the air raids. She played Bach. The concerts were at midday. Listening, we were as silent as the few paintings on the walls. The piano notes and chords seemed to us like a bouquet of flowers held together by a wire of death. We took in the vivid bouquet and ignored the wire.

It was the same year, 1942, that Londoners first heard on the radio – in the summer, I think – Shostakovich's Seventh Symphony, dedicated to besieged Leningrad. He had begun composing it in the city during the siege in 1941. For some of us the symphony was a prophecy. Hearing it, we told ourselves that the resistance of Leningrad, now being followed by that of Stalingrad, would finally lead to the Wehrmacht's defeat by the Red Army. And this is what happened.

Strange how in wartime music is one of the very few things which seem indestructible.

I find the Antonello Crucifixion easily, hung at eye-level, left of the entry to the room. What is so striking about the heads and bodies he painted is not simply their solidity,

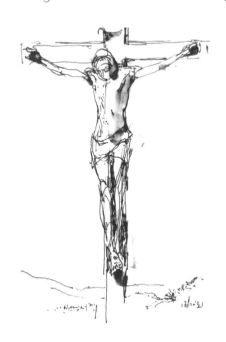

Author's work , from *Bento's Sketchbook,* 2011

but the way the surrounding painted space exerts a pressure on them and the way they then resist this pressure. It is this resistance which makes them so undeniably and physically present. After looking for a long while, I decide to try to draw only the figure of Christ.

A little to the right of the painting, near the entry, there is a chair. Every exhibition room has one and they are for the official gallery attendants, who keep an eye on the visitors, warn them if they go too close to a painting, and answer questions.

As an impecunious student I used to wonder how the attendants were recruited. Could I apply? No. They were elderly. Some women but more men. Was it a job offered to certain city employees before retirement? Did they volunteer? Anyway, they come to know some paintings like their own back gardens. I overheard conversations like this:

'Can you tell us, please, where the works by Velázquez are?'

'Yes, yes. Spanish School. In Room Twenty-three. Straight on, turn right at the end, then take the second on your left.'

'We're looking for his portrait of a stag.'

'A stag? That's to say a male deer?'

'Yes, only his head.'

'We have two portraits of Philip the Fourth – and in one of them his magnificent moustache curls upwards, like antlers do. But no stag, I'm afraid.'

'How odd!'

'Perhaps your stag is in Madrid. What you shouldn't miss here is *Christ in the House of Martha.* Martha's preparing a sauce for some fish, pounding garlic with a pestle and mortar.'

'We were in the Prado but there was no stag there. What a pity!'

'And don't miss our *Rokeby Venus.* The back of her left knee is something.'

The attendants always have two or three rooms to survey and so they wander from one room to another. The chair beside the Crucifixion is for the moment empty. After taking out my sketchbook, a pen, and a handkerchief, I carefully place my small shoulder bag on the chair.

I start drawing. Correcting error after error. Some trivial. Some not. The crucial question is the scale of the cross on the page. If this is not

right, the surrounding space will exert no pressure, and there'll be no resistance. I'm drawing with ink and wetting my index finger with spit. Bad beginning. I turn the page and restart.

I won't make the same mistake again. I'll make others, of course. I draw, correct, draw.

Antonello painted, in all, four Crucifixions. The scene he returned to most, however, was that of Ecce Homo, where Christ, released by Pontius Pilate, is put on display and mocked, and hears the Jewish high priests calling for his Crucifixion.

He painted six versions. All of them close-up portraits of Christ's head, solid in suffering. Both the face and painting of the face are unflinching. The same lucid Sicilian tradition of taking the measure of things – without either sentimentality or flattery.

'Does the bag on the chair belong to you?'

I glance sideways. An armed security guard is scowling and pointing at the chair.

'Yes, it's mine.'

'It's not your chair!'

'I know. I put my bag there because nobody was sitting on it. I'll remove it straight away.'

I pick up the bag, take one step left to the painting, place the bag between my feet on the floor, and re-look at my drawing.

'That bag of yours cannot stay on the floor.'

'You can search it – here's my wallet and here are things to draw with, nothing else.'

I hold the bag open. He turns his back.

I put the bag down and start drawing again. The body on the cross for all its solidity is so thin. Thinner than one can imagine before drawing it.

'I'm warning you. That bag cannot stay on the floor.'

'I've come to draw this painting because it's Good Friday.'

'It's forbidden.'

I continue drawing.

'If you persist,' the security guard says, 'I'll call the Super.'

I hold the drawing up so he can see it.

He's in his forties. Stocky. With small eyes. Or eyes that he makes small with his head thrust forward.

'Ten minutes,' I say, 'and I'll have finished it.'

'I'm calling the Super now,' he says.

'Listen,' I reply, 'if we have to call, let's call somebody from the gallery staff and with a bit of luck they'll explain that it's OK.'

'Gallery staff have nothing to do with us,' he mutters, 'we're independent and our job is security.'

Security, my arse! But I don't say it.

He starts to pace slowly up and down like a sentry. I draw. I'm drawing the feet now.

'I count to six,' he says, 'then I call.'

He's holding his cell phone to his mouth.

'One!'

I'm licking my finger to make grey.

'Two!'

I smudge the ink on the paper with my finger to mark the dark hollow of one hand.

'Three!'

The other hand.

'Four!' He strides towards me.

'Five! Put your bag on your shoulder.'

I explain to him that, given the size of the sketch pad, if I do this, I can't draw.

'Bag on your shoulder!'

He picks it up and holds it in front of my face.

I close the pen, take the bag, and I say 'Fuck' out loud.

'Fuck!'

His eyes open and he shakes his head, smiling.

'Obscene language in a public place,' he announces, 'nothing less. The Super's coming.'

Relaxed, he circles the room slowly.

I drop the bag on the floor, take out my pen, and take another look at the drawing. The ground has to be there to limit the sky. With a few touches I indicate the earth.

In an Annunciation painted by Antonello, the Virgin stands before a shelf on which there is an open Bible. There's no angel. A head-and-shoulders portrait of Mary. The fingers of her two hands placed against her heart are splayed open like the pages of the prophetic book. The prophecy passes between her fingers.

21

When the Super arrives, he stands, arms akimbo, more or less behind me, to announce: 'You will leave the gallery under escort. You have insulted one of my men who was doing his job, and you have shouted obscene words in a public institution. You will now walk in front of us to the main exit. I take it you know the way.'

They escort me down the steps into the square. There they leave me, and energetically jog up the steps, mission accomplished.

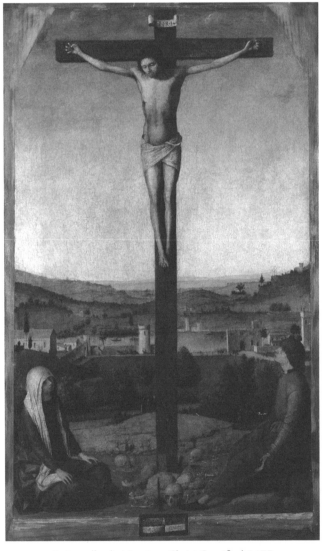

Antonello da Messina, *Christ Crucified*, 1475

5.

Andrea Mantegna
(1430/1–1506)

JOHN BERGER: *How to begin . . . ?*

KATYA BERGER: Let's talk about oblivion.

Is oblivion nothingness?

No. Nothingness is formless and oblivion is circular.

What colour? Blue?

Oblivion doesn't need paint, it sculpts, oblivion leaves traces, like little white pebbles. Nothingness is before and after any pebbles or memory.

The whole of everything can only be grasped by oblivion. This is why oblivion, unlike forgetfulness, has its own accuracy.

Oblivion is survival.

Is oblivion a faculty lent by sleep to wakefulness?

No, oblivion isn't a loan from sleep. Sleep is creative, and oblivion grinds to the bone, penetrates, conserves, reduces to earth.

Maybe oblivion erases not choice but causality. And we are more often mistaken about causes than about choices.

We are the precipitates of what our parents couldn't forget. We are what is left. The world – and our words, like the ones we are saying here – is what is left from everything that has been dispersed. To be oblivious is to travel to the essence which remains. The stone.

Oblivion is a warrant for the future. Everyone is everyone without recognising it. And so they are condemned, until they are modest enough to grasp this fact as oblivion. Everyone is everyone.

Memory and oblivion are not opposites, together they make a whole.

Are the clouds in the Oculo like oblivion?

Yes.

A *painted room* whose paintings *are addressed to somebody* who has just woken, *or is about to sleep.*
 The room is in the Ducal Palace, Mantua. The palace is a seat of power. Imposing. Even brutal. The room by contrast is intimate. It was

Andrea Mantegna, ceiling of Camera degli Sposi, 1465–74

24

conceived as a private room where the prince could receive visitors, in which there was also a matrimonial bed. The paintings were commissioned by the Marquis Ludovico Gonzaga and painted over a period of ten years (1465–74) by Andrea Mantegna.

When it was finished, it was said to be 'the most beautiful room in the world'.

The bed was placed in the south-west corner of the room. On the wall to the left of the bed is painted an outdoor scene with many figures. It's entitled The Meeting, *because it shows Duke Ludovico Gonzaga meeting his son, Cardinal Francesco, and receiving a letter he is bringing him.*

On the wall facing the foot of the bed is an indoor scene of courtiers, in which the Duke holds the letter he has received, and read, and is showing it to his wife.

On the ceiling above the bed is a painted dome which opens on to a painted sky. It's called the Oculus, which means 'the Eye'.

The whole room is painted. We're inside a painting. The two other walls are painted, covered with floral decorations. And so are the curtains that frame and separate those scenes, and the pillars and mouldings on the walls. Everything is painted.

All is representation. We know they are painted curtains. We know they are painted figures, painted sky, painted hills. Everything is surface.

We might pull the painted curtain and hide the painted landscape.

We might open the painted curtain and see the painted landscape next morning.

Mantegna signed the painted room and left his self-portrait among the painted scrolls that decorate one corner of the room.

Here everything is both presented by and hidden in painting.

And so nothing is as stark as the body next to you in bed.

As W. H. Auden wrote five centuries later:

> Lay your sleeping head, my love,
> Human on my faithless arm;
> Time and fevers burn away
> Individual beauty from
> Thoughtful children, and the grave
> Proves the child ephemeral;
> But in my arms till break of day
> Let the living creature lie,
> Mortal, guilty, but to me
> The entirely beautiful.

What is the strategy of the painted room? How does it want to surprise us?

[Katya turns the Oculo to white.]

Mantegna, *The Dead Christ,* 1480

Mantegna was (is) famous for his innovations concerning foreshortening and perspective. Perhaps the most startling example is his *Dead Christ.*

[Projection of *Dead Christ*, Brera, Milano, upon the Oculus panel.]

Remember how we saw it together?

We lay down, one after the other, on the floor of the Brera Museum, in Milan, before the *Dead Christ*, to discover the probable eye-level of the painter, and thus the ideal eye-level for the spectator. The one of us on the floor acted the body, and the other one the painter. We wondered whether, in the Mantegna, the head wasn't slightly too large and the feet a little too small.

Mission accomplished, we saw that there was no error in the proportions, and that the painter was looking down on everything, his eye-level the same as that of the humble third mourner, a little above the two Marys on the left. One could draw a triangle between Christ's head, his pierced feet (strange in English, the echo between sole and soul), and, at the apex of the triangle, the viewer's eye – coinciding with that of the third mourner. [As John speaks, Katya indicates.]

[End of projection of *Dead Christ*. John turns panel back to the Oculo.]

Is there some kind of equivalence between Mantegna's preoccupation, obsession with spatial perspective, particularly in relation to the human body, and a sense of time passing, a temporal perspective? The little angels in the Oculus painting, with their rippling tummies touching their chins, with a tit tickling a lower lip, a pair of buttocks bursting out of a pair of shoulder blades, just beneath a head of curly hair, do they, despite their frivolity, have something to do with a vision of History?

Yes. His fascination for, his intrigue with spatial perspective is inseparable from his insistence on a temporal perspective.

Look at the faces everywhere on these painted walls. Have you ever seen wrinkles, lines on faces better rendered? Have you ever seen

painted wrinkles which are so alive – or, rather, which have been so lived? I've never seen anywhere else such a precise observation of the way time makes its mark on foreheads, eyelids, jowls, or chins.

What time does to a face, in any of the many portraits he made, has rarely been delineated with more vehemence. With other painters, it usually only occurs when the subject, the theme of the image, is 'old age', whereas in Mantegna's painted faces, he makes us see the work of time whatever the age of the sitter. (Amongst his contemporaries there were, it seems, some who were uneasy about being painted by him.)

Consider all the buildings in the landscape which we see through the arch of the fresco called *The Meeting*. They are there under the sky, one after another: a tower in ruins, a tower being built – with tiny workers on the scaffolding. Everywhere a remnant from the past and a plan for the future. Is this not, as well, a form of *perspective*? There is no other term for it . . . If Mantegna hadn't been a painter, he might have been an architect, or a historian, or a geriatrician – or a midwife! [As Katya speaks, John indicates.]

Mantegna, perhaps more than many other Renaissance painters, was devoted to and obsessed by the notion of Antiquity. But to understand what that meant, we have to make an imaginative leap and leave behind modernity, with its promise of continual progress.

There was nothing nostalgic in the Renaissance attachment to Antiquity. Antiquity with its models offered a guide to achieving fully human behaviour. It was exemplary in the strict sense of the word – insofar as it offered in its stories, its reflections, its art, examples of human wisdom, justice, and dignity. Examples which were to be followed, but continually risked to be forgotten.

The past offered rather more promises to the present than the future did. Or, to put it in another way, the more the world left the act of its creation behind, the more confused it would become, unless it studied and learnt from its prototypes which now had to be seen as archetypes.

Mantegna had his own personal collection of antique statues. He drew them. And perhaps they played a part in his fascination for foreshortening. You can move statues around, lie them on the floor, draw them from any point of view.

Yet despite all this experience and observation, the standing life-size figures who surround the bed are inherently immobile.

Right from the beginning, when Mantegna was recognised as a master, people commented on the fact that he painted rocks and human bodies in the same spirit : that for him the existent was first and essentially mineral.

Yes, there's something very mineral in Mantegna's paintings, but I don't see figures being cast, molten, from some giant cauldron; rather, I see a stone or a metal surface, worn, dented, scratched, resistant, a surface reflecting all the different aspects of human experience subject to the flow of time. As if for him the four essential elements weren't air, earth, water, and fire, but stone – or, to be more precise, metal: iron, copper, tin, gold.

The most familiar natural coating, for Mantegna, was rust. And since the fifteenth century, time has worked for him. Under his colours there resided, even in the year 1500, and more so in the year 2000, the colour of rusted metals.

No, not always: in his painting of human scenes, yes. But amongst the angels, in the sky of the Oculus, there is no place for rust. Humans support both the weight of metal and its ageing, its deterioration, a deterioration that brings a certain beauty. Mantegna painted the wrinkles, the lines of faces and their oxidation, revealed by that very special tint, somewhere between green and orange, that metals slowly acquire with time.

There's the colour of rust, *and there's weight.* Metals are heavy.

[John turns the panel to white.]

It's revealing to compare Mantegna with his brother-in-law Giovanni Bellini.

[Projection of the *Madonna and Child* by Giovanni Bellini on to the white side of the panel.]

Giovanni Bellini and Andrea Mantegna were almost exactly the same age. Mantegna married Giovanni's and Gentile's sister. They made versions of each other's paintings and influenced one another. Yet they were so different. Giovanni lived to the age of eighty-six and all his paintings look young; not immature, not tentative, not derivative, but gently full of appetite, or appetites.

And Andrea, even when he was a seventeen-year-old prodigy, was painting like an old man. What he paints is premeditated, patiently weighed up, measured. I don't know any other painter in European art who is older than him.

[End of projection of the *Madonna and Child*.]

There's a sculpture by Mantegna, discovered about twenty years ago. A standing, life-size figure, carved in marble from near Padova, of Saint Euphemia.

She has put her right hand into the jaws of a lion who does not bite but licks her fingers. She's fifteen years old. A young woman wearing elegant clothes. Her face is smooth, utterly unlined. Her expression is that of somebody waiting for the rest of the news she is hearing or witnessing.

Saint Euphemia was a third-century martyr from Asia Minor. She intervened with a local Roman governor on behalf of Christians who were being tortured and thrown to the lions. Take me first!, she commanded. And her composure was such that the other victims became calm and re-found courage. The legend is that when Euphemia was thrown to the wild beasts, they, instead of devouring her, made a hammock with their tails for her.

The expression of the sculptured head of the fifteen-year-old saint has something in common with the old man's look which I was attributing to our painter. The same distance and attentiveness. The same concern for details and the same foreknowledge about the end of all stories. A similar composure.

[Projection of the sculpture of Saint Euphemia upon the white side of the panel.]

We saw her original statue in the Mantegna exhibition at the Louvre, *Saint Euphemia*, determined and a little astounded, her hand, calm

and safe in the jaws of a lion – jaws that are almost hidden behind the hand to which is done no harm. Her fingers, perhaps also the fall of her dress, attract all of our attention. No, not all. My gaze wanders down to the spot where the two creatures – virgin and animal – really merge and come together: their feet. The long toes of their four feet, so similar to each other. Similar in their very Being, in their strangely controlled wildness.

[End of projection of *Saint Euphemia.*]

And so I went through the entire exhibition, at the Louvre, guided by a hunch: Mantegna being somehow fixated on feet. In Vienna, four centuries later, they could have labelled him a foot fetishist! Why feet? Because feet say so much about standing upright and the human condition. They articulate, they carry and transport.

They are the human signature at the bottom of the body.

At the bottom of the page.
 I went to look at *Judith with Her Servant Abra*. The two women have just come out of Holofernes's tent. Judith is handing the general's chopped-off head to her old servant, who is holding open a sack. So: on the left of the painting, one sees this man's head, long-haired and bloody. And on the right? A bed, on which one supposes Holofernes was sleeping before he was attacked. And on the bed there is only a foot visible. Holofernes's foot. We see nothing but the head and foot of the man's body, and they are separated, the spiritual bit and the terrestrial bit. One celestial, the other mineral.
 Other paintings, which were not in the exhibition, come to mind. Above all, of course, the *Dead Christ*, whose feet are in the foreground, as important as his head.

[John turns the panel back to the Oculo.]

I thought of his flying angels whose feet and legs are so emphatic. I thought of his Disciples asleep on the Mount of Olives. Mantegna, with his perspective and foreshortening, seldom missed a chance of tilting our verticality, and thus questioning our priorities!

His passion for Antiquity often led him to put the past in front of the present and future – the future which is symbolised by all the building that takes place in the background of his paintings. He liked to reverse the usual order of things. Head over heels!

Foot. Link between man and ground, hinge between heaven and hell, anchor, plinth, point of balance, the animal sign more distinct than any other.

If I've counted correctly, along the very bottom edge of the two wall frescoes in the *Bridal Chamber*, there are twenty-five human and animal feet. A little behind them are more. The very frontier between the painted scenes and the lived-in room is lined with feet. Moreover, all the human feet – except those of the messenger from afar who has delivered the letter to the Duke – are without shoes. Stockinged feet, dog paws, and a horse's hooves.

This bedroom, designed for a bed on which we lie down, on which we put our feet up so they are level with our heads! [John and Katya get up as they speak.]

[They lie back on the sheet and look at the ceiling.]

There is no more weight. The heaviness of metal is behind us. The force of gravity is absent. Or, if it's still there (our backs are still pressing against the mattress), it's been transcended by a force of attraction, by the invitation to ascend.

Isn't the sleep, which the room offers to the sleeper, trying to do something extraordinary? To bring together the totality of a moment?

One moment.

With its relics from the past, its building sites, and all its different activities, its juxtaposition of daylight and night time, its plants, its animals in mid-movement, the degrees in social standing of all the people present, the details in their clothes, the expressions on their faces, their wrinkles, their whispered asides, their roving looks – and all of it, the whole of it, beneath a sky of little angels, and a cloud.

The sleeper in this room can close her or his eyes on such a sight, reconciled with all the endlessly complicated layers and strata of the real.

And going to sleep, the sleeper will have around her or him, the example, the demonstration of an artist who had the courage, yes, the courage, to consider and accept and include all those simultaneous strata.

Mantegna, like a botanist who takes a specimen from all the plants he comes across. Painted upon the four walls: apricot, orange, lemon, pear, peach, apple, and pomegranate trees, cedars, plane trees, acanthus, pine trees. Mantegna, who sets out to embrace the totality of what the world offers at a given moment.

Only Man separates and gives a pecking order to all these strata and processes and time-flows. And the apparatus he has for doing this, which forces him to do this, is his ego. This apparatus, the ego, designed by nature for man as a mean for his survival, corresponds with nothing else in nature! It's his most mortal part. When a man dies, only this part, only this chopping-up apparatus, disappears. Everything else is recycled. [John and Katja together:] Everyone is everyone.

Last night I had a dream. I was carrying a large shoulder bag – like postmen used to have when delivering letters. I'm not sure whether it was of leather or canvas. Probably plastic. In it were all Mantegna's paintings (one hundred and twelve). Not his frescoes. I was taking them out of the bag, one after another, to look at, and I was doing this lightly (neither they nor the bag had any weight), doing it with pleasure, in order to come to a decision or a conclusion. About what ? I didn't know. I awoke happily.

The Oculus we're now looking into is not proposing an escape, an evasion. Mantegna with his painstaking application and his lifelong courage continually insisted upon facing the real, on not looking away from what happens. It proposes dissolving into.

There is, in this room decorated for sleeping in, something of Death. This something is neither rigid nor morbid. It's to do with the example

of a painter who knew how to exclude himself, bravely, yes, in order to observe the infinite number of events and moments which constitute the world.

Mantegna counts them, adds them up obstinately, brings them together, makes a whole of them. A sum total. He knows how to dissolve. He dissolves himself, he dissolves us in nature. And I dream here of closing my eyes for good, lying down within these four walls which dare to sum up all that is on earth, beyond human perception.

6.

Hieronymous Bosch
(c. 1450–1516)

IN THE HISTORY of painting one can sometimes find strange prophe-
cies. Prophecies that were not intended as such by the painter. It is
almost as if the visible by itself can have its own nightmares. For exam-
ple, in Bruegel's *Triumph of Death*, painted in the 1560s and now in
the Prado Museum, there is already a terrible prophecy of the Nazi
extermination camps.

Most prophecies, when specific, are bound to be bad, for, through-
out history, there are always new terrors – even if a few disappear, yet
there are no new happinesses – happiness is always the old one. It is
the modes of struggle for this happiness which change.

Half a century before Bruegel, Hieronymus Bosch painted his
Millennium Triptych, which is also in the Prado. The left-hand panel
of the triptych shows Adam and Eve in Paradise, the large central
panel describes the Garden of Earthly Delights, and the right-hand
panel depicts Hell. And this hell has become a strange prophecy of the
mental climate imposed on the world at the end of our century by
globalisation and the new economic order.

Let me try to explain how. It has little to do with the symbolism
employed in the painting. Bosch's symbols probably came from the
secret, proverbial, heretical language of certain fifteenth-century

Hieronymus Bosch, *The Garden of Earthly Delights,* 1500–5

millennial sects, who heretically believed that, if evil could be over-come, it was possible to build heaven on earth! Many essays have been written about the allegories to be found in his work.[1] Yet if Bosch's vision of hell is prophetic, the prophecy is not so much in the details – haunting and grotesque as they are – but in the whole. Or, to put it another way, in what constitutes the *space* of hell.

There is no horizon there. There is no continuity between actions, there are no pauses, no paths, no pattern, no past, and no future. There is only the clamour of the disparate, fragmentary present. Everywhere there are surprises and sensations, yet nowhere is there any outcome. Nothing flows through: everything interrupts. There is a kind of spatial delirium.

Compare this space to what one sees in the average publicity slot, or in a typical CNN news bulletin, or any mass media news commentary. There is a comparable incoherence, a comparable wilderness of separate excitements, a similar frenzy.

Bosch's prophecy was of the world-picture which is communicated to us today by the media under the impact of globalisation, with its delinquent need to sell incessantly. Both are like a puzzle whose wretched pieces do not fit together.

1 One of the most original, even if contested, is *The Millennium of Hieronymus Bosch* by Wilhelm Franger (Faber & Faber).

And this was precisely the term that Subcomandante Marcos used in a letter about the new world order last year . . . He was writing from Chiapas, south-east Mexico.[2] He sees the planet today as the battlefield of a Fourth World War. (The Third was the so-called Cold War.) The aim of the belligerents is the conquest of the entire world through the market. The arsenals are financial; there are nevertheless millions of people being maimed or killed every moment. The aim of those waging the war is to rule the world from new, abstract power centres – megapoles of the market, which will be subject to no control except that of the logic of investment. Meanwhile nine-tenths of the women and men living on the planet live with the jagged pieces that do not fit.

The jaggedness in Bosch's panel is so similar that I half expect to find there the seven pieces that Marcos named.

The first piece he named has a dollar sign on it and is green. The piece consists of the new concentration of global wealth in fewer and fewer hands and the unprecedented extension of hopeless poverties.

The second piece is triangular and consists of a lie. The new order claims to rationalise and modernise production and human endeavour. In reality it is a return to the barbarism of the beginnings of the industrial revolution, with the important difference this time round that the barbarism is unchecked by any opposing ethical consideration or principle. The new order is fanatical and totalitarian. (Within its own system there are no appeals. Its totalitarianism does not concern politics – which, by its reckoning, have been superseded – but global monetary control.) Consider the children. One hundred million in the world live in the street. Two hundred million are engaged in the global labour force.

The third piece is round like a vicious circle. It consists of enforced emigration. The more enterprising of those who have nothing try to emigrate to survive. Yet the new order works night and day according to the principle that anybody who does not produce, who does not consume, and who has no money to put into a bank, is redundant. So

2 This letter was published in August 1997 throughout the world press, and notably in *Le Monde Diplomatique*, Paris.

the emigrants, the landless, the homeless are treated as the waste matter of the system: to be eliminated.

The fourth piece is rectangular like a mirror. It consists of an ongoing exchange between the commercial banks and the world racketeers, for crime too has been globalised.

The fifth piece is more or less a pentagon. It consists of physical repression. The Nation States under the new order have lost their economic independence, their political initiative, and their sovereignty. (The new rhetoric of most politicians is an attempt to disguise their political, as distinct from civic or repressive, powerlessness.) The new task of the Nation States is to manage what is allotted to them, to protect the interests of the market's mega-enterprises and, above all, to control and police the redundant.

The sixth piece is the shape of a scribble and consists of breakages. On one hand, the new order does away with frontiers and distances by the instantaneous telecommunication of exchanges and deals, by obligatory free trade zones (NAFTA), and by the imposition everywhere of the single unquestionable law of the market; and on the other hand, it provokes fragmentation and the *proliferation* of frontiers by its undermining of the Nation State – for example, the former Soviet Union, Yugoslavia, etc. 'A world of broken mirrors,' wrote Marcos, 'reflecting the useless unity of the neoliberal puzzle.'

The seventh piece of the puzzle has the shape of a pocket, and consists of all the various pockets of resistance against the new order which are developing across the globe. The Zapatistas in south-east Mexico are one such pocket. Others, in different circumstances, have not necessarily chosen armed resistance. The many pockets do not have a common political programme as such. How could they, existing as they do in the broken puzzle? Yet their heterogeneity may be a promise. What they have in common is their defence of the redundant, the next-to-be-eliminated, and their belief that the Fourth World War is a crime against humanity.

The seven pieces will never fit together to make any sense. This lack of sense, this absurdity, is endemic to the new order. As Bosch foresaw in his vision of hell, there is no horizon. The world is burning.

Every figure is trying to survive by concentrating on his own immediate need and survival. Claustrophobia, at its most extreme, is not caused by overcrowding, but by the lack of any continuity existing between one action and the next that is close enough to be touching it. It is this that is hell.

The culture in which we live is perhaps the most claustrophobic that has ever existed; in the culture of globalisation, as in Bosch's hell, there is no glimpse of an *elsewhere* or an *otherwise*. The given is a prison. And faced with such reductionism, human intelligence is reduced to greed.

Marcos ended his letter by saying: 'It is necessary to build a new world, a world capable of containing many worlds, capable of containing all worlds.'

What the painting by Bosch does is to remind us – if prophecies can be called reminders – that the first step towards building an alternative world has to be a refusal of the world-picture implanted in our minds and all the false promises used everywhere to justify and idealise the delinquent and insatiable need to sell. Another space is vitally necessary.

First, an horizon has to be discovered. And for this we have to refind hope – against all the odds of what the new order pretends and perpetrates.

Hope, however, is an act of faith and has to be sustained by other concrete actions. For example, the action of *approach*, of measuring distances and *walking towards*. This will lead to collaborations which deny discontinuity. The act of resistance means not only refusing to accept the absurdity of the world-picture offered us, but denouncing it. And when hell is denounced from within, it ceases to be hell.

In pockets of resistance as they exist today, the other two panels of Bosch's triptych, showing Adam and Eve and the Garden of Earthly Delights, can be studied by torchlight in the dark . . . we need them.

I would like to quote again the Argentinian poet Juan Gelman.[3]

3 Juan Gelman, *Unthinkable Tenderness*, translated from the Spanish by Joan Lindgren (University of California Press, 1997).

death itself has come with its documentation
we're going to take up again
the struggle
again we're going to begin
again we're going to begin all of us

against the great defeat of the world
little *compañeros* who never end
or
who burn like fire in the memory
again
and again
and again.

7.

Pieter Bruegel the Elder
(c. 1525–69)

WE ALL FEEL better when we think of Leonardo da Vinci. Leonardo represents the heights of human aspiration clouded in mystery (or other words to that effect). Rembrandt serves us contrariwise. Rembrandt represents the dark suffering of genius. We all become forgiving about those who have misunderstood us, when we think of Rembrandt. Thus we force art to console us, and repay it by calling it beautiful.

Of all the great artists the most recalcitrant for this purpose is Bruegel. It is true that he is often presented as the painter of jolly peasants dancing and simple white Christmases. But we are never able to borrow the example of his genius or quote his passion. Indeed, neither is usually mentioned, and there remains in our minds the ghost of an idea, which we would never be so brash as to mention – Bruegel was perhaps just a little too simple.

The awkward truth is that he was the most unforgiving artist who ever lived. In picture after picture Bruegel collected the evidence for a prosecution which he had no sure reason for believing would ever be mounted.

The charge he wanted brought was that of indifference. The indifference of the peasant ploughing to Icarus falling; the indifference of the crowd hurrying to gape at the Crucifixion; the indifference

of the Spanish soldiers (they were only obeying orders) to the pleas of the Flemish whom they loot and massacre; the indifference of the blind; to the announcement that they are being led by the blind; the indifference of the drunk to the living; the indifference of those playing games to precious time passing; the indifference of God to death.

Bruegel's difficulty in believing that the prosecution would ever take place was the result of his not knowing whom to accuse. The peasant bent over his plough could not be held entirely responsible for failing to notice Icarus. And this in turn was the result of Bruegel not being able to imagine the means by which the conditions of his mind might be changed. He had a conscience born historically too soon for the knowledge that might justify it. All he could do was to question – not fully knowing the answer. Yet even to question too obviously was not only immediately and politically dangerous, it also led him into the mortal sin of Pride, the sin which obsessed him (*The Tower of Babel, The Suicide of Saul, The Fall of Lucifer*) because he constantly feared that by the canons of his medieval God he was guilty of it, however circumspect he tried to be.

Yet these very contradictions which beset Bruegel forced him to an extraordinarily original and prophetic way of seeing. He introduced

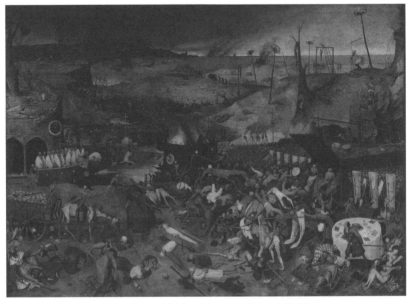

Pieter Bruegel, *The Triumph of Death*, 1562

no scapegoats. He made no neat division between the innocent and the guilty. He refrained from moralising. He set no single figure up as a bad or good example. His moral passion is revealed only in the unwavering determination with which he presents the facts for judgement. It was beyond him to condemn a single act, a single person, because he could not see how most people could behave otherwise. And so, without ever becoming misanthropic, he had to accuse everyone of failing to be different.

It is in this way that the ordinary facts in Bruegel's paintings become crimes in themselves. The crime of the beggar is to be a beggar, the crime of the blind is to be blind, the crime of the soldier is to be in the army, the crime of the snow is to cover the tracks. Bruegel was Brecht's favourite painter. Brecht, in a poem, on 'The Complaisance of Nature', wrote as follows:

> Alas the dog that
> seeks attention
> Rubs and coaxes still
> Against the killer's quick leg.
> Alas the elms with their green shade
> Shelter still the man who raped
> A child at the end of the village.
> And the blind friendly dust
> Urges us even now to forget the traces
> Of murderers.

Bruegel and Brecht, despite the four centuries between them, want the same thing understood: Bruegel instinctively, Brecht because he could see more clearly how people take refuge in their helplessness. They both want it understood that not to resist is to be indifferent, that to forget or not to know is also to be indifferent, and that to be indifferent is to condone.

This – and not because of any coincidence of subject matter – is why Bruegel's paintings are more relevant to modern war and to the concentration camps than almost any painted since.

8.

Giovanni Bellini
(active about 1459, died 1516)

GIOVANNI BELLINI, BORN in 1435, was the first great Venetian painter.
I want to talk about four Madonnas that he painted, their dates rang-
ing over thirty-five years of his life.

The first one was painted in the 1470s, when he himself was forty.
The second, ten years later, when he was in his fifties. The third, ten
years later again. And the last one in about 1505, when Bellini was an
old man of seventy.

Now, perhaps there doesn't seem to be much difference between
these four pictures. They're all of the same subject; they all serve the
same religious function. In each of them the Madonna wears almost
the same clothes. Yet, in fact, behind the development implied by
those paintings lies one of the most daring innovations in the whole
history of art. The subject stays the same. But the artist's attitude to it,
the way he sees it, undergoes a revolutionary change.

Between the first picture and the last there is as great a difference
as between any two pictures by any single artist in the history of
painting.

Bellini's lifelong passion and interest was light. This is not surpris-
ing when you think that he worked round and about Venice. Of course
we couldn't have painting at all without light; without light we can't

see. But what engaged Bellini was not light which, destroying dark-
ness, enables us to distinguish one object from another; it was, rather,
the way that, when light is diffused, it creates a unity of all the objects
that it falls on. This is the reason, for instance, why a whole room, or a
whole landscape, looks quite different at eleven o'clock in the morn-
ing from what it looks like at three o'clock in the afternoon. Perhaps it
would be more accurate to say that Bellini's real interest was daylight.
Light in this sense implies space. It isn't just a spark or a flame; it's a
whole day. And so the struggle in his life was to create in his paintings
the space that could hold and contain all that we mean by daylight.

In the first picture there is very little space. The two figures are
almost like a low relief against the flat wall which shuts out everything
else. In this picture the day is, as it were, only one foot deep.

In the second picture he begins to dare to put the figures in the
open. He has broken down the wall. He lets in the day on either side.
But tentatively. There is still the flat curtain behind them, which
hangs mysteriously from the sky. It seems to me that the space only
begins to seep into this picture from either side.

In the third, the curtain is drawn further back, and now the figures
no longer face us straight on. They're inclined at an angle, and this
angle, this inclination, leads our eye into that landscape behind, into
the day. And yet even here they're still protected, these figures, still
barricaded in. It is not only the curtain; there is also the ledge on
which the child is sitting. This acts rather like the edge of a stage
which separates us from the players and limits the space in which they
can act.

But in the last picture he really achieves it – thirty years after the
first. The figures now are in an open field in the full light of day. We
can walk around them. The whole picture, the whole landscape, is as
spacious as the day is long.

Of this conquest of space – for that is what Bellini's achievement
amounted to – you might say, was it so difficult? Weren't the laws of
perspective known before Bellini's time? Yes, they were. But Bellini
wasn't just interested in creating the illusion of distance. He wanted to
fill the whole space that he brought into his pictures with light, rather
as one fills a tank of water. He wasn't content just to paint the near
objects large and the distant objects small. He wanted to show the way

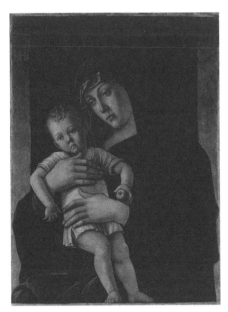

Giovanni Bellini, *Madonna Greca,* 1470

that the light falls evenly between them, and to create, in each picture, the equivalent of that order and unity which light can impose on nature. So there was a second struggle to create a new kind of order and unity in his pictures.

In the first picture you can see the straight line that the right-hand side of the child makes, and how it goes up, this straight line, and coincides so well and so neatly with the Madonna's headdress. The picture is full of calculations and plans like that, which give it its unity and order. But because this painting is flat, without space, this organisation is a question of line. Look, for instance, at the Virgin's hands. Each finger is separate and outlined, so that together the fingers are almost like the keys of a piano. And indeed, the pattern on which the unity of the picture depends, the whole pattern, is based on the contrast of flat lights against flat darks, rather like a piano keyboard.

In the second picture it is still really a question of organising its unity in terms of line – flatly. Certainly the child is now kicking out into space a bit, but look at the two strips of sky and landscape either side. Somehow these work, really, as a kind of flat pattern. They are rather like the graining in the flat slab of marble at the bottom. But in the third picture things begin to change. It is no longer a question of organising lines, but of masses in

Bellini, *The Virgin and Child,* 1480–90

space. You no longer notice the separate fingers of the Madonna's hand, but the way that her whole hand cups and encloses the child's hand and the apple, just as – if the scale were different – it could enclose the hill behind, that hill which looks as if it had been made in exactly the right shape to fit her hand. Or look at her mantle and the way that it goes round in space – round her head – in the same way as the dark trees go round and cover the hill. And then at last, in the final picture, Bellini achieves a complete unity between the figures and the

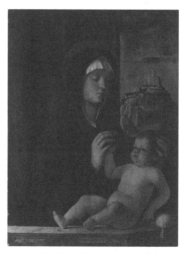

Bellini, *The Virgin and Child*, 1480–1500

whole spacious, light-filled day. Between the Madonna's hands with their fingers just touching is enclosed the same kind of space as the tower on the hill must enclose. The child fills her lap as sunlight must fill a hollow in a landscape. And nature itself is now organised into a unity. The trees on the left are not just lines in a picture; they exist in a landscape and in space. Yet the bird placed there leads our eye up the trees and then inclines our gaze slightly to the right to echo perfectly the way in which the Virgin is inclined to the right.

And so Bellini's interest in daylight led him in his paintings to the conquest of space, led him to relate man to nature in a way that had never occurred before. And the implications of that go, really, far beyond art.

The first picture, which is almost Byzantine, is a picture that belongs to the

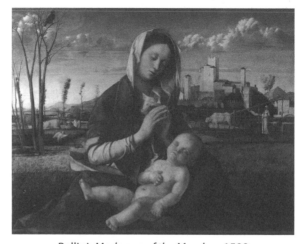

Bellini, *Madonna of the Meadow*, 1500

Middle Ages, to an image on a church wall that shuts out movement and all the traffic of the world. You can only approach it from the front, to worship. But in the last picture, it is a mother in a field. It is not only that she hasn't got a halo: she can now be approached from any direction, even from the back, and that means that she is a part of nature which can be looked at from all sides, questioned, investigated. There is no longer any fixed viewpoint, any fixed centre. Man, as in the classical world which the Renaissance was then discovering, has become his own centre, and so is free to go wherever he dares.

Between the painting of that first picture and the last picture, Christopher Columbus discovered America, Vasco da Gama sailed round the Cape to India, and in Padua, where Bellini himself studied, Copernicus was working out his first theory to prove that the earth travels round the sun. And so the space that Bellini introduced into painting was the exact measure of the new freedom that men were then winning. That is why the difference between these four pictures with the same subject can indeed be called revolutionary.

9.

Matthias Grünewald
(c. 1470–1528)

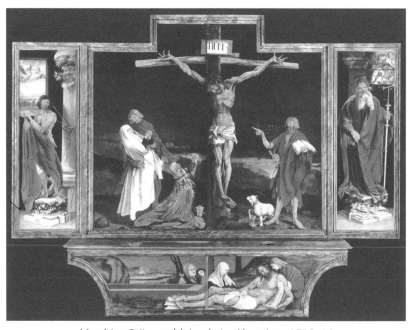

Matthias Grünewald, *Isenheim Altarpiece,* 1512–16

I FIRST WENT to Colmar to look at the Grünewald Altarpiece in the winter of 1963. I went a second time ten years later. I didn't plan it that way. During the intervening years a great deal had changed. Not at Colmar, but generally, in the world, and also in my life. The dramatic point of change was exactly half-way through that decade. In 1968, hopes, nurtured more or less underground for years, were born in

several places in the world and given their names: and in the same year, these hopes were categorically defeated. This became clearer in retrospect. At the time many of us tried to shield ourselves from the harshness of the truth. For instance, at the beginning of 1969, we still thought in terms of a second 1968 possibly recurring.

This is not the place for an analysis of what changed in the alignment of political forces on a world scale. Enough to say the road was cleared for what, later, would be called *normalization*. Many thousands of lives were changed too. But this will not be read in the history books. (There was a comparable, although very different, watershed in 1848, and its effects on the life of a generation are recorded, not in the histories, but in Flaubert's *Sentimental Education*.) When I look around at my friends – and particularly those who were (or still are) politically conscious – I see how the long-term direction of their lives was altered or deflected at that moment just as it might have been by a private event: the onset of an illness, an unexpected recovery, a bankruptcy. I imagine that if they looked at me, they would see something similar.

Normalization means that between the different political systems, which share the control of almost the entire world, anything can be exchanged under the single condition that nothing anywhere is radically changed. The present is assumed to be continuous, the continuity allowing for technological development.

A time of expectant hopes (as before 1968) encourages one to think of oneself as unflinching. Everything needs to be faced. The only danger seems to be evasion or sentimentality. Harsh truth will aid liberation. This principle becomes so integral to one's thinking that it is accepted without question. One is aware of how it might be otherwise. Hope is a marvellous focusing lens. One's eye becomes fixed to it. And one can examine anything.

The altarpiece, no less than a Greek tragedy or a nineteenth-century novel, was originally planned to encompass the totality of a life and an explanation of the world. It was painted on hinged panels of wood. When these were shut, those before the altar saw the Crucifixion, flanked by St Anthony and St Sebastian. When the panels were opened, they saw a Concert of Angels and a Madonna and Child, flanked by an Annunciation and Resurrection. When the

50

panels were opened once again, they saw the apostles and some church dignitaries flanked by paintings about the life of St Anthony. The altarpiece was commissioned for a hospice at Isenheim by the Antonite order. The hospice was for victims of the plague and syphilis. The altarpiece was used to help victims coming to terms with their suffering.

On my first visit to Colmar I saw the Crucifixion as the key to the whole altarpiece and I saw disease as the key to the Crucifixion. 'The longer I look, the more convinced I become that for Grünewald disease represents the actual state of man. Disease is not for him the prelude to death – as modern man tends to fear; it is the condition of life.' This is what I wrote in 1963. I ignored the hinging of the altarpiece. With my lens of hope, I had no need of the painted panels of hope. I saw Christ in the Resurrection 'as pallid with the pallor of death'; I saw the Virgin in the Annunciation responding to the Angel as if 'to the news of an incurable disease'; in the Madonna and Child I seized upon the fact that the swaddling cloth was the tattered (infected) rag which would later serve as loin cloth in the Crucifixion.

This view of the work was not altogether arbitrary. The beginning of the sixteenth century was felt and experienced in many parts of Europe as a time of damnation. And undoubtedly this experience *is* in the altarpiece. Yet not exclusively so. But in 1963 I saw only this, only the bleakness. I had no need for anything else.

Ten years later, the gigantic crucified body still dwarfed the mourners in the painting and the onlooker outside it. This time I thought: the European tradition is full of images of torture and pain, most of them sadistic. How is it that this, which is one of the harshest and most pain-filled of all, is an exception? How is it painted?

It is painted inch by inch. No contour, no cavity, no rise within the contours, reveals a moment's flickering of the intensity of depiction. Depiction is pinned to the pain suffered. Since no part of the body escapes pain, the depiction can nowhere slack its precision. The cause of the pain is irrelevant; all that matters now is the faithfulness of the depiction. This faithfulness came from the empathy of love.

Love bestows innocence. It has nothing to forgive. The person loved is not the same as the person seen crossing the street or washing

her face. Nor exactly the same as the person living his (or her) own life and experience, for he (or she) cannot remain innocent.

Who then is the person loved? A mystery, whose identity is confirmed by nobody except the lover. How well Dostoevsky saw this. Love is solitary even though it joins.

The person loved is the being who continues when the person's own actions and egocentricity have been dissolved. Love recognises a person before the act and the *same* person after it. It invests this person with a value which is untranslatable into virtue.

Such love might be epitomised by the love of a mother for her child. Passion is only one mode of love. Yet there are differences. A child is in process of becoming. A child is incomplete. In what he is, at any given moment, he may be remarkably complete. In the passage between moments, however, he becomes dependent, and his incompleteness becomes obvious. The love of the mother connives with the child. She imagines him more complete. Their wishes become mixed, or they alternate. Like legs walking.

The discovery of a loved person, already formed and completed, is the onset of a passion.

One recognises those whom one does not love by their attainments. The attainments one finds important may differ from those which society in general acclaims. Nevertheless we take account of those we do not love according to the way they fill a contour, and to describe this contour we use comparative adjectives. Their overall 'shape' is the sum of their attainments, as described by adjectives.

A person loved is seen in the opposite way. Their contour or shape is not a surface encountered but an horizon which borders. A person loved is recognised not by attainments but by the *verbs* which can satisfy that person. His or her needs can be quite distinct from those of the lover, but they create value: the value of that love.

For Grünewald the verb was *to paint*. To paint the life of Christ.

Empathy, carried to the degree to which Grünewald carried it, may reveal an area of truth between the objective and subjective. Doctors and scientists working today on the phenomenology of pain might well study this painting. The distortions of form and proportion – the enlargement of the feet, the barrel-chesting of the torso, the

elongation of the arms, the planting out of the fingers – may describe exactly the *felt* anatomy of pain.

I do not want to suggest that I saw more in 1973 than in 1963. I saw differently. That is all. The ten years do not necessarily mark a progress; in many ways they represent defeat.

The altarpiece is housed in a tall gallery with Gothic windows near a river by some warehouses. During my second visit I was making notes and occasionally looking up at the Angel's Concert. The gallery was deserted except for the single guardian, an old man rubbing his hands in woollen gloves over a portable oil stove. I looked up and was aware that something had moved or changed. Yet I had heard nothing and the gallery was absolutely silent. Then I saw what had changed. The sun was out. Low in the winter sky, it shone directly through the Gothic windows so that on the white wall opposite, their pointed arches were printed, with sharp edges, in light. I looked from the 'window lights' on the wall to the light in the painted panels – the painted window at the far end of the painted chapel where the Annunciation takes place, the light that pours down the mountainside behind the Madonna, the great circle of light like an aurora borealis round the resurrected Christ. In each case the painted light held its own. It remained light; it did not disintegrate into coloured paint. The sun went in and the white wall lost its animation. The paintings retained their radiance.

The whole altarpiece, I now realised, is about darkness and light. The immense space of sky and plain behind the Crucifixion – the plain of Alsace crossed by thousands of refugees fleeing war and famine – is deserted and filled with a darkness that appears final. In 1963 the light in the other panels seemed to me frail and artificial. Or, more accurately, frail and unearthly. (A light dreamt of in the darkness.) In 1973 I thought I saw that the light in these panels accords with the essential experience of light.

Only in rare circumstances is light uniform and constant. (Sometimes at sea; sometimes around high mountains.) Normally light is variegated or shifting. Shadows cross it. Some surfaces reflect more light than others. Light is not, as the moralists would have us believe, the constant polar opposite to darkness. Light flares out of darkness.

Look at the panels of the Madonna and the Angel's Consort. When it is not absolutely regular, light overturns the regular measurement of space. Light re-forms space as we perceive it. At first what is in light has a tendency to look nearer than what is in shadow. The village lights at night appear to bring the village closer. When one examines this phenomenon more closely, it becomes more subtle. Each concentration of light acts as a centre of imaginative attraction, so that in imagination one measures *from* it across the areas in shadow or darkness. And so there are as many articulated spaces as there are concentrations of light. Where one is actually situated establishes the primary space of a ground plan. But far from there a dialogue begins with each place in light, however distant, and each proposes another space and a different spatial articulation. Each place where there is brilliant light prompts one to imagine oneself there. It is as though the seeing eye sees echoes of itself wherever the light is concentrated. This multiplicity is a kind of joy.

The attraction of the eye to light, the attraction of the organism to light as a source of energy, is basic. The attraction of the imagination to light is more complex because it involves the mind as a whole and therefore it involves comparative experience. We respond to physical modifications of light with distinct but infinitesimal modifications of spirit, high and low, hopeful and fearful. In front of most scenes one's experience of their light is divided in spatial zones of sureness and doubt. Vision advances from light to light like a figure walking on stepping stones.

Put these two observations, made above, together: hope attracts, radiates as a point, to which one wants to be near, from which one wants to measure. Doubt has no centre and is ubiquitous.

Hence the strength and fragility of Grünewald's light.

On the occasion of both my visits to Colmar it was winter, and the town was under the grip of a similar cold, the cold which comes off the plain and carries with it a reminder of hunger. In the same town, under similar physical conditions, I saw differently. It is a commonplace that the significance of a work of art changes as it survives. Usually however, this knowledge is used to distinguish between 'them' (in the past) and 'us' (now). There is a tendency to picture *them* and their reactions to art as being embedded in history, and at the same

time to credit *ourselves* with an over-view, looking across from what we treat as the summit of history. The surviving work of art then seems to confirm our superior position. The aim of its survival was us.

This is illusion. There is no exemption from history. The first time I saw the Grünewald I was anxious to place *it* historically. In terms of medieval religion, the plague, medicine, the Lazar house. Now I have been forced to place myself historically.

In a period of revolutionary expectation, I saw a work of art which has survived as evidence of the past's despair; in a period which has to be endured, I see the same work miraculously offering a narrow pass across despair.

Grünewald, *Isenheim Altarpiece,* 1512–16

10.

Albrecht Dürer
(1471–1528)

WE ARE MORE than five hundred years away from Dürer's birth. (He was born on 21 May 1471, in Nuremberg.) Those five hundred years may seem long or short, according to one's viewpoint or mood. When they seem short, it appears to be possible to understand Dürer and an imaginary conversation with him becomes feasible. When they seem long, the world he lived in and his consciousness of it appear so remote that no dialogue is possible.

Dürer was the first painter to be obsessed by his own image. No other before him made so many self-portraits. Among his earliest works is a silverpoint drawing of himself aged thirteen. The drawing demonstrates that he was a prodigy – and that he found his own appearance startling and unforgettable. One of the things that made it startling was probably his awareness of his own genius. All his self-portraits reveal pride. It is as though one of the elements of the masterpiece which he intends each time to create is the look of genius that he is observing in his own eyes. In this, his self-portraits are the antithesis of Rembrandt's.

Why does a man paint himself? Among many motives, one is the same as that which prompts any man to have his portrait painted. It is to produce evidence, which will probably outlive him, that he once

existed. His look will remain, and the double meaning of the word 'look' – signifying both his appearance and his gaze – suggests the mystery or enigma which is contained in that thought. His look interrogates us who stand before the portrait, trying to imagine the artist's life.

As I recall these two self-portraits of Dürer, one in Madrid and the other in Munich, I am aware of being – along with thousands of others – the imaginary spectator whose interest Dürer assumed about 485 years ago. Yet at the same time I ask myself how many of the words I am writing could have conveyed their present meaning to Dürer. We approach so close to his face and expression that it is hard to believe that a large part of his experience must escape us. Placing Dürer historically is not the same thing as recognising his own experience. It seems to me important to point this out in the face of so many complacent assumptions of continuity between his time and ours. Complacent because the more this so-called continuity is emphasised, the more we tend, in a strange way, to congratulate ourselves on his genius.

Two years separate the two paintings which so obviously depict the same man in extremely different frames of mind. The second portrait, now in the Prado Museum, Madrid, shows the painter, aged twenty-

Albrecht Dürer, *Self-Portrait in Furred Coat*, 1500;
Dürer, *Self-Portrait*, 1498

seven, dressed like a Venetian courtier. He looks confident, proud, almost princely. There is perhaps a slight over-emphasis on his being dressed up, suggested by, for example, his gloved hands. The expression of his eyes is a little at odds with the debonair cap on his head. It may be that the portrait half-confesses that Dürer is dressing up for a part, that he aspires to a new role. He painted the picture four years after his first visit to Italy. During this visit he not only met Giovanni Bellini and discovered Venetian painting; he also came to realise for the first time how independent-minded and socially honoured painters could be. His Venetian costume and the landscape of the Alps seen through the window surely indicate that the painting refers back to his experience of Venice as a young man. Interpreted into absurdly crude terms, the painting looks as though it is saying: 'In Venice I took the measure of my own worth, and here in Germany I expect this worth to be recognised.' Since his return, he had begun to receive important commissions from Frederick the Wise, the Elector of Saxony. Later he would work for Emperor Maximilian.

The portrait in Munich was painted in 1500. The painting shows the artist in a sombre coat against a dark background. The pose, his hand which holds his coat together, the way his hair is arranged, the expression – or rather the holy lack of it – on his face all suggest, according to the pictorial conventions of the time, a portrait head of Christ. And although it cannot be proved, it seems likely that Dürer intended such a comparison, or at least that he wanted it to cross the spectator's mind.

His intention must have been far from being blasphemous. He was devoutly religious and although, in certain ways, he shared the Renaissance attitude towards science and reason, his religion was of a traditional kind. Later in his life he admired Luther morally and intel-lectually, but was himself incapable of breaking with the Catholic Church. The picture cannot be saying: 'I see myself as Christ.' It must be saying: 'I aspire through the suffering I know to the imitation of Christ.'

Yet, as with the other portrait, there is a theatrical element. In none of his self-portraits, apparently, could Dürer accept himself as he was. The ambition to be something other or more than himself always intervened. The only consistent record of himself he could accept was

the monogram with which, unlike any previous artist, he signed almost everything he produced. When he looked at himself in the mirror he was always fascinated by the possible selves he saw there; sometimes the vision, as in the Madrid portrait, was extravagant, sometimes, as in the Munich portrait, it was full of foreboding.

What can explain the striking difference between the two paintings? In the year 1500 thousands of people in southern Germany believed that the world was just about to end. There was famine, plague, and the new scourge of syphilis. The social conflicts, which were soon to lead to the Peasants' War, were intensifying. Crowds of labourers and peasants left their homes and became nomads searching for food, revenge – and salvation on the day on which the wrath of God would rain fire upon the earth, the sun would go out, and the heavens would be rolled up and put away like a manuscript.

Dürer, who throughout his whole life was preoccupied by the thought of approaching death, shared in the general terror. It was at this time that he made for a relatively wide, popular audience his first important series of woodcuts, and the theme of this series was the Apocalypse.

The style of these engravings, not to mention the urgency of their message, is a further demonstration of how far away we now are from Dürer. According to our categories, their style looks incongruously and simultaneously Gothic, Renaissance, and Baroque. We see it historically bridging a century. For Dürer, as the *end* of history approached and as the Renaissance dream of Beauty, such as he had dreamt in Venice, receded, the style of these woodcuts must have been as instantaneous to that moment and as natural as the sound of his own voice.

I doubt, however, whether any specific event can explain the difference between the two self-portraits. They might have been painted in the same month of the same year; they are complementary to one another; together they form a kind of archway standing before Dürer's later works. They suggest the dilemma, the area of self-questioning, within which he worked as an artist.

Dürer's father was a Hungarian goldsmith who settled in the trading centre of Nuremberg. As the trade then demanded, he was a competent draughtsman and engraver. But in his attitudes and

bearing he was a medieval craftsman. All he had to ask himself concerning his work was 'How?' No other questions posed themselves for him.

By the time he was twenty-three years old his son had become the painter in Europe who was furthest removed from the mentality of the medieval craftsman. He believed that the artist must discover the secrets of the universe in order to achieve Beauty. The first question in terms of art – and in terms of actually travelling (he travelled whenever he could) – was 'Whither?' Dürer could never have achieved this sense of independence and initiative without going to Italy. But, paradoxically, he then became more independent than any Italian painter, precisely because he was an outsider without a modern tradition – the German tradition, until he changed it, belonged to the past. He was the first, one-man, avant-garde.

It is this independence which is expressed in the Madrid portrait. The fact that he does not embrace this independence completely, that it is like a costume which he tries on, is perhaps explained by the fact that he was, after all, his father's son. His father's death in 1502 affected him greatly; he was deeply attached to him. Did he think of his difference from his father as something inevitable and ordained, or as a question of his own free choice, of which he could not be absolutely sure? At different times probably both. The Madrid portrait includes the slight element of doubt.

His independence, combined with the manner of his art, must have given Dürer an unusual sense of power. His art came closer to recreating nature than that of any artist before him. His ability to depict an object must have seemed – as it can still seem today (think of the watercolour drawings of flowers and animals) – miraculous. He used to speak of his portraits as *Konterfei*, a word which emphasises the process of *making exactly like*.

Was his way of depicting, of creating again what he saw before him or in his dreams, in some way analogous to the process by which God was said to have created the world and all that was in it? Perhaps that question occurred to him. If so, it was not a sense of his own virtue which made him compare himself with the godhead, but his awareness of what appeared to be his own creativity. Yet despite this creativity, he was condemned to live as a man in a world full of suffering, a world

against which his creative power was finally of no avail. His self-portrait as Christ is the portrait of a creator on the wrong side of creation, a creator who has played no part in creating himself.

Dürer's independence as an artist was sometimes incompatible with his half-medieval religious faith. These two self-portraits express the terms of this incompatibility. But to say this is to make a very abstract statement. We still do not enter Dürer's experience. He travelled six days once in a small boat to examine, like a scientist, the carcass of a whale. At the same time, he believed in the Horsemen of the Apocalypse. He considered Luther to be 'God's instrument'. How did he concretely ask, how did he really answer, as he gazed at himself in the mirror, the question which his painted face hints at as we stare into it, the question which at its simplest is: 'Of what am I the instrument?'

11.

Michelangelo
(1475–1564)

I AM CRANING my neck to look up at the Sistine Chapel ceiling and the *Creation of Adam* – do you think, like me, that once you dreamt the touch of that hand and the extraordinary moment of withdrawal? And pfff! I picture you in your faraway Galician kitchen restoring a painted Madonna for a small village church. Yes, the restoration here in Rome has been well done. The protests were wrong, and I can tell you why.

The four kinds of space Michelangelo played with on the ceiling – the space of bas-relief, the space of high-relief, the corporeal space of the twenty nudes whom he dreamt as a beatitude as he lay painting on his back, and the infinite space of the heavens – these distinct spaces are now clearer and more astonishingly articulated than they were before. Articulated, Marisa, with the aplomb of a master snooker player! And if the ceiling had been badly cleaned, this would have been the first thing lost.

I've discovered something else too: it leaps to the eye but no one quite faces up to it. Perhaps because the Vatican is so formally imposing. Between its worldly wealth on one hand, and its list of eternal punishments on the other, the visitor is made to feel exceedingly small. The excessive riches of the Church and the excessive

punishments the Church prescribed were really complementary. Without hell, the wealth would have appeared as theft! Anyway, visitors today from all over the world are so awed they forget about their little things.

But not Michelangelo. He painted them, and he painted them with such love they became focal points, so that for centuries after his death, the papal authorities had one male sex after another in the Sistine Chapel covertly scratched out or painted over. Happily there are still quite a few that remain.

During his lifetime he was referred to as 'the sublime genius'. Even more than Titian he assumed – at the very last possible historical moment – the Renaissance role of the artist as supreme creator. His exclusive subject was the human body, and for him that body's sublimity lay revealed in the male sexual organ.

In Donatello's *David* the young man's sex is discreetly in its proper place – like a thumb or a toe. In Michelangelo's *David* the sex is the body's centre and every other part of the body refers back to it with a kind of deference, as if to a miracle. As simple and as beautiful as that. Less spectacularly, but none the less evidently, the same is true of his *Bruges Madonna* and the sex of the infant Christ. It was not lust but a form of worship.

Given this predilection and all the pride of the Renaissance genius, what would you say his imaginary paradise might have been? Might it not have been the fantasy of men giving birth?

The whole ceiling is really about Creation, and for him, in the last coil of his longing, Creation meant everything imaginable being born, thrusting and flying, from between men's legs!

Remember the Medici tomb with the figures of Night and Day, Dusk and Dawn? Two reclining men and two reclining women. The women modestly fold their legs together. Both men part their legs and, pushing, lift their pelvises, as though waiting for a birth. Not a birth of flesh and blood and not – heaven forbid – of symbols either. The birth they await is of the indescribable and endless mystery which their bodies incarnate, and which will emerge from there, from between their parted legs.

And so it is on the ceiling. The visitors in the chapel floor are like figures who have just dropped from between the feet and out of the

skirts of the Prophets and Sibyls. OK. The Sibyls are women, but not really, not when you get close: they are men in drag.

Beyond are the nine scenes of the Creation, and there, at the four corners of each scene, sit the amazing, twisting, immense, labouring male nudes (the *ignudi*), whose presence commentators have found so difficult to explain. They represent, some claim, Ideal Beauty. Then why their effort, why their longing and their labour? No, the twenty young naked men up there have conceived and just given birth to all that is visible and all that is imaginable and all that we see on the ceiling. Man's loved body up there is the *measure* of everything – even of platonic love, even of Eve, even of you.

He once said, talking about the sculptor of the Belvedere Torso (50 BC): 'This is the work of a man who knew more than nature!'

And therein lay the dream, the coiled desire, the pathos, and the illusion.

In 1536, two decades after he finished the ceiling, he started to paint the *Last Judgement* on the gigantic wall behind the altar. Maybe it's the biggest fresco in Europe? Countless figures, all naked, mostly men. Other writers have compared it with the late works of Rembrandt or Beethoven, but I can't follow them. What I see is pure terror and the terror is intimately connected with the ceiling above. Man on this wall is still naked but now the measure of nothing!

Everything has changed. The Renaissance and its spirit is finished. Rome has been sacked. The Inquisition is about to be set up. Everywhere fear has replaced hope, and he is growing old. Maybe it's like our world today.

Suddenly the pictures of Sebastião Salgado come to my mind: his photos of the Brazilian gold mine and of coal miners in Bihar, India. Both artists are appalled by what they have to depict, and both show bodies strained to a similar breaking point, which, somehow, the bodies endure!

There the resemblance ends, for Salgado's figures are working and his are monstrously unemployed. Their energy, their bodies, their huge hands, their senses, have become useless. Mankind has become barren, and there is scarcely any difference between the saved and the

damned. No dream remains in any body, however beautiful that body once was. There is only anger and penance – as if God has abandoned man to nature and nature has become blind! Blind? Finally, it's not true.

He lived and worked for another two decades after he painted the *Last Judgement*. And when he died, at the age of eighty-nine, he was carving a marble Pietà. The so-called unfinished *Rondanini Pietà*.

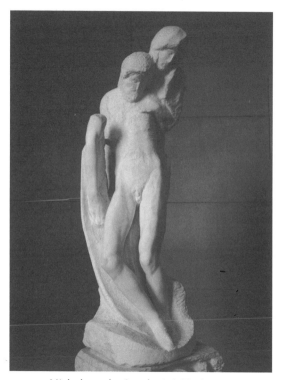

Michelangelo, *Rondanini, Pietà* 1564

The mother who holds up the limp body of her son is in roughly carved stone. The son's two legs and one of his arms are finished and polished. (Maybe they are the remnants of another sculpture he partially destroyed – it doesn't matter: this monument to his energy and solitude stands as it is.) The crossing line, the frontier between the smooth marble and the rough stone, between the flesh and the block of rock, is at the level of Christ's sex.

Sebastio Salgadão, *Mussel Harvest*, 1988

And the immense pathos of this work comes from the fact that the body is returning, is being breathed back with love into the block of stone, into his mother. It is, at last, the opposite of any birth!

I'll send you Salgado's photo of Galician women wading into the Ria de Vigo, searching in the month of October for shellfish at low tide . . .

12.

Titian
(?1485/90–1576)

A CONVERSATION BY *post between Katya Andreadakis and her father, John Berger, about looking at the paintings of Titian today.*

September 1991
Piazza San Marco, Venice

John,

What do I think about Titian? In one word on a postcard: flesh.

Love,
Katya

 C&

September 1991
Amsterdam

Kut,

All right, flesh. First, I see his own, when he's old. Why do I immediately think of Titian as an old man? Out of solidarity – given my

own age? No, I don't think so. It's to do with our century and the bitterness of its experience. It's always searching for rage and wisdom rather than harmony. Late Rembrandts, late Goyas, Beethoven's last sonatas and quartets, late Titians. . . . Imagine the élan of a century whose old master was the young Raphael?

I think of the self-portraits painted when he was in his sixties or seventies. Or himself as the penitent St Jerome, painted when he was in his eighties. (Perhaps it's not a self-portrait, it's only my guess, but I feel he was thinking intensely about himself when he was painting it.)

What do I find? A man who is physically imposing and has considerable authority. You can't take liberties with him. With the late decrepit Rembrandt it would have been easy. This one knows how power works and he has exercised his own. He has turned the trade of being a painter into a profession – like that of a general or an ambassador or a banker. He's the first to do this. And he has the confidence that goes with it.

And also a painterly confidence. In his late works he is the first European to display – rather than hide or disguise – his manual gestures when putting the pigment onto the canvas. Thus he makes painting physically confident in a new way – the act of the painting hand and arm becomes expressive in itself. Other artists like Rembrandt or Van Gogh or Willem de Kooning will follow his example. At the same time his originality and boldness were never foolhardy. His attitude to everything in Venice was realistic.

And yet, yet . . . the more I look at the way he painted himself, the more I see a frightened man. I don't mean a coward. He doesn't take risks but he has courage. He does not normally show his fear. But his brush can't help but touch it. It's most evident in his hands. They're nervous like the hands of a moneylender. Yet his fears could not, I think, have been concerned with money.

A fear of death? The Plague was rampant in Venice. A fear leading to penitence? A fear of judgement? It may have been any of these, but they are too general to help us understand him or to get closer to him. He lives to be a very old man. The fear lasts a long time. A long-drawn-out fear becomes doubt.

What provoked this doubt in him? I suspect it was intimately

connected with Venice, with the city's special kind of wealth and commerce and power. All of which, as you say, had to do with flesh.

Love,

John

ঙ্গ

21 September 1991
Venice, Giudecca

John,

Several times whilst I was wandering through the exhibition, I crossed paths with, was followed by, lost sight of, and then again found myself beside an old man. He was alone and muttering words to himself.

The first time I saw him he was coming back from one of the last rooms and very decidedly making for the painting of *Christ Carrying the Cross*. And there at my side he stopped.

'One uses painting', he suddenly said, 'to clothe oneself, to keep warm . . .'

At first I felt put out and scowled at him, but he went on as if nothing had happened.

'Jesus carries his cross, and me, I carry the art of painting. I wear it like something woolen.'

He had won me over. Now he was making for *The Flight into Egypt*. In some way I must have annoyed him, for he appeared to be angry, spitting out disconnected words.

'The fur, ough! The fur of my painting . . . stuff, stuff . . .'

By *The Portrait of a Gentleman* he spoke directly to the sitter, poking his nose towards the painted nose.

'First I painted you all dressed up, then I did a whole painting of an animal's skin!'

He didn't need to turn around to know that I was following him, and as we passed a group of visitors who were listening to their guide, he said to me out of the corner of his mouth, as if it were a joke:

'Dogs, rabbits, sheep, they all have their fur to keep them warm, and me, I want to imitate them with my brushes!'

When he next spoke, not without a little pride, I wasn't sure whether he was referring to the portrait of a cardinal or to *The Young*

Englishman.

'Nobody else has painted men's beards like that!' he said. 'They're soft as monkey's hair.'

I lost sight of him. And a little later the siren of the alarm system started up. Given that my friend (we had by now smiled at each other) obviously knew little about the rules and routines of modern art exhibitions, I immediately thought of him. No sooner had I done so, than I saw a uniformed official remonstrating with the old man and indicating the statutory distance which must be respected before each canvas. The old man was saying:

'You must surely see, velvet, you must see, velvet is my favourite material and I can't resist its touch.'

From that moment he decided to stay with me. He followed wherever I went. His words, however, remained a monologue without any attempt at conversation.

Whilst I was looking at *Danäe*, he abruptly dragged me towards the Berlin *Self-Portrait*.

'It's a pity they didn't hang them in the same room,' he said. 'The hair on the body, the hair of the head, feathers, nobody can get more naked than that . . . I wash and wash my colours until they look like the coat of an animal. By working on clothes you can make them look worn, silky, clinging, almost like flesh.'

After this effort at speech he seemed a little discouraged. For half an hour he didn't say a word. In front of *Venus and Adonis* he simply verified that I was studying the picture correctly. On my side I showed him my admiration by opening my eyes and my mouth wide.

He seemed to have almost finished.

Before *The Flaying of Marsyas* there was another splutter of words.

'When you skin an animal, you touch the truth about flesh.'

In front of the Pietà, he sat down. I think he sat there for a very long time. At first I didn't know whether to wait, to greet him, or to tell him my own impressions. He made a sign for me to come closer. Certainly he knew that his remarks about fur had impressed me, for instead of talking about the famous hand held before the saint's statue in the Pietà – the hand he was fixedly staring at – he went his own way and repeated:

'Hair is to the body what painting is to the world!'

Then, with a deep laugh, he added something which made me think of you.

'You can burrow into it, you can look underneath it, you can lift it, or you can pull it – but don't try to shave it – it'll always grow again!'

Before turning away from him for good, I had a very clear image of my own body lying naked on a canvas in the exhibition: of moss underneath me, of a dog at my side, of my outlines scarcely separable from the surrounding landscape. A landscape which later Courbet might have walked over. With the grass, the clouds, and the soil, my flesh would then have been the earth's coat.

Love,

Katya

ଔ

October 1991
Haute Savoie

Kut,

All that you say about fur makes me think of his dogs. Was the old man by any chance accompanied by a dog?

I think he loved dogs. Perhaps they calmed or encouraged him. Were they witnesses? Witnesses he could trust. Dumb, dumb witnesses. Perhaps it sometimes happened that whilst painting with his right hand, with his left he ferociously stroked one of his dogs. The fur as company for his fingers, and the dog shifting its weight as his arm moved!

At that time it was something of a fashion to put dogs into paintings. One finds them in Rubens, Velázquez, Veronese, Cranach, Van Dyck . . . Amongst other things they were a kind of go-between between men and women. Ambassadors of desire. They represented (according to their breed and size) both femininity and virility. They were almost human – or they shared the privacy of humans – and yet they were guileless. They were also randy. Randy and nobody could raise their eyebrows – because, after all, they were dogs!

We see them in many of his paintings. In portraits of men and women and in mythological subjects. But nowhere more mysteriously and strangely than in the late picture *A Boy with Dogs*. No other painting like it, and I tend to agree with the experts who mostly dismiss

the idea that this is a detail taken from a larger canvas. What we see is more or less what the old man meant us to see. A boy – how old do you think he is? three? four at the most? – alone in a dark landscape with two dogs and two young pups (perhaps four weeks old?). The boy puts his arm round the white dog – who, I guess, is male – for reassurance. The mother, the bitch, is the only one looking at us, and the pups have nosed their way through the fur to her teats.

Despite the dusk, the scene is calm, peaceful, *comblé*, as the French would say. Nobody wants anything more.

The dogs are the boy's family. I would even say parents. The boy's legs and the two visible legs of the white dog are like four legs of the same table – practically interchangeable. Everyone is waiting – which is to say living.

Isn't waiting the essential occupation of dogs? Learnt maybe because of their proximity to man. Waiting for the next event or the next arrival. Here the last important event, it seems, was birth. Pups and boy born into this bitch of a life. Born to wait for death. Yet meanwhile there's warmth, milk, the mysteries of the fur, and eyes which are speechless.

The old man, of course, wanted your sympathy. No, not sympathy, your interest. Because if you were interested, you would pose for him, and he wanted to paint you! Painting women, he forgot his doubt. But each time he forgot, he was adding to his worry. All the women he painted – from Ariadne to the Repentant Magdalene – represented this worry, which wasn't about women. Each one consoled and at the same time reinforced his worry.

The painting with the dogs is about the consolation. It's a honeyed painting. It's about bliss. The pups have discovered bliss in the fur – as Jove will never find it with Danäe or Danäe with Jove. Meanwhile the other three (the boy and the two adult dogs) are waiting . . . And the two waiting dogs, watching, are the old man's accomplices. They are the nearest he can find to what he has dreamt of painting and to what he paints with.

Love,
John

CR

November 1991
Athens

John,

I try to find an answer to the question: What made him paint? And I can only hear a word, coming from all the chaos of physical matter, as if from the bottom of a black well.

Desire. His desire (as befits an eminently virile painter) was, if not to cut into appearances, at least to penetrate and lose himself in the skin of things. Yet, being human and being a painter, he came up against the impossibility of doing this: the heart of nature, the animal in man, the world's pelt – they can never be seized, and, above all, they are unrepeatable, unreproducible. And so, for a while, like many of his contemporaries, he used his skill to show that everything was vanity, *vanitas vanitatis*: beauty, wealth, art.

The women in his pictures – or rather this woman with her special simplicity and innocence – is to him a relentless reminder of his artistic impotence and defeat. Him the master! Perhaps it was women who embodied the doubt you talk about? Naked, the colours of flesh are for drowning in. Never have the painted bodies of women demanded as much as his do, to be touched, to be pressed with the hands – as Mary Magdalene presses her hand through her hair against her own breast. Yet, like all other bodies in paintings across the whole world, those painted by Titian can be neither touched nor plunged into.

Gradually he came to understand that in the very impotence of his art (this art which continually underlined the virility of the men it depicted) there might be a hidden miracle. With the sables and bristles of his brushes – instead of rendering the texture of the world's hide – he could twist its limbs! Unable to reproduce, he could transform and transfigure. Instead of being the servant of appearances, obliged to lick their boots, he could impose his will upon them. Produce arms or hands which could never exist. Bend limbs against their nature. Fuzz objects to the point of their becoming unrecognisable. Make contours so tremble that they come to depict matter without any outline. Deny the difference between bodies and corpses. (I'm thinking of the last Pietà.)

I pack in all kinds of questions concerning power, prestige, even the question of the dog, in this train of thought, which is a little too abstract.

The truth is that Titian's art is itself untouchable, inviolable. It calls out and then it forbids. We stay open-mouthed.

Love,
Katya

☙

Titian, *Boy with Dogs in a Landscape*, 1570–75

<div align="right">

December 1991
Paris

</div>

Kut,

Vanitas vanitatis. In 1575 the Plague ravaged Venice, killing almost a third of the city's inhabitants. The old man, aged nearly a hundred, died from the Plague in 1576. As did also his son. After their deaths, their house on the Biri Grande, full of pictures and precious objects, was looted. And the following year a fire in the Ducal Palace destroyed paintings by Bellini, Veronese, Tintoretto, and the old man.

I see you today, not in the Piazza San Marco, but on the terrace of your flat in Athens. In Gyzi, where all the kitchens and bedrooms overlook one another and the washing hangs between

telephone cables and hibiscus flowers. Perhaps Athens is the antipodes of Venice? Dry, makeshift, ungovernable. A city of merchants, national heroes, and the widows of heroes, where nobody dresses up.

And I'm writing in a Paris suburb and I've been to the Sunday market. I saw young couples there, pale, not well dressed against the rain, wearing jeans, hair lacquered, with city acne, holding hands, pushing prams, teasing in argot, each one with their thin, crooked-toothed dodge for a happiness. And as I watched them I said to myself: What would they say about *The Flaying of Marsyas*? Who knows? Everyone lives legends.

In *The Flaying of Marsyas* a lap-dog is licking drops of blood off the ground below where Marsyas is strung up. On the right there's another dog, held by a boy, who is very like the one in the painting with the pups.

Titian, *The Flaying of Marsyas*, 1570–76

The story is that Marsyas, the satyr-artist, entered a musical contest with the god Apollo, and lost. Under the agreed conditions, the winner could do what he liked with the loser, and Apollo chose to flay the satyr alive. There are some convincing allegorical interpretations. But what interests me is why the old man chose this subject. It's very close to what he told you in the gallery. Satyrs were, by definition, creatures who revealed how skin was like fur, and both were the outer coverings of a mystery. A kind of clothing which one couldn't unbutton or unzip except with a killing knife.

The two men in the Marsyas canvas, with their blades and their careful precision (I have seen peasants skin goats with exactly the same gestures) are the precursors of Fontana and Saura, who, in our century, slashed the canvases they painted in pursuit of what lay beyond the skin of the canvas, deep in the wound.

But even after one has accepted the subject and interpreted it, one finds oneself face to face with something more startling. The scene (which in life would be an abominable scene of torture) is bathed in a light of honey and an atmosphere of elegiac fulfillment.

You find exactly the same atmosphere in the *Nymph and Shepherd*, painted at the same time. Yet the *Nymph and Shepherd* is a love scene (like any popular love song heard on a Walkman) and in it the shepherd is playing the pipes which cost Marsyas his life!

Find him in Athens and ask him what he meant.

It must be the season of pomegranates.

Love,

John

CR

January 1993
Gyzi, Athens

John,

You're right, it's the season for pomegranates. I'm looking at one now. Split open by the centrifugal energy of its own ripeness. He would have been able to paint its vivid blood and its granular flesh – except that it's too exotic, too eastern for him. Rather, I see for him the stone of a peach. Enlarged enormously and flattened, I see such a stone as the ground of his painting, as a kind of lining to the canvas.

76

You ask whether I've come across the old man here in Athens as I walk around. I looked for him. I examined the roughest walls, hoping to find his shadow in the roughness. I looked through the most opaque windows in case he was hiding behind them. I fingered the many kinds of cloth: perhaps he was using them to cover his body. In vain.

Now I understand I'll never see him again in the form of an old man. In Venice he was simply wearing one of his disguises. Just as Zeus transformed himself into a ram of gold so as to take Danäe, the old man continually transforms himself, according to the circumstances, the place, the desire.

If he shows himself to me here, it is in fact in the rough walls darkened by the filthy air of Athens, or in the soil – a dry earth slightly dampened by the rain, or in a cloud in the sky, cottony, curdled, grey; in the noise of a motorbike, farting, coughing, spitting.

Each time I know it's him, for he tells me the same thing in the same voice: Scratch, scratch, he says, scratch everything you can scratch! And the word boils in the depth of his throat.

I heard this voice nearly every day during the six months when I was confined to bed in Gyzi. In the wall beside the bed there was a large poster (it's still there) of his painting of Danäe. During the interminable hours lying there, I could either look through my window, which gave on to a second window, beyond which another life was being lived, or I could look at the telly (beyond which there was the pretense of other lives being lived), or I could look at his painting: a woman, nude, always the same, lying on a sheet with cushions around her.

A woman painted as from the inside and only clothed in her skin afterwards. The opposite of what Goya did when he undressed the Maja. The old man first put himself inside – or behind – the canvas, and from there he burrowed his way towards the visible surface of the body. In the case of both painters, it is the breasts which are revealing. In the Titian you have to be inside the body to feel the fullness of her right breast: its imperceptible shadow is evoked so minimally you feel nothing, if you don't feel it from the inside. Yet this makes it all the more real, all the more quivering, all the more desirable. Whereas in the Goya the protuberance, the swelling, is too clear, too held up by a bodice which has disappeared, too visible, and therefore not carnal enough. No?

The old man was avid. For cash, for women, for power, for more years to live. He was jealous of God. Angry. So he started to imitate Him. He didn't only reproduce, like so many other painters, the appearance of things created by God, but he started to give these things, as God had done, a skin, a hide of fur, hair, fat, an epidermis, folds, wrinkles. (Or he did the opposite, he took off the covering of flesh, as in *The Flaying of Marsyas*: he cut it open to demonstrate the skill of his own flesh-art.)

No other artist gets so close to making us believe in the palpitating life of what he paints. And he gets there by not only copying nature, but equally by knowing how to turn the spectator's brain. He knows where *we* place the life, the warmth, the tenderness in his painted bodies. He works like Shakespeare. You have the impression, before their works, that an arm or a word can say everything, because, like magicians, they know exactly where the human spirit loves to drown itself. In this way they are greater than God, for they know everything about their fellow men and women. And this is their vengeance.

I imagine a picture he might have painted, as you once imagined a nonexistent Frans Hals. It would show Eve being created from Adam's rib. Flesh coming out of flesh. God placing his hands on matter and bringing to life another life. The setting would be a forest where there are tree trunks and lots of moss. Two inert, naked forms in the mud, whose substance seems to be alive. Finally, the act of painting, continually repeated like fornication, becomes a body. Not as with Pygmalion, where everything is washed marble. Here it becomes a body, along with everything which may be obscene. Eve born of Adam as the universe was born of God, as painting is born of Titian, as life can be born of art, as I was born of you, as Chloe was born of me.

So I have to tell you I see him everywhere, the old man, I see him even in your granddaughter who is more beautiful than light, sweeter than fire, more gentle than water. Already she has won over our death . . .

Love,
Katya

CR

Titian (?1485/90–1576)

Kut,

Could it be that all flesh is what we'll call feminine – even the flesh of men?

Maybe what is specifically male are men's fantasies, ambitions, ideas, obsessions. And, to some degree, their skin. But could their flesh be female? In the *Marsyas* are the men waiting to see this?

In *La Mise au Tombeau*, Christ's body palpitates from the interior in the same way as Danäe's, but evoking pity instead of desire. Pity and desire, both are carnal. Both concern what has been born in the most immediate way imaginable. Both lead to a similar kind of touching.

Love,

John

❧

February 1993
Athens

John,

Titian, painter of flesh and guts, their rumblings and liquids. Painter of hair and the tamed beast in man. Painter of the skin as an entry or exit – like the shining surface of water for the diver, the surface to which he comes back after his dive to the depths of the body and its hidden organs, comes back with the secret of a *personality*. (Notice how much his portraits of gentlemen say about their inner life.)

Of course the flesh is not only feminine! If women throughout the centuries have remained desirable and you haven't grown tired of it, this is partly the result of the little lie, as old as the world, which proposes that all flesh is feminine. It's a pure convention whereby men use the bodies of women to speak of their own passive desires, their desire to behave with abandon, to lie suppliant on a bed. Men have *delegated* to women this aspect of desire. The woman's body has become, not only the object, but also the ambassador of masculine desire. Or rather, simply of desire, regardless of gender. The skin of men, where it is soft – have you noticed? – is softer than the skin of women.

He was the painter of flesh which commands rather than invites. 'Take me.' 'Drink me,' it orders. He may have disguised himself as an old man or as a dog, but he also disguised himself in women. Titian as Mary Magdalene, as Aphrodite!

And here I think we come close to something concerning his power: he wore the disguise of everything he painted. He was trying to be everywhere. Competing with God. He wanted to create from his palette nothing less than life, and to rule over the universe. And his despair (the doubt you asked about) was that he couldn't, like Pan, *be everything*. He could only create pictorially and wear disguises. His fear was of being only a man, not a god as well, not a woman as well, not a mist, not a lump of earth. Of being only a man!

Danäe's breast, so marvelous, so suggestive and so impalpable, reveals, at one and the same time, all the limits and all the triumph of his pictorial creation when compared with God's.

Love,
Katya

13.

Hans Holbein the Younger (1497/8–1543)

'WHEN SOMEBODY IS dead, you can see it from two hundred yards away,' says Goya in a play we wrote, 'his silhouette goes cold.'

I wanted to see Holbein's painting of the dead Christ. He painted it in 1552, when he was twenty-five. It is long and thin – like a slab in a morgue, or like the predella of an altarpiece – although it seems that this painting never joined an altarpiece. There is a legend that Holbein painted it from the corpse of a Jew drowned in the Rhine.

I'd heard and read about the picture. Not least from Prince Myshkin in *The Idiot*. 'That painting!' he exclaimed. 'That painting! Do you realise what it could do? It could make a believer lose his faith.'

Dostoevsky must have been as impressed as Prince Myshkin, for he makes Hypolyte, another character in *The Idiot*, say: 'Supposing on the day before his agony the Lord had seen this picture, would he have been able to go to his crucifixion and death as he did?'

Holbein painted an image of death, without any sign of redemption. Yet what exactly is its effect?

Mutilation is a recurrent theme in Christian iconography. The lives of the martyrs, St Catherine, St Sebastian, John the Baptist, the Crucifixion, the Last Judgement. Murder and rape are common subjects in painted classical mythology.

Before Pollaiuolo's *St Sebastian*, instead of being horrified (or convinced) by his wounds, one is seduced by the naked limbs of both executioners and executed. Before Rubens's *Rape of the Daughters of Leucippus*, one thinks of nights of exchanged love. Yet this sleight-of-hand by which one set of appearances replaces another (the martyrdom becomes an Olympics: the rape becomes a seduction) is nevertheless an acknowledgement of an original dilemma: How can the brutal be made visibly acceptable?

The question begins with the Renaissance. In medieval art the suffering of the body was subservient to the life of the soul. And this was an article of faith which the spectator brought with him to the image; the life of the soul did not have to be demonstrated in the image itself. A lot of medieval art is grotesque – that is to say a reminder of the worthlessness of everything physical. Renaissance art idealises the body and reduces brutality to gesture. (A similar reduction occurs in Westerns: see John Wayne or Gary Cooper.) Images of consequential *brutality* (Bruegel, Grünewald, etc.) were marginal to the Renaissance tradition of harmonising dragons, executions, cruelty, massacres.

At the beginning of the nineteenth century Goya, because of his unflinching approach to horror and brutality, was the first modern artist. Yet those who choose to look at his etchings would never choose to look at the mutilated corpses they depict with such fidelity. So we are forced back to the same question, which one might formulate differently: How does catharsis work in visual art, if it does?

Painting is distinct from the other arts. Music by its nature transcends the particular and the material. In the theatre words redeem acts. Poetry speaks to the wound but not to the torturers. Yet the silent transaction of painting is with appearances, and it is rare that the dead, the hurt, the defeated, or the tortured *look* either beautiful or noble.

A painting can be pitiful?

How is pity made visible?

Perhaps it's born in the spectator in face of the picture?

Why does one work produce pity when another does not? I don't believe pity comes into it. A lamb chop painted by Goya touches more pity than a massacre by Delacroix.

So, how does catharsis work?

It doesn't. Paintings don't offer catharsis. They offer something else, similar but different.

What?

I don't know. That's why I want to see the Holbein.

<p style="text-align:center">ல</p>

We thought the Holbein was in Berne. The evening we arrived we discovered it was in Basel. Because we had just crossed the Alps on a motorbike, the extra hundred kilometres seemed too far. The following morning we visited instead the museum in Berne.

It is a quiet, well-lit gallery rather like a space vessel in a film by Kubrick or Tarkovsky. Visitors are asked to pin their entrance tickets onto their lapels. We wandered from room to room. A Courbet of three trout, 1873. A Monet of ice breaking up on a river, 1882. An early cubist Braque of houses in L'Estaque, 1908. A love song with a new moon by Paul Klee, 1939. A Rothko, 1963.

How much courage and energy were necessary to struggle for the right to paint in different ways! And today these canvases, outcome of that struggle, hang peacefully beside the most conservative pictures: all united within the agreeable aroma of coffee, wafted from the cafeteria next to the bookshop.

The battles were fought over what? At its simplest – over the language of painting. No painting is possible without a pictorial language, yet with the birth of modernism after the French Revolution, the use of any language was always controversial. The battles were between custodians and innovators. The custodians belonged to institutions that had behind them a ruling class or an élite who needed appearances to be rendered in a way which sustained the ideological basis of their power.

The innovators were rebels. Two axioms to bear in mind here: sedition is, by definition, ungrammatical; the artist is the first to recognise when a language is lying. I was drinking my second cup of coffee and still wondering about the Holbein, a hundred kilometres away.

Hypolyte in *The Idiot* goes on to say: 'When you look at this painting, you picture nature as a monster, dumb and implacable. Or rather – and however unexpected the comparison may be it is closer to

the truth, much closer – you picture nature as an enormous modern machine, unfeeling, dumb, which snatched, crushed and swallowed up a great Being, a Being beyond price, who, alone, is worth the whole of nature . . .'

Did the Holbein so shock Dostoevsky because it was the opposite of an ikon? The ikon redeems by the prayers it encourages with closed eyes. Is it possible that the courage not to shut one's eyes can offer another kind of redemption?

I found myself before a landscape painted at the beginning of the century by an artist called Caroline Müller – *Alpine Chalets at Sulward near Isenflushul*. The problem about painting mountains is always the same. The technique is dwarfed (like we all are) by the mountain, so the mountain doesn't live; it's just there, like the tombstone of a distant grey or white ancestor. The only European exceptions I know are Turner, David Bomberg, and the contemporary Berlin painter Werner Schmidt.

In Caroline Müller's rather dull canvas three small apple trees made me take in my breath. *They* had been seen. Their having-been-seen could be felt across eighty years. In that little bit of the picture the pictorial language the painter was using ceased to be just accomplished and became urgent.

Any language as taught always has a tendency to close, to lose its original signifying power. When this happens it can go straight to the cultivated mind, but it bypasses the thereness of things and events.

'Words, words, mere words, no matter from the heart.'

Without a pictorial language, nobody can render what they see. With one, they may stop seeing. Such is the odd dialectic of the practice of painting or drawing appearances since art began.

We came to an immense room with fifty canvases by Ferdinand Hodler. A gigantic life's work. Yet in only one of the paintings had he forgotten his accomplishment and could we forget that we were looking at virtuoso pigment. It was a relatively small picture and it showed the painter's friend Augustine Dupin, dying in her bed. Augustine was seen. The language, in being used, had opened.

Was the Jew who drowned in the Rhine seen in this sense by the twenty-five-year-old Holbein? And what might this being-seen mean?

I returned to look at the paintings I'd studied earlier. In the Courbet

of the three fish, hanging gaffed from a branch, a strange light permeates their plumpness and their wet skins. It has nothing to do with glistening. It is not on the surface but comes through it. A similar but not identical light (it's more granular) is also transmitted through the pebbles on the river's edge. This light-energy is the true subject of the painting.

In the Monet the ice on the river is beginning to break up. Between the jagged opaque pieces of ice there is water. In this water (but not of course on the ice) Monet could see the still reflections of the poplars on the far bank. And these reflections, glimpsed *behind* the ice, are the heart of the painting.

In the Braque of L'Estaque, the cubes and triangles of the houses and the V forms of the trees are not imposed upon what his eye saw (as happens later with the mannerists of Cubism), but somehow drawn from it, brought forward from behind, salvaged from where the appearances had begun to come into being and had not yet achieved their full particularity.

In the Rothko the same movement is even clearer. His life's ambition was to reduce the substance of the apparent to a pellicle thinness, aglow with what lay behind. Behind the grey rectangle lies mother-of-pearl, behind the narrow brown one, the iodine of the sea. Both oceanic.

Rothko was a consciously religious painter. Yet Courbet was not. If one thinks of appearances as a frontier, one might say that painters search for messages which cross the frontier: messages which come from the back of the visible. And this, not because all painters are Platonists, but because they look so hard.

Image-making begins with interrogating appearances and making marks. Every artist discovers that drawing – when it is an urgent activity – is a two-way process. To draw is not only to measure and put down, it is also to receive. When the intensity of looking reaches a certain degree, one becomes aware of an equally intense energy coming towards one, through the appearance of whatever it is one is scrutinising. Giacometti's life's work is a demonstration of this.

The encounter of these two energies, their dialogue, does not have the form of question and answer. It is a ferocious and inarticulated dialogue. To sustain it requires faith. It is like a burrowing in the dark,

a burrowing under the apparent. The great images occur when the two tunnels meet and join perfectly. Sometimes when the dialogue is swift, almost instantaneous, it is like something thrown and caught.

I offer no explanation for this experience. I simply believe very few artists will deny it. It's a professional secret.

The act of painting – when its language opens – is a response to an energy which is experienced as coming from behind the given set of appearances. What is this energy? Might one call it the will of the visible that sight should exist? Meister Eckardt talked about the same reciprocity when he wrote: 'The eye with which I see God is the same eye with which he sees me.' It is the symmetry of the energies which offers us a clue here, not the theology.

Every real act of painting is the result of submitting to that will, so that in the painted version the visible is not just interpreted but allowed to take its place actively in the community of the painted. Every event which has been really painted – so that the pictorial language opens – joins the community of everything else that has been painted. Potatoes on a plate join the community of a loved woman, a mountain, or a man on a cross. This – and this only – is the redemption which painting offers. This mystery is the nearest painting can offer to catharsis.

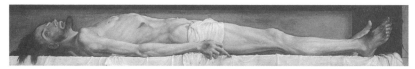

Hans Holbein the Younger, *The Body of the Dead Christ in the Tomb*, 1520–22

14.

Caravaggio
(1571–1610)

EACH IS GOING to his own rest. But they are all returning to the world, and its first gift is its space; later, its second gift will be a flat table and a bed. For the most fortunate the bed is shared.

Even after the great separation we shall return to you at the end of the day, out of the unimpeded sky, and you will recognise us by our fatigue and by the heaviness of our heads on your bodies, of which we had such need.

According to whether we are in the same place or separated one from the other, I know you twice. There are two of you.

When you are away, you are nevertheless present for me. This presence is multiform: it consists of countless images, passages, meanings, things known, landmarks, yet the whole remains marked by your absence, in that it is diffuse. It is as if your person becomes a place, your contours horizons. I live in you then like living in a country. You are everywhere. Yet in that country I can never meet you face to face.

Partir est mourir un peu. I was very young when I first heard this sentence quoted and it expressed a truth I already knew. I remember it now because the experience of living in you as if you were a country, the only country in the world where I can never conceivably meet you

face to face, this is a little like the experience of living with the memory of the dead. What I did not know when I was very young was that nothing can take the past away: the past grows gradually around one, like a placenta for dying.

In the country which is you I know your gestures, the intonations of your voice, the shape of every part of your body. You are not physically less real there, but you are less free.

What changes when you are there before my eyes is that you become unpredictable. What you are about to do is unknown to me. I follow you. You act. And with what you do, I fall in love again.

One night in bed you asked me who was my favourite painter. I hesitated, searching for the least knowing, most truthful answer. Caravaggio. My own reply surprised me. There are nobler painters and painters of greater breadth of vision. There are painters I admire more and who are more admirable. But there is none, so it seems – for the answer came unpremeditated – to whom I feel closer.

The few canvases from my own incomparably modest life as a painter, which I would like to see again, are those I painted in the late 1940s of the streets of Livorno. This city was then war-scarred and poor, and it was there that I first began to learn something about the ingenuity of the dispossessed. It was there too that I discovered that I wanted as little as possible to do in this world with those who wield power. This has turned out to be a lifelong aversion.

The complicity I feel with Caravaggio began, I think, during that time in Livorno. He was the first painter of life as experienced by the popolaccio, the people of the backstreets, les sans-culottes, the lumpenproletariat, the lower orders, those of the lower depths, the underworld. There is no word in any traditional European language which does not either denigrate or patronise the urban poor it is naming. That is power.

Following Caravaggio up to the present day, other painters – Brower, Ostade, Hogarth, Goya, Géricault, Guttuso – have painted pictures of the same social milieu. But all of them – however great – were genre pictures, painted in order to show others how the less fortunate or the more dangerous lived. With Caravaggio, however, it was not a question of presenting scenes but of seeing itself. He does

not depict the underworld for others: his vision is one that he shares with it.

In art-historical books Caravaggio is listed as one of the great innovating masters of chiaroscuro and a forerunner of the light and shade later used by Rembrandt and others. His vision can of course be considered art-historically as a step in the evolution of European art. Within such a perspective *a* Caravaggio was almost inevitable, as a link between the high art of the Counter-Reformation and the domestic art of the emerging Dutch bourgeoisie, the form of this link being that of a new kind of space, defined by darkness as well as by light. (For Rome and for Amsterdam damnation had become an everyday affair.)

For the Caravaggio who actually existed – for the boy called Michelangelo born in a village near Bergamo, not far from where my friends, the Italian woodcutters, come – light and shade, as he imagined and saw them, had a deeply personal meaning, inextricably entwined with his desires and his instinct for survival. And it is by this, not by any art-historical logic, that his art is linked with the underworld.

His chiaroscuro allowed him to banish daylight. Shadows, he felt, offered shelter as can four walls and a roof. Whatever and wherever he painted he really painted interiors. Sometimes – for *The Flight into Egypt* or one of his beloved John the Baptists – he was obliged to include a landscape in the background. But these landscapes are like rugs or drapes hung up on a line across an inner courtyard. He only felt at home – no, that he felt nowhere – he only felt relatively at ease *inside*.

His darkness smells of candles, over-ripe melons, damp washing waiting to be hung out the next day: it is the darkness of stairwells, gambling corners, cheap lodgings, sudden encounters. And the promise is not in what will flare against it, but in the darkness itself. The shelter it offers is only relative, for the chiaroscuro reveals violence, suffering, longing, mortality, but at least it reveals them intimately. What has been banished, along with the daylight, are distance and solitude – and both these are feared by the underworld.

Those who live precariously and are habitually crowded together develop a phobia about open spaces which transforms their frustrating lack of space and privacy into something reassuring. He shared those fears.

The Calling of St Matthew depicts five men sitting round their usual table, telling stories, gossiping, boasting of what one day they will do, counting money. The room is dimly lit. Suddenly the door is flung open. The two figures who enter are still part of the violent noise and light of the invasion. (Berenson wrote that Christ, who is one of the figures, comes in like a police inspector to make an arrest.)

Two of Matthew's colleagues refuse to look up, the other two younger ones stare at the strangers with a mixture of curiosity and condescension. Why is he proposing something so mad? Who's protecting him, the thin one who does all the talking? And Matthew, the tax-collector with a shifty conscience which has made him more unreasonable than most of his colleagues, points at himself and asks: Is it really I who must go? Is it really I who must follow you?

How many thousands of decisions to leave have resembled Christ's hand here! The hand is held out towards the one who has to decide, yet it is ungraspable because so fluid. It orders the way, yet offers no direct support. Matthew will get up and follow the thin stranger from the room, down the narrow streets, out of the district. He will write his gospel, he will travel to Ethiopia and the South Caspian and Persia. Probably he will be murdered.

And behind the drama of this moment of decision in the room at the top of the stairs, there is a window, giving onto the outside world. Traditionally in painting, windows were treated either as sources of light or as frames framing nature or framing an exemplary event outside. Not so this window. No light enters by it. The window is opaque. We see nothing. Mercifully we see nothing because what is outside is bound to be threatening. It is a window through which only the worst news can come.

Caravaggio was a heretical painter: his works were rejected or criticised by the Church because of their subject matter, although certain Church figures defended him. His heresy consisted of transposing religious themes into popular tragedies. The fact that for *The Death of the Virgin* he reputedly took as a model a drowned prostitute is only half the story: the more important half is that the dead woman is laid out as the poor lay out their dead, and the mourners mourn her as the poor mourn. As the poor still mourn.

There's no cemetery at Marinella or Selinunte, so when somebody dies we take him to the station and send him to Castelvetrano. Then us fishermen stick together. We pay our respects to the stricken family. 'He was a good man. It's a real loss, he had lots of good years ahead of him.' Then we go off to tend to our business in the port, but we never stop talking about the deceased and for three whole days we don't go out to fish. And close relatives or friends feed the mourners' families for at least a week.

Other Mannerist painters of the period produced turbulent crowd scenes, but their spirit was very different; a crowd was seen as a sign of calamity – like fire or flood – and the mood was of terrestrial damnation. The spectator observed, from a privileged position, a cosmic theater. By contrast, Caravaggio's congested canvases are simply made up of individuals living cheek-by-jowl, coexisting in a confined space.

The underworld is full of theatre, but one that has nothing to do with either cosmic effects or ruling-class entertainment. In the daily theatre of the underworld everything is close-to and emphatic. What is being 'played' may any moment become 'for real'. There is no protective space and no hierarchical focus of interest. Caravaggio was continually being criticised for exactly this – the lack of discrimination in his paintings, their overall intensity, their lack of a proper distance.

The underworld displays itself in hiding. This is the paradox of its social atmosphere and the expression of one of its deepest needs. It has its own heroes and villains, its own honour and dishonour, and these are celebrated by legends, stories, daily performances. The last are often somewhat like rehearsals for real exploits. They are scenes, created on the spur of the moment, in which people play themselves, pushed to the limit. If these 'performances' did not take place, the alternative moral code and honour of the underworld would be in danger of being forgotten – or, to put it better, the negative judgement, the opprobrium of the surrounding society, would advance apace.

The underworld's survival and pride depend upon theatre, a theatre where everyone is flamboyantly playing and proving

himself, and yet where an individual's survival may well depend on his lying low or his not being seen. The consequent tension produces a special kind of expressive urgency in which gestures fill all the space available, in which a life's desire may be expressed by a glance. This amounts to another kind of overcrowding, another kind of density.

Caravaggio is the painter of the underworld, and he is also the exceptional and profound painter of sexual desire. Beside him most heterosexual painters look like pimps undressing their 'ideals' for the spectator. He, though, had eyes only for the desired.

Desire changes its character by 180 degrees. Often, when first aroused, it is felt as the desire to have. The desire to touch is, partly, the desire to lay hands on, to take. Later, transformed, the same desire becomes a desire to be taken, to lose oneself within the desired. From these two opposed moments come one of the dialectics of desire; both moments apply to both sexes and they oscillate. Clearly the second moment, the desire to lose oneself within, is the most abandoned, the most desperate, and it is the one that Caravaggio chose (or was compelled) to reveal in many of his paintings.

The gestures of his figures are sometimes – given the nominal subject matter – ambiguously sexual. A six-year-old child fingers the Madonna's bodice; the Madonna's hand invisibly caresses his thigh under his shirt. An angel strokes the back of St Matthew's evangelical hand like a prostitute with an elderly client. A young St John the Baptist holds the foreleg of a sheep between his legs as if it were a penis.

Almost every act of touching which Caravaggio painted has a sexual charge. Even when two different substances (fur and skin, rags and hair, metal and blood) come into contact with one another, their contact becomes an act of touching. In his painting of a young boy as Cupid, the feather of one of the boy's wing tips touches his own upper thigh with a lover's precision. That the boy can control his reaction, that he does not allow himself to quiver in response, is part of his deliberate elusiveness, of his half-mocking, half-acknowledging practice as a seducer. I think of the marvelous Greek poet Cavafy:

For a month we loved each other
Then he went away, I think to Smyrna,
To work there; we never saw each other again.
The grey eyes – if he lives – have lost their beauty;
The beautiful face will have been spoiled.
O Memory, preserve them as they were.
And, Memory, all you can of this love of mine
Whatever you can bring back to me tonight.

There is a special facial expression which, painted, exists only in Caravaggio. It is the expression on Judith's face in *Judith and Holofernes*, on the boy's face in the *Boy Being Bitten by a Lizard*, on Narcissus's face as he gazes into the water, on David's as he holds up the head of Goliath by the giant's hair. It is an expression of closed concentration and openness, of force and vulnerability, of determination and pity. Yet all those words are too ethical. I have seen a not dissimilar expression on the face of animals – before mating and before a kill.

To think of it in sado-masochistic terms would be absurd. It goes deeper than any personal predilection. If it vacillates, this expression, between pleasure and pain, passion and reluctance, it is because such a dichotomy is inherent in sexual experience itself. Sexuality is the result of an original unity being destroyed, of separation. And, in this world as it is, sexuality promises, as nothing else can, momentary completion. It touches a love to oppose the original cruelty.

The faces he painted are illuminated by that knowledge, deep as a wound. They are the faces of the fallen – and they offer themselves to desire with a truthfulness which only the fallen know to exist.

To lose oneself within the desired. How did Caravaggio express that in the way he painted bodies? Two young men, half dressed or undressed. Although young, their bodies bear the marks of use and experience. Soiled hands. A thigh already going to fat. Worn feet. A torso (with its nipple like an eye) which was born, grew up, sweats, pants, turns sleepless in the night – never a torso sculpted from an ideal. Not being innocent, their bodies contain experience.

And this means that their sentience can become palpable; on the other side of their skin is a universe. The flesh of the desired body is not a dreamt-of destination, but an immediate point of departure. Their very appearance beckons towards the *implicit* – in the most unfamiliar, carnal sense of that word. Caravaggio, painting them, dreams of their depths.

In Caravaggio's art, as one might expect, there is no property. A few tools and recipients, chairs and a table. And so around his figures there is little of interest. A body flares with light in an interior of darkness. The impersonal surroundings – like the world outside the window – can be forgotten. The desired body disclosed in the darkness, the darkness which is not a question of the time of

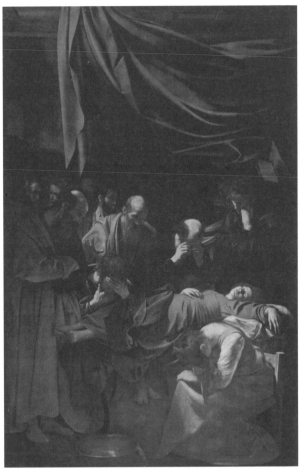

Caravaggio, *The Death of the Virgin*, 1604–06

day or night but of life as it is on this planet, the desired body, flaring like an apparition, beckons beyond – not by provocative gesture, but by the undisguised fact of its own sentience, promising the universe lying on the far side of its skin, calling you to leave. On the desired face an expression which goes further, much further, than invitation; for it is an acknowledgment of the self, of the cruelty of the world and of the one shelter, the one gift: to sleep together. Here. Now.

15.

Frans Hals
(1582/3–1666)

IN MY MIND'S eye I see the story of Frans Hals in theatrical terms.

The first act opens with a banquet that has already been going on for several hours. (In reality these banquets often continued for several days.) It is a banquet for the officers of one of the civic guard companies of Haarlem – let us say the St George's Company of 1627. I chose this one because Hals's painted record of the occasion is the greatest of his civic guard group portraits.

The officers are gay, noisy, and emphatic. Their soldierly air has more to do with the absence of women and with their uniforms than with their faces or gestures, which are too bland for campaigning soldiers. And on second thoughts even their uniforms seem curiously unworn. The toasts which they drink to one another are to eternal friendship and trust. May all prosper together!

One of the most animated is Captain Michiel de Wael – downstage wearing a yellow jerkin. The look on his face is the look of a man certain that he is as young as the night and certain that all his companions can see it. It is a look that you can find at a certain moment at most tables in any night-club. But before Hals it had never been recorded. We watch Captain de Wael as the sober always watch a man getting tipsy – coldly and very aware of being an outsider. It is like

watching a departure for a journey we haven't the means to make. Twelve years later Hals painted the same man wearing the same chamois jerkin at another banquet. The stare, the look, has become fixed and the eyes wetter. If he can, he now spends the afternoons drinking at club bars. And his throaty voice as he talks and tells stories has a kind of urgency which hints that once, a long way back when he was young, he lived as we have never done.

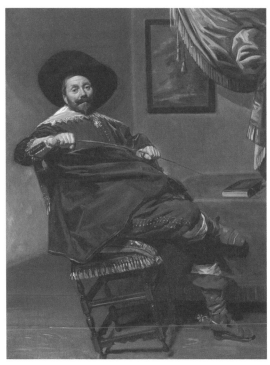

Frans Hals, *Portrait of Willem van Heythuysen, Seated on a Chair Holding a Hunting Crop*, 1625

Hals is at the banquet – though not in the painting. He is a man of nearly fifty, also drinking heavily. He is at the height of his success. He has the reputation of being wilful and alternately lethargic and violent. (Twenty years ago there was a scandal because they said he beat his wife to death when drunk. Afterwards he married again and had eight children.) He is a man of very considerable intelligence. We have no evidence about his conversation but I am certain that it was quick, epigrammatic, critical. Part of his attraction must have lain in the fact

that he behaved as though he actually enjoyed the freedom in which his companions believed in principle. His even greater attraction was in his incomparable ability as a painter. Only he could paint his companions as they wished. Only he could bridge the contradiction in their wish. Each must be painted as a distinct individual and, at the same time, as a spontaneous natural member of the group.

Who are these men? As we sensed, they are not soldiers. The civic guards, although originally formed for active service, have long since become purely ceremonial clubs. These men come from the richest and most powerful merchant families in Haarlem, which is a textile-manufacturing centre.

Haarlem is only eleven miles from Amsterdam, and twenty years before Amsterdam had suddenly and spectacularly become the financial capital of the entire world. Speculation concerning grain, precious metals, currencies, slaves, spices, and commodities of every kind is being pursued on a scale and with a success that leaves the rest of Europe not only amazed but dependent on Dutch capital.

A new energy has been released and a kind of metaphysic of money is being born. Money acquires its own virtue – and, on its own terms, demonstrates its own tolerance. (Holland is the only state in Europe without religious persecution.) All traditional values are being either superseded or placed within limits and so robbed of their absolutism. The States of Holland have officially declared that the Church has no concern with questions of usury within the world of banking. Dutch arms-merchants consistently sell arms, not only to every contestant in Europe, but also, during the cruellest wars, to their own enemies.

The officers of the St George's Company of the Haarlem Civic Guard belong to the first generation of the modern spirit of Free Enterprise. A little later Hals painted a portrait which seems to me to depict this spirit more vividly than any other painting or photograph I have ever seen. It is of Willem van Heythuysen.

What distinguishes this portrait from all earlier portraits of wealthy or powerful men is its instability. Nothing is secure in its place. You have the feeling of looking at a man in a ship's cabin during a gale. The table will slide across the floor. The book will fall off the table. The curtain will tumble down.

Furthermore, to emphasise and make a virtue out of this precariousness, the man leans back on his chair to the maximum angle of possible balance, and tenses the switch which he is holding in his hands so as almost to make it snap. And it is the same with his face and expression. His glance is a momentary one, and around his eyes you see the tiredness which is the consequence of having always, at each moment, to calculate afresh.

At the same time the portrait in no way suggests decay or disintegration. There may be a gale but the ship is sailing fast and confidently. Today van Heythuyzen would doubtless be described by his associates as being 'electric', and there are millions who model themselves – though not necessarily consciously – on the bearing of such men.

Put van Heythuyzen in a swivel chair, without altering his posture, pull the desk up in front of him, change the switch in his hands to a ruler or an aluminium rod, and he becomes a typical modern executive, sparing a few moments of his time to listen to your case.

But to return to the banquet. All the men are now somewhat drunk. The hands that previously balanced a knife, held a glass between two fingers, or squeezed a lemon over the oysters, now fumble a little. At the same time their gestures become more exaggerated – and more and more directed towards us, the imaginary audience. There is nothing like alcohol for making one believe that the self one is presenting is one's true, up to now always hidden, self.

They interrupt each other and talk at cross-purposes. The less they communicate by thought, the more they put their arms round each other. From time to time they sing, content that at last they are acting in unison, for each, half lost in his own fantasy of self-presentation, wishes to prove to himself and to the others only one thing – that he is the truest friend there.

Hals is more often than not a little apart from the group. And he appears to be watching them as we are watching them.

The second act opens on the same set with the same banqueting table, but now Hals sits alone at the end of it. He is in his late sixties or early seventies, but still very much in possession of his faculties. The passing of the intervening years has, however, considerably changed the atmosphere of the scene. It has acquired a curiously mid-nineteenth-century

air. Hals is dressed in a black cloak, with a black hat somewhat like a nineteenth-century top hat. The bottle in front of him is black. The only relief to the blackness is his loose white collar and the white page of the book open on the table.

The blackness, however, is not funereal. It has a rakish and defiant quality about it. We think of Baudelaire. We begin to understand why Courbet and Manet admired Hals so much.

The turning point occurred in 1645. For several years before that, Hals had received fewer and fewer commissions. The spontaneity of his portraits which had so pleased his contemporaries became unfashionable with the next generation, who already wanted portraits which were more morally reassuring – who demanded in fact the prototypes of that official bourgeois hypocritical portraiture which has gone on ever since.

In 1645 Hals painted a portrait of a man in black looking over the back of a chair. Probably the sitter was a friend. His expression is another one that Hals was the first to record. It is the look of a man who does not believe in the life he witnesses, yet can see no alternative. He has considered, quite impersonally, the possibility that life may be absurd. He is by no means desperate. He is interested. But his intelligence isolates him from the current purpose of men and the supposed purpose of God. A few years later Hals painted a self-portrait displaying a different character but the same expression.

As he sits at the table it is reasonable to suppose that he reflects on his situation. Now that he receives so few commissions, he is in severe financial difficulties. But his financial crisis is secondary in his own mind to his doubts about the meaning of his work.

When he does paint, he does so with even greater mastery than previously. But this mastery has itself become a problem. Nobody before Hals painted portraits of such immediacy. Earlier artists painted portraits of greater dignity and greater sympathy, implying greater permanence. But nobody before seized upon the momentary personality of the sitter as Hals has done. It is with him that the notion of 'the speaking likeness' is born. Everything is sacrificed to the demands of the sitter's immediate presence.

Or almost everything, for the painter needs a defence against the threat of becoming the mere medium through whom the sitter presents

himself. In Hals's portraits his brush marks increasingly acquire a life of their own. By no means all of their energy is absorbed by their descriptive function. We are not only made acutely aware of the subject of the painting, but also of *how* it has been painted. With 'the speaking likeness' of the sitter is also born the notion of the virtuoso performance by the painter, the latter being the artist's protection against the former.

Yet it is a protection that offers little consolation, for the virtuoso performance satisfies the performer only for the duration of the performance. Whilst he is painting, it is as though the rendering of each face or hand by Hals is a colossal gamble for which all the sharp, rapid brushstrokes are the stakes. But when the painting is finished, what remains? The record of a passing personality and the record of a performance which is over. There are no real stakes. There are only careers. And with these – making a virtue of necessity – he has no truck.

Whilst he sits there, people – whose seventeenth-century Dutch costumes by now surprise us – come to the other end of the table and pause there. Some are friends, some are patrons. They ask to be painted. In most cases Hals declines. His lethargic manner is an aid. And perhaps his age as well. But there is also a certain defiance about his attitude. He makes it clear that, whatever may have happened when he was younger, he no longer shares their illusions.

Occasionally he agrees to paint a portrait. His method of selection seems arbitrary: sometimes it is because the man is a friend, sometimes because the face interests him. (It must be made clear that this second act covers a period of several years.) When a face interests him, we perhaps gather from the conversation that it is because in some way or another the character of the sitter is related to the problem that preoccupies Hals, the problem of what it is that is changing so fundamentally during his lifetime.

It is in this spirit that he paints Descartes, that he paints the new, ineffective professor of theology, that he paints the minister Herman Langelius who 'fought with the help of God's words, as with an iron sword, against atheism', that he paints the twin portraits of Alderman Geraerdts and his wife.

The wife in her canvas is standing, turned to the right and offering a rose in her outstretched hand. On her face is a compliant smile. The husband in his canvas is seated, one hand limply held up to receive the rose. His expression is simultaneously lascivious and appraising. He has no need to make the effort of any pretence. It is as though he is holding out his hand to take a bill of credit that is owing to him.

At the end of the second act a baker claims a debt of 200 florins from Hals. His property and his paintings are seized and he is declared bankrupt.

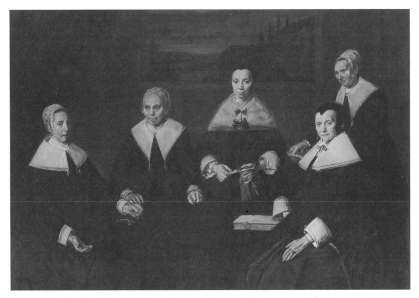

Hals, *Regentesses of the Old Men's Alms House, Haarlem,* 1664

The third act is set in the old men's almshouse of Haarlem. It is the almshouse whose men and women governors Hals was commissioned to paint in 1664. The two resulting paintings are among the greatest he ever painted.

After he went bankrupt, Hals had to apply for municipal aid. For a long while it was thought that he was actually an inmate of the almshouse – which today is the Frans Hals Museum – but apparently this was not the case. He experienced, however, both extreme poverty and the flavour of official charity.

In the centre of the stage the old men who are inmates sit at the same banqueting table as featured in the first act, with bowls of soup before them. Again it strikes us as a nineteenth-century scene – Dickensian. Behind the old men at the table, Hals, facing us, is between two canvases on easels. He is now in his eighties. Throughout the act he peers and paints on both canvases, totally without regard to what is going on elsewhere. He has become thinner, as very old men can.

On the left on a raised platform are the men governors whom he is painting on one canvas; on the right, on a similar platform, are the women governors whom he is painting on the other canvas.

The inmates between each slow spoonful stare fixedly at us or at one of the two groups. Occasionally a quarrel breaks out between a pair of them.

The men governors discuss private and city business. But whenever they sense that they are being stared at, they stop talking and take up the positions in which Hals painted them, each lost in his own fantasy of morality, their hands fluttering like broken wings. Only the drunk with the large tilted hat goes on reminiscing and occasionally proposing a mock banquet toast. Once he tries to engage Hals in conversation.

(I should point out here that this is a theatrical image; in fact the governors and governesses posed singly for these group portraits.)

The women discuss the character of the inmates and offer explanations for their lack of enterprise or moral rectitude. When they sense that they are being stared at, the woman on the extreme right brings down her merciless hand on her thigh and this is a sign for the others to stare back at the old men eating their soup.

The hypocrisy of these women is not that they give while feeling nothing, but that they never admit to the hate now lodged permanently under their black clothes. Each is secretly obsessed with her own hate. She puts out crumbs for it every morning of the endless winter until finally it is tame enough to tap on the glass of her bedroom window and wake her at dawn.

Darkness. Only the two paintings remain – two of the most severe indictments ever painted. They are projected side by side to fill a screen across the whole stage.

Offstage there is the sound of banqueting. Then a voice announces: 'He was eighty-four and he had lost his touch. He could no longer control his hands. The result is crude and, considering what he once was, pathetic.'

<div align="center">CR</div>

STORIES ARRIVE IN the head in order to be told. Sometimes paintings do the same. I will describe it as closely as I can. First, however, I will place it art-historically as the experts always do. The painting is by Frans Hals. My guess would be that it was painted sometime between 1645 and 1650.

The year 1645 was a turning point in Hals's career as a portrait painter. He was in his sixties. Until then he had been much sought after and commissioned. From then onwards, until his death as a pauper twenty years later, his reputation steadily declined. This change of fortune corresponded with the emergence of a different kind of vanity.

Now I will try to describe the painting. The large canvas is a horizontal one – 1.85 by 1.30 metres. The reclining figure is a little less than life-size. For a Hals – whose careless working methods often led to the pigment cracking – the painting is in good condition; should it

ever find its way to a sale room, it would fetch – given that its subject matter is unique in Hals's *oeuvre* – anything between two and six million dollars. One should bear in mind that, as from now, forgeries may be possible.

So far the identity of the model is understandably a mystery. She lies there naked on the bed, looking at the painter. Obviously there was some complicity between them. Fast as Hals worked, she is bound to have posed during several hours for him. Yet her look is appraising and sceptical.

Was she Hals's mistress? Was she the wife of a Haarlem burgher who commissioned the painting; and if so, where did such a patron intend to hang it? Was she a prostitute who begged Hals to do this painting of herself – perhaps to hang in her own room? Was she one of the painter's own daughters? (There is an opening here to a promising career for one of the more detective of our European art historians.)

What is happening in this room? The painting gave me the impression that neither painter nor model saw beyond their present acts, and therefore it is these, undertaken for their own sake, which remain so mysterious. Her act of lying there on the dishevelled bed in front of the painter, and his act of scrutinising and painting her in such a way that her appearances were likely to outlive them both.

Apart from the model, the bottom two-thirds of the canvas are filled with the bed, or rather with the tousled, creased white sheet. The top third is filled with a wall behind the bed. There is nothing to be seen on the wall, which is a pale brown, the colour of flax or cardboard, such as Hals often used as a background. The woman, with her head to the left, lies along and slightly across the bed. There is no pillow. Her head, turned so as to watch the painter, is pillowed on her own two hands.

Her torso is twisted, for whereas her bust is a little turned towards the artist, her hips face the ceiling and her legs trail away to the far side of the bed near the wall. Her skin is fair, in places pink. Her left elbow and foot break the line of the bed and are profiled against the brown wall. Her hair is black, crow black. And so strong are the art-historical conventions by which we are conditioned that, in this seventeenth-century painting, one is as surprised by the fact that she has pubic hair as one would be surprised in life by its absence.

How easily can you imagine a naked body painted by Hals? One has to discard all those black clothes which frame the experiencing faces and nervous hands, and then picture a whole body painted with the same degree of intense laconic observation. Not strictly an observation of forms as such – Hals was the most anti-Platonic of painters – but of all the traces of experience left on those forms.

He painted her breasts as if they were entire faces, the far one in profile, the near one in a three-quarter view, her flanks as if they were hands with the tips of their fingers disappearing into the black hair of her stomach. One of her knees is painted as if it revealed as much about her reactions as her chin. The result is disconcerting because we are unused to seeing the experience of a body painted in this way; most nudes are as innocent of experience as aims unachieved. And disconcerting, for another reason yet to be defined, because of the painter's total concentration on painting her – her, nobody else and no fantasy of her.

It is perhaps the sheet which most immediately proposes that the painter was Hals. Nobody but he could have painted linen with such violence and panache – as though the innocence suggested by perfectly ironed white linen was intolerable to his view of experience. Every cuff he painted in his portraits informs on the habitual movements of the wrist it hides. And here nothing is hidden. The gathered, crumpled, slewed sheet, its folds like grey twigs woven together to make a nest, and its highlights like falling water, is unambiguously eloquent about what has happened on the bed.

What is more nuanced is the relation between the sheet, the bed, and the figure now lying so still upon it. There is a pathos in this relationship which has nothing to do with the egotism of the painter. (Indeed, perhaps he never touched her and the eloquence of the sheet is that of a sexagenarian's memory.) The tonal relationship between the two is subtle, in places her body is scarcely darker than the sheet. I was reminded a little of Manet's *Olympia* – Manet who so much admired Hals. But there, at this purely optical level, the resemblance ends, for whereas 'Olympia', so evidently a woman of leisure and pleasure, reclines on her bed attended by a black servant, one is persuaded that the woman now lying on the bed

painted by Hals will later remake it and wash and iron the sheets. And the pathos lies precisely in the repetition of this cycle: woman as agent of total abandon, woman in her role as cleaner, folder, tidier. If her face mocks, it mocks, among other things, the surprise men feel at this contrast – men who vainly pride themselves on their homogeneity.

Her face is unexpected. As the body is undressed, the look, according to the convention of the nude, must simply invite or become masked. On no account should the look be as honest as the stripped body. And in this painting it is even worse, for the body too has been painted like a face open to its own experience.

Yet Hals was unaware of, or indifferent to, the achievement of honesty. The painting has a desperation within it which at first I did not understand. The energy of the brush strokes is sexual and, at the same time, the paroxysm of a terrible impatience. Impatience with what?

In my mind's eye I compared the painting with Rembrandt's *Bathsheba* which (if I'm right about the dates) was painted at almost the same time, in 1654. The two paintings have one thing in common. Neither painter wished to idealise his model, and this meant that neither painter wished to make a distinction, in terms of looking, between the painted face and body. Otherwise the two paintings are not only different but opposed. By this opposition the Rembrandt helped me to understand the Hals.

Rembrandt's image of Bathsheba is that of a woman loved by the image maker. Her nakedness is, as it were, original. She is as she is, before putting her clothes on and meeting the world, before being judged by others. Her nakedness is a function of her being and it glows with the light of her being.

The model for Bathsheba was Hendrickje, Rembrandt's mistress. Yet the painter's refusal to idealise her cannot simply be explained by his passion. At least two other factors have to be taken into account.

First there is the realist tradition of seventeenth-century Dutch painting. This was inseparable from another 'realism' which was an essential ideological weapon in the rise to an independent, purely secular power by the Dutch trading and merchant bourgeoisie. And

second, *contradicting this*, Rembrandt's religious view of the world. It was this dialectical combination which allowed or prompted the older Rembrandt to apply a realist practice more radically than any other Dutch painter to the subject of individual experience. It is not his choice of biblical subjects which matters here, but the fact that his religious view offered him the principle of *redemption*, and this enabled him to look unflinchingly at the ravages of experience with a minimal, tenuous hope.

All the tragic figures painted by Rembrandt in the second half of his life – Hannan, Saul, Jacob, Homer, Julius Civilis, the self-portraits – are attendant. None of their tragedies is baulked and yet *being painted* allows them to wait; what they await is meaning, a final meaning to be conferred upon their entire experience.

The nakedness of the woman on the bed painted by Hals is very different from Bathsheba's. She is not in a natural state, prior to putting her clothes on. She has only recently taken them off, and it is her raw experience, just brought back from the world outside the room with the flax-coloured wall, that lies on the bed. She does not, like Bathsheba, glow from the light of her being. It is simply her flushed perspiring skin that glows. Hals did not believe in the principle of redemption. There was nothing to counteract the realist practice, there was only his rashness and courage in pursuing it. It is irrelevant to ask whether or not she was his mistress, loved or unloved. He painted her in the only way he could. Perhaps the famous speed with which he painted was partly the result of summoning the necessary courage for this, of wanting to be finished with such looking as quickly as possible.

Of course there is pleasure in the painting. The pleasure is not embedded in the act of painting – as with Veronese or Monet – but the painting refers to pleasure. Not only because of the history which the sheet tells (or pretends to tell like a storyteller) but also because of the pleasure to be found in the body lying on it.

The hair-thin cracks of the pigment, far from destroying, seem to enhance the luminosity and warmth of the woman's skin. In places it is only this warmth which distinguishes the body from the sheet: the sheet by contrast looks almost greenish, like ice. Hals's genius was to render the full physical quality of such superficiality. It's as if in

painting he gradually approached his subjects until he and they were cheek to cheek. And this time in this skin-to-skin proximity, there was already pleasure. Add to this that nakedness can reduce us all to two common denominators and that from this simplification comes a kind of assuagement.

I am aware of failing to describe properly the desperation of the painting. I will try again, beginning more abstractly. The era of fully fledged capitalism, which opened in seventeenth-century Holland, opened with both confidence and despair. The former – confidence in individuality, navigation, free enterprise, trade, the *bourse* – is part of accepted history. The despair has tended to be overlooked or, like Pascal's, explained in other terms. Yet part of the striking evidence for this despair is portrait after portrait painted by Hals from the 1630s onwards. We see in these portraits of men (not of the women) a whole new typology of social types and, depending upon the individual case, a new kind of anxiety or despair. If we are to believe Hals – and he is nothing else if not credible – then today's world did not arrive with great rejoicing.

In face of the painting of the woman on the bed I understood for the first time to what degree, and how, Hals may have shared the despair he so often found in his sitters. A potential despair was intrinsic to his practice of painting. He painted appearances. Because the visible *appears* one can wrongly assume that all painting is about appearances. Until the seventeenth century most painting was about inventing a visible world; this invented world borrowed a great deal from the actual world but excluded contingency. It drew – in all senses of the word – conclusions. After the seventeenth century a lot of painting was concerned with disguising appearances; the task of the new academies was to teach the disguises. Hals began and ended with appearances. He was the only painter whose work was profoundly prophetic of the photograph, though none of his paintings is 'photographic'.

What did it mean for Hals as a painter to begin and end with appearances? His practice as a painter was not to reduce a bouquet of flowers to their appearance, nor a dead partridge, nor distant figures in the street; it was to reduce closely observed *experience* to appearance. The pitilessness of this exercise paralleled the

pitilessness of every value being systematically reduced to the value of money.

Today, three centuries later, and after decades of publicity and consumerism, we can note how the thrust of capital finally emptied everything of its content and left only the shard of appearances. We see this now because a political alternative exists. For Hals there was no such alternative, any more than there was redemption.

When he was painting those portraits of men whose names we no longer know, the *equivalence* between his practice and their experiences of contemporary society may well have afforded him and them – if they were prescient enough – a certain satisfaction. Artists cannot change or make history. The most they can do is to strip it of pretences. And there are different ways of doing this, including that of demonstrating an existent heartlessness.

Yet when Hals came to paint the woman on the bed it was different. Part of the power of nakedness is that it seems to be unhistorical. Much of the century and much of the decade are taken off with the clothes. Nakedness seems to return us to nature. Seems because such a notion ignores social relations, the forms of emotion and the bias of consciousness. Yet it is not entirely illusory, for the power of human sexuality – its capacity to become a passion – depends upon the promise of a new beginning. And this *new* is felt as not only referring to the individual destiny, but equally to the cosmic which, in some strange way, during such a moment, both fills and transcends history. The evidence for the fact that it happens like this is the repetition in love poetry everywhere, even during revolutions, of cosmic metaphors.

In this painting there could be no equivalence between Hals's practice as a painter and his subject, for his subject was charged, however prematurely, however nostalgically, with the potential promise of a new beginning. Hals painted the body on the bed with the consummate skill that he had acquired. He painted its experience as appearance. Yet his act of painting the woman with the crow-black hair could not respond to the sight of her. He could invent nothing new and he stood there, desperate, at the very edge of appearances.

And then? I imagine Hals putting down his brushes and palette and sitting down on a chair. By now the woman had already gone

out and the bed was stripped. Seated, Hals closed his eyes. He did not close them in order to doze. With his eyes shut, he might envisage, as a blind man envisages, other pictures painted at another time.

16.

Diego Velázquez
(1599–1660)

THE IMAGE IMPRESSED me when I set eyes upon it for the first time. It was as if it was already familiar, as if, as a child, I had already seen the same man framed in a doorway. The picture was painted by Velázquez around 1640. It is an imaginary, half-life-size portrait of Aesop.

He stands there, keeping a rendezvous. With whom? A bench of judges? A gang of bandits? A dying woman? Travellers asking for another story?

Where are we? Some say that the wooden bucket and the Chamois leather indicate a tannery, and these same commentators remember Aesop's fable about the man who learnt gradually to ignore the stench of tanning hides. I'm not entirely convinced. Perhaps we are at an inn, amongst travellers on the road. His boots are as used as nags with sway backs. Yet at this moment he is surprisingly dust-free and clean. He has washed and douched his hair, which is still a little damp.

His itinerant pilgrim's robe has long since taken on the shape of his body, and his dress has exactly the same expression as his face. It has reacted as cloth to life, in the same way as his face has reacted as skin and bone. Robe and face appear to share the same experience.

His gaze now makes me hesitate. He is intimidating, he has a kind of arrogance. A pause for thought. No, he is not arrogant. But he does not suffer fools gladly.

Who was the painter's model for this historical portrait of a man who lived two thousand years earlier? In my opinion it would be rash to assume that the model was a writer, or even a regular friend of Velázquez. Aesop is said to have been a freed slave – born perhaps in Sardinia. One might believe the same of the man standing before us. The power of his presence is of the kind which belongs exclusively to those without power. A convict in a Sicilian prison said to Danilo Dolci: 'With all this experience reading the stars all over Italy, I've plumbed the depths of the universe. All of humanity under Christendom, the poor, the rich, princes, barons, counts, have revealed to me their hidden desires and secret practices.'[1]

Diego Velázquez, *Aesop*, 1639–40

Legend has it that at the end of his life Aesop too was condemned for theft. Perhaps the model was an ex-convict, a one-time galley slave, whom Velázquez, like Don Quixote, met on the road. In any case he knows 'their hidden desires and their secret practices'.

Like the court dwarfs painted by Velázquez, he watches the spectacle of worldly power. As in the eyes of the dwarfs, there is an irony in his regard, an irony that pierces any conventional rhetoric. There, however, the resemblance ends, for the dwarfs were handicapped at

1 Danilo Dolce, *Sicilian Lives* (New York: Pantheon, 1981), p. 171.

birth. Each dwarf has his own expression, yet all of them register a form of resignation which declares: This time round, normal life was bound to exclude me. Aesop has no such exemption. He is normal.

The robe clothes him and at the same time reminds us of the naked body underneath. This effect is heightened by his left hand, inside the robe against his stomach. And his face demonstrates something similar concerning his mind. He observes, watches, recognises, listens to what surrounds him and is exterior to him, and at the same time he ponders within, ceaselessly arranging what he has perceived, trying to find a sense which goes beyond the five senses with which he was born. The sense found in what he sees, however precarious and ambiguous it may be, is his only possession. For food or shelter he is obliged to tell one of his stories.

How old is he? Between fifty and sixty-five? Younger than Rembrandt's Homer, older than Ribera's Aesop. Some say the original storyteller lived to the age of seventy-five. Velázquez died at sixty-one. The bodies of the young are gifts – both to themselves and others. The goddesses of ancient Greece were carriers of this gift. The bodies of the powerful, when old, become unfeeling and mute – already resembling the statues which they believe will be their due after their death.

Aesop is no statue. His physique embodies his experience. His presence refers to nothing except what he has felt and seen. Refers to no possessions, to no institution, to no authority or protection. If you weep on his shoulder, you'll weep on the shoulder of his life. If you caress his body, it will still recall the tenderness it knew in childhood.

Ortega y Gasset describes something of what I feel in this man's presence:

> At another time we shall see that, while astronomy for example is not a part of the stellar bodies it researches and discovers, the peculiar vital wisdom we call 'life experience' is an essential part of life itself, constituting one of its principal components or factors. It is this wisdom that makes a second love necessarily different from a first one, because the first love is already there and one carries it rolled up within. So if we resort to the image, universal and ancient

as you will see, that portrays life as a road to be travelled and travelled again – hence the expressions 'the course of life, *curriculum vitae*, decide on a career' – we could say that in walking along the road of life we keep it with us, know it; that is, the road already travelled curls up behind us, rolls up like a film. So that when he comes to the end, man discovers that he carries, stuck there on his back, the entire roll of the life he led.[2]

He carries the roll of his life with him. His virility has little to do with mastery or heroism, but a lot to do with ingenuity, cunning, a certain mockery, and a refusal to compromise. This last refusal is not a question of obstinacy but of having seen enough to know one has nothing to lose. Women often fall in love with energy and disillusion, and in this they are wise for they are doubly protected. This man, elderly, ragged, carrying nothing but his tattered life's work, has been, I believe, memorable to many women. I know old peasant women with faces like his.

He has now lost his male vanity. In the stories he tells he is not the hero. He is the witness become historian, and in the countryside this is the role which old women fill far better than men. Their reputations are behind them and count for nothing. They become almost as large as nature. (There is an art-historical theory that Velázquez, when painting this portrait, was influenced by an engraving by Giovanni Battista Porta which made a physiognomical comparison between the traits of a man and an ox. Who knows? I prefer my recollection of old peasant women.)

His eyes are odd, for they are painted less emphatically than anything else in the picture. You almost have the impression that everything else has been painted *except* his eyes, that they are all that remains of the ground of the canvas.

Yet everything in the picture, apart from the folio and his hand holding it, points to them. Their expression is given by the way the head is held and by the other features: mouth, nose, brow. The eyes perform – that is to say they look, they observe and little escapes them, yet they do not react with a judgement. This man is neither

2 José Ortega y Gasset, *Historical Reason* (New York: W. W. Norton, 1984), p. 187.

protagonist nor judge nor satirist. It is interesting to compare Aesop with Velázquez's companion painting (same size and formula) of Menippus. Menippus, one of the early cynics and a satirist, looks out at the world, as at something he has left behind, and his leaving affords him a certain amusement. In his stance and expression there is not a trace of Aesop's compassion.

Indirectly, Aesop's eyes tell a lot about storytelling. Their expression is reflective. Everything he has seen contributes to his sense of the enigma of life: for this enigma he finds partial answers – each story he tells is one – yet each answer, each story, uncovers another question, and so he is continually failing and this failure maintains his curiosity. Without mystery, without curiosity, and without the form imposed by a partial answer, there can be no stories – only confessions, communiqués, memories, and fragments of autobiographical fantasy which for the moment pass as novels.

I once referred to storytellers as Death's Secretaries. This was because all stories, before they are narrated, begin with the end. Walter Benjamin said: 'Death is the sanction of everything that the storyteller can tell. He has borrowed his authority from death.' Yet my phrase was too romantic, not contradictory enough. No man has less to do with death than this one. He watches life as life might watch itself.

A story for Aesop. It was the sixth of January, Twelfth Night. I was invited into the kitchen of a house I'd never been into before. Inside were some children and a large, bobtail sheep-dog with a coarse grey coat and matted hair over her eyes. My arrival frightened the dog, and she started to bark. Not savagely but persistently. I tried talking to her. Then I squatted on the floor so as to be the same size as her. Nothing availed. Ill at ease, she went on barking. We sat round the table, eight or nine of us, drank coffee and ate biscuits. I offered her a biscuit at arm's length. Finally, she took it. When I offered her another, close to my knee, she refused. She never bites, said the owner. And this remark prompted me to tell a story.

Twenty-five years ago I lived in a suburb on the edge of a European city. Near the flat were fields and woods where I walked every morning before breakfast. At a certain point, by a makeshift shed where some Spaniards were living, I always passed the same dog. Old, grey, blind

in one eye, the size of a boxer, and a mongrel if ever there was one. Each morning, rain or sunny, I would stop, speak to her, pat her head, and then continue on my way. We had this ritual. Then one winter's day she was no longer there. To be honest I didn't give it a second thought. On the third day, however, when I approached the shed, I heard a dog's bark and then a whine. I stopped, looked around. Not a trace. Perhaps I had imagined it. Yet no sooner had I taken a few steps than the whining started again, turning into a howl. There was snow on the ground. I couldn't even see the tracks of a dog. I stopped and walked towards the shed. And there, at my feet, was a narrow trench for drain pipes, dug, presumably, before the ground was frozen. Five feet deep with sheer sides. The dog had fallen into the trench and couldn't get out. I hesitated. Should I try to find its owner? Should I jump down and lift it out?

As I walked away, my demon's voice hissed: Coward!

Listen, I replied, she's blind, she's been there for a day or two.

You don't know, hissed the demon.

At least all night, I said. She doesn't know me and I don't even know her name!

Coward!

So I jumped down into the trench. I calmed her. I sat with her till the moment came to lift her up to the level of my shoulders and put her on the ground. She must have weighed a good thirty kilos. As soon as I lifted – as was to be expected – she bit me. Deep into the pad of my thumb and my wrist. I scrambled out and hurried off to the doctor. Later I found the dog's owner, an Italian, and he gave me his card and wrote on the back of it the name and address of his insurance company. When I recounted what had happened to the insurance agent, he raised his eyebrows.

The most improbable story I've ever heard! he said.

I pointed at my bandaged right arm in its sling.

Then you're mad! he said.

The owner of the dog asked me to report to you.

Of course! You're in it together. How much do you earn?

At that moment I was inspired. Ten thousand a month, I lied.

Please take a seat, sir.

The people listening around the table laughed. Somebody else told a story and then we got to our feet, for it was time to go. I walked

over to the door, buttoning up my coat. The dog came across the room in a straight line towards me. She took my hand in her mouth, gently, and backed away, tugging.

She wants to show you the stable where she sleeps, said one of the children.

But no, it was not to the stable door the dog was taking me, it was to the chair where I had been sitting. I sat down again and the dog lay down by my feet, undisturbed by the laughter of everyone else in the room and watchful for the smallest sign that I intended to leave.

A small story for Aesop. You can make what you like of it. How much can dogs understand? The story becomes a story because we are not quite sure; because we remain sceptical either way. Life's experience of itself (and what else are stories if not that?) is always sceptical.

Legend has it that Pyrrho, the founder of scepticism, was at first a painter. Later he accompanied Alexander the Great on his voyage through Asia, gave up painting, and became a philosopher, declaring that appearances and all perceptions were illusory. (One day somebody should write a play about Pyrrho's journey.) Since the fourth century BC, and more precisely during the last two centuries, the sense of the term 'scepticism' has radically changed. The original sceptics rejected any total explanation (or solution) concerning life because they gave priority to their experience that a life really lived was an enigma. They thought of their philosophical opponents as privileged, protected academicians. They spoke for common experience against elitism. They believed that if God existed, he was invisible, unanswerable, and certainly didn't belong to those with the longest noses.

Today scepticism has come to imply aloofness, a refusal to be engaged, and very often – as in the case of logical positivism – privileged pedantry. There was a certain historical continuity from the early sceptics through the heretics of the Middle Ages to modern revolutionaries. By contrast, modern scepticism challenges nobody and dismantles only theories of change. This said, the man before us is a sceptic in the original sense.

If I did not know the painting was by Velázquez, I think I would still

say it came from Spain. Its intransigence, its austerity, and its scepticism are very Spanish. Historically, Spain is thought of as a country of religious fervour, even fanaticism. How to reconcile this with the scepticism I am insisting upon? Let us begin with geography.

Cities have always been dependent on the countryside for their food; is it possible that they are similarly dependent on the countryside for much of their ontology, for some of the terms in which they explain man's place in the universe?

It is outside the cities that nature, geography, climate, have their maximum impact. They determine the horizons. Within a city, unless one climbs a tower, there is no horizon.

The rate of technological and political change during our century has made everyone aware of history on a world scale. We feel ourselves to be creatures not only of history but of a universal history. And we are. Yet the supremacy given to the historical has perhaps led us to underestimate the geographical.

In the Sahara one enters the Koran. Islam was born of, and is continually reborn from, a nomadic desert life whose needs it answers, whose anguish it assuages. Already I am writing too abstractly so that one forgets the weight of the sky on the sand or on the rock which has not yet become sand. It is under this weight that a prophetic religion becomes essential. As Edmond Jabès has written:

> In the mountain the sense of infinitude is disciplined by heights and depths and by the sheer density of what you confront; thus you yourself are limited, defined as an object among other objects. At sea there is always more than just water and sky; there is the boat to define your difference from both, giving you a human place to stand. But in the desert the sense of the infinite is unconditional and therefore truest. In the desert you're left utterly to yourself. And in that unbroken sameness of sky and sand, you're nothing, absolutely nothing.

The blade (the knife, the sword, the dagger, the sickle) occupies a special place in Arabic poetry. This is not unrelated to its usefulness

as a weapon and as a tool. Yet the knife-edge has another meaning too. Why is the knife so true to this land? Long before the slanders and half-truths of European Orientalism ('the cruelty of the scimitar'), the blade was a reminder of the thinness of life. And this thinness comes, very materially, from the closeness in the desert between sky and land. Between the two there is just the height for a horseman to ride or a palm to grow. No more. Existence is reduced to the narrowest seam, and if you inhabit that seam, you become aware of life as an astonishing *outside* choice, of which you are both witness and victim.

Within this awareness there is both fatalism and intense emotion. Never fatalism and indifference.

'Islam', writes Hasam Saab, 'is, in a sense, a passionate protest against naming anything sacred except God.'

In the thin stratum of the living laid on the sand like a nomad's carpet, no compromise is possible because there are no hiding places; the directness of the confrontation produces the emotion, the helplessness, the fatalism.

The interior tableland of Spain is, in a certain sense, more negative than the desert. The desert promises nothing and in its negation there are miracles to be found. The Will of God, the oasis, the alpha, the *ruppe vulgaire* – for example. The Spanish steppe is a landscape of *broken* promises. Even the backs of its mountains are broken. The typical form of the *meseta* is that of a man cut down, a man who has lost his head and shoulders, truncated by one terrible horizontal blow. And the geographical repetition of these horizontal cuts interminably underlines how the steppe has been lifted up towards the sky to bake in the summer (it is the horizontals which continually suggest the oven) and to freeze in the winter, coated with ice.

In certain areas the Spanish steppe produces wheat, maize, sunflowers, and vines. But these crops, less tough than briars, thistles, or the *jara*, risk being burnt or frozen out. Little lends itself to their survival. They have to labour, like the men who cultivate them, in the face of an inherent hostility. In this land even the rivers are mostly enemies rather than allies. For nine months of the year they are dried-out ravines – obstacles; for two months they are wild, destructive torrents.

The broken promises, like the fallen stones and the salt gravel, appear to guarantee that everything will be burnt to dust, turning first black and then white. And history? Here one learns that history is no more than the dust raised by a flock of sheep. All architecture on the tableland is defensive, all monuments are like forts. To explain this entirely by national military history – the Arab occupation, the Wars of Reconquest – is, I think, too simple. The Arabs introduced light into Spanish architecture. The essential Spanish building, with its massive doors, its defensive walls, its four-facedness, and its solitude, is a response to the landscape as representation, a response to what its signs have revealed about the origins of life.

Those who live there and work on this land live in a world visibly without promise. What promises is the invisible and lies behind the apparent. Nature, instead of being compliant, is indifferent. To the question 'Why is man here?' it is deaf, and even its silence cannot be counted as a reply. Nature is ultimately dust (the Spanish term for ejaculation is 'throwing dust') – in face of which nothing remains except the individual's ferocious faith or pride.

What I am saying here should not be confused with the character of the Spanish men and women. Spaniards are often more hospitable, truer to their promises, more generous, more tender than many other people. I am not talking about their lives but about the stage on which they live.

In a poem called 'Across the Land of Spain', Antonio Machado wrote:

> You will see battle plains and hermit steppes
> – in these fields there is nothing of the garden in the Bible –
> here is a land for the eagle, a bit of planet
> crossed by the wandering shadow of Cain.

Another way of defining the Spanish landscape of the interior would be to say that it is unpaintable. And there are virtually no paintings of it. There are of course many more unpaintable landscapes in the world than paintable ones. If we tend to forget this (with our portable easels and colour slides!) it is the result of a kind of Eurocentrism. Where nature on a large scale lends itself to being painted is the

exception rather than the rule. (Perhaps I should add that I would be the last to forget about the specific social-historical conjuncture necessary for the production of pure landscape painting, but that is another story.) A landscape is never unpaintable for purely descriptive reasons; it is always because its sense, its meaning, is not *visible*, or else lies elsewhere. For example, a jungle is paintable as a habitation of spirits but not as a tropical forest. For example, all attempts to paint the desert end up as mere paintings of sand. The desert is elsewhere – in the sand drawings of the Australian Aborigines, for instance.

Paintable landscapes are those in which what is visible enhances man – in which natural appearances make *sense*. We see such landscapes around every city in Italian Renaissance painting. In such a context there is no distinction between appearance and essence – such is the classic ideal.

Those brought up in the unpaintable *meseta* of the Spanish hinterland are convinced that essence can never be visible. The essence is in the darkness behind closed lids. In another poem, called 'The Iberian God', Machado asks:

Who has ever seen the face of the God of Spain?

> My heart is waiting
> for that Spaniard with rough hands
> who will know how to carve from the ilex of Castile
> the austere God of that brown earth.

The unpaintability of a landscape is not a question of mood. A mood changes according to the time of day and season. The Castilian steppe at noon in summer – desiccated as a dried fish – is different in mood from the same steppe in the evening when the broken mountains on the horizon are as violet as living sea anemones. In Goya's Aragon the summer dust of endless extension becomes, in the winter when the north-east *cierzo* is blowing, a frost that blindfolds. The mood changes. What does not change is the scale, and what I want to call the *address* of the landscape.

The scale of the Spanish interior is of a kind which offers no possibility of any focal centre. This means that it does not lend itself to

being looked at. Or, to put it differently, *there is no place to look at it from*. It surrounds you but it never faces you. A focal point is like a remark being made to you. A landscape that has no focal point is like a silence. It constitutes simply a solitude that has turned its back on you. Not even God is a visual witness there – for God does not bother to look there, the visible is nothing there. This surrounding solitude of the landscape which has turned its back is reflected in Spanish music. It is the music of a voice surrounded by emptiness. It is the very opposite of choral music. Profoundly human, it carries like the cry of an animal. Not because the Spaniards are animal-like, but because the territory has the character of an unchartable vastness.

By 'address' I mean what a given landscape addresses to the indigenous imagination: the background of meaning which a landscape suggests to those familiar with it. It begins with what the eye sees every dawn, with the degree to which it is blinded at noon, with how it feels assuaged at sunset. All this has a geographical or topographical basis. Yet here we need to understand by geography something larger than what is usually thought. We have to return to an earlier geographical experience, before geography was defined purely as a natural science. The geographical experience of peasants, nomads, hunters – but perhaps also of cosmonauts.

We have to see the geographic as a representation of an invisible origin: a representation which is constant yet always ambiguous and unclear because what it represents is about the beginning and end of everything. What we actually see (mountains, coastlines, hills, clouds, vegetation) are the temporal consequences of a nameless, unimaginable event. We are still living that event, and geography – in the sense I'm using it – offers us signs to read concerning its nature.

Many different things can fill the foreground with meaning: personal memories; practical worries about survival – the fate of a crop, the state of a water supply; the hopes, fears, prides, hatreds engendered by property rights; the traces of recent events and crimes (in the countryside all over the world crime is one of the favourite subjects of conversation). All these, however, occur against a common constant background which I call the landscape's *address*, consisting of the way a landscape's 'character' determines the imagination of those born there.

The address of many jungles is fertile, polytheistic, mortal. The address of deserts is unilinear and severe. The address of western Ireland or Scotland is tidal, recurring, ghost-filled. (This is why it makes sense to talk of a Celtic landscape.) The address of the Spanish interior is timeless, indifferent, and galactic.

The scale and the address do not change with mood. Every life remains open to its own accidents and its own purpose. I am suggesting, however, that geography, apart from its obvious effects on the biological, may exercise a cultural influence on how people envisage nature. This influence is a visual one, and since until very recently nature constituted the largest part of what men saw, one can further propose that a certain geography encourages a certain relation to the visible.

Spanish geography encourages a scepticism towards the visible. No sense can be found there. The essence lies elsewhere. The visible is a form of desolation, appearances are a form of debris. What is essential is the invisible self, and what may lie behind appearances. The self and the essential come together in darkness or blinding light.

The language of Spanish painting came from the other side of the Pyrenees. This is to say it was a language originally born of the scientific visual curiosity of the Italian Renaissance and the mercantile realism of the Low Countries. Later this language becomes baroque, then neoclassicist and romantic. But throughout its evolution it remains – even during its mannerist fantasy phase – a visual language constructed around the credibility of natural appearances and around a three-dimensional materialism. One has only to think of Chinese or Persian or Russian ikonic art to appreciate more clearly the *substantiality* of the main European tradition. In the history of world art, European painting, from the Renaissance until the end of the nineteenth century, is the most corporeal. This does not necessarily mean the most sensuous, but the most corporeally addressed to the living-within-their-bodies, rather than to the soul, to God, or to the dead.

We can call this corporeality humanist if we strip the word of its moral and ideological connotations. Humanist insofar as it places the living human body at the centre. Such a humanism can occur, I believe, only in a temperate climate within landscapes that lend

themselves, when the technological means are available and the social relations permit, to relatively rich harvests. The humanism of the visual language of European painting presumes a benign, kind nature. Perhaps I should emphasise here that I'm talking about the language as such, and not about what can be said with it. Poussin in *Arcadia* and Callot in his *Horrors of War* were using the same language, just as were Bellini with his Madonnas and Grünewald with his victims of the plague.

Spain at the beginning of the sixteenth century was the richest and most powerful country in Europe: the first European power of the Counter-Reformation. During the following centuries of rapid decline and increasing poverty, it nevertheless continued as a nation to play a European role, above all as a defender of the Catholic faith. That its art should be European, that its painters practised in a European language (often working in Italy) is therefore not surprising. Yet just as Spanish Catholicism was unlike that in any other European country, so was its art. The great painters of Spain took European painting and turned it against itself. It was not their aim to do so. Simply, their vision, formed by Spanish experience, could not stomach that painting's humanism. A language of plenty for a land of scarcity. The contrast was flagrant, and even the obscene wealth of the Spanish church couldn't bridge it. Once again Machado, the greatest poet of Spanish landscape, points a way to an answer:

> O land of Alvorgonzalez,
> In the heart of Spain,
> Sad land, poor land,
> So sad that it has a soul!

There is a canvas by El Greco of St Luke, the patron saint of painters. In one hand he is holding a paintbrush and, in his other, an open book against his torso. We see the page in the book on which there is an image of the Madonna and Child.

Zurbarán painted at least four versions of the face of Christ, printed miraculously on St Veronica's head-cloth. This was a favourite subject of the Counter-Reformation. The name Veronica, given to the woman who is said to have wiped Christ's face with her scarf as he

carried the cross to Golgotha, is doubtless derived from the words *vera icona*, true image.

In the El Greco and the Zurbarán we are reminded of how *thin* even a true image is. As thin as paper or silk.

In bullfighting the famous pass with the cape is called a St Veronica. The bullfighter holds his cape up before the bull, who believes the cape is the matador. As the bull advances with his head down, the matador slowly withdraws the cape and flaunts it so that it becomes no more than a scrap of material. He repeats this pass again and again, and each time the bull believes in the solidity and corporeality of what has been put before his eyes, and is deceived.

Ribera painted at least five versions of a philosopher holding a looking-glass, gazing at his own reflection and pondering the enigma of appearances. The philosopher's back is turned to us, so that we see his face properly only in the mirror which offers, once again, an image as thin as its coat of quicksilver.

Another painting by Ribera shows us the blind Isaac blessing his youngest son, Jacob, whom he believes to be Esau. With the connivance of Rebecca, his mother, Jacob is tricking his father with the kidskin he has wrapped around his wrist and arm. The old man, feeling the hairy arm, believes he is blessing Esau, his eldest son, the hirsute shepherd. I cannot remember ever seeing another painting of this subject. It is an image devoted to demonstrating graphically how surfaces, like appearances, deceive. Not simply because the surface is superficial, but because it is false. The truth is not only deeper, it is elsewhere.

The iconographic examples I have given prepare the way for a generalisation I want to make about *how* the Spanish masters painted – regardless of subject or iconography. If this *how* can be seized, we will come nearer to understanding something intrinsic to the Spanish experience of the momentous and of the everyday. *The Spanish masters painted all appearances as though they were a superficial covering.*

A covering like a veil? Veils are too light, too feminine, too transparent. The covering the painters imagined was opaque. It had to be, for otherwise the darkness it dressed would seep through, and the image would become as black as night.

Like a curtain? A curtain is too heavy, too thick, and it obliterates every texture save its own. According to the Spanish masters, appearances were a kind of skin. I am always haunted by Goya's two paintings *The Maja Dressed* and *The Maja Undressed*. It is significant that this dressed-undressed painting game occurred to a Spaniard, and remains unique in the history of art – the white skin of the naked maja is as much a covering as was her costume. What she *is* remains undisclosed, invisible.

The appearance of everything – even of rock or of armour – is equally a skin, a membrane. Warm, cold, wrinkled, fresh, dry, humid, soft, hard, jagged, the membrane of the visible covers everything we see with our eyes open, and it deceives us as the cape deceives the bull.

In Spanish painting there are very few painted eyes that are openly *looking*. Eyes are there to suggest the inner and invisible spirit of the painted person.

In El Greco they are raised to heaven. In Velázquez – think again of his portraits of the court dwarfs – their eyes are masked from vision as if by a terrible cataract; the eyes of his royal portraits are marvellously painted orbs, jellies, but they do not scrutinise like those painted by Hals, who was his contemporary a thousand miles to the north.

In Ribera and Zurbarán eyes look inward, lost to the world. In Murillo the windows of the soul are decorated with tinsel. Only Goya might seem to be the exception – particularly in the portraits of his friends. But if you place these portraits side by side, a curious thing becomes evident: their eyes have the same expression: an unflinching, lucid resignation – as if they had already seen the unspeakable, as if the existent could no longer surprise them and was scarcely worth observing any more.

Spanish art is often designated as realist. In a sense, it is. The surfaces of the objects painted are studied and rendered with great intensity and directness. The existent is stated, never simply evoked. There is no point in seeing through appearances, because behind them there is nothing to see. Let the visible be visible without illusion. The truth is elsewhere.

In *The Burial of Count Orgaz*, El Greco paints the armour of the dead count and, reflected on its metal, the image of St Stephen, who

is lifting up the corpse by its legs. In *The Spoliation* he uses the same virtuoso device. On the armour of the knight standing beside Christ is reflected, in gladiola-like flames, the red of the Saviour's robe. In El Greco's 'transcendental' world, the sense of touch, and therefore of the tangible reality of surfaces, is everywhere. He had a magnificent wardrobe for dressing up his saints. There's not another garment-painter like him.

In the more austere work of Ribera and Zurbarán, the cloak covers the body, the flesh covers the bones, the skull contains the mind. And the mind is what? Darkness and invisible faith. *Behind* the last surface is the unpaintable. Behind the pigment on the canvas is what counts, and it corresponds to what lies behind the lids of closed eyes.

The wound in Spanish painting is so important because it penetrates appearances, reaches behind them. Likewise the tatters and rags of poverty – of course they reflect both the reality and the cult of poverty, but visually what they do is to tear apart, to reveal the next surface, and so take us nearer to the last, behind which the truth begins.

The Spanish painters, with all their mastery, set out to show that the visible is an illusion, only useful as a reminder of the terror and hope within the invisible. Think, by contrast, of a Piero della Francesca, a Raphael, a Vermeer, in whose work all is visibility and God, above all, is the all-seeing.

Goya – when he was past the age of fifty and deaf – broke the mirror, stripped off the clothes, and saw the bodies mutilated. In the face of the first modern war, he found himself in the darkness, on the far side of the visible, and from there he looked back on the debris of appearances (if that sounds like a metaphor, look at the late brush drawings), picked up the pieces, and rearranged them together. Black humour, black painting, flares in the night of *The Disasters of War* and the *Disparates*. (In Spanish *disparate* means 'folly', but its Latin root means 'divide, separate'.) Goya worked with the scattered, disfigured, hacked fragments of the visible. Because they are broken fragments, we see what lies behind: the same darkness that Zurbarán, Ribalta, Maino, Murillo, and Ribera had always presumed.

Maybe one of the *Disparates* comments on this reversal, by which the presumed dark behind appearances becomes the evident dark

between their mutilated pieces. It shows a horse that turns its head to seize between its teeth the rider, who is a woman in a white dress. That which once you rode annihilates you.

Yet the reality of what Goya experienced and expressed is not finally to be found in any symbol, but simply in the way he drew. He puts parts together without considering the whole. Anatomy for him is a vain, rationalist exercise that has nothing to do with the savagery and suffering of bodies. In front of a drawing by Goya our eyes move from part to part, from a hand to a foot, from a knee to a shoulder, as though we were watching an action in a film, as though the parts, the limbs, were separated not by centimetres but by seconds.

In 1819, when he was seventy-three, Goya painted *The Last Communion of St Joseph de Calasanz*, the founder of a religious order, who educated the poor for nothing and in one of whose schools Goya had been educated as a child in Saragossa. In the same year Goya also painted a small picture of the Agony in the Garden.

In the first painting the old grey-faced, open-mouthed man kneels before the priest, who is placing the Host on his tongue. Beyond the two foreground figures is the congregation in the dark church: children, several men of different ages, and perhaps, on the extreme left, a self-portrait of the painter. Everything in the painting diminishes before the four pairs of praying hands we can see: the saint's, another old man's, the painter's, and a younger man's. They are painted with furious concentration – by the painter who, when he was young, was notorious for the cunning with which he avoided hands in his portraits to save himself time. The fingertips of each pair of hands interlace loosely, and the hands cup with a tenderness that only young mothers and the very old possess, cup – as if protecting the most precious thing in the world – nothing, *nada*.

St Luke tells the story of Christ on the Mount of Olives in the following words:

And he came out, and went, as he was wont, to the Mount of Olives; and his disciples followed him. And when he was at the place, he said unto them, Pray that ye enter not into temptation. And he was withdrawn from them about a stone's cast, and kneeled down, and prayed, saying Father, if thou be willing,

remove this cup from me; nevertheless not my will, but thine, be done. And there appeared an angel unto him from heaven, strengthening him. And being in an agony he prayed more earnestly; and his sweat was as it were great drops of blood falling down to the ground.

Christ is on his knees, arms outstretched, like the prisoner awaiting, for another second, his execution on the third of May 1808.

It is said that in 1808, when Goya began drawing *The Disasters of War*, his manservant asked him why he depicted the barbarism of the French. 'To tell men eternally', he replied, 'not to be barbarians.'

The solitary figure of Christ is painted on a ground of black with scrubbed brush marks in pale whites and greys. It has no substance at all. It is like a tattered white rag whose silhouette against the darkness makes the most humanly expressive gesture imaginable. Behind the rag is the invisible.

What makes Spanish painting Spanish is that in it is to be discovered the same anguish as the landscapes of the great *mesa* of the interior often provoked on those who lived and worked among them. In the Spanish galleries of the Prado, in the centre of modern Madrid, a Spanish earth, measured not by metres but by 'a stone's cast', onto which sweat falls like drops of blood, is present everywhere, insistent and implicit. The Spanish philosopher Miguel de Unamuno has defined it very exactly: 'Suffering is, in effect, the barrier which unconsciousness, matter, sets up against consciousness, spirit; it is the resistance to will, the limit which the visible universe imposes upon God.'

Velázquez was as calm as Goya was haunted. Nor are there any signs of religious fervour or passion in his work. His art is the most unprejudiced imaginable – everything he sees receives its due; there is no hierarchy of values. Before his canvases we are not aware of the thinness of surfaces, for his brush is too suave to separate surface from space. His paintings seem to come to our eyes like nature itself, effortlessly. Yet we are disturbed even as we admire. The images, so masterly, so assured, so tactful, have been conceived on a basis of total scepticism.

Unprejudiced, effortless, sceptical – I repeat the epithets I have used and they yield a sense: an image in a mirror. Velázquez's deliberate use of mirrors in his work has been the subject of several art-historical treatises. What I'm suggesting here, however, is more sweeping. He treated all appearances as being the equivalent of reflections in a mirror. That is the spirit in which he quizzed appearances, and this is why he discovered, long before anyone else, a miraculous, purely optical (as distinct from conceptual) verisimilitude.

But if all appearances are the equivalent of reflections, what lies behind the mirror? Velázquez's scepticism was founded upon his faith in a dualism which declared: Render unto the visible what is seen, and to God what is God's. This is why he could paint so sceptically with such certitude.

Consider Velázquez's canvas which was once called *The Tapestry Makers* and is now entitled *The Fable of Arachne*. It was always thought to be one of the painter's last works, but recently certain art historians (for reasons which to me are not very convincing) have dated it ten years earlier. In any case everyone is agreed that it is the nearest thing we have to a testament from Velázquez. Here he reflects upon the practice of image-making.

The story of Arachne, as related by Ovid, tells how a Lydian girl (we see her on the right, winding a skein of wool into a ball) made such famous and beautiful tapestries that she challenged the goddess of the arts and crafts, Pallas, to a contest. Each had to weave six tapestries. Pallas inevitably won and, as a punishment, turned Arachne into a spider. (The story is already contained in her name.) In the painting by Velázquez both are at work (the woman on the left at the spinning wheel is Pallas) and in the background in the lighted alcove there is a tapestry by Arachne which vaguely refers to Titian's painting *The Rape of Europa*. Titian was the painter whom Velázquez most admired.

Velázquez's canvas was originally somewhat smaller. Strips were added to the top and the left and the right in the eighteenth century. The overall significance of the scene, however, has not been changed. Everything we see happening is related to what we can call the cloth or the garment of appearances. We see the visible being created from spun thread. The rest is darkness.

Let us move across the foreground from left to right. A woman holds back a heavy red curtain as if to remind the spectator that what she or he is seeing is only a temporary revelation. Cry 'Curtain!' and everything disappears as off a stage.

Behind this woman is a pile of unused coloured cloths (a stock of appearances not yet displayed) and, behind that, a ladder up which one climbs into darkness.

Pallas at the spinning wheel spins a thread out of the debris of sheared wool. Such threads, when woven, can become a kerchief like the one she is wearing on her head. Equally, the golden threads, when woven, can become flesh. Look at the thread between her finger and thumb and consider its relation to her bare, outstretched leg.

To the right, seated on the floor, another woman is carding the wool, preparing it for the life it will assume. With Arachne, winding a skein of spun wool into a ball with her back to us, we have an ever-clearer allusion as to how the thread can become either cloth or flesh. The skein, her outstretched arm, the shirt on her back, her shoulders, are all made of the same golden stuff, partaking of the same life: whilst hanging on the wall behind we see the dead, inert material of the sheep's wool before it has acquired life or form. Finally, on the extreme right, the fifth woman carries a basket from which flows a golden, diaphanous drapery, like a kind of surplus.

To underline even further the equivalence of flesh and cloth, appearance and image, Velázquez has made it impossible for us to be sure which figures in the alcove are woven into the tapestry and which are free-standing and 'real'. Is the helmeted figure of Pallas part of the tapestry or is she standing in front of it? We are not sure.

The ambiguity with which Velázquez plays here is of course a very old one. In Islamic and Greek and Indian theology the weaver's loom stands for the universe and the thread for the thread of life. Yet what is specific and original about this painting in the Prado is that everything in it is revealed against a background of darkness, thus making us acutely aware of the *thinness* of the tapestry and therefore of the *thinness* of the visible. We come back, despite all the signs of wealth, to the rag.

Before this painting by Velázquez we are reminded of Shakespeare's recurring comparison of life with a play.

> These our actors,
> As I foretold you, were all spirits and
> Are melted into air, into thin air:
> And, like the baseless fabric of this vision,
> The cloud-capped towers, the gorgeous palaces,
> The solemn temples, the great globe itself,
> Yea, all which it inherit, shall dissolve
> And, like this insubstantial pageant faded,
> Leave not a rack behind.

This famous quotation (Shakespeare died at the age of fifty-two, when Velázquez was seventeen) leads us back to the scepticism of which I have already spoken. Spanish painting is unique in both its faithfulness and its scepticism towards the visible. Such scepticism is embodied in the storyteller standing before us.

Looking at him, I am reminded that I am not the first to pose unanswerable questions to myself, and I begin to share something of his composure: a curious composure for it coexists with hurt, with pain, and with compassion. The last, essential for storytelling, is the complement of the original scepticism: a tenderness for experience, because it is human. Moralists, politicians, merchants ignore experience, being exclusively concerned with actions and products. Most literature has been made by the disinherited or the exiled. Both states fix the attention upon experience and thus on the need to redeem it from oblivion, to hold it tight in the dark.

He is no longer a stranger. I begin, immodestly, to identify with him. Is he what I have wanted to be? Was the doorway he appeared in during my childhood simply my wished-for future? Where exactly is he?

One might have expected it from Velázquez! I think he's in front of a mirror. I think the entire painting is a reflection. Aesop is looking at himself. Sardonically, for his imagination is already elsewhere. In a minute he will turn and join his public. In a minute the mirror will

reflect an empty room, through whose wall the sound of occasional laughter will be heard.

CR

THE PRADO IN MADRID is unique as a meeting place. The galleries are like streets, crowded with the living (the visitors) and the dead (the painted).

But the dead have not departed; the 'present' in which they were painted, the present invented by their painters, is as vivid and inhabited as the lived present of the moment. Occasionally more vivid. The inhabitants of those painted moments mingle with the evening's visitors and together, the dead and the living, they transform the galleries into a Rambla.

I go in the evening to find the portraits of the buffoons painted by Velázquez. They have a secret which it has taken me years to fathom and which maybe still escapes me. Velázquez painted these men with the same technique and the same sceptical but uncritical eye as he painted the infantas, the kings, courtiers, serving maids, cooks, ambassadors. Yet between him and the buffoons there was something different, something conspiratorial. And their discreet, unspoken conspiracy concerned, I believe, appearances – that's to say, in this context, what people look like. Neither they nor he were the dupes or slaves of appearances; instead they played with them – Velázquez as a master-conjurer, they as jesters.

Of the seven court jesters of whom Velázquez painted close-up portraits three were dwarfs, one was boss-eyed, and two were rigged out in absurd costumes. Only one looked relatively normal – Pablo from Valladolid.

Their job was to distract from time to time the Royal Court and those who carried the burden of ruling. For this the buffoons of course developed and used the talents of clowns. Yet the abnormalities of their own appearances also played an important role in the amusement they offered. They were grotesque freaks who demonstrated by contrast the finesse and nobility of those watching them. Their deformities confirmed the elegance and stature of their masters. Their masters and the children of their masters were Nature's prodigies; they were Nature's comic mistakes.

The buffoons themselves were well aware of this. They were Nature's jokes and they took over the laughter. Jokes can joke back at the laughter they provoke, and then those laughing become the funny ones – all prodigious circus clowns play upon this seesaw.

The Spanish buffoon's private joke was that what anyone looks like is a passing affair. Not an illusion, but something temporary, both for the prodigies and the mistakes! (Transience is a joke too: look at the way great comics take their exits.)

The buffoon I love most is Juan Calabazas. Juan the Pumpkin. He's not one of the dwarfs, he's the one who squints. There are two portraits of him. In one he's standing, and holding at arm's length, mockingly, a painted, miniature medallion portrait, whilst in his other hand he's holding a mysterious object which commentators haven't exactly identified – it's thought to be part of some kind of grinding machine and is probably an allusion (like 'with a screw loose') to his being a simpleton, as was also, of course, his nickname, Pumpkin. In this canvas Velázquez, the master-conjurer and portrait painter, colludes with the Pumpkin's joke: How long do you really think looks last?

In the second, later portrait of Juan the Pumpkin, he's squatting on the floor so he's the height of a dwarf and he is laughing and speaking and his hands are eloquent. I look into his eyes.

They are unexpectedly still. His whole face is flickering with laughter – either his own or the laughter he's provoking, but in his eyes there's no flicker; they are impassive and still. And this isn't the consequence of his squint, because the gaze of the other buffoons, I suddenly realise, is similar. The various expressions of their eyes all contain a comparable stillness, which is exterior to the duration of the rest.

This might suggest a profound solitude, but with the buffoons it doesn't. The mad can have a fixed look in their eyes because they are lost in time, unable to recognise any reference point. Géricault, in his piteous portrait of the madwoman in the Paris hospital of La Salpêtrière (painted in 1819 or 1820), revealed this haggard look of absence, the gaze of someone banished from duration.

The buffoons painted by Velázquez are as far away as the woman in La Salpêtrière from the normal portraits of honour and rank; but

they are different, for they are not lost and they have not been banished. They simply find themselves – after the laughter – beyond the transient.

Juan the Pumpkin's still eyes look at the parade of life and at us through a peephole from eternity. This is the secret that a meeting in the Rambla suggested to me.

17.

Rembrandt
(1606–69)

JUST OUTSIDE AMSTERDAM there lives an old, well-known, and respected Dutch painter. He has worked hard throughout his life – but he has only produced, as far as the world knows, a few drawings and one large canvas which is in the National Museum. I went to see his second major work, a triptych of the war. We spoke of war, old age, the vocation of the painter. He opened the door of his studio to let me go in first. The huge canvases were white. After years of work he had that day calmly destroyed them. The second major work of his life was still unfinished.

The point of this story is that it shows how persistently something very like Calvinism can still influence Dutch art even today. In itself the Calvinist religion has discouraged art, and all important Dutch artists have had to fight against it. But it has influenced them neverthe-less. It has often made them moralists and extremists. Their central fight – as with my friend – has been with their own consciences.

Mr. Valentiner's most interesting essay on Rembrandt and Spinoza[1] describes how these two men, whom he believes must surely have

1 W. R. Valentiner, *Rembrandt and Spinoza: A Study of the Spiritual Conflicts in Seventeenth-Century Holland* (London: Phaidon, 1957).

Rembrandt, *Slaughtered Ox*, 1655

met, both had to fight the State Church in their different ways. In the month that Rembrandt was declared bankrupt, Spinoza, then a student, was excommunicated for his views by the rabbis of his synagogue. Later, the Calvinist Church Council at the Hague issued a condemnation of Spinoza. Eleven years before, Hendrickje Stoffels, Rembrandt's much-loved mistress, whom he could not marry on account of a clause in his wife, Saskia's, will, had been summoned to appear before the Amsterdam Council and confess 'that she lived with Rembrandt as a whore'.

The other thing that the philosopher and the painter, who were so different in temperament, had in common was their moral concern with ethical problems. For Spinoza this concern was conscious and direct – even supplying the title for his principal work. For Rembrandt it was partly conscious – in his choice of parables and Bible stories as subjects – but, more important, it was intuitive.

As soon as we drop the habit of looking at paintings exclusively from the point of view of form, it becomes clear that Rembrandt was

the first modern painter. He was the first artist to take the tragic isolation of the individual as his recurring theme, just as he was the first great artist to experience a comparable alienation from his own society. And it was this theme which presented him with his ethical problem: a problem which – to put it very simply – he solved by compassion.

In an article as brief as this, one cannot prove in detail the connection between Calvinism, Spinoza's pantheism, and Rembrandt's charity. One can only point out that they all arose from the need to explain the new commercial-competitive relations between men. Calvinism overrides the problems by claiming that God has already chosen certain souls to be damned. Spinoza strives to create a new *unity* of pure philosophical logic round nature. Rembrandt appeals: 'There but for the grace of God . . .'

Mr. David Lewis in his essay on Mondrian[2] describes lucidly and appreciatively how this painter arrived at the doctrine behind his most severely abstract art. But he does not relate his art or his ideas to the Dutch tradition. This, I think, is a pity. Mondrian was a fervent moralist. He believed that his geometric abstractions heralded a modern order of society, in which 'the tragic', the result of conflict with nature, and of excessive individuality, would finally be made to disappear. The austerity of his later works (emphasised by the tenderness almost amounting to sentimentality of his earlier representational paintings) undoubtedly owed something to his Calvinist background – even though he rejected this. The completeness of his system of thought and his method of arguing is very closely related to Spinoza's. While his single-mindedness – however we assess its result in terms of art – recalls Rembrandt's or Van Gogh's. Nor is this only an academic interest today. As soon as one recognises the discipline, logic, and ethical preoccupation that lie behind Mondrian's work, one realises that his art, although called abstract, has absolutely nothing to do with the nihilism of the currently fashionable form of abstract painting – Tachisme.

<div style="text-align:center">∝</div>

2 David Lewis, *Mondrian, 1872–1944* (London: Faber, 1957).

THE ESSENTIAL CHARACTER of oil painting has been obscured by an almost universal misreading of the relationship between its 'tradition' and its 'masters'. Certain exceptional artists in exceptional circumstances broke free of the norms of the tradition and produced work that was diametrically opposed to its values: yet these artists are acclaimed as the tradition's supreme representatives: a claim which is made easier by the fact that after their death, the tradition closed around their work, incorporating minor technical innovations, and continuing as though nothing of principle had been disturbed. This is why Rembrandt or Vermeer or Poussin or Chardin or Goya or Turner had no followers but only superficial imitators.

From the tradition a kind of stereotype of 'the great artist' has emerged. This great artist whose lifetime is consumed by struggle: partly against material circumstances, partly against himself. He is imagined as a kind of Jacob wrestling with an Angel. (The examples extend from Michelangelo to Van Gogh.) In no other culture has the artist been thought of in this way. Why then in this culture? We have already referred to the exigencies of the open art market. But the struggle was not only to love. Each time a painter realised that he was dissatisfied with the limited role of painting as a celebration of material property and of the status that accompanies it, he inevitably found himself struggling with the very language of his own art as understood by the tradition of his calling.

The two categories of exceptional works and average (typical) works are essential to our argument. But they cannot be applied mechanically as critical criteria. The critic must understand the terms of the antagonism. Every exceptional work was the result of a prolonged successful struggle. Innumerable works involved no struggle. There were also prolonged yet unsuccessful struggles.

To be an exception, a painter whose vision had been formed by this tradition, and who has probably studied as an apprentice or student from the age of sixteen, needed to recognise his vision for what it was, and then to separate it from the usage for which it has been developed. Single-handed he had to contest himself as a painter in a way that denied the seeing of a painter. This meant that he saw himself doing something that nobody else could foresee. The degree of effort required is suggested in two self-portraits by Rembrandt.

The first was painted in 1634, when he was twenty-eight; the second thirty years later. But the difference between them amounts to something more than the fact that age has changed the painter's appearance and character.

The first painting occupies a special place in, as it were, the film of Rembrandt's life. He painted it in the first year of his marriage. In it he is showing off Saskia, his bride. Within six years she will be dead. The painting is cited to sum up the so-called happy period of the artist's life. Yet if one approaches it now without sentimentality, one sees that it employs the traditional methods for their traditional purposes. His

Rembrandt, *Rembrandt and Saskia in the Scene of the Prodigal Son in the Tavern*, 1635-36

individual style may be becoming recognizable. But it is no more than the style of a new performer playing a traditional role. The painting as a whole remains an advertisement for this sitter's good fortune, prestige, and wealth. (In this case Rembrandt's own.) And like all such advertisements it is heartless.

Rembrandt, *Self-Portrait*, 1658

In the later painting he has turned the tradition against itself. He has wrested its language away from it. He is an old man. All has gone except a sense of the question of existence, of existence as a question. And the painter in him who is both more and less than the old man has found the means to express just that, using a medium which has been traditionally developed to exclude any such question.

 CR

AT THE AGE OF SIXTY-THREE he died, looking, even by the standards of his time, very old. Drink, debts, the death through the Plague of those nearest to him are amongst the explanations of the ravages done. But the self-portraits hint at something more. He grew old in a climate of economic fanaticism and indifference – not dissimilar to the climate of the period we are living through. The human could no longer simply be copied (as in the Renaissance), the human was no longer self-evident: it had to be found in the darkness. Rembrandt himself was obstinate, dogmatic, cunning, capable of a kind of brutality. Do not let us turn him into a saint. Yet he was looking for a way out of the darkness.

He drew because he liked drawing. It was a daily reminder of what surrounded him. Painting – particularly in the second half of his life – was for him something very different: it was a search for an exit from the darkness. Perhaps the drawings – with their extraordinary lucidity – have prevented us seeing the way he really painted.

He seldom made preliminary drawings; he began painting straight-away on the canvas. There is little of either linear logic or spatial continuity in his paintings. If the pictures convince, they do so because details, parts, emerge and come out to meet the eye. Nothing is laid out before us as it is in the work of his contemporaries like Ruysdael or Vermeer.

Whereas in his drawings he was a total master of space, of proportion, the physical world he presents in his paintings is seriously dislocated. In art studies about him this has not been emphasised enough. Perhaps because one needs to be a painter rather than a scholar to perceive it clearly.

There is an early painting of a man (it's himself) before an easel in a studio. The man is not much more than half the size he should be! In the marvellous late painting *Woman at an Open Door* (Berlin) Hendrickje's right arm and hand are the size of those of a Hercules! In *Abraham's Sacrifice* (St Petersburg) Isaac has the physique of a youth but in proportion to his father is no larger than an eight-year-old!

Baroque art loved foreshortenings and improbable juxtapositions, but, even if he profited by the liberties won by the Baroque, the dis-

locations in his paintings are in no way similar, for they are not *demonstrative*: they are almost furtive.

In the sublime *St Matthew and Angel* (the Louvre) the impossible space over the Evangelist's shoulder for the Angel's head is furtively insinuated, as if by the whisper the Angel is whispering into the writer's ear. Why in his paintings did he forget – or ignore – what he could do with such mastery in his drawings? Something else – something antithetical to 'real' space – must have interested him more.

Leave the museum. Go to the emergency department of a hospital. Probably in a basement because the X-ray units are best placed underground. There are the wounded and the sick being wheeled forward, or waiting for hours, side by side, on their trolleys, until the next expert can give them attention. Often it is the rich, rather than the most sick, who pass first. Either way, for the patients, there underground, it is too late to change anything.

Each one is living in her or his own corporeal space, in which the landmarks are a pain or a disability, an unfamiliar sensation or a numbness. The surgeons when operating cannot obey the laws of this space – it is not something learnt in Dr Tulip's Anatomy Lesson. Every good nurse, however, becomes familiar by touch with it – and on each mattress, with each patient, it takes a different form.

It is the space of each sentient body's awareness of itself. It is not boundless like subjective space: it is always finally bound by the laws of the body, but its landmarks, its emphasis, its inner proportions are continually changing. Pain sharpens our awareness of such space. It is the space of our first vulnerability and solitude. Also of disease. But it is also, potentially, the space of pleasure, well-being, and the sensation of being loved. Robert Kramer, the filmmaker, defines it: 'Behind the eyes and throughout the body. The universe of circuits and synapses. The worn paths where the energy habitually flows.' It can be felt by touch more clearly than it can be seen by sight. He was the painterly master of this corporeal space.

Consider the four hands of the couple in *The Jewish Bride*. It is their hands, far more than their faces, which say: Marriage. Yet how did he get there – to this corporeal space?

Bathsheba Reading David's Letter (the Louvre). She sits there

life-size and naked. She is pondering her fate. The king has seen her and desires her. Her husband is away at the wars. (How many millions of times has it happened?) Her servant, kneeling, is drying her feet. She has no choice but to go to the king. She will become pregnant. King David will arrange for her fond husband to be killed. She will mourn for her husband. She will marry King David and bear him the son who will become King Solomon. A fatality has already begun, and at the centre of this fatality is Bathsheba's desirability as a wife.

And so he made her nubile stomach and navel the focus of the entire painting. He placed them at the level of the servant's eyes. And painted them with love and pity as if they were a face. There isn't another belly in European art painted with a fraction of this devotion. It has become the centre of its own story.

On canvas after canvas he gave to a part of a body or to parts of bodies a special power of narration. The painting then speaks with several voices – like a story being told by different people from different points of view. Yet these 'points of view' can exist only in a corporeal space which is incompatible with territorial or architectural space. Corporeal space is continually changing its measures and focal centres, according to circumstances. It measures by waves, not metres. Hence its necessary dislocations of 'real' space.

The Holy Family (Munich). The Virgin is seated in Joseph's workshop. Jesus is asleep on her lap. The relation between the Virgin's hand holding the baby, her bare breast, the baby's head, and his outstretched arm is absurd in terms of any conventional pictorial space: nothing fits, stays in its proper place, is the correct size. Yet the breast with its drop of milk speaks to the baby's face. The baby's hand speaks to the amorphous landmass which is his mother. Her hand listens to the infant it is holding.

His best paintings deliver coherently very little to the spectator's point of view. Instead, the spectator intercepts (overhears) dialogues between parts gone adrift, and these dialogues are so faithful to a corporeal experience that they speak to something everybody carries within them. Before his art, the spectator's body remembers its own inner experience.

Commentators have often remarked on the 'innerness' of Rembrandt's

images. Yet they are the opposite of ikons. They are carnal images. The flesh of the *Flayed Ox* is not an exception but typical. If they reveal an 'innerness' it is that of the body, what lovers try to reach by caressing and by intercourse. In this context the last word takes on both a more literal and more poetic meaning. Coursing between.

About half of his great masterpieces (portraits apart) depict the act or the preliminary act – the opening of the outstretched arms – of an embrace. *The Prodigal Son, Jacob and the Angel, Danaë, David and Absalom, The Jewish Bride* . . .

Nothing comparable is to be found in the *oeuvre* of any other painter. In Rubens, for instance, there are many figures being handled, carried, pulled, but few, if any, embracing. In nobody else's work does the embrace occupy this supreme and central position. Sometimes the embrace he paints is sexual, sometimes not. In the fusion between two bodies not only desire can pass, but also pardon or faith. In his *Jacob and the Angel* (Berlin) we see all three and they become inseparable.

Public hospitals, dating from the Middle Ages, were called in France Hôtels-Dieu. Places where shelter and care were given in the name of God to the sick or dying. Beware of idealisation. The Hôtel-Dieu in Paris was so overcrowded during the Plague that each bed was 'occupied by three people, one sick, one dying, and one dead'.

Yet the term Hôtel-Dieu, interpreted differently, can help to explain him. The key to his vision, which had to dislocate classical space, was the New Testament. 'Who lives in love lives in God and God in him . . . We know that we live in him and he in us because he has given us of his Spirit.' (The First Epistle of John, ch. 4)

'He in us'. What the surgeons found in dissecting was one thing. What he was looking for was another. Hôtel-Dieu may also mean a body in which God resides. In the ineffable, terrible late self-portraits, he was waiting, as he gazed into his own face, for God, knowing full well that God is invisible.

When he painted freely those he loved or imagined or felt close to, he tried to enter their corporeal space as it existed at that precise moment, he tried to enter their Hôtel-Dieu. And so to find an exit from the darkness.

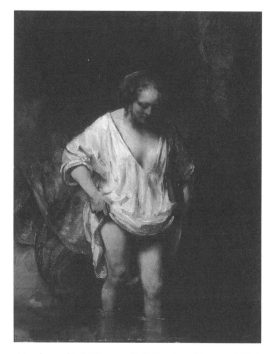

Rembrandt, *A Woman Bathing in a Stream*, 1654

Before the small painting of A *Woman Bathing* (London) we are with her, inside the shift she is holding up. Not as voyeurs. Not lecherously like the Elders spying on Susannah. It is simply that we are led, by the tenderness of his love, to inhabit her body's space.

For Rembrandt, the embrace was perhaps synonymous with the act of painting, and both were just this side of prayer.

რ

IT IS STRANGE HOW art historians sometimes pay so much attention, when trying to date certain paintings, to 'style', inventories, bills, auction lists, and so little to the painted evidence concerning the model's age. It is as if they do not trust the painter on this point. For example when they try to date and arrange in chronological order Rembrandt's paintings of Hendrickje Stoffels. No painter was a greater expert about the process of ageing, and no painter has left us a more intimate record of the great love of his life. Whatever the documentary conjectures may allow, the paintings make it clear that the love between Hendrickje and the

painter lasted for about twenty years, until her death, six years before his.

She was ten or twelve years younger than he. When she died she was, on the evidence of the paintings, at the very least forty-five, and when he first painted her she could certainly not have been older than twenty-seven. Their daughter, Cornelia, was baptised in 1654. This means that Hendrickje gave birth to their child when she was in her mid thirties.

The *Woman in Bed* (from Edinburgh) was painted, by my reckoning, a little before or a little after the birth of Cornelia. The historians suggest that it may be a fragment taken from a larger work representing the wedding night of Sarah and Tobias. A biblical subject for Rembrandt was always contemporary. If it is a fragment, it is certain that Rembrandt finished it, and bequeathed it finally to the spectator, as his most intimate painting of the woman he loved.

There are other paintings of Hendrickje. Before the *Bathsheba* in the Louvre or the *Woman Bathing* in the National Gallery (London), I am wordless. Not because their genius inhibits me, but because the experience from which they derive and which they express – desire experiencing itself as something as old as the known world, tenderness experiencing itself as the end of the world, the eyes' endless rediscovery as if for the first time of a familiar body – all this comes before and goes beyond words. No other paintings lead so deftly and powerfully to silence. Yet in both, Hendrickje is absorbed in her own actions. In the painter's vision of her there is the greatest intimacy, but there is no mutual intimacy between them. They are paintings which speak of his love, not of hers.

In the paintings of the *Woman in Bed* there is a complicity between the woman and the painter. This complicity includes both reticence and abandon, day and night. The curtain of the bed, which Hendrickje lifts up with her hand, marks the threshold between daytime and nighttime.

In two years, by daylight, Rembrandt will be declared bankrupt. Ten years before by daylight, Hendrickje came to work in Rembrandt's house as nurse for his baby son. In the light of Dutch

seventeenth-century accountability and Calvinism, the house-
keeper and the painter were distinct and separate responsibilities.
Hence their reticence.

> At night they leave their century.
> A necklace hangs loose across her breasts,
> And between them lingers –
> yet is it a lingering
> and not an incessant arrival? –
> the perfume of forever.
> A perfume as old as sleep,
> as familiar to the living as to the dead.

Leaning forward from her pillows, she lifts up the curtain with the
back of her hand, for its palm, its face is already welcoming,
already making a gesture which is preparatory to the act of touch-
ing his head.

She has not yet slept. Her gaze follows him as he approaches. In
her face the two of them are reunited. Impossible now to separate the
two images: his image of her in bed, as he remembers her; her image
of him as she sees him approaching their bed. It is nighttime.

CR

THE LATE REMBRANDT self-portraits contain or embody a paradox:
they are clearly about old age, yet they address the future. They assume
something coming towards them apart from Death.

Twenty years ago in front of one of them in the Frick Collection
(New York), I wrote the following lines:

> The eyes from the face
> two nights look at the day
> the universe of his mind
> doubled by pity
> nothing else can suffice.
> Before a mirror
> silent as a horseless road
> he envisaged us

deaf dumb
returning overland
to look at him
in the dark.

At the same time there is a cheek, an insolence, in the painting which makes me think of a verbal self-portrait in a story I like very much by the American polemicist and fiction writer Andrea Dworkin:

> I have no patience with the untorn, anyone who hasn't weathered rough weather, fallen apart, been ripped to pieces, put herself back together, big stitches, jagged cuts, nothing nice. Then something shines out. But these ones all shined up on the outside, the ass wigglers, I'll be honest, I don't like them. Not at all.

Big stitches, jagged cuts. That's how the paint is put on.

Yet, finally, if we want to get closer to what makes the late self-portraits so exceptional, we have to relate them to the rest of the genre. How and why do they differ from most other painted self-portraits?

The first known self-portrait dates from the second millennium BC. An Egyptian bas-relief which shows the artist in profile drinking from a jar that his patron's servant is offering him at a feast where there are many other people. Such self-portraits – for the tradition continued until the early Middle Ages – were like artists' signatures to the crowded scenes being depicted. They were a marginal claim that said: *I also was present.*

Later, when the subject of St Luke painting the Virgin Mary became popular, the painter often painted himself in a more central position. Yet he was there because of his act of painting the Virgin: he was not yet there to look into himself.

One of the first self-portraits to do precisely this is Antonello da Messina's, which is permanently in the National Gallery (London). This painter (1430–79), who was the first southern painter to use oil paint, had an extraordinary Sicilian clarity and compassion – such as one finds later in artists like Varga, Pirandello, or Lampedusa. In the self-portrait, he looks at himself as if looking at his own judge. There is not a trace of dissimilation.

150

In most of the self-portraits that were to follow, play-acting or dissimilation was endemic. And there is a phenomenological reason for this. A painter can draw his left hand as if it belonged to somebody else. Using two mirrors he can draw his own profile as if observing a stranger. But when he looks straight into a mirror, he is caught in a trap: his reaction to the face he is seeing changes that face. Or, to put it in another way, that face can offer itself something it likes or loves. The face arranges itself. Caravaggio's painting of Narcissus is a perfect demonstration.

It is the same for all of us. We play-act when we look in the bathroom mirror, we instantly make an adjustment to our expression and our face. Quite apart from the reversal of the left and right, nobody else ever sees us as we see ourselves above the washbasin. And this dissimilation is spontaneous and uncalculated. It's as old as the invention of the mirror.

Throughout the history of self-portraits a similar 'look' occurs again and again. If the face is not hidden in a group, one can recognise a self-portrait a mile off, because of its particular kind of theatricality. We watch Dürer playing Christ, Gauguin playing the outcast, Delacroix the dandy, the young Rembrandt the successful Amsterdam trader. We can be moved as if by overhearing a confession, or amused as by a boast. Yet before most self-portraits, because of the exclusive complicity existing between the eye observing and the returned gaze, we have a sense of something opaque, a sense of watching the drama of a double-bind which excludes us.

True, there are exceptions: self-portraits which do look at *us*: a Chardin, a Tintoretto, a copy of a Frans Hals self-portrait when he was bankrupt, Turner as a young man, the old Goya as an exile in Bordeaux. Nevertheless, they are few and far between. And so how is it that during the last ten years of his life Rembrandt painted nearly twenty portraits which address us directly?

When you're trying to do a portrait of somebody else, you look very hard at them, searching to find what is there, trying to trace what has happened to the face. The result (sometimes) may be a kind of likeness, but usually it is a dead one, because the presence of the sitter and the tight focus of observation have inhibited your response. The sitter leaves. And it can then happen that you begin again, referring not any

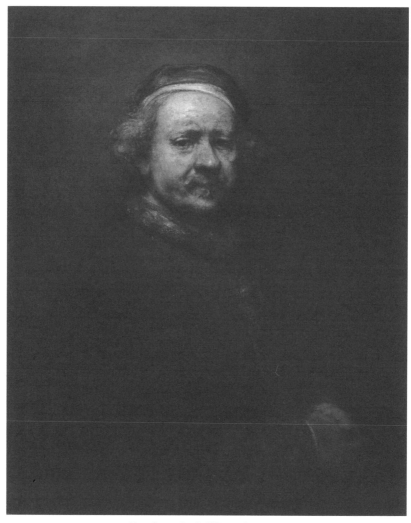

Rembrandt, *Self Portrait*, 1669

more to a face in front of you, but to the recollected face which is now inside you. You no longer peer; you shut your eyes. *You begin to make a portrait of what the sitter has left behind in your head.* And now there is a chance that it will be alive.

Is it possible that Rembrandt did something similar with himself? I believe he used a mirror only at the beginning of each canvas. Then he put a cloth over it, and worked and reworked the canvas until the painting began to correspond to an image of himself which had been left behind after a lifetime. This image

was not generalised, it was very specific. Each time he made a portrait he chose what to wear. Each time he was highly aware of how his face, his stance, his appearance had changed. He studied the damage unflinchingly. Yet, at a certain moment, he covered the mirror so that he no longer had to adjust his gaze to his gaze, and then he continued to paint only from what had been left behind inside him. Freed from the double-bind, he was sustained by a vague hope, an intuition, that later it would be others who would look at him with a compassion that he could not allow himself.

<div align="center">∞</div>

THE ROADS ARE STRAIGHT, the distance between towns long. The sky is making a new proposition to the earth. I imagine travelling alone between Kalisz and Kielce a hundred and fifty years ago. Between the two names there would always have been a third – the name of your horse. Your horse's name the constant between the names of the towns you approach and the towns you leave behind.

I see a sign for Tarnów to the south. At the end of the nineteenth century Abraham Bredius, the compiler of the first modern catalogue of Rembrandt paintings, discovered a canvas in a castle there.

'When I saw a magnificent four-in-hand passing my hotel and learnt from the porter that it was Count Tarnowski who had become engaged some days before to the ravishing Countess Potocka, who would bring him a considerable dowry, I had little idea that this man was also the fortunate owner of one of the most sublime works by our great master.'

Bredius left the hotel and made a long and difficult journey by train – he complained that for miles the train travelled at a walking pace – to the Count's castle. There he spotted a canvas of a horse and rider, which he unhesitatingly attributed to Rembrandt, considering it a masterpiece that had been forgotten for a century. It was given the title of *The Polish Rider*.

Nobody today knows precisely who or what the painting represented for the painter. The rider's coat is typically Polish – a *kontusz*. Likewise the rider's headgear. This is probably why the painting was

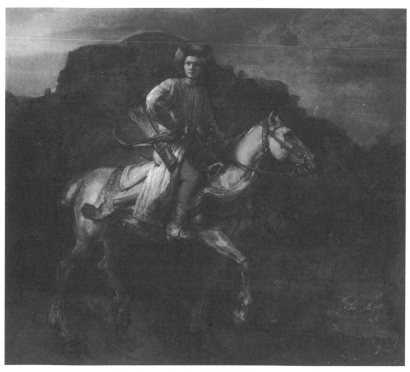

Rembrandt, *The Polish Rider*, 1655

bought by a Polish nobleman in Amsterdam, and taken to Poland at the end of the eighteenth century.

When I first saw the painting in the Frick Collection in New York, where it ended up, I felt it might be a portrait of Rembrandt's beloved son, Titus. It seemed to me – and it still does – a painting about leaving home.

A more scholarly theory suggests that the painting may have been inspired by a Pole, Jonaz Szlichtyng, who, during Rembrandt's time in Amsterdam, was something of a rebel-hero in dissident circles. Szlichtyng belonged to a sect that followed the sixteenth-century Sienese theologian Lebo Sozznisi, who denied that Christ was the son of God – for, if he were, the religion would cease to be monotheistic. If the painting was inspired by Jonaz Szlichtyng it offers an image of a Christlike figure, who is a man, only a man, setting out, mounted on a horse, to meet his destiny.

Do you think you are going fast enough to get away from me? she asks as she draws up beside me at the first traffic light in Kielce.

I notice that she is driving with her shoes kicked off, her bare feet on the pedals.

No question of leaving you behind, I say, straightening my back and putting both feet on the ground.

Then why so fast?

I don't reply, for she knows the answer.

In speed there is a forgotten tenderness. She had a way, when driving, of lifting her right hand from the steering wheel so that she could see the dials on the dashboard without having to move her head a centimetre. And this small movement of her hand was as neat and precise as that of a great conductor before an orchestra. I loved her surety.

When she was alive I called her Liz, and she called me Met. She liked the nickname Liz because during her life up to that moment it would have been inconceivable that she should answer to such a vulgar abbreviation. 'Liz' implied a law had been broken and she adored broken laws.

Met is the name given to a flight navigator in a novel by Saint-Exupéry. Perhaps *Vol de Nuit*. She was much better read than I, but I was more street-wise, and perhaps this is why she named me after a navigator. The idea of calling me Met came to her while driving through Calabria. Whenever we got out of the car she put on a hat with a wide brim. She detested suntan. Her skin was as pale as the Spanish royal family's in the time of Velázquez.

What brought us together? Superficially it was curiosity – almost everything about us, including our ages, was undisguisedly different. Between us there were many first times. Yet more profoundly, it was an unspoken acknowledgement of the same sadness which brought us together. There was no self-pity. If she had perceived a trace of this in me she would have cauterised it. And I, as I say, loved her surety, which is incompatible with self-pity. A sadness that was like the crazy howl of a dog at the full moon.

For different reasons, the two of us believed that style was indispensable for living with a little hope, and either you lived with hope or in despair. There was no middle way.

Style? A certain lightness. A sense of shame excluding certain actions or reactions. A certain proposition of elegance. The supposition that,

despite everything, a melody can be looked for and sometimes found. Style is tenuous, however. It comes from within. You can't go out and acquire it. Style and fashion may share a dream, but they are created differently. Style is about an invisible promise. This is why it requires and encourages a talent for endurance and an ease with time. Style is very close to music.

We spent evenings listening wordlessly to Bartók, Walton, Britten, Shostakovich, Chopin, Beethoven. Hundreds of evenings. It was the period of 33"records which one had to turn over by hand. And those moments of turning the record over, and slowly lowering the arm with its diamond needle, were moments of a hallucinating plenitude, grateful and expectant, only comparable with the other moments, also wordless, when one of us was on top of the other making love.

So, why the howl? Style comes from within, yet style has to borrow its assurance from another time and then lend it to the present, and the borrower has to leave a pledge with that other time. The passionate present is invariably too short for style. Liz, aristocrat that she was, borrowed from the past, and I borrowed from a revolutionary future.

Our two styles were surprisingly close. I'm not thinking about the accoutrements of life or brand names. I'm remembering how we were when walking through a forest drenched by rain, or when arriving at Milan's central railway station in the small hours of the morning. Very close.

Yet when we looked deeply into one another's eyes, defying the risks involved in this, of which we were fully aware, both of us came to realise that the times being borrowed from were chimera. This was the sadness. This is what made the dog howl.

The traffic light turns green. I overtake her and she follows. After we've left Kielce behind, I give a sign to announce I'm going to stop. We both pull up along the edge of another forest, darker than the last one. Her car window is already down. The very fine hair by her temple, sweeping back behind her ear, is delicately tangled. Delicately because to untangle it with my fingers would require delicacy. Around the glove compartment of the dashboard she has stuck different coloured feathers.

Met, she says, there were days on end, you remember, when we got

rid of the vulgarity of History. Then after a while, you'd go back, deserting me, again and again. You were addicted.

To what?

You were addicted – she touches several of the feathers with her fingers – you were addicted to the making of history, and you chose to ignore that those who believe they're making history already have their hands on power, or imagine having their hands on power, and that this power, as sure as the night is long, Met, will confuse them! After a year or so they won't know what they're doing. She lets her hand fall onto her thigh.

History has to be endured, she goes on, has to be endured with pride, an absurd pride that is also – God knows why – invincible. In Europe the Poles are the centuries-old specialists in such an endurance. That is why I love them. I've loved them since I met pilots from Squadron 303 during the war. I never questioned them, I listened to them. And when they asked me, I danced with them.

A wooden dray loaded down with new timber emerges from the forest. The pair of horses are covered with lather and sweat because the wheels sink deep into the soft earth of the forest track.

The soul of this place has a lot to do with horses, she says, laughing. And you with your famous historical laws, you didn't know any better than Trotsky how to rub down a horse! Maybe one day – who can tell? – maybe one day you'll come back into my arms without your famous historical laws.

She makes a gesture such as I cannot describe. She simply adjusts her head, so that I can see her hair and the nape of her neck.

Supposing you had to choose an epitaph? she asks.

If I had to chose an epitaph, I'd choose *The Polish Rider*, I tell her.

You can't choose a painting as an epitaph!

I can't?

It's wonderful when there's somebody to pull off your boots for you. 'She knows how to get his boots off' is a proverbial Russian compliment. I pull off my own tonight. And, once off, being motorbike boots, they stand apart. They are different, not because they have metal in certain places as a protection, nor because they have an added piece

of leather near the toecap so that they resist the wear and tear of flicking the gear pedal up, nor because they have a phosphorescent sign around the calf so that the rider is more visible at night in the headlights of the vehicle behind, but because, pulling them off, I have the feeling of stepping to the side of the many thousands of kilometres we have ridden together, they and I. They could be the seven-league boots that so fascinated me as a child. The boots I wanted to take everywhere with me, for even then I was dreaming of roads, although the road made me shit-scared.

I love the painting of the Polish Rider as a child might, for it is the beginning of a story being told by an old man who has seen many things and never wants to go to bed.

I love the rider as a woman might: his nerve, his insolence, his vulnerability, the strength of his thighs. Liz is right. Many horses course through dreams here.

In 1939 units of Polish cavalry armed with swords charged against the tanks of the invading Panzer divisions. In the seventeenth century, the 'Winged Horsemen' were feared as the avenging angels of the eastern plains. Yet the horse means more than military prowess. Over the centuries Poles have been continually obliged to travel or emigrate. Across their land without natural frontiers the roads never end.

The equestrian habit is still sometimes visible in bodies and the way they move. The gesture of putting the right foot in a stirrup and hoicking the other leg over comes to my mind whilst sitting in a pizza bar in Warsaw watching men and women who have never in their lives mounted or even touched a horse, and who are drinking Pepsi-Cola.

I love the Polish Rider's horse as a horseman who has lost his mount and has been given another might. The gift horse is a bit long in the tooth – the Poles call such a nag a *szkapa* – but he's an animal whose loyalty has been proven.

Finally I love the landscape's invitation, wherever it may lead.

18.

Willem Drost
(1633–1659)

A HOUSE STANDS on one side of a square in which there are tall poplars. The house, built just before the French Revolution, is older than the trees. It contains a collection of furniture, paintings, porcelain, armour which, for over a century, has been open to the public as a museum. The entry is free, there are no tickets, anybody can enter.

The rooms on the ground floor and up the grand staircase, on the first floor, are all the same as they were when the famous collector first opened his house to the nation. As you walk through them, something of the preceding eighteenth century settles lightly on your skin like powder. Like eighteenth-century talc.

Many of the paintings on display feature young women and shot game, both subjects testifying to the passion of pursuit. Every wall is covered with oil paintings hung close together. The outside walls are thick. No sound from the city outside penetrates.

In a small room on the ground floor, which was previously a stable for horses and is now full of showcases of armour and muskets, I imagined I heard the sound of a horse blowing through its nostrils. Then I tried to imagine choosing and buying a horse. It must be like owning nothing else. Better than owning a painting. I

also imagined stealing one. Perhaps it would have been more complicated, owning a stolen horse, than adultery? Commonplace questions to which we'll never know the answer. Meanwhile I wandered from gallery to gallery.

A chandelier in painted porcelain, the candles held aloft by an elephant's trunk, the elephant wearing green, the porcelain made and painted in the royal factory in Sèvres, first bought by Madame Pompadour. Absolute monarchy meant that every creature in the world was a potential servant, and one of the most persistent services demanded was Decoration.

At the other end of the same gallery was a bedroom commode which belonged to Louis XV. The inlay is in rosewood, the rococo decorations in polished bronze.

Most of the visitors, like me, were foreigners, more elderly than young, and all of them slightly on tiptoe, hoping to find something indiscreet. Such museums turn everyone into inquisitive gossips

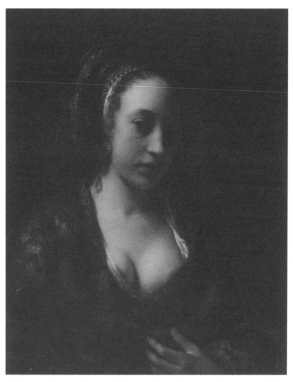

Willem Drost, *Young Woman in a Brocade Gown*, c.1654

with long noses. If we dared, and could, we'd look into every drawer.

In the Dutch part of the collection, we passed drunken peasants, a woman reading a letter, a birthday party, a brothel scene, a Rembrandt, and a canvas by one of his pupils. The latter intrigued me immediately. I moved on and then quickly came back to look at it several times.

This pupil of Rembrandt was called Willem Drost. He was probably born in Leiden. In the Louvre in Paris there is a Bathsheba painted by him which echoes Rembrandt's painting of the same subject painted in the same year. Drost must have been exactly contemporary with Spinoza. We don't know where or when he died.

She is not looking at the spectator. She is looking hard at a man she desired, imagining him as her lover. This man could only have been Drost. The only thing we know for certain about Drost is that he was desired precisely by this woman.

I was reminded of something of which one is not usually reminded in museums. To be so desired – if the desire is also reciprocal – renders the one who is desired fearless. No suit of armour from the galleries downstairs ever offered, when worn, a comparable sense of protection. To be desired is perhaps the closest anybody can reach in this life to feeling immortal.

It was then that I heard a voice. Not a voice from Amsterdam, a voice from the great staircase in the house. It was high-pitched yet melodious, precise yet rippling, as if about to dissolve into laughter. Laughter shone on it like light through a window onto satin. Most surprising of all, it was resolutely a voice speaking to a crowd of people; when it paused there was silence. I couldn't distinguish the words, so my curiosity forced me, without a moment's hesitation, to return to the staircase. Twenty or more people were slowly coming up it. Yet I couldn't make out who had been speaking. All of them were waiting for her to begin again.

'At the top of the staircase on the left you will see a three-tiered embroidery table, a woman's table, where she left her scissors and her needlework and her work could still be seen, which was better, don't you think, than hiding it away in a drawer? Locked drawers were for letters. This piece belonged to the Empress Josephine. The little oval blue plaques, which wink at you, are by Wedgwood.'

I saw her for the first time. She was coming up the staircase alone. Everything she wore was black. Flat black shoes, black stockings, black skirt, black cardigan, a black band in her hair. She was the size of a large marionette, about four feet tall. Her pale hands hovered or flew through the air as she talked. She was elderly and I had the impression that her thinness was to do with slipping through time. Yet there was nothing skeletal about her. If she was like one of the departed, she was like a nymph. Around her neck she wore a black ribbon with a card attached to it. On the card was printed the famous name of the Collection and, in smaller letters, her own name. Her first name was Amanda. She was so small that the card looked absurdly large, like a label pinned to a dress in a shop window, announcing a last-minute bargain.

'In the showcase over there you can see a snuff box made of carnelian and gold. In those days young women as well as men took snuff. It cleared the head and sharpened the senses.' She raised her chin, threw her head back, and sniffed.

'This particular snuff box has a secret drawer in which the owner kept a tiny gouache portrait, no larger than a postage stamp, of his mistress. Look at her smile. I would say it was she who gave him the snuff box. Carnelian is a red variety of agate, mined in Sicily. The colour perhaps reminded her in some way of him. Most women, you see, see men as either red or blue.' She shrugged her frail shoulders. 'The red ones are easier.'

When she stopped talking, she did not look at the public but turned her back and walked on. Despite her smallness, she walked much faster than her followers. She was wearing a ring on her left thumb. I suspect that her black hair was a wig for I'm sure she prefers wigs to rinses.

Our walk through the galleries began to resemble a walk through a wood. This was a question of how she placed us, herself, and what she was talking about. She consistently prevented us from crowding around whatever she was explaining. She pointed out an item as if it were a deer to be glimpsed as it crossed our path between two distant trees. And wherever she directed our attention, she always kept herself elusively to the side, as if she had just stepped out from behind another tree. We came upon a statue, its marble turning a little green because of the shade and dampness.

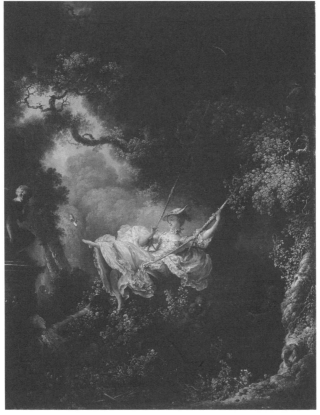

Jean-Honoré Fragonard, *The Swing*, 1767

'The statue depicts Friendship consoling Love,' she murmured, 'for Madame de Pompadour's relation with Louis the Fifteenth is now platonic, which hasn't stopped her wearing – has it? – the most gorgeous dress.'

Downstairs, one gilded timepiece after another chimed four.

'Now we go', she said, holding her head high, 'to another part of the wood. Here all is fresh, and everyone is freshly dressed – including the young lady on the swing. No statues of Friendship, all the statues here are cupids. The swing was put up in the spring. One of her slippers – you notice? – has already been kicked off! Intentionally? Unintentionally? Who can tell? As soon as a young lady, freshly dressed, sits herself there on the seat of the swing, such questions are hard to answer, no feet on the ground. The husband is pushing her from behind. Swing high, swing low. The lover is hidden in the

bushes in front of her where she told him to be. Her dress – it's less elaborate, more casual, than Madame de Pompadour's and frankly I prefer it – is of satin with lace flounces. Do you know what they called the red of her dress, they called it peach, though personally I never saw a peach of that colour, any more than I ever saw a peach blushing. The stockings are white cotton, a little roughish compared to the skin of the knees they cover. The garters, pink ones to match the slippers, are too small to go higher up the leg without pinching. Notice her hidden lover. The foot which lost the slipper is holding up her skirt and petticoats high – their lace and satin rustle softly in the slipstream – and nobody, I promise you, nobody in those days wore underwear! His eyes are popping out of his head. As she intended him to do, he can see all.'

Abruptly the words stopped, and she made a rustling noise with her tongue behind clenched teeth, as though she were pronouncing only the consonants of the words 'lace' and 'satin' without the vowels. Her eyes were closed. When she opened them, she said: 'Lace is a kind of white writing which you can only read when there's skin behind it.'

Then she stepped sideways out of sight. The guided tour was over.

Before anybody could ask a question or thank her, she disappeared into an office behind the book counter. When she came out, half an hour later, she had taken off the ribbon around her neck with its card and put on a black overcoat. If she had stood beside me, she would have come up to my elbows, no more.

She walked briskly down the front steps of the house into the square where the poplars are. She was carrying an old flimsy Marks and Spencer's plastic bag which looked as if it might tear.

This endeavour, when it has reference to the mind alone, is called will (*voluntas*); but when it refers simultaneously to the mind and body it is called appetite (*appetitus*), which therefore is nothing else than the essence of man, from the nature of which all things which help in his preservation necessarily follow; and therefore man is determined for acting in this way. Now between appetite and desire (*cupiditas*) there is no difference but this, that desire usually has reference to men insofar as they are conscious of their

appetite; and therefore it may be defined as appetite with conscious-
ness thereof. It may be gathered from this, then, that we endeavour,
will, seek, or desire nothing because we deem it good; but on the
contrary, we deem a thing good because we endeavour, will, seek,
or desire it.

<div align="right">(Ethics, Part III, Proposition IX)</div>

What was in the Marks and Spencer's bag? I imagine a cauliflower,
a pair of resoled shoes, and seven wrapped presents. The presents are all
for the same person and each one is numbered and tied up with the
same golden twine. In the first a sea shell. A small conch about the size
of a child's fist, perhaps the size of her fist. The shell is the colour of
silverish felt, veering towards peach. The swirls of its brittle encrusta-
tions resemble the lace flounces on the dress of the woman on the
swing, and its polished interior is as pale as skin habitually sheltered
from the sun.

The second present: a bar of soap, bought at a Boots chemist shop
and labelled Arcadia. It smells of a back you can touch but can't see
because you're facing the front.

The third packet contains a candle. The price tag says 8.5 EURO.
In the fourth another candle. Not made of wax this time but in a glass
tumbler which looks as if it is full of sea water with sand and very small
shells at the bottom. The wick appears to be floating on the surface. A
printed label stuck onto the glass says: Never leave a burning candle
unattended.

The fifth present: a paper bag of a brand of sweets called wine
gums. This brand has existed for a century. Probably they are the
cheapest sweets in the world. Despite their very varied and acid
colours, they all taste of pear drops.

The sixth present is an audio cassette of Augustinian nuns singing 'O
Filii et Filiae', a thirteenth-century plainsong written by Jean Tisserand.

The seventh is a box of graphite sticks and pencils. Soft. Medium.
Hard. Traces made by the soft graphite are jet black like thick hair,
and traces made by the hard are like hair turning grey. Graphite, as
skins do, has its own oils. It is a very different substance from the burnt
ash of charcoal. Its sheen when applied on paper is like the sheen on
lips. With one of the graphite pencils she has written on a piece of

paper which she has put in the box: 'On the last hour of the last day, one must remember this.'

Then I went back to look at the woman who was in love with the Dutch painter.

John Berger, *From a Woman's Portrait by Willem Drost*

19.

Jean-Antoine Watteau
(1684–1721)

DELICACY IN ART is not necessarily the opposite of strength. A water-colour on silk can have a more powerful effect on the spectator than a ten-foot figure in bronze. Most of Watteau's drawings are so delicate, so tentative, that they almost appear to have been done in secret; as though he were drawing a butterfly that had alighted on a leaf in front of him and was frightened that the movement or noise of his chalk on the paper would scare it away. Yet at the same time they are drawings which reveal an enormous power of observation and feeling.

This contrast gives us a clue to Watteau's temperament and the underlying theme of his art. Although he mostly painted clowns, harlequins, fêtes, and what we would now call fancy-dress balls, his theme was tragic: the theme of mortality. He suffered from tuberculosis and probably sensed his own early death at the age of thirty-seven. Possibly he also sensed that the world of aristocratic elegance he was employed to paint was doomed too. The courtiers assemble for *The Embarkation for Cythera* (one of his most famous paintings), but the poignancy of the occasion is due to the implication that when they get there it will not be the legendary place they expect – the guillotines will be falling. (Some critics suggest that the courtiers are

returning from Cythera, but either way there is a poignant contrast between the legendary and the real.) I do not mean that Watteau actually foresaw the French Revolution or painted prophesies. If he had, his works might be less important today than they are, because the prophesies would now be outdated. The theme of his art was simply change, transience, the brevity of each moment – poised like the butterfly.

Such a theme could have led him to sentimentality and wispy nostalgia. But it was at this point that his ruthless observation of reality turned him into a great artist. I say ruthless because an artist's observation is not just a question of his using his eyes; it is the result of his honesty, of his fighting with himself to understand what he sees. Look at his self-portrait. It is a slightly feminine face: the gentle eyes, like the eyes of a woman painted by Rubens, the mouth full for pleasure, the fine ear tuned to hear romantic songs or the romantic echo of the sea in the shell that is the subject of another of his drawings. But look again further, for behind the delicate skin and the impression of dalliance is the skull. Its implications are only whispered, by the dark accents under the right cheek bone, the shadows round the eyes, the drawing of the ear that emphasises the temple in front of it. Yet this whisper, like a stage whisper, is all the more striking because it is not a shout. 'But', you may object, 'every drawing of a head discloses a skull because the form of any head depends on the skull.' Of course. There is, however, all the difference in the world between a skull as structure and a skull as a presence. Just as eyes can gaze through a mask, thus belying the disguise, so in this drawing bone seems to gaze through the very flesh, as thin in places as silk.

In a drawing of a woman with a mantle over her head Watteau makes the same comment by opposite means. Here instead of contrasting the flesh with the bone beneath it, he contrasts it with the cloth that is over it. How easy it is to imagine this mantle preserved in a museum – and the wearer dead. The contrast between the face and the drapery is like the contrast in a landscape drawing between the clouds in the sky above and the cliff and buildings beneath. The line of the woman's mouth is as transient as the silhouette of a bird in flight.

168

On a sketchbook page with two drawings of a child's head on it, there is also a marvellous study of a pair of hands tying a ribbon. And here analysis breaks down. It is impossible to explain why that loosely tied knot in the ribbon can so easily be transformed into a symbol of the loosely tied knot of human life; but such a transformation is not far-fetched and certainly coincides with the mood of the whole page.

I do not want to suggest that Watteau was always consciously concerned with mortality, that he was morbidly concerned with death. Not at all. To his contemporary patrons this aspect of his work was probably invisible. He never enjoyed great success, but he was appreciated for his skill – very serious in, for example, his portrait of a Persian diplomat – his elegance, and for what would then have seemed his romantic languor. And today one can also consider other aspects of his work: for instance, his masterly technique of drawing.

He usually drew with a chalk – either red or black. The softness of this medium enabled him to achieve the gentle, undulating sense of movement that is typical of his drawing. He described as no other artist has done the way silk falls and the way light falls on the falling silk. His boats ride on the swell of the sea and the light glances along their hulls with the same undulating rhythm. His studies of animals are full of the *fluency* of animal movement. Everything has its tidal movement, slow or edging – look at the cats' fur, the children's hair, the convolutions of the shell, the cascade of the mantle, the whirlpool of the three grotesque faces, the gentle river-bend of the nude flowing to the floor, the delta-like folds across the Persian's gown. Everything is in flux. But within this flux, Watteau placed his accents, his marks of certainty that are impervious to every current. These marks make a cheek turn, a thumb articulate with a wrist, a breast press against an arm, an eye fit into its socket, a doorway have depth, or a mantle circle a head. They cut into every drawing, like slits in silk, to reveal the anatomy beneath the sheen.

The mantle will outlast the woman whose head it covers. The line of her mouth is as elusive as a bird. But the blacks either side of her neck make her head solid, precise, turnable, energetic, and thus – alive. It is the dark, accented lines which give the figure or the form life by momentarily checking the flow of the drawing as a whole.

On another level, human consciousness is such a momentary check against the natural rhythm of birth and death. And, in the same way, Watteau's consciousness of mortality, far from being morbid, increases one's awareness of life.

20.

Francisco de Goya
(1746–1828)

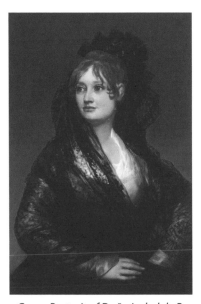

Francisco Goya, *Portrait of Doña Isabel de Parcel,* 1805

I FIRST MET JANOS ABOUT two years before he began this journal, at the National Gallery. (It is remarkable how, for those who suffer a desire for art, so much does begin and end in it.) We were both standing near the Goya portrait of Doña Isabel when a girl art student strode up to look at it. She had loose dark hair which she flicked back from her face by tossing her head, and she wore a tight black skirt – this was before the fashion for jeans – which looked as

though it were held up like a towel and might at any moment come apart but without in the least disconcerting her. She stood in front of the painting, leaning slightly backwards with one hand on her hip, and so echoing quite unconsciously the pose of Doña Isabel herself. I noticed Janos, a tall man in a huge black overcoat, looking at her and then at the painting with considerable amusement. He glanced at me, still smiling. His eyes in their much-creased sockets were very bright. He looked an energetic sixty. I smiled back. When the girl strode off into the next gallery, we both went up to the Goya. 'The living and the undying,' he said in a deep, noticeably foreign voice. 'What a choice!'

Closer to him now, I could study more carefully the expression of his face. It was an urban face, experienced, strained, travelled: but it could still register surprise. It was the opposite of polished. Given the context, it was obvious that he was a painter, and his hands were stained with printing ink; yet in another context one might have guessed that he was a gardener or park-keeper. He was clearly a solitary and had clearly never in his life had a secretary. He had a large nose with hairs coming out of the nostrils; a thick but drawn mouth; a bald brow and top to his head; and a thrusting crooked chin. He stood very upright.

When I inquired what his name was and he told me, I just recognised it. I dimly remembered having seen a book of anti-Nazi war drawings published seven or eight years before. They had struck me because unlike most such drawings they were not expressionist; if, however, I had thought any more about the artist, I had assumed that he had gone back to the Continent. Later, when I used to mention his name to people in the art world, the majority looked blank. He was known to a few isolated groups: to one or two left-wing intellectuals, to a few Berlin émigrés, to the Hungarian Embassy, to a number of young painters whom he had met personally, and – presumably – to MI5.

⊗

GOYA'S GENIUS AS a graphic artist was that of a commentator. I do not mean that his work was straightforward reportage, far from it; but that he was much more interested in events than states of mind. Each work

appears unique not on account of its style but on account of the incident upon which it comments. At the same time, these incidents lead from one to another so that their effect is culminative – almost like that of film shots.

Indeed, another way of describing Goya's vision would be to say that it was essentially theatrical. Not in the derogatory sense of the word, but because he was constantly concerned with the way action might be used to epitomise a character or a situation. The way he composed was theatrical. His works always imply an encounter. His figures are not gathered round a natural centre so much as assembled from the wings. And the impact of his work is also dramatic. One doesn't analyse the processes of vision that lie behind an etching by Goya; one submits to its climax.

Goya's method of drawing remains an enigma. It is almost impossible to say *how* he drew: where he began a drawing, what method he had of analysing form, what system he worked out for using tone. His work offers no clues to answer these questions because he was only interested in *what* he drew. His gifts, technical and imaginative, were prodigious. His control of a brush is comparable to Hokusai's. His power of visualising his subject was so precise that often scarcely a line is altered between preparatory sketch and finished plate. Every drawing he made is undeniably stamped with his personality. But despite all this, Goya's drawings are in a sense as impersonal, as automatic, as lacking in temperament as footprints – the whole interest of which lies not in the prints themselves but in what they reveal of the incident that caused them.

What was the nature of Goya's commentary? For despite the variety of the incidents portrayed, there is a constant underlying theme. His theme was the consequences of Man's neglect – sometimes mounting to hysterical hatred – of his most precious faculty, Reason. But Reason in the eighteenth-century materialistic sense: Reason as a discipline yielding Pleasure derived from the Senses. In Goya's work the flesh is a battleground between ignorance, uncontrolled passion, superstition on the one hand and dignity, grace, and pleasure on the other. The unique power of his work is due to the fact that he was so *sensuously* involved in the terror and horror of the betrayal of Reason.

In all Goya's works – except perhaps the very earliest – there is a strong sensual and sexual ambivalence. His exposure of physical corruption in his royal portraits is well known. But the implication of corruption is equally there in his portrait of Doña Isabel. His Maja undressed, beautiful as she is, is *terrifyingly* naked. One admires the delicacy of the flowers embroidered on the stocking of a pretty courtesan in one drawing, and then suddenly, immediately, one foresees in the next the mummer-headed monster that, as a result of the passion aroused by her delicacy, she will bear as a son. A monk undresses in a brothel and Goya draws him, hating him, not in any way because he himself is a puritan, but because he senses that the same impulses that are behind this incident will lead in the Disasters of War to soldiers castrating a peasant and raping his wife. The huge brutal heads he put on hunchback bodies, the animals he dressed up in official robes of office, the way he gave to the cross-hatched tone on a human body the filthy implication of fur, the rage with which he drew witches – all these were protests against the abuse of human possibilities. And what makes Goya's protests so desperately relevant for us, after Buchenwald and Hiroshima, is that he knew that when corruption goes far enough, when the human possibilities are denied with sufficient ruthlessness, both ravager and victim are made bestial.

Then there is the argument about whether Goya was an objective or subjective artist; whether he was haunted by his own imaginings, or by what he saw of the decadence of the Spanish Court, the ruthlessness of the Inquisition and the horror of the Peninsular War. In fact, this argument is falsely posed. Obviously Goya sometimes used his own conflicts and fears as the starting point for his work, but he did so because he consciously saw himself as being typical of his time. The intention of his work was highly objective and social. His theme was what man was capable of doing to man. Most of his subjects involve action between figures. But even when the figures are single – a girl in prison, an habitual lecher, a beggar who was once 'somebody' – the implication, often actually stated in the title, is 'Look what has been done to them.'

I know that certain other modern writers take a different view. Malraux, for instance, says that Goya's is 'the age-old religious accent of useless suffering rediscovered, perhaps for the first time, by a man who believed himself to be indifferent to God'. Then he goes on to say

174

that Goya paints 'the absurdity of being human' and is 'the greatest interpreter of anguish the West has ever known'. The trouble with this view, based on hindsight, is that it induces a feeling of subjection much stronger than that in Goya's own work: only one more shiver is needed to turn it into a feeling of meaningless defeat. If a prophet of disaster is proved right by later events (and Goya was not only recording the Peninsular War, he was also prophesying) then that prophecy does not increase the disaster; to a very slight extent it lessens it, for it demonstrates that man can foresee consequences, which, after all, is the first step towards controlling causes.

The despair of an artist is often misunderstood. It is never total. It excepts his own work. In his own work, however low his opinion of it may be, there is the hope of reprieve. If there were not, he could never summon up the abnormal energy and concentration needed to create it. And an artist's work constitutes his relationship with his fellow men. Thus for the spectator the despair expressed by a work can be deceiving. The spectator should always allow his comprehension of that despair to be qualified by *his* relationship with his fellow men: just as the artist does implicitly by the very act of creation. Malraux, in my opinion – and in this he is typical of a large number of disillusioned intellectuals – does not allow this qualification to take place; or if he does, his attitude to his fellow men is so hopeless that the weight of the despair is in no way lifted.

One of the most interesting confirmations that Goya's work was outward-facing and objective is his use of light. In his works it is not, as with all those who romantically frighten themselves, the dark that holds horror and terror. It is the light that discloses them. Goya lived and observed through something near enough to total war to know that night is security and that it is the dawn that one fears. The light in his work is merciless for the simple reason that it shows up cruelty. Some of his drawings of the carnage of the Disasters are like film shots of a flare-lit target after a bombing operation; the light floods the gaps in the same way.

Finally and in view of all this one tries to assess Goya. There are artists such as Leonardo or even Delacroix who are more analytically interesting than Goya. Rembrandt was more profoundly compassionate in his understanding. But no artist has ever achieved greater honesty than Goya: honesty in the full sense of the word, meaning facing the facts *and* preserving one's ideals. With the most patient craft

Goya could etch the appearance of the dead and the tortured, but underneath the print he scrawled impatiently, desperately, angrily, 'Why?' 'Bitter to be present', 'This is why you have been born', 'What more can be done?' This is worse'. The inestimable importance of Goya for us now is that his honesty compelled him to face and to judge the issues that still face us.

<center>CR</center>

FIRST, SHE LIES there on the couch in her fancy-dress costume: the costume which is the reason for her being called a Maja. Later, in the same pose, and on the same couch, she is naked.

Ever since the paintings were first hung in the Prado at the beginning of this century, people have asked: Who is she? Is she the Duchess of Alba? A few years ago the body of the Duchess of Alba was exhumed and her skeleton measured in the hope that this would prove that it was not she who had posed! But then, if not she, who?

One tends to dismiss the question as part of the trivia of court gossip. But then when one looks at the two paintings there is indeed a mystery implied by them which fascinates. But the question has been wrongly put. It is not a question of *who*? We shall never know, and if we did we would not be much the wiser. It is a question of *why*? If we could answer that we might learn a little more about Goya.

My own explanation is that *nobody* posed for the nude version. Goya constructed the second painting from the first. With the dressed version in front of him, he undressed her in his imagination and put down on the canvas what he imagined. Look at the evidence.

There is the uncanny identity (except for the far leg) of the two poses. This can only have been the result of an *idea*: 'Now I will imagine her clothes are not there.' In actual poses, taken up on different occasions, there would be bound to be greater variation.

More important, there is the drawing of the nude, the way the forms of her body have been visualised. Consider her breasts – so rounded, high, and each pointing outwards. No breasts, when a figure is lying, are shaped quite like that. In the dressed version we find the explanation. Bound and corseted, they assume exactly that shape and, supported, they will retain it even when the figure is lying. Goya has taken off the silk to reveal the skin, but has forgotten to reckon with the form changing.

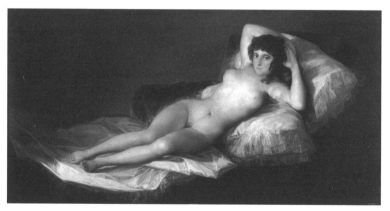

Goya, *The Nude Maja*, 1797–1800

The same is true of her upper arms, especially the near one. In the nude it is grotesquely, if not impossibly, fat – as thick as the thigh just above the knee. Again, in the dressed version we see why. To find the outline of a naked arm Goya has had to guess within the full, pleated shoulders and sleeves of her jacket, and has miscalculated by merely simplifying instead of reassessing the form.

Compared to the dressed version, the far leg in the nude has been slightly turned and brought towards us. If this had not been done, there would have been a space visible between her legs and the whole boat-like form of her body would have been lost. Then, paradoxically, the nude would have looked *less* like the dressed figure. Yet if the leg were really moved in this way, the position of both hips would change too. And what makes the hips, stomach, and thighs of the nude seem to float in space – so that we cannot be certain at what angle they are to the bed – is that, although the far leg has been shifted, the form of the near hip and thigh has been taken absolutely directly from the clothed body, as though the silk there was a mist that had suddenly lifted.

Indeed the whole near line of her body as it touches the pillows and sheet, from armpit to toe, is as unconvincing in the nude as it is convincing in the first painting. In the first, the pillows and the couch sometimes yield to the form of the body, sometimes press against it: the line where they meet is like a stitched line – the thread disappearing and reappearing. Yet the line in the nude version is like the frayed edge of a cut-out, with none of this 'give-and-take' which a figure and its surroundings always establish in reality.

The face of the nude jumps forward from the body, not because it has been changed or painted afterwards (as some writers have suggested), but because it has been *seen* instead of conjured up. The more one looks at it, the more one realises how extraordinarily vague and insubstantial the naked body is. At first its radiance deceives one into thinking that this is the glow of flesh. But is it not really closer to the light of an apparition? Her face is tangible. Her body is not.

Goya was a supremely gifted draughtsman with great powers of invention. He drew figures and animals in action so swift that clearly he must have drawn them without reference to any model. Like Hokusai, he knew what things looked like almost instinctively. His knowledge of appearances was contained in the very movement of his fingers and wrist as he drew. How then is it possible that the lack of a model for this nude should have made his painting unconvincing and artificial?

The answer, I think, has to be found in his motive for painting the two pictures. It is possible that both paintings were commissioned as a new kind of scandalous *trompe l'oeil* – in which in the twinkling of an eye a woman's clothes disappeared. Yet at that stage of his life Goya was not the man to accept commissions on other men's trivial terms. So if these pictures were commissioned, he must have had his own subjective reasons for complying.

What then was his motive? Was it, as seemed obvious at first, to confess or celebrate a love affair? This would be more credible if we could believe that the nude had really been painted from life. Was it to brag of an affair that had not in fact taken place? This contradicts Goya's character; his art is unusually free from any form of bravado. I suggest that Goya painted the first version as an informal portrait of a friend (or possibly mistress), but that as he did so he became obsessed by the idea that suddenly, as she lay there in her fancy dress looking at him, she might have no clothes on.

Why 'obsessed' by this? Men are always undressing women with their eyes as a quite casual form of make-believe. Could it be that Goya was obsessed because he was afraid of his own sexuality?

There is a constant undercurrent in Goya which connects sex with violence. The witches are born of this. And so, partly, are his protests against the horrors of war. It is generally assumed that he protested because of what he witnessed in the hell of the Peninsular War. This is

true. In all conscience he identified himself with the victims. But with despair and horror he also recognised a potential self in the torturers.

The same undercurrent blazes as ruthless pride in the eyes of the women he finds attractive. Across the full, loose mouths of dozens of faces, including his own, it flickers as a taunting provocation. It is there in the charged disgust with which he paints men naked, always equating their nakedness with bestiality – as with the madmen in the madhouse, the Indians practising cannibalism, the priests awhoring. It is present in the so-called Black paintings which record orgies of violence. But most persistently it is evident in the way he painted all flesh.

It is difficult to describe this in words, yet it is what makes nearly every Goya portrait unmistakably his. The flesh has an expression of its own – as features do in portraits by other painters. The expression varies according to the sitter, but it is always a variation on the same demand: the demand for flesh as food for an appetite. Nor is that a rhetorical metaphor. It is almost literally true. Sometimes the flesh has a bloom on it like fruit. Sometimes it is flushed and hungry-looking, ready to devour. Usually – and this is the fulcrum of his intense psycho-logical insight – it suggests both simultaneously: the devourer and the to-be-devoured. All Goya's monstrous fears are summed up in this. His most horrific vision is of Satan eating the bodies of men.

One can even recognise the same agony in the apparently mundane painting of the butcher's table. I know of no other still life in the world which so emphasises that a piece of meat was recently living, sentient flesh, which so combines the emotive with the literal meaning of the word 'butchery'. The terror of this picture, painted by a man who has enjoyed meat all his life, is that it is not a still life.

If I am right in this, if Goya painted the nude Maja because he was haunted by the fact that he imagined her naked – that is to say imagined her flesh with all its provocation – we can begin to explain why the paint-ing is so artificial. He painted it to exorcise a ghost. Like the bats, dogs, and witches, she is another of the monsters released by 'the sleep of reason', but, unlike them, she is beautiful because desirable. Yet to exor-cise her as a ghost, to call her by her proper name, he had to identify her as closely as possible with the painting of her dressed. He was not paint-ing a nude. He was painting the apparition of a nude within a dressed

woman. This is why he was tied so faithfully to the dressed version and why his usual powers of invention were so unusually inhibited.

I am not suggesting that Goya intended us to interpret the two paintings in this way. He expected them to be taken at their face value: the woman dressed and the woman undressed. What I am suggesting is that the second, nude version was probably an *invention* and that perhaps Goya became imaginatively and emotionally involved in its 'pretence' because he was trying to exorcise his own desires.

Why do these two paintings seem surprisingly modern? We assumed that the painter and model were lovers when we took it for granted that she agreed to pose for the two pictures. But their power, as we now see it, depends upon there being so *little* development between them. The difference is only that she is undressed. This should change everything, but in fact it only changes our way of looking at her. She herself has the same expression, the same pose, the same distance. All the great nudes of the past offer invitations to share their golden age; they are naked in order to seduce and transform us. The Maja is naked but indifferent. It is as though she is not aware of being seen – as though we were peeping at her secretly through a keyhole. Or rather, more accurately, as though she did not know that her clothes had become 'invisible'.

In this, as in much else, Goya was prophetic. He was the first artist to paint the nude as a stranger: to separate sex from intimacy: to substitute an aesthetic of sex for an energy of sex. It is in the nature of energy to break bounds: and it is the function of aesthetics to construct them. Goya, as I have suggested, may have had his own reason for fearing energy. In the second half of the twentieth century the aestheticism of sex helps to keep a consumer society stimulated, competitive, and dissatisfied.

☙

IN EACH CORNER of the ceiling there are cobwebs. In an hour Alec will give the violets back to Jackie, in an hour he will get to hell out of here. He doesn't really believe in the ten bob. It seems to him that if *Office Day* is ever to begin again, Corker and he will have to pretend that the day Corker kissed the floor never happened. And if they pretend it never happened, then Alec was never offered his rise. He goes across to the cracked draining board where the old brown teapot is always left to drain

Goya, *The Clothed Maja*, 1800–05

upside down. There he begins another line of reasoning for not believing in the ten bob. It begins: I can't help being sorry for the *Poor Bugger*. He pours the hot water into the pot to warm it. He is sorry for Corker because since lunchtime Corker has grown old and incapable. He imagines Corker in his dressing-gown tomorrow morning making his breakfast here – Alec himself is now putting two teaspoonfuls of tea into the pot – and the poor bugger won't get much of a breakfast. But more than anything else, he is sorry for Corker because of all that remains unforeseeable, unknown, unsaid. Alec isn't certain why Corker left his sister in such a hurry, or why she is dying, or why Corker said Fucking Heavy, or why he keeps a loaded revolver in his drawer, or why he says he'll have Bandy Brandy for a housekeeper, or why he is behaving like a drunk upstairs, but he is certain that Corker couldn't explain why either. Corker, it seems to Alec, is being hustled along as though there was a 100-m.p.h. gale behind him. It's a man-made gale that has got into a tunnel and Corker is being hustled through the catacombs. The kettle, boiling, whistles. Alec has never seen a catacomb but, as he pours from the kettle he can feel and hear the crusts of fur that have formed over the years inside (they weigh one side of the kettle down and they make a brittle tinkling noise) and these suggest to him the fleshless, encrusted, mineral and subterranean world which he uses as a metaphor to describe to himself what he imagines to be the nature of Corker's suffering. He goes across to the cupboard. On one shelf a few odd cups and saucers and plates. On another shelf a packet of salt, some tea, a roll of biscuits and a small, almost empty pot of Marmite. On the lowest shelf are the

sheets and pillow cases which Corker mentioned. Alec leaves the cups on the Marmite shelf and bends down to examine the sheets. If Corker explains nothing, Alec can search for himself. The sheets don't look new. Presumably Corker smuggled them out of West Winds. Did he also have a double-bed there? Behind the sheets he can now see two boxes. One is a white cardboard box with nothing written on it. He opens it. Inside is a bottle, about the size of a gin bottle. It is unopened. The label is in a foreign language but Alec reads the word Kummel and recognises it as the kind of booze Corker was talking about in Vienna. The second box is golden coloured and has *Allure* written over it in an embossed, black and sloping script. Alec carefully sees whether this one will open too. It will. Inside is a tray of chocolates of different shapes and in different deep-coloured silver-papers. A few of the chocolates have been eaten and their deep-coloured cups left. Above the tray, resting against the inside of the lid, is a picture, like a gigantic cigarette card. It shows a woman lying naked on her back on a bed. She has dark hair and big eyes but no hair between her legs so that she must have been shaved. She is small and about the same size as Jackie. Her skin is very white – even the under-neaths of her feet are white. It looks like a photograph but it is coloured and might be a painting. Underneath is written Maja Undressed. Alec looks down again at the chocolates and pointlessly starts counting how many have been eaten. Seven. He pictures Corker eating them in bed. Then he pictures him looking at the woman whilst he eats them. *Help!* he thinks, and shuts the box and puts them both back behind the folded sheets which are glossy with ironing. He takes the two cups to the table beside the gas stove. The milk is always kept in the wooden cupboard underneath the sink to keep it cool. On the windowsill above the sink are the violets. The lead waste-pipe U-bends through the cupboard. The difference between the milk that goes into the bottle and the waste water that goes through the pipe suggests to him the different histories of his penis and Corker's. He sighs and kicks the door shut with his foot. He renotices the violets and retraces their history. He asks himself why Corker can't be like other men, like other men but just older than some. He remembers Corker the baby on the blue cushion. He remembers Corker saying that Kummel is quite strong. It crosses his mind that he might open the bottle and put some in Corker's tea. As he gives him the cup, he will say: with love from Maja. Then the old man might fall asleep

in a drunken stupor, muttering Maja! Maja! My love! The fucker, thinks Alec, the drunken fucker who knelt down on his knees to lick the floor. Alec pours the milk into the two cups. One is slightly cracked. He has jumbo-size vegetable dishes but no decent cups. When Alec pours the tea on top of the milk and it goes the familiar ginger-brown, he remembers Jackie making tea for breakfast this morning. Tea, tea, tea, tea, he thinks, and each tea represents somebody wanting a gingerbrown cupful, himself drinking tea in Jackie's mother's kitchen, his own mother, his brothers taking their tea cans to work, the cycling club when it's raining and stopping at a caff, the boys hanging around the tea stall by the station at two in the morning. It is true that corker also likes tea but Corker is different. Corker with his chocolate-box and round tables and fancy sentiments, and these all get dragged in when he drinks a cup and Alec has to sit there listening. Alec can't blame him for what he was born like. But he now sees the conclusion of the second line of reasoning for not believing in the ten bob: I can't help being sorry for the poor bugger but I can't stay with him for ever, well, can I?

<p style="text-align:center">❧</p>

ACT 1, SCENE 4

DAY. SPRING (1794). *Duchess's residence. To right of chapel a bed with muslin hangings.* DUCHESS *bent over bed murmuring.* GARDENER *painting wheel of carriage.* GOYA *opens carriage door, climbs down.* GARDENER *stops painting. Both men watch* DUCHESS, *who continues her ministrations to sick child in bed.*

DUCHESS: Going away, going away, soon there'll be no pain left, I'll take it all away. Don't fret, give it to me, little one . . .

GARDENER: If she had a child of her own – the Duke, they say, is not a breeding animal.

DUCHESS: Sip, darling, from the lemons of our very own garden.

GOYA: Nobody on earth should be allowed to have a voice like hers.

DUCHESS: Did you dream the world was bad? No, no, only theirs, not ours. It's cooling – if I press it against you – see – it cools, it cools my honey.

GOYA: It's so beautiful, it cuts your throat from ear to ear, a voice like hers.

DUCHESS: There, the hurt is coming, come to me, come to me, we'll mend everything, feather by feather . . . come, little pain, come to Cayetana, come, little death.

GOYA: My mother used to say death was a feather.

GARDENER: Your mother, Don Francisco, is a woman who weighs her words.

DUCHESS: Don't come too close, both of you. Not too close. His eyes are closed.

GARDENER: The swallowing disease?

DUCHESS: Peace.

GOYA: Scarlet fever?

GARDENER: The illness of the marshes?

GOYA: Typhoid?

[DWARF *leaps up, tears down hangings and jumps out of bed.*]

DWARF: Growing pains!

[GOYA, *seized with a fit of rage, swears at the* GARDENER.]

DUCHESS: Why are you so angry? Come and sit beside me. Let us say good day to each other. Good day, Frogman.

GOYA: How does your husband put up with that creature?

DUCHESS: My husband puts up with nothing. He plays Haydn.

GOYA: And I put up with everything.

DUCHESS: Don't you think others have the right to play jokes? Does every caprice have to be signed by the master on a plate?

GARDENER: My God! Do you hear what she says! You've shown her, haven't you? You've shown her. How many times have I told you to show nobody? It's dangerous for nineteen reasons.

DUCHESS: Baturros! Baturros! You don't know how to live. Neither of you even knows the difference between a coachman and master. Listen how he talks to you.

GOYA: (*To* GARDENER) She has only seen one or two donkeys.

GARDENER: And the donkey is who? Twenty reasons. Have you ever heard anybody stop talking here? Never. Prattle! The Devil needs nothing more.

DUCHESS: And in Aragon, sir?

GARDENER: In Aragon, Your Duchess, men measure their words, use them sparingly and keep them.

[GOYA *makes friendly sign to* GARDENER, *who returns to the carriage, picks up a paint pot, gets in, shuts door.*]

DUCHESS: Are you still angry? I have arranged something special for you.

GOYA: More theatre with the Dwarf?

DUCHESS: Do you know why I call him Amore?

GOYA: I killed a man once.

DUCHESS: I've never met a man who hasn't boasted of killing another. Even my husband says he killed a man . . . a flautist it seems. No more need for anger. I want to show you something.

[GARDENER *pulls down blind of carriage window.* DUCHESS *enters the ruined chapel, followed by* GOYA. *Silence. We do not see the painting they are looking at.*]

DUCHESS: I acquired it at the age of thirteen when I got married.

GOYA: He was impervious. He judged nothing. He kept his eternal distance. Only his glance caresses her.

DUCHESS: His glance! What does his glance matter? There's a woman there, lying on a bed, naked. I watch her every night after my prayers. It's she who counts.

GOYA: For very little, she counts for very little. Look at the draperies which echo and enclose her body. He knew exactly what he was doing.

DUCHESS: She counts for very little! Your impudence! You peer at us, you get a cunning kick out of pinning us with your brushes to your sheets, your canvases, and then you boast: He knew exactly what he was doing! You know nothing. Men see only surfaces, only appearances. Incorrigibly stiff, incorrigibly rigid, the lot of you! Male monuments to your everlasting erections!

GOYA: I could do better.

DUCHESS: How would you paint me?

GOYA: Lying on your back, legs crossed. Your eyes looking into mine.

DUCHESS: Dressed?

GOYA: For those who wish.

DUCHESS: Undressed! Coward!

GOYA: First dressed!

DUCHESS: What patience! What restraint.

GOYA: Next, in the twinkling of an eye, undressed.

DUCHESS: With my consent.

GOYA: With your consent, Cayetana, or without it. I can tear off your clothes. I can strip you as well as I can paint you. Here! (*He points to his head.*) That's where I have an edge over Velázquez. No mirrors. I advance on my stomach. Mix my colours with spunk.

DUCHESS: Your colours, sir, are your business. It will be done from memory. You will paint me when you are alone. You will remember all the women you have known, all the women you have stripped – as you so eloquently put it – you will close your eyes and see them again and then you will use all your effort, all your virility, all

your speed to recall what distinguishes every square centimetre of the body of the Thirteenth Duchess of Alba from the body of any other woman now or hereafter. From memory. It will be a solitary proof of your love . . . Afterwards I promise you a month in the country . . . the two of us together.

[GARDENER *climbs out of carriage, starts painting wheel. GOYA crosses stage.*]

 GOYA: More and more and more and more . . . brazen!

[GOYA *enters carriage.* DUCHESS *waves a handkerchief.*]

 DUCHESS: Work fast, Frogman.

[*Lights fade*]

 [...]

ACT 2, SCENE 8

Night (1811). The same as previous scene except that the line on which prints are pegged now crosses the whole room. GOYA *is fingering the prints on the line.* GARDENER *is splitting wood with an axe for the fire.*

 GARDENER: I brought in the barosma plants this morning. I've never known such cold so early. I was a bit frightened for them.

 GOYA: Frightened for what?

 GARDENER: The barosma plants.

 GOYA: In God's name what are they?

 GARDENER: The little bushes in the pots with white flowers. The ones in the courtyard.

 GOYA: White, did you say?

[GARDENER *nods.*]

Blind! All of you. You're blind! The flowers you're frightened for are pink. Not white. White, if you must, but stained with blood. Stop! Don't move your arms. Keep the axe there, Juan.

[GARDENER, *with axe raised above his head, freezes.* GOYA *continues to examine prints.*]

GARDENER: If you need a drawing, Don Francisco, better do it quickly.

GOYA: Keep the axe there! Drawing! Drawings come by themselves. You just untie the sack, lift it up, tip it, and out pours the debris. Drawings are debris. Don't move, Juan.

GARDENER: I have to now.

GOYA: I thought you were strong. I thought you had the shoulders of a bull.

GARDENER: There's a louse in my armpit.

GOYA: Don't move. Which one? I'll find it for you.

GARDENER: The left.

[GOYA *pulls up* GARDENER'S *shirt, searches, spectacles on the end of his nose.*]

GOYA: Can see nothing! Need a candle.

GARDENER: [*Starting to laugh*] It's tickling.

[GOYA *steps back.* GARDENER *lowers axe and splits wood.*]

GOYA: I wanted to give the log at your feet a little more time.

GARDENER: In the circumstances a double cruelty.

[GOYA *doesn't understand.* GARDENER *takes paper from table and writes on it:* DOUBLE CRUELTY.]

GOYA: If logs could see, if they had eyes, if they could count minutes, it would be better for the axe to descend immediately. But logs can't count.

GARDENER: You've never heard what they call men in Malaga?

GOYA: Men?

GARDENER: They call a man a log with nine holes!

[GOYA *counts the holes.*]

GOYA: Did you find any rice today?

GARDENER: No. The French took everything before leaving, and what they didn't take the British have pillaged. Either that or people don't want to sell to us any more. They look dangerous when I ask. In my opinion, Don Francisco, we should prepare to go into hiding. Only the illness of Doña Josefa has prevented me saying this before. I know a place where we can go.

[GOYA *appears not to have heard.* GARDENER *writes on paper:* HIDING?]

GOYA: There's not the slightest cause for alarm. I've already offered my services to the victors. Conquerors need painters and sculptors. Never forget that. Victory is ephemeral – as ephemeral as played music. Victory pictures are like wedding pictures, except there's no bride present. The bride is their own triumph. I don't know why, but it has always been so throughout history. So they want mother-fucking portraits of themselves with their invisible bride. And I can do these portraits like no one else can. I have a weakness for victors – above all for their collars, their boots, their victory robes. I think we were all meant to be triumphant. Before there was any destiny, we were children of a triumph. We were all born of an ejaculation.

[*Enter* DOCTOR.]

DOCTOR: Your wife is asking to see you. I have one thing more to say to my husband, she says.

[*Exit* DOCTOR *hurriedly.*]

GOYA: Soon I'll do the Duke of Wellington. He insists upon a horse.

GARDENER: Don Federico has already gone into hiding.

GOYA: When the Whore's Desired One returns to sit on our throne, I shall paint him with a sword under his hand and a cocked hat under his arm. And if he won't sit for me, I'll paint him from memory. (*Looks in mirror.*) Everyone will forgive me.

GARDENER: The washerwomen say you're not so deaf you don't hear the clink of reales in the money bags. That's how you know when to change sides, they say.

GOYA: Everyone will forgive me.

[*Enter* DOCTOR.]

DOCTOR: I regret to have to tell you, Don Francisco, it's too late. Your wife is dead.

[GOYA *falls to his knees.*]

GOYA: Even my wife will forgive me.

[GOYA *remains kneeling with bowed head. Imperceptible sound of the sea. Abruptly he scrambles to his feet.*]

If only men didn't forgive!

[GOYA *grasps the clothes line with both hands and walks beside it, holding on like a man in a gale.*]

Do you know how much is unforgiveable? Do you know there are acts which can never be forgiven? Nobody sees them. Not even God.

[*Sea becomes louder.*]

The perpetrators bury what they do from themselves and others with words. They call their victims names, they fasten labels to them, they repeat stories. Everything is prepared by curses and insults and whispering and speeches and chatter. The Devil works with words. He has no need of anything else. He distributes words with innocent working of the tongue and the roof of the mouth and the vocal chords, people talk themselves into evil, and afterwards with the same words and the same wicked numbers they hide what they've done, so it's forgotten, and what is forgotten is forgiven.

[GOYA *comes to a print.*]

What is engraved doesn't forgive.

[GOYA *falls to his knees.*]

Do not forgive us, O Lord. Let us see the unforgivable so we may never forget it.

[GOYA *somehow gets to his feet, walks to exit where* DOCTOR *entered.*]

Forgive me, Josefa, forgive me . . .

ACT 3

Early spring morning (1827/8). Sunshine. The garden of Goya's house in Bordeaux. (The scene is almost identical with that of the cemetery.) GARDENER on ladder is pruning a vine against a wall. Enter GOYA (now over eighty) with stick, accompanied by FEDERICO (same age).

GOYA: (*Pointing*) There's a Goldfinch, there in the almond tree – do you see him?

FEDERICO: I tell you every morning, Francisco, me eyes are failing.

[*The two old men stand still. GOYA imitates song of Goldfinch.*]

GOYA: That's how he sings, Goldfinch.

FEDERICO: Your new painting?

GOYA: Two centuries ago in Amsterdam a Dutchman painted Goldfinch.

FEDERICO: (*Shouting*) How's the new painting?

GOYA: Sky's wrong behind the head. Never had trouble with a sky before.

FEDERICO: French skies are not the same. Look at it. Milky. French bakeries are different too. With age, I regret to say, I find myself from time to time becoming greedy.

[FEDERICO *takes a brioche out of his pocket, offers half to* GOYA. *They sit.*]

GOYA: Have you said yet: 'With age, I regret to say, I find myself from time to time becoming greedy'?

[FEDERICO *throws crumbs to the birds.*]

I slept better this night. No dreams. That's why you arrived before I was up.

FEDERICO: Didn't matter. I had plenty to think about . . . there are spies from the Holy Office sent here to Bordeaux. I'm sure of it. Don Tiburcio has refused to give us any more money for the paper.

GOYA: Which one?

FEDERICO: Our paper in Spanish – the one I edit.

GOYA: I'll do a lithograph for you.

FEDERICO: The only explanation is that they threatened to maltreat Don Tiburcio's family in Valencia. Meanwhile we owe three hundred to the printer.

GOYA: Soon there'll be more exile papers in the world than stars in the sky.

FEDERICO: Just three hundred to pay the printer.

GOYA: My lithographs aren't selling. People don't want to know. They want everything in colour and stereo . . . What's the latest news from our country?

FEDERICO: The latest! The dark ages. The Constitution annulled and void. Thought manacled. People disappearing in the streets. Torture. Electric shocks. Underground garages. The gluttony of terror. The same as I tell you every morning, my friend. Will anybody ever bring news of a different sort? The latest, Paco, is that we're already living in the future. Not the one we fought and died for. The one the giants substituted for ours . . . That's the latest. Will it ever be different?

GOYA: If you're quiet for a moment, I'll do Nightingale.

FEDERICO: If I didn't know better, Frogman, I'd say you'd gone simple.

GOYA: Then don't ask simple questions like: 'Will anybody ever bring news of a different sort?'

FEDERICO: So you heard me?

GOYA: Of course not.

FEDERICO: Everywhere the restoration of the past. Everywhere boasts about what was once thought shameful. (*Shouting*) Tell me what's left of our hopes.

GOYA: This! (*Imitates Goldfinch.*) What's left of our hopes is a long despair which will engender new hopes. Many, many hopes . . . I'm going to live to be as old as Titian.

[*Enter* PEPA.]

PEPA: Your hot chocolate is waiting in the house.

FEDERICO: Everything should be clear, except hot chocolate which should be thick.

GOYA: Has he said it again?

[PEPA *nods and takes* GOYA's *arm. Exit* FEDERICO *and* GARDENER, *carrying ladder, towards house.* PEPA *and* GOYA *walk slowly towards swing. They speak softly, almost whispering.* GOYA *has no difficulty in hearing.*]

Have you read the pages I marked of Francisco de Quevedo y Villegas?

PEPA: All of them.

GOYA: And?

PEPA: They were about the Last Judgement.

GOYA: And the story about me?

PEPA: The painter Hieronymus Bosch finds himself in hell and there he's cross-questioned. When you were a painter on the earth,

they ask him, why did you paint so many deformed men? And Hieronymus replies to them: Because I don't believe in Devils.

GOYA: Correct.

[PEPA *sits on a swing.* GOYA *stands before her.*]

Do you know who is the favourite in the asylum down by the river? Napoleon! I counted fifteen men wearing hats, and on the hats scraps of paper with the words 'I am Napoleon' written on them. Do you know why Napoleon appeals to the mad?

PEPA: No.

GOYA: Because Napoleon was mad enough to boast, 'I have an annual income of three hundred thousand men!'

[PEPA *picks off some flowers, offers them to* GOYA.]

PEPA: On Friday at 2 p.m. in the Place d'Aquitaine, there will be a public execution, with the guillotine, French style.

GOYA: I shall be there.

PEPA: A poor wretch called Jean Bertain who murdered his brother-in-law.

GOYA: Perhaps the brother-in-law was raping his niece. Amongst men pity is rare.

PEPA: When you feel pity, you close your eyes.

GOYA: I have eyes in the back of my head. They never close. Do you love me a little?

PEPA: A little, a lot, passionately?

GOYA: If I painted a miniature on ivory it could hang between your breasts. Am I mad, Pepa?

[GOYA *sits on a stool, takes his head in his hands.*]

A man bends double between a pair of lips. He tries to get into the mouth. When he is in, it's very difficult for him to get out. One must name everything one sees for what it is. Never stop looking at

consequences. The only chance against barbarism. To see consequences.

PEPA: Don't torture yourself, Francisco. It happens at the end of the morning – it passes, it goes away. Let's play together. In our family album (*Opens a book on her knees*) I put a

Goya, *The Truth Has Died*, 1810–20

picture of a young man. He's wearing a large black hat and he has dark piercing eyes.

GOYA: Doubtless he was very ambitious.

PEPA: Large, sensuous mouth. Strong appetites.

GOYA: In our family album I put a picture of a man standing before an easel.

PEPA: Around the brim of his hat there are candles.

GOYA: He worked all night.

PEPA: Quel panache! He has very smart, tight trousers. And now the same man, older. He's wearing glasses.

GOYA: He'd seen too much.

PEPA: He has a good complexion and he has a white silk scarf round his neck.

GOYA: It was already the year of the French Revolution.

PEPA: In our family album I put a picture of a man standing against a blackness. He looks stunned – stunned by the fact he's still alive.

GOYA: He's simply old – almost seventy. Madrid is infected by the plague and it has killed Amore.

PEPA: The expression changes but it's always the same man.

GOYA: It's perhaps the same man. But it's not me.

PEPA: Yes, it's you and it's your art, you painted the pictures.

[*Suddenly* GOYA *loses interest. He is staring hard at the Duchess of Alba's grave beyond the swing. The* DUCHESS *appears.* PEPA *cannot see her.*]

GOYA: Leave me now, Pepa.

PEPA: Your art, Don Francisco.

GOYA: Go to hell with my art!

PEPA: You were a prophet. In your art you foresaw the future.

[DUCHESS *advances towards* GOYA.]

GOYA: Come, come.

PEPA: With such compassion . . .

GOYA: Get out, I tell you, fuck off.

[GOYA *chases* PEPA *out of the garden with his stick. He turns to the audience.*]

Voyeurs! Fuck off!

[*His back to the audience, he watches* DUCHESS *undress for him, as in a striptease.*]

My darling life.

[DUCHESS *opens her arms to him.*]

DUCHESS: Everything is for you, every feather. Come, my love, come, come, my frogman.

[DUCHESS *disappears.* GOYA *falls in a heap onto the ground. The stage is silent. As if the curtain should now come down but the mechanism doesn't work.* PEPA *enters, sits on the ground, places* GOYA's *head on her lap.*]

PEPA: Every time you do the same thing. She always escapes from

you. You're never quick enough.

GOYA: I walk on sticks . . .

[*Enter from different directions all other actors, dressed as they were in the Prologue. GARDENER, masked, goes over to beehive. PEPA gently disengages herself from GOYA, gets to her feet and rings the bell. The actors begin to leave the cemetery exactly as in the Prologue. PEPA rejoins GOYA.*]

Goya, *Will She Live Again*, 1810–20

WIDOW: (*To herself*) Let a little justice come to this earth, dear Lord.

DOCTOR: (*To ACTRESS*) You wanted to seduce your father so you became an actress.

GOYA: (*To PEPA*) Have they finished? Is my portrait done?

PEPA: Yes, it's done.

GOYA: They must sign it.

PEPA: It's done.

GOYA: Am I dead, Pepa?

PEPA: Don't worry. For tonight, you're well and truly dead.

[LEANDRO *is the last to leave.*]

LEANDRO: (*Shouting to PEPA*) Wear your new white dress!

GOYA: That's good . . .

[GOYA *closes his eyes and sleeps. GARDENER blows smoke into hive. White curtain, without image or signature, descends.*]

21.

Honoré Daumier
(1808–79)

HONORE DAUMIER DIED, aged seventy, in 1879. Until the last year of his life fewer than a dozen of his paintings were publicly exhibited. Baudelaire and a few friends recognised him as a painter. Most people insisted upon labelling him a great cartoonist. For his last few years he was blind; blind from having produced during his lifetime four thousand finished lithographs for the press. He always hoped – but in vain – to stop the grind and become a painter.

Such, briefly, was the tragedy of Daumier's private life. The question for us today is whether or not to endorse the tragedy. Can we separate Daumier the great cartoonist from Daumier the painter and then regret the lost opportunities of the latter? Should we carry his canvases respectfully into the Museum of Fine Arts and leave the piles of old newspapers outside?

I think not. Daumier could never have been the timeless painter that he is, had he not also been the weekly cartoonist. Nor shall we be able to appreciate the startling originality of his paintings until we have understood this point. I am not of course condoning the harsh economic necessity which compelled him to work to demand year in and year out. The balance between the two functions could have been very different and much happier. But some balance between the two was intrinsic to his genius.

The subject of his paintings had already been developed by the cartoonist: the lawyers who gather like ravens wherever there is distress; the thin man (Quixote) facing the fat man (Panza); the connoisseurs who resemble the rare, limited editions they search for; the bourgeois who hates paying; the worker who spends himself; the full-bodied heroines who suggest that a realistic society could well be as generous as a mother with her children.

I believe that there is another connection between the cartoonist and the painter which is far deeper than the relatively superficial one of subject matter. Daumier was a great painter not because of his subjects, but because of the way he painted them. What is the essential element in Daumier's paintings? Surely it is the light.

His use of light is unique. Light becomes so active on his canvases that one almost has to consider it a protagonist. The figures often suffer from the light. It catches them unawares as they rest in the darkness – like Sancho or the painter in his studio – and then models them so that we can grasp them in elementary and therefore unflattering terms. Or else it shows them up as they move or act in front of it. We see them, silhouetted, and the light around them increases the meaning of their movements – the child looking up against the light of his mother, Don Quixote riding towards the clouds, the refugees creeping towards the horizon, the washerwomen descending with their work. The light buffets them as we know life will.

Nor is that mere metaphor. If one looks closely at the canvases one can see how Daumier actually drew the silhouetted figures with the brush with which he was painting the light sky or wall behind them. The light brush knocks off their corners.

Daumier's light, then, is an active force. But for what purpose does it act? It is at this point that we begin to see how unique Daumier was, and perhaps still is. Other painters made light active: Rembrandt, Millet, the Impressionists. Yet each for a very different purpose. In Rembrandt, the figures generate their own light: it is they who illumine the darkness round themselves. In Daumier, the light lights the figures for us to see, but does not allow *them* to see more clearly. Millet, too, lets the light cut the silhouette of figures, but his is the light of heaven, it has an infinite receding perspective to it; whereas Daumier's

is simply the light of a white backdrop. The Impressionists made light primary. But their light is impartial, it transforms everything equally. And Daumier's is partisan; it lights only what he wishes to bring to our urgent attention.

The paintings which come nearest to Daumier's are the late Goyas, the nightmare pictures of crowd scenes which he painted in his own house in Madrid. They suggest the same effect, in photographic terms, of being overexposed. The similarity is due, I think, to the fact that Goya, like Daumier, was highly conscious of being a witness: of his duty to expose, this time in the social sense of the term. The difference between them is that Goya worked by night and Daumier by day. Goya feared the light for what it would reveal. Daumier hated the inertia of darkness.

I believe that for understanding Daumier's art the most helpful comparison we can make is with another medium altogether. His contemporaries compared his social observation with Balzac's. I should like to compare the nature of his images with Eisenstein's. Look at the man on a rope against a wall. Allow for the different distortions of the medium, and this could be from a film of the 1920s. Light now is the silver screen in front of which we see the shadows of action. We sense that the drama of the incident has only been discovered by looking upwards or sideways in an unusual direction. We are aware that no single position of the legs could be right. We watch him while he moves. We recognise him in passing, and then cannot forget him.

Yet the profound similarity is not just a question of an almost accidental, technical, prophecy in one picture. When once we have made the comparison it becomes obvious. Imagine making a film using some of Daumier's cartoons as a visual script: they would be perfect. And the reason for this is that, like a film director, Daumier saw every incident that he painted as part of an unfolding process, as an image whose meaning could and should never be complete in itself. This is also why he had such difficulty in 'finishing' his paintings. If he had made them definitive he would have betrayed the whole nature of his vision.

This brings us back to the organic connection which existed between the painter and the cartoonist. Both as a political

commentator and as a social satirist, Daumier knew that he was recording processes and habits which could be changed. Indeed he hoped, by recording them, to make people change them. All the time he was using his imagination to foresee the consequences of what he was revealing. When he showed a man who was hungry watching another man eat, he knew that the story could not end there. Finally the man who was hungry must claim his food. When he showed the ennui of the bourgeoisie, he knew that in the end this ennui must destroy the material basis of the bourgeois's comfort. When he showed men and women working he was not just concerned with recording their gestures; he knew that their labour supported the whole of society and so he wanted to show their role as historic.

Just at the time when academic 'history' painting, with its old battle scenes and romantic triumphs, was becoming played out, Daumier introduced into the visual arts a new sense of history: a sense of the continuous force of historic change working in the everyday life around him. He realised that his own work became part of this force by representing it. In his cartoons he represented it by the passion of his direct comment. In his paintings he represented it

Honoré Daumier, *Nadar Elevating Photography to Art*, 1863

by his use of light – the light against which men act – as an active agent itself. Daumier painted – to condense the argument – by the light of history.

CR

WHAT DISTINGUISHES DAUMIER'S work from that of his contemporaries is its unique corporality. His protagonists approach us differently and we accost them differently. They have their own anatomy, their own relationship to Effort. Their caricatured faces are like bodies; their 'realistic' bodies are like faces. Look at the mother and child to the right. They are a single face.

This is due to the fact that Daumier mostly drew and composed, not from what he set up in a secluded studio, but from what he remem-

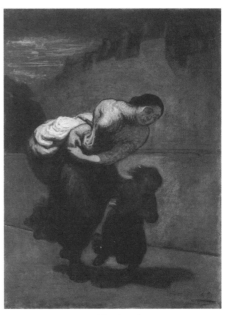

Daumier, *The Burden*, 1865

bered and recalled again and again from figures and scenes he had observed in the streets. His models were the crowd.

Daumier's natural affinity, I would say, was with the *saltimbanques* whom he portrayed without any romanticism but with great affection. They performed at street-level, they persuaded people to pause, they made music, they lifted weights, they persuaded everyone, between guffaws of laughter, that they could love one another, and with their skills and bare hands they momentarily released a kind of grace.

At another moment on another day the *saltimbanques* could make the Washerwoman with her monstrous load, make her and her child smile with a smile of which no government minister of that time would ever have been capable.

22.

J. M. W. Turner
(1775–1851)

THERE HAS NEVER been another painter like Turner. And this is because he combined in his work so many different elements. There is a strong argument for claiming that it is Turner, not Dickens or Wordsworth or Walter Scott or Constable or Landseer, who, in his genius, represents most fully the character of the British nineteenth century. And it may be this which explains the fact that Turner is the only important artist who both before and after his death in 1851 had a certain popular appeal in Britain. Until recently a wide public felt that somehow, mysteriously, dumbly (in the sense that his vision dismisses or precludes words), Turner was expressing something of the bedrock of their own varied experience.

Turner was born in 1775, the son of a backstreet barber in central London. His uncle was a butcher. The family lived a stone's throw from the Thames. During his life Turner travelled a great deal, but in most of his chosen themes water, coastlines, or river banks recur continually. During the last years of his life he lived – under the alias of Captain Booth, a retired sea captain – a little further down the river at Chelsea. During his middle years he lived at Hammersmith and Twickenham, both overlooking the Thames.

He was a child prodigy and by the age of nine he was already earning money by colouring engravings; at fourteen he entered the Royal

Academy Schools. When he was eighteen he had his own studio, and shortly afterwards his father gave up his trade to become his son's studio assistant and factotum. The relation between father and son was obviously close. (The painter's mother died insane.)

It is impossible to know exactly what early visual experiences affected Turner's imagination. But there is a strong correspondence between some of the visual elements of a barber's shop and the elements of the painter's mature style, which should be noticed in passing without being used as a comprehensive explanation. Consider some of his later paintings and imagine, in the backstreet shop, water, froth, steam, gleaming metal, clouded mirrors, white bowls or basins in which soapy liquid is agitated by the barber's brush and detritus deposited. Consider the equivalence between his father's razor and the palette knife which, despite criticisms and current usage, Turner insisted upon using so extensively. More profoundly – at the level of childish phantasmagoria – picture the always possible combination, suggested by a barber's shop, of blood and water, water and blood. At the age of twenty Turner planned to paint a subject from the Apocalypse entitled *The Water Turned to Blood*. He never painted it. But visually, by way of sunsets and fires, it became the subject of thousands of his later works and studies.

Many of Turner's earlier landscapes were more or less classical, referring back to Claude Lorrain, but influenced also by the first Dutch landscapists. The spirit of these works is curious. On the face of it, they are calm, 'sublime', or gently nostalgic. Eventually, however, one realises that these landscapes have far more to do with art than nature, and that as art they are a form of pastiche. And in pastiche there is always a kind of restlessness or desperation.

Nature entered Turner's work – or rather his imagination – as violence. As early as 1802 he painted a storm raging round the jetty at Calais. Soon afterwards he painted another storm in the Alps. Then an avalanche. Until the 1830s the two aspects of his work, the apparently calm and the turbulent, existed side by side, but gradually the turbulence became more and more dominant. In the end violence was implicit in Turner's vision itself; it no longer depended upon the subject. For example, the painting entitled *Peace: Burial at Sea* is, in its own way, as violent as the painting *The Snowstorm*. The former is like an image of a wound being cauterised.

The violence in Turner's paintings appears to be elemental: it is expressed by water, by wind, by fire. Sometimes it appears to be a quality which belongs just to the light. Writing about a late painting called *The Angel Standing in the Sun*, Turner spoke of light *devouring* the whole visible world. Yet I believe that the violence he found in nature only acted as a confirmation of something intrinsic to his own imaginative vision. I have already suggested how this vision may have been partly born from childhood experience. Later it would have been confirmed, not only by nature, but by human enterprise. Turner lived through the first apocalyptic phase of the British Industrial Revolution. Steam meant more than what filled a barber's shop. Vermilion meant furnaces as well as blood. Wind whistled through valves as well as over the Alps. The light which he thought of as devouring the whole visible world was very similar to the new productive energy which was challenging and destroying all previous ideas about wealth, distance, human labour, the city, nature, the will of God, children, time. It is a mistake to think of Turner as a virtuoso painter of natural effects – which was more or less how he was officially estimated until Ruskin interpreted his work more deeply.

The first half of the British nineteenth century was profoundly unreligious. This may have forced Turner to use nature symbolically. No other convincing or accessible system of symbolism made a deep moral appeal, but its moral sense could not be expressed directly. *Burial at Sea* shows the burial of the painter Sir David Wilkie, who was one of Turner's few friends. Its references are cosmic. But as a statement, is it essentially a protest or an acceptance? Do we take more account of the impossibly black sails or of the impossibly radiant city beyond? The questions raised by the painting are moral – hence, as in many of Turner's later works, its somewhat claustrophobic quality – but the answers given are all ambivalent. No wonder that what Turner admired in painting was the ability to cast doubt, to throw into mystery. Rembrandt, he said admiringly, 'threw a mysterious doubt over the meanest piece of common'.

From the outset of his career Turner was extremely ambitious in an undisguisedly competitive manner. He wanted to be recognised not only as the greatest painter of his country and time, but among the greatest of all time. He saw himself as the equal of Rembrandt and

Watteau. He believed that he had outpainted Claude Lorrain. This competitiveness was accompanied by a marked tendency towards misanthropy and miserliness. He was excessively secretive about his working methods. He was a recluse in the sense that he lived apart from society by choice. His solitariness was not a by-product of neglect or lack of recognition. From an early age his career was a highly successful one. As his work became more original, it was criticised. Sometimes his solitary eccentricity was called madness; but he was never treated as being less than a great painter.

He wrote poetry on the themes of his paintings, he wrote and sometimes delivered lectures on art, in both cases using a grandiloquent but vapid language. In conversation he was taciturn and rough. If one says that he was a visionary, one must qualify it by emphasising hardheaded empiricism. He preferred to live alone, but he saw to it that he succeeded in a highly competitive society. He had grandiose visions which achieved greatness when he painted them and were merely bombastic when he wrote about them, yet his most serious conscious attitude as an artist was pragmatic and almost artisanal: what drew him to a subject or a particular painting device was what he called its *practicability* – its capacity to yield a painting.

Turner's genius was of a new type which was called forth by the British nineteenth century, but more usually in the field of science or engineering or business. (Somewhat later the same type appeared as hero in the United States.) He had the ability to be highly successful, but success did not satisfy him. (He left a fortune of £140,000.) He felt himself to be alone in history. He had global visions which words were inadequate to express and which could only be presented under the pretext of a *practical* production. He visualised man as being dwarfed by immense forces over which he had no control but which nevertheless he had discovered. He was close to despair, and yet he was sustained by an extraordinary productive energy. (In his studio after his death there were 19,000 drawings and watercolours and several hundred oil paintings.)

Ruskin wrote that Turner's underlying theme was Death. I believe rather that it was solitude and violence and the impossibility of redemption. Most of his paintings are as if about the aftermath of crime. And what is so disturbing about them – what actually allows

them to be seen as beautiful – is not the guilt but the global indifference that they record.

On a few notable occasions during his life Turner was able to express his visions through actual incidents which he witnessed. In October 1834, the Houses of Parliament caught fire. Turner rushed to the scene, made furious sketches, and produced the finished painting for the Royal Academy the following year. Several years later, when he was sixty-six years old, he was on a steamboat in a snowstorm and afterwards painted the experience. Whenever a painting was based on a real event he emphasised, in the title or in his catalogue notes, that the work was the result of first-hand experience. It was as though he wished to prove that life – however remorselessly – confirmed his vision. The full title of *The Snowstorm* was *Snowstorm. Steamboat off a Harbour's Mouth Making Signals in Shallow Water, and going by the Lead. The Author was in this storm on the night the Ariel left Harwich*. When a friend informed Turner that his mother had liked the snowstorm painting, Turner remarked: 'I did not paint it to be understood, but I wished to show what such a scene was like: I got sailors to lash me to the mast to observe it; I was lashed for four hours, and I did not expect to escape, but I felt bound to record it if I did. But no one had any business to like the picture.'

'But my mother went through just such a scene, and it brought it all back to her.'

'Is your mother a painter?'

'No.'

'Then she ought to have been thinking of something else.'

The question remains what made these works, likeable or not, so new, so different. Turner transcended the principle of traditional landscape: the principle that a landscape is something which unfolds before you. In *The Burning of the Houses of Parliament* the scene begins to extend beyond its formal edges. It begins to work its way round the spectator in an effort to outflank and surround him. In *The Snowstorm* the tendency has become fact. If one really allows one's eye to be absorbed into the forms and colours on the canvas, one begins to realise that, looking at it, one is in the centre of a maelstrom: there is no longer a near and a far. For example, the lurch into the distance is not, as one would expect, *into* the picture, but out of it towards the

right-hand edge. It is a picture which precludes the outsider spectator.

Turner's physical courage must have been considerable. His courage as an artist before his own experience was perhaps even greater. His truthfulness to that experience was such that he destroyed the tradition to which he was so proud to belong. He stopped painting totalities. *The Snowstorm* is the total of everything which can be seen and grasped by the man tied to the mast of that ship. There is *nothing* outside it. This makes the idea of anyone liking it absurd.

Perhaps Turner did not think exactly in these terms. But he followed intuitively the logic of the situation. He was a man alone, surrounded by implacable and indifferent forces. It was no longer possible to believe that what he saw could ever be seen from the outside – even though this would have been a consolation. Parts could no longer be treated as wholes. There was either nothing or everything.

In a more practical sense he was aware of the importance of totality in his life's work. He became reluctant to sell his paintings. He wanted as many of his pictures as possible to be kept together, and he became obsessed by the idea of bequeathing them to the nation so that they could be exhibited as a whole. 'Keep them together,' he said. 'What is the use of them but together?' Why? Because only then might they conceivably bear obstinate witness to his experience for which, he believed, there was no precedent and no great hope of future understanding.

23.

Jean-Louis-André-Théodore Géricault
(1791–1824)

DURING THAT WINTER, walking around the centre of Paris, I couldn't stop thinking about a portrait. It's of an unknown man and was painted some time in the early twenties of the nineteenth century. The portrait was the image on the posters, at every street corner, announcing a large Géricault exhibition at the Grand Palais.

The painting in question was discovered in an attic in Germany, along with four other similar canvases, forty years after Géricault's early death. Soon afterwards it was offered to the Louvre, who refused it. Imagined in the context of the denunciation and drama of the *Raft of the Medusa*, which had already been hanging in the museum for forty years, the offered portrait would at that time have had a nondescript air. Yet now it has been chosen to represent the same painter's entire *oeuvre*. What changed? Why has this frail portrait become today so eloquent, or, more precisely, so haunting?

Behind everything that Géricault imagined and painted – from his wild horses to the beggars he recorded in London – one senses the same vow: Let me face the affliction, let me discover respect and, if possible, find a beauty! Naturally the beauty he hoped to find meant turning his back on most official pieties.

Théodore Géricault, *Portrait of a Kleptomaniac*, 1822

He had much in common with Pasolini:

> I force myself to understand everything,
> ignorant as I am of any life that isn't
> mine, till, desperate in my nostalgia,
>
> I realise the full experience
> of another life; I'm all compassion,
> but I wish the road of my love for
>
> this reality would be different, that I
> then would love individuals, one by one.

The portrait on the poster was once entitled *The Mad Murderer*, later, *The Kleptomaniac*. Today it is catalogued as *The Monomaniac of Stealing*. Nobody any longer knows the man's proper name.

The sitter was an inmate of the asylum of La Salpêtrière, in the centre of Paris. Géricault painted there ten portraits of people certified as insane. Five of these canvases survived. Among them is another unforgettable one of a woman. In the museum of Lyon, it was originally entitled *The Hyena of the Salpêtrière*. Today she is known as *The Monomaniac of Envy*.

Exactly why Géricault painted these patients we can only guess. Yet the way he painted them makes it clear that the last thing he was concerned with was the clinical label. His very brush marks indicate he knew and thought of them by their names. The names of their souls. The names which are no longer known.

A decade or two earlier, Goya had painted scenes of incarcerated mad people, chained and naked. For Goya, however, it was their acts that counted, not their interiority. Before Géricault painted his sitters in La Salpêtrière perhaps nobody, neither painter, nor doctor, nor kith, nor kin, had ever looked for so long and so hard into the face of someone categorised and condemned as mad.

In 1942 Simone Weil wrote: 'Love for our neighbour, being made of creative attention, is analogous to genius.' When she wrote this she was certainly not thinking about art.

> The love of our neighbour in all its fullness simply means being able to say to him: 'What are you going through?' It is a recognition that the sufferer exists, not only as a unit in a collection, or a specimen from the social category labelled 'unfortunate', but as a man, exactly like we are, who was one day stamped with a special mark of affliction. For this reason it is enough, but it is indispensable to know how to look at him in a certain way.

For me, Géricault's portrait of the man with tousled hair and disarranged collar, and with eyes which no guardian angel protects, demonstrates the 'creative attention' and contains the 'genius' to which Simone Weil refers.

Yet why was this painting so haunting in the streets of Paris? It pinched us between two fingers. I will try to explain the first finger.

There are many forms of madness which start as theatre. (As Shakespeare, Pirandello, and Artaud knew so well.) Folly tests its strength in rehearsals. Anyone who has been beside a friend beginning to fall into madness will recognise this sense of being forced to become an audience. What one sees at first on the stage is a man or a woman, alone, and beside them – like a phantom – the inadequacy of all given explanations to explain the everyday pain being suffered. Then he or she approaches the phantom and confronts the terrible

space existing between spoken words and what they are meant to mean. In fact this space, this vacuum, *is* the pain. And finally, because like nature it abhors a vacuum, madness rushes in and fills the space and there is no longer any distinction between stage and world, playing and suffering.

Between the experience of living a normal life at this moment on the planet and the public narratives being offered to give a sense to that life, the empty space, the gap, is enormous. The desolation lies *there*, not in the facts. This is why a third of the French population are ready to listen to Le Pen. The story he tells – evil as it is – seems closer to what is happening in the streets. Differently, this is also why people dream of 'virtual reality'. Anything – from demagogy to manufactured onanistic dreams – anything, anything, to close the gap! In such gaps people get lost, and in such gaps people go mad.

In all five of the portraits Géricault painted in La Salpêtrière the sitters' eyes are looking elsewhere, askance. Not because they are focused on something distant or imagined, but because, by now, they habitually avoid looking at what is near. What is near provokes a vertigo because it is inexplicable according to the explanations offered.

How often today can one encounter a not dissimilar glance refusing to focus on the near – in trains, parking lots, bus queues, shopping precincts . . .

There are historical periods when madness appears to be what it is: a rare and abnormal affliction. There are other periods – like the one we have just entered – when madness appears to be typical.

All this describes the first of the two fingers with which the image of the man with tousled hair pinched us. The second finger comes from the compassion of the image.

Post-modernism is not usually applied to compassion. It might be both useful and humbling to apply it.

Most revolts in history were made to restore a justice which had been long abused or forgotten. The French Revolution, however, proclaimed the world principle of a Better Future. From that moment onwards all political parties of both left and right were obliged to make a promise which maintained that the amount of suffering in the world was being and would be reduced. Thus all affliction became, to some degree, a reminder of a hope. Any pain witnessed, shared, or

suffered remained of course pain, but could be partly transcended by being felt as a spur towards making greater efforts for a future where that pain would not exist. Affliction had an historical outlet! And, during these two tragic centuries, even tragedy was thought of as carrying a promise.

Today the promises have become barren. To connect this barren-ness solely with the defeat of communism is short-sighted. More far-reaching are the ongoing processes by which commodities have replaced the future as a vehicle of hope. A hope which inevitably proves barren for its clients, and which, by an inexorable economic logic, excludes the global majority. To buy a ticket for this year's Paris–Dakar Rally to give to the man with tousled hair makes us madder than he.

So we face him today without an historical or a modern hope. Rather we see him as a consequence. And this, by the natural order of things, means we see him with indifference. We don't know him. He's mad. He's been dead for more than a hundred and fifty years. Each day in Brazil a thousand children die of malnutrition or illnesses which in Europe are curable. They're thousands of miles away. You can do nothing.

The image pinched. In it there is a compassion that refutes indif-ference and is irreconcilable with any easy hope.

To what an extraordinary moment this painting belongs in the history of human representation and awareness! Before it, no stranger would have looked so hard and with such pity at a lunatic. A little later and no painter would have painted such a portrait without exhorting a glimmer of a modern or romantic hope. Like Antigone's, the lucid compassion of this portrait coexists with its powerlessness. And those two qualities, far from being contradictory, affirm one another in a way that victims can acknowledge but only the heart can recognise.

This, however, should not prevent us from being clear. Compassion has no place in the natural order of the world, which operates on the basis of necessity. The laws of necessity are as unex-ceptional as the laws of gravitation. The human faculty of compassion opposes this order and is therefore best thought of as being in some way supernatural. To forget oneself, however briefly, to identify with a stranger to the point of fully recognising her or him, is to defy

necessity, and in this defiance, even if small and quiet and even if measuring only 60 × 50 cm, there is a power which cannot be measured by the limits of the natural order. It is not a means and it has no end. The Ancients knew this.

> 'I did not think', said Antigone, 'your edicts strong enough
> To overrule the unwritten unalterable laws
> Of God and heaven, you being only a man.
> They are not of yesterday or today, but everlasting,
> Though where they came from, none of us can tell.'

The poster looked down on the streets of Paris as might a ghost. Not the ghost of the man with tousled hair, nor Géricault's. But the ghost of a special form of attention, which for two centuries had been marginalised but which every day now was becoming less obsolete. This is the second finger.

Pinched, what do we do? Wake up, perhaps.

24.

Jean-François Millet
(1814–75)

MILLET'S HOLY HUMBLE peasants have been used to illustrate many moral lessons and have comforted many uneasy consciences: the consciences of those who have borne everything 'with fortitude', but who suspect themselves of perhaps having accepted too much too passively: also, the consciences of those who, living off the labour of others, have nevertheless always believed that in an indescribable sort of way (and God help those who describe it too explicitly) the labourer has a nobility which they themselves lack. And, above all, Millet's pictures have been quoted to persuade the confined to count the blessings in their cells; they have been used as a kind of pictorial label round the great clerical bottle of Bromide prescribed to quieten every social fever and irritation. This is a more important part of the history of Millet's art than the fact that highbrow fashion has ignored him for the last thirty or forty years. Otherwise what is important is that such artists as Degas, Monet, Van Gogh, Sickert, all accepted as a matter of course that he was a great draughtsman. In fact, Michelangelo, Poussin, Fragonard, Daumier, Degas, can all be cited in discussing his work – though it is only necessary to do so in order to convince the 'art-loving' public, misled by its textbooks, that Millet was not just a kind of John the Baptist forerunner of the Pre-Raphaelites or of Watts.

But when that has been said, it is the moral issue which is *the* issue that Millet raises.

Millet was a moralist in the only way that a great artist can be: by the power of his identification with his subjects. He chose to paint peasants because he was one, and because – under a somewhat similar influence to the unpolitical realists today – he instinctively hated the false elegance of the beau monde. His genius was the result of the fact that, choosing to paint physical labour, he had the passionate, highly sensuous, and sexual temperament that could lead him to intense physical identification. Sir Kenneth Clark makes much of the point that at the age of thirty-five he gave up painting nudes which were – but only in the mythology they employed – a little like eighteenth-century boudoir art. Yet there was no inhibited puritanism behind this decision. Millet objected to Boucher because 'he did not paint nude women, but only little creatures undressed'.

As for the nature of Millet's power of identification, this is clearly revealed in one of his remarks about a drawing by Michelangelo: 'When I saw that drawing of his in which he depicts a man in a fainting fit – I felt like the subject of it, as though I were racked with pain. I suffered with the body, with the limbs, that I saw suffer.'

In the same way he strode forward with *The Sower*, felt the weight of the hand on a lap even when it was obscured in shadow (see his etching *Mother Feeding Her Child*), embraced with the harvesters the trusses of hay, straightened his back with the hoers, clenched his leg to steady the log with the wood-cutters, leant his weight against the tree trunk with the shepherdess, sprawled at midday on the ground with the exhausted. This was the extent of his moral teaching. When he was accused of being a socialist, he denied it – although he continued to work in the same way and suffer the same accusation – because socialism seemed to him to have nothing to do with the truth he had experienced and expressed: the truth of the peasant driven by the seasons: the truth so dominating that it made it absolutely impossible for him to conceive of any other life for a peasant. It is fatal for an artist's moral sense to be in advance of his experience of reality. (Hogarth's wasn't; Greuze's was.) Millet, without a trace of sentimentality, told the truth as he knew it: the passive acceptance of the couple in *The Angelus* was a small part of the truth. And the sentimentality and false morality afterwards foisted upon this picture will

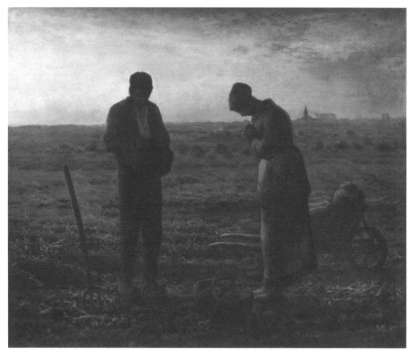

Jean-François Millet, *The Angelus*, 1857–59

prove – perhaps already has proved – to be temporary. In the history of nineteenth- and twentieth-century art the same story is repeated again and again. The artist, isolated, knows that his maximum moral responsibility is to struggle to tell the truth; his struggle is on the near side, not the far, of drawing moral conclusions. The public, or certain sections of it, then draw moral conclusions to disguise the truth: the artist's work is called immoral – Balzac, Zola; or is requisitioned for false preaching – Millet, Dostoevsky; or, if neither of these subterfuges work, it is dismissed as being naive – Shelley, Brecht.

ᝳ

JEAN-FRANÇOIS MILLET died in 1875. After his death and until recently, a number of his paintings, particularly *The Angelus*, *The Sower*, and *The Gleaners*, were among the best-known painted images in the world. I doubt whether even today there is a peasant family in France who do not know all three pictures through engravings, cards, ornaments, or plates. *The Sower* became both the trademark for a US bank and a symbol of revolution in Peking and Cuba.

As Millet's popular reputation spread, his 'critical' reputation declined. Originally, however, his work had been admired by Seurat, Pissarro, Cézanne, Van Gogh. Commentators talk today of Millet becoming a posthumous victim of his own popularity. The questions raised by Millet's art are more far-reaching

Millet, *The Angelus* detail on butter dish, 1857–59

and more disturbing than this suggests. A whole tradition of culture is in question.

In 1862 Millet painted *Winter with Crows*. It is nothing but a sky, a distant copse, and a vast deserted plain of inert earth, on which have been left a wooden plough and a harrow. Crows comb the ground whilst waiting, as they will all winter. A painting of the starkest simplicity. Scarcely a landscape but a portrait in November of a plain. The horizontality of that plain claims everything. To cultivate its soil is a continual struggle to encourage the vertical. This struggle, the painting declares, is back-breaking.

Millet's images were reproduced on such a wide scale because they were unique: no other European painter had treated rural labour as the central theme of his art. His life's work was to introduce a new subject into an old tradition, to force a language to speak of what it had ignored. The language was that of oil painting; the subject was the peasant as individual *subject*.

Some may want to contest this claim by citing Brueghel and Courbet. In Brueghel, peasants form a large part of the crowd which is mankind: Brueghel's subject is a collectivity of which the peasantry as a whole is only a part; no man has yet been condemned in perpetuity to solitary individuality and all men are equal before the last judgement; social station is secondary.

Courbet may have painted *The Stonebreakers* in 1850 under Millet's influence (Millet's first Salon 'success' was with *The Winnower*, exhibited in 1848). But essentially Courbet's imagination was sensuous,

concerned with the sources of sense experience rather than with the subject of them. As an artist of peasant origin, Courbet's achievement was to introduce into painting a new kind of substantiality, perceived according to senses developed by habits different from those of the urban bourgeois. The fish as caught by a fisherman, the dog as chosen by a hunter, the trees and snow as what a familiar path leads through, a funeral as a regular village meeting. What Courbet was weakest at painting was the human eye. In his many portraits, the eyes (as distinct from the lids and eye sockets) are almost interchangeable. He refused any insight inwards. This explains why the peasant *as subject* could not be his theme.

Among Millet's paintings are the following experiences: scything, sheep shearing, splitting wood, potato lifting, digging, shepherding, manuring, pruning. Most of the jobs are seasonal, and so their experience includes the experience of a particular kind of weather. The sky behind the couple in *The Angelus* (1859) is typical of the stillness of early autumn. If a shepherd is out at night with his sheep, hoar frost on their wool is as likely as moonlight. Because Millet was inevitably addressing an urban and privileged public, he chose to depict moments which emphasise the harshness of the peasant experience – often a moment of exhaustion. Job and, once again, season determine the expression of this exhaustion. The man with a hoe leans, looking unseeing up at the sky, straightening his back. The haymakers lie prostrate in the shade. The man in the vineyard sits huddled on the parched earth surrounded by green leaves.

So strong was Millet's ambition to introduce previously unpainted experience that sometimes he set himself an impossible task. A woman dropping seed potatoes into a hole scooped out by her husband (the potatoes in mid-air!) may be filmable, but is scarcely paintable. At other times his originality is impressive. A drawing of cattle with a shepherd dissolving into darkness, the scene absorbing dusk like dunked bread absorbs coffee. A painting of earth and bushes, just discernible by starlight, as blanketed masses.

> The universe sleeps
> And its gigantic ear
> Full of ticks

That are stars

Is now laid on its paw

Mayakovsky

Such experiences had never been painted before – not even by Van de Neer, whose night scenes were still delineated as if they were day scenes. (Millet's love of night and half-light is something to come back to.)

What provoked Millet to choose such new subject matter? It is not enough to say that he painted peasants because he came from a peasant family in Normandy and, when young, had worked on the land. Any more than it is correct to assume that the 'biblical' solemnity of his work was the result of his own religious faith. In fact, he was an agnostic.

In 1847, when he was thirty-three, he painted a small picture entitled *Return from the Fields* which shows three nymphs – seen somewhat in the manner of Fragonard – playing on a barrow of hay. A light rustic idyll for a bedroom or private library. It was one year later that he painted coarsely the taut figure of *The Winnower* in the dark of a barn where dust rises from his basket, like the dust of white brass, a sign of the energy with which his whole body is shaking the grain. And two years later, *The Sower* striding downhill, broadcasting his grain, a figure symbolising the bread of life, whose silhouette and inexorability are reminiscent of the figure of death. What inspired the change in Millet's painting after 1847 was the revolution of 1848.

His view of history was too passive and too pessimistic to allow him any strong political convictions. Yet the years of 1848 to 1851, the hopes they raised and suppressed, established for him, as for many others, the claim of democracy: not so much in a parliamentary sense, as in the sense of the rights of man being universally applicable. The artistic style which accompanied this modern claim was realism: realism because it revealed hidden social conditions, realism because (it was believed) all could recognise what it revealed.

After 1847, Millet devoted the remaining twenty-seven years of his life to revealing the living conditions of the French peasantry. Two-thirds of the population were peasants. The revolution of 1789

had freed the peasantry from feudal servitude, but by the middle of the nineteenth century they had become victims of the 'free exchange' of capital. The annual interest the French peasantry had to pay on mortgages and loans was equal to that paid on the entire annual national debt of Britain, the richest country in the world. Most of the public who went to look at paintings in the Salon were ignorant of the penury which existed in the countryside, and one of Millet's conscious aims was 'to disturb them in their contentment and leisure'.

His choice of subject also involved nostalgia. In a double sense. Like many who leave their village, he was nostalgic about his own village childhood. For twenty years he worked on a canvas showing the road to the hamlet where he was born, finishing it two years before he died. Intensely green, sewn together, the shadows as substantially dark as the lights are substantially light, this landscape is like a garment he once wore (*The Hameau Cousin*). And there is a pastel of a well in front of a house with geese and chickens and a woman, which made an extraordinary impression on me when I first looked at it. It is drawn realistically and yet I saw it as the site of every fairy story which begins with an old woman's cottage. I saw it as a hundred times familiar, although I knew I had not seen it before; the 'memory' was inexplicably in the drawing itself. Later I discovered in Robert L. Herbert's exemplary catalogue to the 1976 exhibition that this scene was what was visible in front of the house where Millet was born, and that consciously or unconsciously the artist had enlarged the proportions of the well by two-thirds so that they coincided with his childhood perception.

Millet's nostalgia, however, was not confined to the personal. It permeated his view of history. He was sceptical of the Progress being proclaimed on every side and saw it, rather, as an eventual threat to human dignity. Yet unlike William Morris and other romantic medievalists, he did not sentimentalise the village. Most of what he knew about peasants was that they were reduced to a brutal existence, especially the men. And, however conservative and negative his overall perspective may have been, he sensed, it seems to me, two things which, at the time, few others foresaw: that the poverty of the city and its suburbs, and that the market created by industrialisation, to which the peasantry was being sacrificed, might one day entail the loss of all

sense of history. This is why for Millet the peasant came to stand for man, and why he saw his paintings as having an historic function.

The reactions to his paintings were as complex as Millet's own feelings. Straightaway he was labelled a socialist revolutionary. With enthusiasm by the left. With outraged horror by the centre and right. The latter were able to say about his *painted* peasants what they feared but dared not say about the real ones, who were still working on the land, or the five million who were drifting landless towards the cities: *they look like murderers, they are cretins, they are beasts not men, they are degenerate*. Having said these things, they accused Millet of inventing such figures.

Towards the end of the century, when the economic and social stability of capitalism was more assured, his paintings offered other meanings. Reproduced by the church and commerce, they reached the countryside. The pride with which a class first sees itself recognisably depicted in a permanent art is full of pleasure, even if the art is flawed and the truth harsh. The depiction gives an historic resonance to their lives. A pride which was, before, an obstinate refusal of shame becomes an affirmation.

Meanwhile the original Millets were being bought by old millionaires in America who wanted to re-believe that the best things in life are simple and free.

And so how are we to judge this advent of a new subject into an old art? It is necessary to emphasise how conscious Millet was of the tradition he inherited. He worked slowly from drawings, often returning to the same motif. Having chosen the peasant as subject, his life's effort was to do him justice by investing him with dignity and permanence. And this meant joining him to the tradition of Giorgione, Michelangelo, the Dutch seventeenth century, Poussin, Chardin.

Look at his art chronologically and you see the peasant emerging, quite literally, from the shadows. The shadows are the corner traditionally reserved for genre painting – the scene of low life (tavern, servant's quarters), glimpsed in passing, indulgently, even enviously, by the traveller on the high road where there is space and light. *The Winnower* is still in the genre corner, but enlarged. *The Sower* is a phantom figure, oddly uncompleted as a painting, striding forward to claim a place. Up to about 1856 Millet produced other genre paintings – shepherd girls

in the shade of trees, a woman churning butter, a cooper in his work-shop. But already in 1853, in *Going to Work*, the couple leaving home for the day's work on the plain – they are modelled on Masaccio's *Adam and Eve* – have moved to the forefront and become the centre of the world assumed by the painting. And from now on, this is true in all of Millet's major works which include figures. Far from presenting these figures as something marginal seen in passing, he does his utmost to make them central and monumental. And all these paintings – in differing degrees – fail.

They fail because no unity is established between figures and surroundings. The monumentality of the figures refuses the painting. And vice versa. As a result the cut-out figures look rigid and theatrical. The moment lasts too long. By contrast, the same figures in equivalent drawings or etchings are alive and belong to the moment of drawing which includes all their surroundings. For example, the etching of *Going to Work*, made ten years after the painting, is a very great work, comparable with the finest etching by Rembrandt.

What prevented Millet achieving his aim as a painter? There are two conventional fallback answers. Most nineteenth-century sketches were better than finished works. A doubtful art-historical generalisa-tion. Or: Millet was not a born painter!

I believe that he failed because the language of traditional oil paint-ing could not accommodate the subject he brought with him. One can explain this ideologically. The peasant's interest in the *land*, expressed through his actions, is incommensurate with scenic land-scape. Most (not all) European landscape painting was addressed to a visitor from the city, later called a tourist; the landscape is *his* view, the splendour of it is *his* reward. Its paradigm is one of those painted orien-tation tables which name the visible landmarks. Imagine a peasant suddenly appearing at work between the table and the view, and the social/human contradiction becomes obvious.

The history of forms reveals the same incompatibility. There were various iconographic formulae for integrating figures and landscape. Distant figures like notes of colour. Portraits to which the landscape is a background. Mythological figures, goddesses and so on, with which nature interweaves to 'dance to the music of time'. Dramatic figures, whose passions nature reflects and illustrates. The visitor or solitary

onlooker who surveys the scene, an *alter ego* for the spectator himself. But there was no formula for representing the close, harsh, patient physicality of a peasant's labour *on*, instead of *in front of*, the land. And to invent one would mean destroying the traditional language for depicting scenic landscape.

In fact, only a few years after Millet's death, this is exactly what Van Gogh tried to do. Millet was his chosen master, both spiritually and artistically. He made dozens of paintings copied closely from engravings from Millet. In these paintings Van Gogh united the working figure with his surroundings by the gestures and energy of his own brushstrokes. Such energy was released by his intense sense of empathy with the subject.

But the result was to turn the painting into a personal vision, which was characterised by its 'handwriting'. The witness had become more important than his testimony. The way was open to expressionism and, later, to abstract expressionism, and the final destruction of painting as a language of supposedly objective reference. Thus Millet's failure and setback may be seen as an historic turning point. The claim of universal democracy was inadmissible for oil painting. And the consequent crisis of meaning forced most painting to become autobiographical.

Why not inadmissible, too, for drawing and graphic work? A drawing records a visual experience. An oil painting, because of its uniquely large range of tones, textures, and colours, pretends to reproduce the visible. The difference is very great. The virtuoso performance of the oil painting assembles all aspects of the visible to conduct them to a single point: the point of view of the empirical onlooker. And it insists that such a view constitutes visibility itself. Graphic work, with its limited means, is more modest; it only claims a single aspect of visual experience, and therefore is adaptable to different uses.

Millet's increasing use of pastel towards the end of his life, his love of half-light in which visibility itself becomes problematic, his fascination with night scenes, suggest that intuitively he may have tried to resist the demand of the privileged onlooker for the world arranged as his view. It would have been in line with Millet's sympathies, for did not the inadmissibility of the peasant as a subject into

224

the European tradition of painting prefigure exactly the absolute conflict of interests which exists today between first and third worlds? If this is the case, Millet's life's work shows how nothing can resolve this conflict unless the hierarchy of our social and cultural values is radically altered.

25.

Gustave Courbet
(1819–77)

BECAUSE COURBET WAS a declared and incorruptible Socialist (he was of course imprisoned for the part he played in the Commune and at the end of his life was driven into exile in Switzerland), reactionary critics have pretended that his politics were nothing to do with his art – they couldn't deny his art itself if only because of his important influence on later artists such as Manet and Cézanne; progressive critics, on the other hand, have tended to assume that his art is great as an automatic result of his political loyalty. So it is pertinent to ask exactly how his socialism was implied in his paintings, how his attitude to life was reflected in the innovations of his art.

First, though, it is necessary to clean off some of the mud that has stuck. Because Courbet was uncompromising in his convictions, because his work and his way of life 'vulgarly' proved that art was as relevant to the back-parlour, the workshop, the cell, as to the drawing room, because his paintings never offered the slightest possibility of escape from the world as it was, he was officially rejected in his lifetime and has since been only grudgingly admitted. He has been accused of being bombastic. Look at his self-portrait in prison. He sits by the window quietly smoking his pipe, the invitation of the sunlight in the courtyard outside the only comment on his confinement. Or

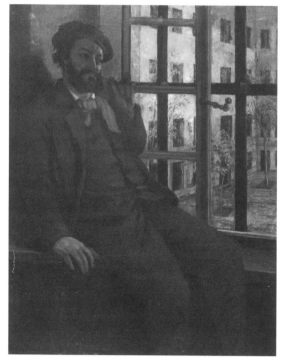

Gustave Courbet, *Self-Portrait at Sainte Pélagie*, 1872–73

look at his copy of the Rembrandt self-portrait. He had the humility to impose that discipline on himself at the age of fifty. He has been accused of coarseness. Look at a Normandy seascape, in which the receding air between the empty sea and the low clouds holds firmly but with an extraordinary finesse all the mystery implied by the apparent fact and the actual illusion of an horizon. He has been charged with sentimentality. Look at his painting of the great hooked trout; its truth to the essential facts forces one to feel the weight of the fish, the power with which, struggling, his tail would slap the rocks, the cunning necessary to play him, the deliberation necessary to gaff him – he would be too large to net. Occasionally, of course, such criticisms are fair, yet no artist only paints masterpieces, and the work, say, of Constable (whom Courbet in his independent contribution to landscape painting somewhat resembled), Corot, or Delacroix is just as unequal, but is far less frequently singled out for prejudiced attack.

But to return to the main problem: Courbet believed in the independence of the artist – he was the first painter to hold a one-man

show. Yet to him this meant independence from art for art's sake, from the prevailing Romantic view that the artist or his work were more important than the existence of the subject painted, and from the opposing Classic view that the inspiration of all art was absolute and timeless. He realised that the artist's independence could only be productive if it meant his freedom to identify himself with his living subject, to feel that *he* belonged to *it*, never vice versa. For the painter as such that is the meaning of Materialism. Courbet expressed it in words – this indestructible relationship between human aspiration and actual fact – when he wrote, 'Savoir pour pouvoir – telle fut ma pensée.' But Courbet's acknowledgement, with all the force of his imagination, of the actuality of the objects he painted never deteriorated into naturalism: a thoughtless superficial goggling at appearances – a tripper's view of a beauty spot, for instance. One does not just feel that every scene he painted *looked* like that but that it was *known* like that. His country landscapes were revolutionary insofar as they presented real places without suggesting any romantic antithesis with the city, but within them – not imposed upon them – one can also discover a sense of potential Arcadia: a local recognition that for playing children and courting couples such ordinary scenes might gather familiar magic. A magnificent nude in front of a window and landscape is an uncompromising portrayal of a woman undressed – subject to many of the same laws as the trout; but, at the same time, the picture evokes the shock of the unexpected loneliness of nudity: the personal shock that inspires lovers, expressed in another way in Giorgione's *Tempest*. His portraits (the masterpieces of Jules Vallès, Van Wisselingh, the Hunter) are particular people; one can imagine how they will alter; one can imagine their clothes worn, ill-fitting, by somebody else; yet they share a common dignity because all are seen with the knowledge of the same man's affection. The light plays on them kindly because all light is welcome that reveals the form of one's friends.

A parallel principle applies to Courbet's drawing and grasp of structure. The basic form is always established first, all modulations and outcrops of texture are then seen as organic variations – just as eccentricities of character are seen by a friend, as opposed to a stranger, as part of the whole man.

To sum up in one sentence, one might say that Courbet's socialism was expressed in his work by its quality of uninhibited Fraternity.

∞

NO ARTIST'S WORK IS reducible to *the* independent truth; like the artist's life – or yours or mine – the life's work constitutes its own valid or worthless truth. Explanations, analyses, interpretation, are no more than frames or lenses to help the spectator focus his attention more sharply on the work. The only justification for criticism is that it allows us to see more clearly.

Several years ago I wrote that two things needed explaining about Courbet because they remained obscure. First, the true nature of the materiality, the density, the weight of his images. Second, the profound reasons why his work so outraged the bourgeois world of art. The second question has since been brilliantly answered – not, surprisingly, by a French scholar, but by British and American ones: Timothy Clark in his two books, *Image of the People* and *The Absolute Bourgeois*, and Linda Nochlin in her book *Realism*.

The first question, however, remains unanswered. The theory and programme of Courbet's realism have been socially and historically explained, but how did he practise it with his eyes and hands? What is the meaning of the unique way in which he rendered appearances? When he said: art is 'the most complete expression of an existing thing', what did he understand by *expression*?

The region in which a painter passes his childhood and adolescence often plays an important part in the constitution of his vision. The Thames developed Turner. The cliffs around Le Havre were formative in the case of Monet. Courbet grew up in – and throughout his life painted and often returned to – the valley of the Loue on the western side of the Jura mountains. To consider the character of the countryside surrounding Ornans, his birthplace, is, I believe, one way of constructing a frame which may bring his work into focus.

The region has an exceptionally high rainfall: approximately fifty-one inches a year, whereas the average on the French plains varies from thirty-one inches in the west to sixteen inches in the centre. Most of this rain sinks through the limestone to form subterranean channels. The Loue, at its source, gushes out of the rocks as an already

substantial river. It is a typical karst region, characterised by outcrops of limestone, deep valleys, caves, and folds. On the horizontal strata of limestone there are often marl deposits which allow grass or trees to grow on top of the rock. One sees this formation – a very green landscape, divided near the sky by a horizontal bar of grey rock – in many of Courbet's paintings, including *A Burial at Ornans*. Yet I believe that the influence of this landscape and geology on Courbet was more than scenic.

Let us first try to visualise the mode of appearances in such a landscape in order to discover the perceptual habits it might encourage. Due to its folds, the landscape is *tall*: the sky is a long way off. The predominant colour is green: against this green the principal events are the rocks. The background to appearances in the valley is dark – as if something of the darkness of the caves and subterranean water has seeped into what is visible.

From this darkness whatever catches the light (the side of a rock, running water, the bough of a tree) emerges with a vivid, gratuitous but only partial (because much remains in shadow) clarity. It is a place where the visible is discontinuous. Or, to put it another way, where the visible cannot always be assumed and has to be grasped when it does make its appearance. Not only the abundant game, but the place's mode of appearances, created by its dense forests, steep slopes, waterfalls, twisting river – encourages one to develop the eyes of a hunter.

Many of these features are transposed into Courbet's art, even when the subjects are no longer his home landscape. An unusual number of his outdoor figure paintings have little or no sky in them (*The Stonebreakers, Proudhon and His Family, Girls on the Banks of the Seine, The Hammock*, most of the paintings of bathers). The light is the lateral light of a forest, not unlike light underwater which plays tricks with perspective. What is disconcerting about the huge *Studio* painting is that the light of the painted wooded landscape on the easel is the light that suffuses the crowded Paris room. An exception to this general rule is the painting *Bonjour Monsieur Courbet*, in which he depicts himself and his patron against the sky. This, however, was a painting consciously situated on the faraway plain of Montpelier.

I would guess that water occurs, in some form or another, in about two-thirds of Courbet's paintings – often in the foreground. (The rural

bourgeois house in which he was born juts out over the river. Running water must have been one of the first sights and sounds which he experienced). When water is absent from his paintings, the foreground forms are frequently reminiscent of the currents and swirls of running water (for example, *The Woman with a Parrot, The Sleeping Spinning Girl*). The lacquered vividness of objects, which catch the light in his paintings, often recalls the brilliance of pebbles or fishes seen through water. The tonality of his painting of a trout underwater is the same as the tonality of his other paintings. There are whole landscapes by Courbet which might be landscapes reflected in a pond, their colour glistening on the surface, defying atmospheric perspective (for example, *The Rocks at Mouthier*).

He usually painted on a dark ground, on which he painted darker still. The depth of his paintings is always due to darkness – even if, far above, there is an intensely blue sky; in this his paintings are like wells. Wherever forms emerge from the darkness into the light, he defines them by applying a lighter colour, usually with a palette knife. Leaving aside for the moment the question of his painterly skill, this action of the knife reproduced, as nothing else could, the action of a stream of light passing over the broken surface of leaves, rock, grass, a stream of light which confers life and conviction but does not necessarily reveal structure.

Correspondences like these suggest an intimate relationship between Courbet's practice as a painter and the countryside in which he grew up. But they do not in themselves answer the question of what *meaning* he gave to appearances. We need to interrogate the landscape further. Rocks are the primary configuration of this landscape. They bestow identity, allow focus. It is the outcrops of rock which create the presence of the landscape. Allowing the term its full resonance, one can talk about *rock faces*. The rocks are the character, the spirit of the region. Proudhon, who came from the same area, wrote: 'I am pure Jurassic limestone.' Courbet, boastful as always, said that in his paintings, 'I even make stones think.'

A rock face is always there. (Think of the Louvre landscape which is called *The Ten o'Clock Road*.) It dominates and demands to be seen, yet its appearance, in both form and colour, changes according to light and weather. It continually offers different facets of itself to visibility.

Compared to a tree, an animal, a person, its appearances are only very weakly normative. A rock can look like almost anything. It is undeniably itself, and yet its substance does not posit any particular form. It emphatically exists and yet its appearance (within a few very broad geological limitations) is arbitrary. It is only like it is, this time. Its appearance is, in fact, the limit of its meaning.

To grow up surrounded by such rocks is to grow up in a region in which the visible is both lawless and irreduceably real. There is visual fact but a minimum of visual order. Courbet, according to his friend Francis Wey, was able to paint an object convincingly – say a distant pile of cut wood – *without knowing what it was*. That is unusual amongst painters, and it is, I think, very significant.

In the early romantic *Self-Portrait with a Dog*, he painted himself, surrounded by the darkness of his cape and hat, against a large boulder. And there his own face and hand are painted in exactly the same spirit as the stone behind. They were comparable visual phenomena, possessing the same visual reality. If visibility is lawless, there is no hierarchy of appearances. Courbet painted everything – snow, flesh, hair, fur, clothes, bark – as he would have painted it had it been a rock face. Nothing he painted has interiority – not even, amazingly, his copy of a Rembrandt self-portrait – but everything is depicted with amazement: amazement because to see, where there are no laws, is to be constantly surprised.

It may now seem that I am treating Courbet as if he were 'timeless', as unhistorical as the Jura mountains which so influenced him. This is not my intention. The landscape of the Jura influenced his painting in the way that it did, given the historical situation in which he was working as a painter, and given his specific temperament. Even by the standards of Jurassic time, the Jura will have 'produced' only one Courbet. The 'geographical interpretation' does no more than ground, give material, visual substance to, the social-historical one.

It is hard to summarise Timothy Clark's percipient and subtle research on Courbet in a few sentences.[1] He allows us to see the political period in all its complexity. He places the legends that surrounded

1 T. J. Clark, *Image of the People: Gustave Courbet and the 1848 Revolution* (London: Thames and Hudson, 1973).

the painter: the legend of the country buffoon with a gift for the paint-brush; the legend of the dangerous revolutionary; the legend of the coarse, drunken, thigh-slapping provocateur. (Probably the truest and most sympathetic portrait of Courbet is by Jules Vallès in his *Cri du Peuple.*)

And then Clark shows how in fact in the great works of the early 1850s Courbet, with his inordinate ambition, with his genuine hatred of the bourgeoisie, with his rural experience, with his love of the theat-rical, and with an extraordinary intuition, was engaged in nothing less than a double transformation of the art of painting. Double because it proposed a transformation of subject matter and audience. For a few years he was able to work, inspired by the ideal of both becoming popular for the first time.

The transformation involved 'capturing' painting as it was and altering its address. One can think of Courbet, I believe, as the last master. He learnt his prodigious skill in handling paint from the Venetians, from Rembrandt, from Velázquez, from Zurbarán, and others. As a practitioner he remained traditionalist. Yet he acquired the skills he did without taking over the traditional values which those skills had been designed to serve. One might say he stole his professionalism.

For example: the practice of nude painting was closely associated with values of tact, luxury, and wealth. The nude was an erotic orna-ment. Courbet stole the practice of the nude and used it to depict the 'vulgar' nakedness of a countrywoman with her clothes in a heap on a river bank. (Later, as disillusion set in, he too produced erotic orna-ments, like *The Woman with a Parrot.*)

For example: the practice of seventeenth-century Spanish realism was closely connected with the religious principle of the moral value of simplicity and austerity and the dignity of charity. Courbet stole the practice and used it in *The Stonebreakers* to present desperate unre-deemed rural poverty.

For example: the Dutch seventeenth-century practice of painting group portraits was a way of celebrating a certain *esprit de corps*. Courbet stole the practice for *Burial at Ornans* to reveal a mass soli-tude in face of the grave.

The hunter from the Jura, the rural democrat, and the bandit

233

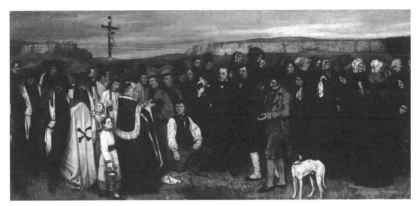

Courbet, *A Burial at Ornans*, 1849–50

painter came together in the same artist for a few years between 1848 and 1856 to produce some shocking and unique images. For all three personae, appearances were a direct experience, relatively unmediated by convention, and for that very reason astounding and unpredictable. The vision of all three was both matter-of-fact (termed by his opponents *vulgar*) and innocent (termed by his opponents *stupid*). After 1856, during the debauch of the Second Empire, it was only the hunter who sometimes produced landscapes which were still unlike those by any other painter, landscapes on which snow might settle.

In the *Burial* of 1849–50 we can glimpse something of the soul of Courbet, the single soul which, at different moments, was hunter, democrat, and bandit painter. Despite his appetite for life, his bragging and proverbial laughter, Courbet's view of life was probably sombre if not tragic.

Along the middle of the canvas, for its whole length (nearly seven yards), runs a zone of darkness, of black. Nominally this black can be explained by the clothes of the massed mourners. But it is too pervasive and too deep – even allowing for the fact that over the years the whole painting has darkened – for its significance to stop there. It is the dark of the valley landscape, of the approaching night, and of the earth into which the coffin will be placed. Yet I think this darkness also had a social and personal significance.

Emerging from the zone of darkness are the faces of Courbet's family, friends, and acquaintances at Ornans, painted without

234

idealisation and without rancour, painted without recourse to a pre-established norm. The painting was called cynical, sacrilegious, brutish. It was treated as if it were a plot. Yet what was involved in the plot? A cult of the ugly? Social subversion? An attack on the church? The critics searched the painting in vain to discover clues. Nobody discovered the source of its actual subversion.

Courbet had painted a group of men and women as they might appear when attending a village funeral, and he had refused to organise (harmonise) these appearances into some false – or even true – higher meaning. He had refused the function of art as the moderator of appearances, as that which ennobles the visible. Instead, he had painted life-size, on twenty-one square metres of canvas, an assembly of figures at a graveside, which announced *nothing* except: This is how we appear. And precisely to the degree to which the art public in Paris received this announcement from the countryside, they denied its truth, calling it vicious exaggeration.

In his soul Courbet may have foreseen this; his grandiose hopes were perhaps a device for giving him the courage to continue. The insistence with which he painted – in the *Burial*, in *The Stonebreakers*, in *The Peasants of Flagey*, whatever emerged into the light, insisting on every apparent part as equally valuable, leads me to think that the ground of darkness signified entrenched ignorance. When he said that art 'is the most complete expression of an existing thing', he was opposing art to any hierarchical system or to any culture whose function is to diminish or deny the expression of a large part of what exists. He was the only great painter to challenge the chosen ignorance of the cultured.

26.

Edgar Degas
(1834–1917)

YOU SAY THE LEG supports the body
But have you never seen
The seed in the ankle
 Whence the body grows?

You say (if you are the builder of bridges
I think you are) each pose
Must have its natural equilibrium
But have you never seen
Recalcitrant muscles of dancers
 Hold their unnatural own?

You say (if as rational
As I hope you are) the biped's evolution
Was accomplished long ago
But have you never seen
The still miraculous sign
A little in from the hip
Predicting nine inches below
 Bodies fork in two?

Then let us look together
(We who both know
Light's the go-between
Of space and time)
Let us look at this figure
To verify
 I my goddess
 And you the stress.

Think in terms of bridges.
See, the road of leg and back
Hingeing at hip and shoulder
Holds firm from palm to heel
Single leg as pier
Thigh above the knee
Cantilevering member.

Think in terms of bridges
Over what men once called Lethe.
See, the ordinary body we cross through
Vulnerable, inhabited, warm
Stands the strain too.
Dead Load, Live Load
And Longitudinal Drag.

So let the bridge this dancer arches for us
Stand the strain of all old prejudice
So let's verify again,
 You my goddess
 And I the stress.

<div align="center">∞</div>

THERE IS LOVE, he once said, and there is a life's work, and one only has one heart. So he chose. He put his heart into his life's work. I hope to show to what effect.

His mother, a French American from New Orleans, died when he, her first-born, was only thirteen years old. Apparently, no other woman

ever entered into his emotional life. He became a bachelor, looked after by housekeepers. Due to the family banking business he had few material worries. He collected paintings. He was cantankerous. Was called 'a terrible man'. Lived in Montmartre. During the Dreyfus Affair he assumed the conventional anti-Semitism of the average bourgeois. The later photos show a frail old man, kippered by solitude. Edgar Degas.

What makes the story strange is that Degas's art was supremely concerned with women and their bodies. This concern has been misunderstood. Commentators have appropriated the drawings and statues to underwrite their own prejudices, either misogynist or feminist. Now, eighty years after Degas stopped working, it may be time to look again at what the artist left behind. Not as insured masterpieces – the market value of his work has long been established – but as an aid to living.

Pragmatically. Between 1866 and 1890 he made a number of small bronzes of horses. All of them reveal an intense and lucid observation. Nobody before – not even Géricault – had rendered horses with such a masterly naturalism and fluency. But around 1888 a qualitative change takes place. The style remains exactly the same, but the energy is different. And the difference is flagrant. Any child would spot it immediately. Only some art moralists might miss it. The early bronzes are of horses seen, marvellously seen, out there in the passing, observable world. The later ones are of horses, not only observed but quiveringly perceived from within. Their energy has not just been noted, but submitted to, undergone, borne, as though the sculptor's hands had felt the terrible nervous energy of the horse in the clay he was handling.

The date of this change coincides with Degas's discovery of Muybridge's photographs, which showed for the first time how the legs of horses actually moved when cantering and galloping. And Degas's use of these photographs accords perfectly with the positivist spirit of the epoch. What brought about the *intrinsic* change, however, defies any positivism. Nature, instead of being an object of investigation, becomes a subject. The later works all seem to obey the demands of the model rather than the will of the artist!

Yet perhaps we may be mistaken about the will of this particular artist. For instance, he never expected his statues to be exhibited: they

were not made to be finished and presented. His interest in them lay elsewhere.

When Ambrose Vollard, the Impressionists' dealer, asked Degas why he didn't have his statuettes cast in bronze, he replied that the tin-and-copper alloy known as bronze was said to be eternal, and he hated nothing more than what was fixed!

Of the seventy-four Degas sculptures that exist in bronze today, all but one were cast after his death. In many cases the original figures, modelled in clay or wax, had deteriorated and crumbled. Seventy others were too far gone to be redeemed.

What can we deduce from this? The statuettes had already served their purpose. (Towards the end of his life Degas stopped exhibiting anything.) The statuettes were not made as sketches or preparatory studies for some other work. They were made for their own sake, yet they had served their purpose: they had reached their point of apogee and so could be abandoned.

The apogee point for him was when the drawn entered the drawing, when the sculpted passed into the sculpture. This was the only rendezvous and transfer that interested him.

I can't explain how the drawn enters a drawing. I only know that it does. One gets closest to understanding this when actually drawing. On Degas's tombstone in the cemetery of Montmartre the only words written are: '*Il aimait beaucoup le dessin.*' ('He liked drawing very much.')

Let us now think of the charcoal drawings, pastels, monotypes, and bronzes of women. Sometimes they are presented as ballet dancers, sometimes as women at their toilette, sometimes (particularly in the monotypes) as

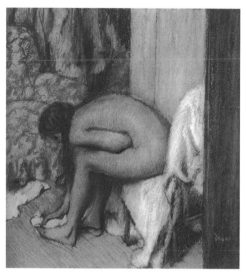

Edgar Degas, *After the Bath*, 1886

prostitutes. Their presentation is unimportant: the ballet, the bathtub, or the bordel were, for Degas, only pretexts. This is why any critical discussion about a pictorial 'scenario' usually misses the point. Why was Degas so fascinated by women washing themselves? Was he a keyhole voyeur? Did he consider all women tarts? (There is an excellent essay by Wendy Lesser in her book *His Other Half* in which she dismantles such questions.)

The truth is that Degas simply invented or used any occasion to pursue his study of the human body. It was usually women's bodies because he was heterosexual and so women amazed him more than men, and amazement is what prompted his kind of drawing.

Straightaway there were people who complained that the bodies he depicted were deformed, ugly, bestial, contorted. They even went so far as to assert that he hated those he drew!

This misunderstanding arose because he disregarded the conventions of physical beauty as conventionally transmitted by art or literature. And, for many viewers, the more a body is naked, the more it should be clothed in convention, the more it should fit a norm, either a perverse or an idealised one; the naked have to wear the uniform of a regiment! Whereas Degas, starting from his amazement, wanted each profile of the particular body he was remembering, or watching, to surprise, to be improbable, for only then would its uniqueness become palpable.

Degas's most beautiful works are indeed shocking, for they begin and end with the commonplace – with what Wendy Lesser calls 'the dailiness' of life – and always they find there something unpredictable and stark. And in this starkness is a memory of pain or of need.

There is a statuette of a masseuse massaging the leg of a reclining woman which I read, in part, as a confession. A confession, not of his failing eyesight, nor of any suppressed need to paw women, but of his fantasy, as an artist, of alleviating by touching – even if the touch was that of a stick of charcoal on tracing paper. Alleviating what? The fatigue to which all flesh is heir . . .

Many times he stuck additional strips of paper on to his drawings because, master that he was, he lost control of them. The image led

240

him further than he calculated going, led him to the brink, where he momentarily gave way to the other. All his late works of women appear unfinished, abandoned. And, as with the bronze horses, we can see why: at a certain instant the artist disappeared and the model entered. Then he desired no more, and he stopped.

When the model 'entered', the hidden became as present on the paper as the visible. A woman, seen from the back, dries her foot which is posed on the edge of a bath. Meanwhile the invisible front of her body is also there, known, recognised, by the drawing.

A feature of Degas's late works is how the outlines of bodies and limbs are repeatedly and heavily worked. And the reason is simple: on the edge (at the brink), everything on the other, invisible, side is crying out to be recognised and the line searches . . . until the invisible comes in.

Watching the woman standing on one leg and drying her foot, we are happy for what has been recognised and *admitted*. We feel the existent recalling its own Creation, before there was any fatigue, before the first brothel or the first spa, before the solitude of narcissism, at the moment when the constellations were given names. Yes, this is what we sense watching her keeping her balance.

So what did he leave behind, if it wasn't finished masterpieces?

Do we not all dream of being known, known by our backs, legs, buttocks, shoulders, elbows, hair? Not psychologically recognised, not socially acclaimed, not praised, just nakedly known. Known as a child is by its mother.

One might put it like this. Degas left behind something very strange. His name. His name, which, thanks to the example of his drawings, can now be used as a verb. 'Degas me. Know me like that! Recognise me, dear God! Degas me.'

ஐ

WHAT LIES IN THE FOLDS? The folds of the classical ballet dancers' costumes and bodies as drawn and painted by Degas, that is. The question is prompted by 'Degas and the Ballet: Picturing Movement', the exhibition at the Royal Academy in London. The sumptuous

catalogue contains a quotation from Baudelaire: 'Dance is poetry with arms and legs; it is matter, gracious and terrible, animated, embellished by movement.'

In Degas's compositions with several dancers, their steps, postures, and gestures often resemble the almost geometric, formal letters of an alphabet, whereas their bodies and heads are recalcitrant, sinuous, and individual. 'Dance is poetry with arms and legs . . .'

Degas was obsessed by the art of classical ballet, because to him it said something about the human condition. He was not a balletomane looking for an alternative world to escape into. Dance offered him a display in which he could find, after much searching, certain human secrets. The exhibition tellingly demonstrates the parallels between Degas's highly original work and the development of photography and the invention of the movie camera. These technological advances both led to discoveries about how human and animal bodies move and operate: a horse galloping, a bird flying, etc.

Without doubt, Degas was intrigued by these innovations and made use of them, but I believe that what obsessed him was closer to what obsessed Michelangelo and Mantegna. All three were fascinated by the human capacity for martyrdom. All three wondered if it wasn't this that defined mankind. The human quality Degas most admired was endurance.

Let's go closer. In drawing after drawing, pastel after pastel, painting after painting, the contours of Degas's dancing figures become, at a certain point, darkly insistent, tangled and dusky. It may be around an elbow, a heel, an armpit, a calf muscle, the nape of a neck. The image goes dark – and this darkness has nothing to do with any logical shadow.

In the first place, it's the result of the artist correcting, changing, and re-correcting the precise placing of the limb, hand or ear in question. His pencil or pastel notes, readjusts, notes again with more emphasis the advancing or receding edge of a continually moving body. Speed is crucial. Yet these 'darknesses' also suggest the darkness of folds or fissures: they acquire an expressive function of their own. Which is what?

Go closer still. A classical ballet dancer controls and moves her entire indivisible body, but her most dramatic movements concern her two legs and two arms, which we can think of as pairs: two couples sharing

the same torso. In everyday life, the two couples and torso live and operate side by side, compliant, contiguous, united by a centripetal energy, directed inwards. Yet, by contrast, in classical dance the pairs are separated, the body's energy is often centrifugal, thrown outwards – and every square centimetre of flesh becomes taut with a kind of solitude.

The dark folds or fissures in these images express the solitude being felt by a part

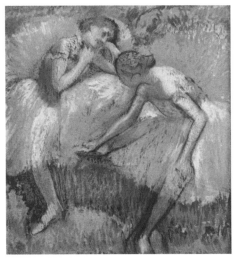

Degas, *Two Dancers at Rest*, 1898

of a limb or torso, which is accustomed to company, to being touched by fellow parts, but which when dancing has to go it alone. The darknesses express the pain of such a disconjuncture and the endurance necessary for bridging it imaginatively. Hence the grace and the starkness to which Baudelaire referred when he said 'gracious and terrible'.

Now look at Degas's studies of dancers who are taking a brief rest, particularly those he made towards the end of his life. They are among the most paradisiacal images I know, yet they are far from the Garden of Eden. While resting, the dancers' limbs are reunited. An arm reposes along the whole length of a leg. A hand refinds a foot to touch it, the fingers matching each toe. Their multiple solitudes are for a moment over. A chin rests on a knee. Contiguity is blissfully re-established. Often their eyes are half-closed and their faces look bland, as if recalling a transcendence.

The transcendence they are remembering is the aim of the art of dancing: the aim of a dancer's entire wracked body to become one with the music. What is astounding is that Degas's images capture this experience silently. With folds but without sound.

27.

Ferdinand 'Le Facteur' Cheval
(1836–1924)

VERY FEW PEASANTS become artists – occasionally perhaps the son or daughter of peasants has done so. This is not a question of talent, but of opportunity and free time. There are some songs and, recently, a few autobiographies about peasant experience. There is the marvellous philosophical work of Gaston Bachelard. Otherwise there is very little. This lack means that the peasant's soul is as unfamiliar or unknown to most urban people as is his physical endurance and the material conditions of his labour.

It is true that in mediaeval Europe peasants sometimes became artisans, masons, even sculptors. But they were then employed to express the ideology of the Church, not, directly, their own view of the world. There is, however, one colossal work, which resembles no other and which is a direct expression of peasant experience. It is about this work – which includes poetry, sculpture, architecture – that I want now to talk.

A country postman, as my 27,000 comrades, I walked each day from Hauterives to Tersanne – in the region where there are still traces of the time when the sea was here – sometimes going through snow and ice, sometimes through flowers. What can a man do when

walking everlastingly through the same setting, except to dream? I built in my dreams a palace passing all imagination, everything that the genius of a simple man can conceive – with gardens, grottoes, towers, castles, museums, and statues: all so beautiful and graphic that the picture of it was to live in my mind for at least ten years . . .

When I had almost forgotten my dream, and it was the last thing I was thinking about, it was my foot which brought it all back to me. My foot caught on something which almost made me fall: I wanted to know what it was: it was a stone of such strange shape that I put it in my pocket to admire at leisure. The next day, passing through the same place, I found some more, which were even more beautiful. I arranged them together there and then on the spot and was amazed . . . I searched the ravines, the hillside, the most barren and desolate places . . . I found tufa which had been petrified by water and which is also wonderful . . .

This is where my trials and tribulations began. I then brought along some baskets. Apart from the 30 km a day as postman, I covered dozens with my basket on my back, full of stones. Each commune has its own particular type of very hard stone. As I crossed the countryside I used to make small piles of these stones: in the evenings, I returned with my wheelbarrow to fetch them. The nearest were four to five km away, sometimes ten. I sometimes set out at two or three in the morning.

The writer is Ferdinand Cheval, who was born in 1836 and died in 1924, and who spent thirty-three years building his 'palace passing all imagination'. It is still to be found in Hauterives, the village where he was born, in the Department of the Drôme, France.

> In the evening when night has fallen,
> And other men are resting.
> I work at my palace.
> No one will know my suffering.
> In the minutes of leisure
> Which my duty allows me
> I have built this palace of a thousand and one nights –
> I have carved my own monument

Today the Palace is crumbling, its sculptures disintegrating, and its texts, inscribed on or cut into the walls, are being slowly effaced. It is less than eighty years old. Most buildings and sculptures fare better, because they belong to a mainstream tradition which lays down principles for whom they should be made, and, afterwards, for how they should be preserved. This work is naked and without tradition because it is the work of a single 'mad' peasant.

Ferdinand Cheval, *Palais Ideal*, 1879–1912

There are now a number of books of photographs about the Palace, but the trouble with photographs – and even in film – is that the viewer stays in his chair. And the Palace is about the experience of being inside itself. You do not *look* at it any more than you look at a forest. You either enter it or you pass it by.

As Cheval has explained, the origin of its imagery was stones: stones which, shaped during geological times, appeared to him as caricatures. 'Strange sculptures of all kinds of animals and caricatures. Impossible for man to imitate. I said to myself: since nature wants to make sculpture, I will make the masonry and architecture for it.' As you look into these stones, they become creatures, mostly birds or animals. Some look at you. Some you only glimpse as they disappear

back into the stones from which they emerged briefly as profiles. The Palace is full of a life that is never entirely visible.

Except for a few exceptions which I will discuss later, there are no definitively exterior surfaces. Every surface refers, for its reality, inwards. The animals return to within the stones; when you are not looking, they re-emerge. Every appearance changes. Yet it would be wrong to think of the Palace as dream-like. This was the mistake of the Surrealists, who were the first to 'discover' it in the thirties. To psychologise it, to question Cheval's unconscious, is to think in terms which never explain its uniqueness.

<p style="text-align:center">☙</p>

Despite its title, its model is not a palace but a forest. Within it are contained many smaller palaces, châteaux, temples, houses, lairs, earths, nests, holes, etc. The full content or population of the Palace is impossible to establish. Each time you enter it, you see something more or different. Cheval ended up by doing far more than just making the masonry and architecture for the sculptures of nature. He began to make his own. But nature remained his model: not as a depository of fixed appearances, not as the source of all taxonomy, but as an example of continual metamorphosis. If I look immediately in front of me now, I see:

a pine tree
a calf, large enough for the pine tree to be its horn
a snake
a Roman vase
two washerwomen, the size of moles
an otter
a lighthouse
a snail
three friends nestling in coral
a leopard, larger than the lighthouse
a crow

Such a list would have to be multiplied several thousand times in order to make even a first approximate census. And as soon as you

realise that, you realise how foreign to the spirit of the work such an exercise would be. Its function is not to present but to surround.

Whether you climb up its towers, walk through its crypts, or look up at a façade from the ground, you are aware of having *entered* something. You find yourself in a system which includes the space you occupy. The system may change its own image, suggesting different metaphors at different times. I have already compared it with a forest. In parts it is like a stomach. In other parts it is like a brain – the physical organ in the skull, not the abstract *mind*.

What surrounds you has a physical reality. It is constructed of sandstone, tufa, quicklime, sand, shells, and fossils. At the same time, all this diverse material is unified and made mysteriously figurative. I do not now speak of the population of its images. I speak of the mineral material as a whole being arranged to represent a living organic system.

A kind of tissue connects everything. You can think of it as consisting of leaves, folds, follicles, or cells. All Cheval's sustained energy, all his faith, went into creating this. It is in this tissue that you feel the actual rhythm of his movements as he moulded the cement or placed his stones. It was in seeing this tissue grow beneath his hands that he was confirmed. It is this tissue which surrounds you like a womb.

I said the basic unit of this tissue suggested a kind of leaf or fold. Perhaps the closest I can get to defining it, or fully imagining it – inside the Palace or far away – is to think of the ideal leaf which Goethe writes about in his essay 'On the Metamorphosis of Plants'. From this archetypal leaf all plant forms derived.

In the Palace this basic unit implies a process of reproduction; not the reproduction of appearances: the reproduction of itself in growth.

Cheval left the Drôme once in his life: as a young man to work for a few months in Algeria. He gained his knowledge of the world via the new popular encyclopedic magazines which came on the market during the second quarter of the nineteenth century. This knowledge enabled him to aspire to a world, as distinct from a local and partial, view. (Today modern means of communication are having, in

different parts of the world, a comparable political effect. Peasants will eventually visualise themselves in global terms.)

Without a global aspiration, Cheval could never have sustained the necessary confidence to work alone for thirty-three years. In the Middle Ages the Church had offered a universal view, but its craftsmen mostly worked within the constraint of a prescribed iconography in which the peasant view had a place but was not formative. Cheval emerged, alone, to confront the modern world with his peasant vision intact. And according to this vision he built his Palace.

It was an incredibly improbable event, depending on so many contingencies. Of temperament. Of geography. Of social circumstance. The fact, for instance, that he was a postman and so had a small pension. If he had been a peasant working his own land, he could never have afforded the 93,000 hours spent on the Palace. Yet he remained organically and consciously a member of the class into which he was born. 'Son of a peasant, it is as a peasant that I wish to live and die in order to prove that in my class too there are men of energy and genius.'

The character of the Palace is determined by two essential qualities: physicality (it contains no abstract sentimental appeals, and Cheval's statements all emphasise the enormous physical labour of its construction) and innerness (its total emphasis on what is within and being within). Such a combination does not exist in modern urban experience but is profoundly typical of peasant experience.

The notion of the *visceral* may perhaps be used here as an example. A word of warning, however, is necessary. To think of peasant attitudes as being more 'gutsy' than urban ones is to miss the point and to resort to an ignorant cliché.

A stable door. Hanging from a nail, a young goat being skinned and eviscerated by a grandfather deploying the point of his pocket-knife with the greatest delicacy, as if it were a needle. Beside him the grandmother holding the intestines in her arms to make it easier for her husband to detach the stomach without perforating it. One yard in front, sitting on the ground, oblivious for a moment of his grandparents, a four-year-old grandson, playing with a cat and rubbing its nose against his own. The visceral is an everyday, familiar category from an early age to peasants.

By contrast, the urban horror of the visceral is encouraged by unfamiliarity, and is linked with urban attitudes to death and birth. Both have become secret, removed moments. In both it is impossible to deny the primacy of inner, invisible processes.

The ideal urban surface is a brilliant one (e.g., chrome) which reflects what is in front of it, and seems to deny that there is anything visible behind it. Its antithesis is the flank of a body rising and falling as it breathes. Urban experience concentrates on recognising what is outside for what it is, measuring it, testing it, and treating it. When what is inside has to be explained (I am not talking now in terms of molecular biology but in terms of everyday life), it is explained as a mechanism, yet the measures of the mechanics used always belong to the outside. The outside, the exterior, is celebrated by continuous visual reproduction (duplication) and justified by empiricism.

To the peasant the empirical is naive. He works with the never entirely predictable, the emergent. What is visible is usually a sign for him of the state of the invisible. He touches surfaces to form in his mind a better picture of what lies behind them. Above all, he is aware of following and modifying processes which are beyond him, or anybody, to start or stop: he is always aware of being within a process himself.

A factory line produces a series of identical products. But no two fields, no two sheep, no two trees are alike. (The catastrophes of the green revolution, when agricultural production is planned from above by city experts, are usually the result of ignoring specific local conditions, of defying the laws of natural heterogeneity.) The computer has become the storehouse, the 'memory' of modern urban information: in peasant cultures the equivalent storehouse is an oral tradition handed down through generations; yet the real difference between them is this: the computer supplies, very swiftly, the exact answer to a complex question; the oral tradition supplies an ambiguous answer – sometimes even in the form of a riddle – to a common practical question. Truth as a certainty. Truth as an uncertainty.

Peasants are thought of as being traditionalists when placed in historical time: but they are far more accustomed to living with change in cyclical time.

A closeness to what is unpredictable, invisible, uncontrollable, and cyclic predisposes the mind to a religious interpretation of the world. The peasant does not believe that Progress is pushing back the frontiers of the unknown, because he does not accept the strategic diagram implied by such a statement. In his experience the unknown is constant and central: knowledge surrounds it but will never eliminate it. It is not possible to generalise about the role of religion among peasants but one can say that it articulates another profound experience: their experience of production through work.

I have said that a few surfaces in Cheval's Palace do not refer inwards for their reality. These include the surfaces of some of the buildings he reproduces, like the White House in Washington, DC, the Maison Carrée in Algiers. The others are the surfaces of human faces. All of them are enigmatic. The human faces hide their secrets, and it is possible, as with nothing else in the Palace, that their secrets are unnatural. He has sculpted them with respect and suspicion.

Cheval himself called his Palace a temple to nature. Not a temple to the nature of travellers, landscapists, or even Jean-Jacques Rousseau, but to nature as dreamt by a genius expressing the vision of a class of cunning, hardened survivors.

In the centre of the Palace is a crypt, surrounded by sculpted animals – only towards his animals did Cheval show his capacity for tenderness. Between the animals are shells, stones with eyes hidden in them, and, linking everything, the tissue of the first leaf. On the ceiling of this crypt, in the form of a circle, Cheval wrote, 'Here I wanted to sleep.'

28.

Paul Cézanne
(1839–1906)

ANY EUROPEAN WHO lived during the twentieth century and was passionate about painting had to come to terms with the mystery, the achievement, the failure or the triumph of Paul Cézanne's life's work. He died six years after the century began, aged sixty-seven. He was a prophet, although like many prophets this was not what he set out to be.

At the Musée du Luxembourg in Paris, there is now a magnificent exhibition of seventy-five paintings from all periods of his life. This offers us the chance to look at him, in all his originality, yet again. To me, after a lifetime's companionship with him, the show was a revelation. I forgot about Impressionism, Cubism, twentieth-century art history, Modernism, Post-Modernism – and saw only the story of his love affair, his liaison, with the visible. And I saw it like a diagram, one of those diagrams you find in a booklet of instructions about how to use a new appliance or tool.

Let's begin with the black found in many of his earliest works, painted when he was in his twenties. It's a black like no other in painting. Its dominance is somewhat similar to the darkness in late Rembrandts, only this black is far more tangible. It's like the black of a box that contains everything that exists in the substantial world.

About ten years further into his career, Cézanne begins to take colours out of the black box: not primary colours, but complex, substantial colours, and he searches to find places for them in what he is looking at so hard: a roof or an apple for a red, a body for a skin colour, a particular area of sky between clouds for a blue. These colours he takes out are like woven fabric, except that, instead of being made from thread or cotton, they are made from the traces a paint-brush or palette knife leaves in oil paint.

Then, during the last twenty years of his life, Cézanne begins to apply those swabs of colour to the canvas, not where they correspond to the local colour of an object, but where they can indicate a path for our eyes through space, receding or oncoming. He leaves more and more patches of the white canvas untouched. These patches are not mute, though: they represent the emptiness, the hollow openness, from which the substantial emerges.

Cézanne's prophetic late works are about creations – the creation of the world or, if you wish, the universe. I'm tempted now to call the black box, which I see as his starting point, a black hole – yet to do so would be a verbal trick and, therefore, too easy. Whereas what Cézanne did was obstinate, persistent, difficult.

During his journey as a painter, I believe his state of mind changed eschatologically, his thinking becoming more apocalyptic. From the very beginning, the enigma of the substantial obsessed him. Why are things solid? Why is everything, including ourselves as human beings, made of stuff? In his very early work, he tended to re-duce the substantial to the corporeal: the hu-man body in which we are condemned to live. And he was acutely aware of what being flesh meant: our de-sires, our blind long-ings, and our aptitude for gratuitous violence. Hence his repeated

Paul Cézanne, *La Pendule Noire*, 1869–71

choice of subjects such as murder and temptation. It was perhaps better that the black box be kept shut.

Gradually, however, Cézanne began to expand the notion or sensation of corporeality, so that it could include things that we do not normally think of as having a body. This is particularly evident in his still lifes. The apples he painted have the autonomy of bodies. Each apple is self-possessed, each has been held in his hand and recognised as unique. His empty porcelain bowls are waiting to be filled. Their emptiness is expectant. His milk jug is incontestable.

In the third and final phase of Cézanne's life's work, according to my notional diagram, he pushed the notion of corporeality further still. A teenager, probably his son, lies on the grass by a river somewhere near Paris and is visibly touched by the air around him – in the same way as his Mont Sainte Victoire in Provence is touched by the sunlight and wind of a particular day's weather. Cézanne was discovering a complementarity between the equilibrium of the body and the inevitability of landscape. The indentations of some rocks in the forest of Fontainebleau have the intimacy of armpits. His late *baigneuses* form ranges like mountains. The deserted quarry at Bibémus looks like a portrait.

What is the secret behind this? Cézanne's conviction that what we perceive as the visible is not a given but a construction, put together by nature and ourselves. 'The landscape', he said, 'thinks itself in me, and I am its consciousness.' He also said: 'Colour is the place where our brain and the universe meet.'

This is how he unpacked his black box.

29.

Claude Monet
(1840–1926)

TOO MUCH HAS been made of Cézanne's famous remark that if Monet was only an eye, what an eye! More important now, perhaps, to acknowledge and question the sadness in Monet's eyes, a sadness which emerges from photograph after photograph.

Little attention has been paid to this sadness because there is no place for it in the usual art-historical version of the meaning of Impressionism. Monet was the leader of the Impressionists – the most consistent and the most intransigent – and Impressionism was the beginning of Modernism, a kind of triumphal arch through which European art passed to enter the twentieth century.

There is some truth in this version. Impressionism *did* mark a break with the previous history of European painting and a great deal of what followed – Post-Impressionism, Expressionism, Abstraction – can be thought of as being partly engendered by this first modern movement. It is equally true that today, after half a century, Monet's later works – and particularly the water lilies – appear now to have prefigured the work of artists such as Pollock, Tobey, Sam Francis, Rothko.

It is possible to argue, as Malevich did, that the twenty paintings which Monet made in the early 1890s of the façade of Rouen

Cathedral, as seen at different times of day and under different weather conditions, were the final systematic proof that the history of painting would never be the same again. This history had henceforward to admit that every appearance could be thought of as a mutation and that visibility itself should be considered flux.

Furthermore, if one thinks of the claustrophobia of mid-nineteenth-century bourgeois culture, it is impossible not to see how Impressionism appeared as a liberation. To paint out of doors in front of the motif; to observe directly; to accord to light its proper hegemony in the domain of the visible; to relativise all colours (so that everything sparkles); to abandon the painting of dusty legends and all direct ideology; to speak of everyday appearances within the experience of a wide urban public (a day off, a trip to the country, boats, smiling women in sunlight, flags, trees in flower – the Impressionist vocabulary of images is that of a popular dream, the awaited, beloved, secular Sunday); the innocence of Impressionism – innocence in the sense that it did away with the secrets of painting, everything was there in the full light of day, there was nothing more to hide, and amateur painting followed easily – how could all this not be thought of as a liberation?

Why can't we forget the sadness in Monet's eyes, or simply acknowledge it as something personal to him, the result of his early

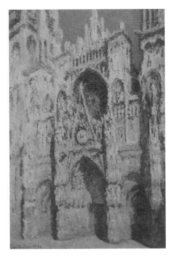

Claude Monet, *Cathédrale de Rouen*, 1892–93

poverty, the death of his first wife when so young, his failing eyesight when old? And in any case, are we not running the risk of explaining the history of Egypt as the consequence of Cleopatra's smile? Let us run the risk.

Twenty years before painting the façade of Rouen Cathedral, Monet painted (he was thirty-two years old) *Impression Soleil Levant*, and from this the critic Castagnary coined the term 'Impressionist'. The painting is a view of the port of Le Havre, where Monet was brought up as a child. In the foreground is the tiny silhouette of a man standing and rowing with another figure in a dinghy. Across the water, masts and derricks are dimly visible in the morning twilight. Above, but low in the sky, is a small orange sun, and below, its inflamed reflection in the water. It is not an image of dawn (Aurora), but of a day slipping in, as yesterday slipped out. The mood is reminiscent of Baudelaire's 'Le Crépuscule de Matin', in which the coming day is compared to the sobbing of somebody who has just been woken.

Yet what is it that exactly constitutes the melancholy of this painting? Why, for example, don't comparable scenes, as painted by Turner, evoke a similar mood? The answer is the painting method, precisely that practice which was to be called Impressionist. The transparency of the thin pigment representing the water – the thread of the canvas showing through it, the swift broken-straw-like brushstrokes suggesting ripples of spars, the scrubbed-in areas of shadow, the reflections staining the water, the optical truthfulness and the *objective* vagueness, all this renders the scene makeshift, threadbare, decrepit. It is an image of homelessness. Its very insubstantiality makes shelter in it impossible. Looking at it, the idea occurs to you of a man trying to find his road home through a theatre décor. Baudelaire's lines in 'La Cygne', published in 1860, belong to the slow intake of breath before the accuracy and the refusal of this scene.

> . . . La forme d'une ville
> Change plus vite, hélas, que le coeur d'un mortel.

If Impressionism was about 'impressions', what change did this imply in the relation between seen and seer? (Seer here meaning

both painter and viewer.) You do not have an *impression* of a scene with which you feel yourself to be long-standingly familiar. An impression is more or less fleeting; it is what is *left behind* because the scene has disappeared or changed. Knowledge can coexist with the known; an impression, by contrast, survives alone. However intensely and empirically observed at the moment, an impression later becomes, like a memory, impossible to verify. (Throughout his life Monet complained, in letter after letter, about not being able to complete a painting already begun, because the weather and therefore the subject, the motif, had irredeemably changed.) The new relation between scene and seer was such that now the scene was more fugitive, more chimerical than the seer. And there we find ourselves returned to the same lines by Baudelaire: 'La forme d'une ville . . .'

Suppose we examine the experience offered by a more typical Impressionist painting. In the spring of the same year as *Le Soleil Levant* (1872) Monet painted two pictures of a lilac tree in his garden at Argenteuil. One shows the tree on a cloudy day and the other on a sunny day. Lying on the lawn beneath the tree in both pictures are three barely distinguishable figures. (They are thought to be Camille, Monet's first wife, Sisley, and Sisley's wife.)

In the overcast picture these figures resemble moths in the lilac shade; in the second, dappled with sunlight, they become almost as invisible as lizards. (What betrays their presence is in fact the viewer's past experience; somehow the viewer distinguishes the mark of a profile with a tiny ear from the other almost identical marks which are only leaves.)

In the overcast picture the flowers of the lilac glow like mauve copper; in the second picture the whole scene is alight, like a newly lit fire: both are animated by a different kind of light energy, there is apparently no longer a trace of decrepitude, everything radiates. Purely optically? Monet would have nodded his head. He was a man of few words. Yet it goes much further.

Before the painted lilac tree you experience something unlike anything felt in front of any earlier painting. The difference is not a question of new optical elements, but of a new relation between what you are seeing and what you have seen. Every spectator can recognise

258

this after a moment's introspection; all that may differ is the personal choice of which paintings reveal the new relation most vividly. There are hundreds of Impressionist paintings, painted during the 1870s, to choose from.

The painted lilac tree is both more precise and more vague than any painting you have seen before. Everything has been more or less sacrificed to the optical precision of its colours and tones. Space, measurement, action (history), identity, all are submerged within the play of light. One must remember here that *painted* light, unlike the real thing, is *not* transparent. The painted light covers, buries, the painted objects, a little like snow covering a landscape. (And the attraction of snow to Monet, the attraction of things being lost without a loss of first-degree reality, probably corresponded to a deep psychological need.) So the new energy *is* optical? Monet was right to nod his head? The painted light dominates everything? No, because all this ignores how the painting actually works on the viewer.

Given the precision and the vagueness, you are forced to re-see the lilacs of your own experience. The precision triggers your visual memory, while the vagueness welcomes and accommodates your memory when it comes. More than that, the uncovered memory of your sense of sight is so acutely evoked that other appropriate memories of other senses – scent, warmth, dampness, the texture of a dress, the length of an afternoon – are also extracted from the past. (One cannot help but think again of Baudelaire's *Correspondances*.) You fall through a kind of whirlpool of sense memories towards an ever receding moment of pleasure, which is a moment of total re-cognition.

The intensity of this experience can be hallucinating. The fall into and towards the past, with its mounting excitement, which, at the same time, is the mirror-opposite of expectation, for it is a return, a withdrawal, has something about it which is comparable with an orgasm. Finally everything is simultaneous with and indivisible from the mauve fire of the lilac.

And all this follows – surprisingly – from Monet's affirmation, with slightly different words on several occasions, that 'the motif is for me altogether secondary; what I want to represent is what exists

between the motif and me' (1895). What *he* had in mind were colours; what is bound to come into the viewer's mind are memories. If, in a generalised way, Impressionism lends itself to nostalgia (obviously in particular cases the intensity of the memories precludes nostalgia) it is not because we are living a century later, but simply because of the way the paintings always demanded to be read.

What then has changed? Previously the viewer entered into a painting. The frame or its edges were a threshold. A painting created its own time and space which were like an alcove to the world, and their experience, made clearer than it usually is in life, endured changeless and could be visited. This had little to do with the use of any systematic perspective. It is equally true, say, of a Sung Chinese landscape. It is more a question of permanence than space. Even when the scene depicted was momentary – for example, Caravaggio's *Crucifixion of St Peter* – the momentariness is held within a continuity: the arduous pulling up of the cross constitutes part of the permanent assembly point of the painting. Viewers passed one another in Piero della Francesca's *Tent of Solomon* or on Grünewald's *Golgotha* or in the bedroom of Rembrandt. But not in Monet's *Gare de St Lazare*.

Impressionism closed that time and that space. What an Impressionist painting shows is painted in such a way that *you are compelled to recognise that it is no longer there*. It is here and here only that Impressionism is close to photography. You cannot enter an Impressionist painting; instead it extracts your memories. In a sense it is more active than you – the passive viewer is being born; what you receive is taken from what happens *between* you and it. No more within it. The memories extracted are often pleasurable – sunlight, river banks, poppy fields – yet they are also anguished, because each viewer remains alone. The viewers are as separate as the brushstrokes. There is no longer a common meeting place.

Let us now return to the sadness in Monet's eyes. Monet believed that his art was forward-looking and based on a scientific study of nature. Or at least this is what he began by believing and never renounced. The degree of sublimation involved in such a belief is

poignantly demonstrated by the story of the painting he made of Camille on her death bed. She died in 1879, aged thirty-two. Many years later Monet confessed to his friend Clemenceau that his need to analyse colours was both the joy and torment of his life. To the point where, he went on to say, I one day found myself looking at my beloved wife's dead face and just systematically noting the colours, according to an automatic reflex!

Without doubt the confession was sincere, yet the evidence of the painting is quite otherwise. A blizzard of white, grey, purplish paint blows across the pillows of the bed, a terrible blizzard of loss which will for ever efface her features. In fact there can be very few death-bed paintings which have been so intensely felt or subjectively expressive.

And yet to this – the consequence of his own act of painting – Monet was apparently blind. The positivistic and scientific claims he made for his art never accorded with its true nature. The same was equally true of his friend Zola. Zola believed that his novels were as objective as laboratory reports. Their real power (as is so evident in *Germinal*) comes from deep – and dark – unconscious feeling. At this period the mantle of progressive positivist enquiry sometimes hid the very same premonition of loss, the same fears, of which, earlier, Baudelaire had been the prophet.

And this explains why *memory* is the unacknowledged axis of all Monet's work. His famous love of the sea (in which he wanted to be buried when he died), of rivers, of water, was perhaps a symbolic way of speaking of tides, sources, recurrence.

In 1896 he returned to paint again one of the cliffs near Dieppe which he had painted on several occasions fourteen years earlier (*Falaise à Vavengeville, Gorge du Petit-Ailly*). The painting, like many of his works of the same period, is heavily worked, encrusted, and with the minimum of tonal contrast. It reminds you of thick honey. Its concern is no longer the instantaneous scene, as revealed in the light, but rather the slower dissolution of the scene by the light, a development which led towards a more decorative art. Or at least this is the usual 'explanation' based on Monet's own premises.

It seems to me that this painting is about something quite different. Monet worked on it, day after day, believing that he was

interpreting the effect of sunlight as it dissolved every detail of grass and shrub into a cloth of honey hung by the sea. But he wasn't, and the painting has really very little to do with sunlight. What he himself was dissolving into the honey cloth were all his previous memories of that cliff, so that it should absorb and contain them all. It is this almost desperate wish to save *all* which makes it such an amorphous, flat (and yet, if one recognises it for what it is, touching) image.

And something very similar is happening in Monet's paintings of the water lilies in his garden during the last period of his life (1900–26) at Giverny. In these paintings, endlessly reworked in face of the optically impossible task of combining flowers, reflections, sunlight, underwater reeds, refractions, ripples, surface, depths, the real aim was neither decorative nor optical; it was to preserve everything essential about the garden, which he had made, and which now as an old man he loved more than anything else in the world. The painted lily pond was to be a pond that remembered all.

And here is the crux of the contradiction which Monet as a painter lived. Impressionism closed the time and space in which previously painting had been able to preserve experience. And, as a result of this closure, which of course paralleled and was finally determined by other developments in late-nineteenth-century society, both painter and viewer found themselves more alone than ever before, more ridden by the anxiety that their own experience was ephemeral and meaningless. Not even all the charm and beauty of the Île de France, a Sunday dream of paradise, was a consolation for this.

Only Cézanne understood what was happening. Single-handed, impatient, but sustained by a faith that none of the other Impressionists had, he set himself the monumental task of creating a new form of time and space within the painting, so that finally experience might again be shared.

ର

THERE ARE DOUBTLESS many ways of taking in the marvellously arranged exhibition of Claude Monet currently at the Grand Palais in Paris. The visitor can follow it like walking along a country path, along

262

coastlines and through forests, a path that eventually leads to Giverny, where the painter created his beloved garden and tried, again and again in his old age, to paint his famous Nymphéas. The nature this path leads us through is very recognisably French – as is the term 'Impressionism' – a nature that entices you to fall in love with the France of a hundred years ago.

Alternatively, a visitor can select a single canvas – say, *Petit Ailly, Varengeville, Plein Soleil* (1897). Monet painted this clifftop, the wildly overgrown gully running down to the sea, and the so-called Fisherman's House several times. For him the subject was inexhaustible. Standing before the painting, you can let your eye lose itself, as it follows the 'commas' of touch after touch of oil paint. These countless touches then interweave to make not a cloth but a basket of sunlight, containing every imaginable summer sound of the Normandy coast, until this basket becomes your own afternoon.

Or, again, you can take the opportunity offered by the exhibition to try, eighty-four years after his death, to rethink Monet. Not for the sake of engaging in academic art-historical arguments but in the hope of defining more clearly what his art achieved and how it works on us.

Monet is traditionally thought of as the master, the monument, of the Impressionists, who were inspired by new subjects they discovered out of doors in the natural light brought on by the time of day and the weather. Their aim was to seize a vision of passing moments, often happy moments. Light and colour took precedence over form and narrative, and their art was based on the closest observation of ever-changing atmospheric effects. They both celebrated and contested the ephemeral. All this in a cultural climate in which Positivism and Pragmatism counted for a lot.

Monet painted the façade of Rouen Cathedral thirty times, each canvas seizing a different and new transformation as the light changed. He painted the same two haystacks in a field twenty times. Sometimes he was satisfied, often he was frustrated. Nevertheless he continued, searching for something more, determined to be more faithful, but to what? To the passing moment?

Like many innovative artists, Monet, I believe, was unclear about what he had achieved. Or, to be more precise, he could not name

his achievement. He could only recognise it intuitively, and then doubt it.

For rethinking Monet, a key painting is *Camille Monet sur Son Lit de Mort* (1879). We see her head against the pillows, a head scarf around her face, her mouth and eyes neither shut nor open, her shoulders limp. The colours are those of shadows and of fading sunlight on a hillock (the pillows) on which snow is falling. The lancing brushstrokes are diagonal. We are watching Camille's immobile face through a blizzard of loss. Most death-bed paintings make one think of undertakers. Not this one, which is about the act of leaving, about going elsewhere. And it is one of the great images of mourning.

Ten years before Camille's early death Monet had painted a corner of a field under snow where, distantly, on a small gate, a magpie is perched. He called the painting *La Pie*. Our eyes are drawn towards this little black-and-white bird because he's the focal point of the composition, and also because we know that at any moment he will fly off. He's on the point of leaving. He's about to go elsewhere.

A year after Camille's death, Monet painted a series of canvases about the breaking up of thick ice on the Seine. It was a subject he had tackled before. He called it *La Débâcle*. He was fascinated by the disintegration and, above all, the dislocation of the ice, which, before the thaw, had been fixed, solid, regular. And now, irregular, was carried downstream by the current.

Some of the broken, whitish rectangles of this ice make me think of unpainted floating canvases. Did the same thought cross his mind? We'll never know.

All his paintings are about flow. But is it, as the Impressionists' doctrine assumed, the flow of time? I don't think so.

A long while after painting Camille on her death bed, Monet confessed to his friend Georges Clemenceau about the pain or shock he felt when he suddenly realised, while painting it, that he was studying her pallid face and noting the tiny variations of tone and colour brought about by death, as if they were an observable every-day matter! He ended by saying: '*Ainsi de la bête qui tourne sa meule.*

264

Plaignez-moi, mon ami.' (Like the beast who turns his millstone. Pity me, my friend.)

He complains because when he puts his brushes down, he can't explain what he was doing, or where his brush marks were leading him.

Monet once revealed that he wanted to paint not things in themselves but the air that touched things – the enveloping air. The enveloping air offers continuity and infinite extension. If Monet can paint the air, he can follow it like following a thought. Except that the air operates wordlessly and, when painted, is visibly present only in colours, touches, layers, palimpsests, shades, caresses, scratches. As he approaches this air, it takes him, along with his original subject, elsewhere. The flow is no longer temporal but substantial and extensive.

The air takes him and the original subject where then? To other things it has enveloped or will envelop but for which we have no fixed name. (To call them abstract is only to give them the name of our ignorance.)

Monet often referred to an instantaneity he was trying to seize. The air, because it is part of an indivisible substance that is infinitely extensive, transforms this instantaneity into an eternity.

The paintings of the façade of the cathedral in Rouen cease to be records of fugitive effects and become replies to correspondences with other things belonging to the infinitely extensive. And in this way the envelope of air that was touching the cathedral is permeated both by the painter's painstaking perception of the cathedral and by a confirmation of those perceptions received from places without an address.

The paintings of the haystacks respond to the energy of summer heat, to the four stomachs of a cow when chewing the cud, to reflections in water, to rocks in the sea, to bread, to flecks of hair, to the pores of a living skin, to hives, to brains . . .

In rethinking Monet I want to suggest that visitors to the exhibition see the canvases there not as records of the local and ephemeral but as vistas onto what is universal and eternal. The elsewhere, which is their obsession, is extensive rather than temporal, metaphoric rather than nostalgic.

One of Monet's favourite flowers was the iris. No other flower demands so forcefully to be painted. This has something to do with the way they open their petals, already perfectly printed. Irises are like prophecies, simultaneously astounding and calm. Maybe that's why he loved them.

30.

Vincent van Gogh
(1853–90)

FOR AN ANIMAL its natural environment and habitat are a given; for man, despite the faith of the empiricists, reality is not a given: it has to be continually sought out, held – I am tempted to say *salvaged*. One is taught to oppose the real to the imaginary, as though the first were always at hand and the second distant, far away. This opposition is false. Events are always to hand. But the coherence of these events – which is what one means by reality – is an imaginative construction. Reality always lies beyond – and this is as true for materialists as for idealists. For Plato, for Marx. Reality, however one interprets it, lies beyond a screen of clichés. Every culture produces such a screen, partly to facilitate its own practices (to establish habits) and partly to consolidate its own power. Reality is inimical to those with power.

All modern artists have thought of their innovations as offering a closer approach to reality, as a way of making reality more evident. It is here, and only here, that the modern artist and revolutionary have sometimes found themselves side by side, both inspired by the idea of pulling down the screen of clichés, clichés which have increasingly become unprecedentedly trivial and egotistical.

Yet many such artists have reduced what they found beyond the screen, to suit their own talent and social position as artists. When this

has happened they have justified themselves with one of the dozen variants of the theory of art for art's sake. They say: Reality is art. They hope to extract an artistic profit from reality. Of no one is this less true than Van Gogh.

One knows from his letters how intensely he was aware of the screen. His whole life story is one of an endless yearning for reality. Colours, the Mediterranean climate, the sun, were for him vehicles going towards this reality; they were never objects of longing in themselves. This yearning was intensified by the crises he suffered when he felt that he was failing to salvage any reality at all. Whether these crises are today diagnosed as being schizophrenic or epileptic changes nothing; their content, as distinct from their pathology, was a vision of reality consuming itself like a phoenix.

One also knows from his letters that nothing appeared more sacred to Van Gogh than work. He saw the physical reality of labour as being, simultaneously, a necessity, an injustice, and the essence of humanity throughout history. The artist's creative act was for him only one among many such acts. He believed that reality could best be approached through work, precisely because reality itself was a form of production.

His paintings speak of this more clearly than do words. Their so-called clumsiness, the gestures with which he drew with pigment upon the canvas, the gestures (invisible today but imaginable) with which he chose and mixed his colours on the palette, all the gestures with which he handled and manufactured the stuff of the painted image, are analogous to the *activity* of the existence of what he is painting. His paintings imitate the active existence – the labour of being – of what they depict.

A chair, a bed, a pair of boots. His act of painting them was far nearer than that of any other painter to the carpenter's or the shoemaker's act of making them. He brings together the elements of the product – legs, crossbars, back, seat – sole, uppers, tongue, heel – as though he too were fitting them together, *joining* them, and as if this *being joined* constituted their reality.

Before a landscape this same process was far more complicated and mysterious, yet it followed the same principle. If one imagines God creating the world from earth and water, from clay, his way of handling

it to make a tree or a cornfield might well resemble the way that Van Gogh handled paint when he painted a tree or cornfield. He was human, there was nothing divine about him. If, however, one thinks of the creation of the world, one can imagine the act only through the visual evidence, here and now, of the energy of the forces in play. And to these energies, Van Gogh was terribly attuned.

When he painted a small pear tree in flower, the act of the sap rising, of the bud forming, the bud breaking, the flower opening, the styles thrusting out, the stigmas become sticky, these acts were all present for him in the act of painting. When he painted a road, the roadmakers were there in his imagination. When he painted the turned earth of a ploughed field, the gesture of the blade turning the earth was included in his own act. Wherever he looked he saw the labour of existence; and this labour, recognised as such, was what constituted reality for him.

When he painted his own face, he painted the production of his destiny, past and future, rather as palmists believe they can read such a production in the lines of the hand. His contemporaries, who considered him abnormal, were not all as stupid as is now assumed. He painted compulsively – no other painter was ever compelled in a comparable way.

And his compulsion? It was to bring the two acts of production – that of the canvas and that of the reality depicted – ever closer and closer. This compulsion derived not from an idea about art – this is why it never occurred to him to profit from reality – but from an overwhelming feeling of empathy. 'I admire the bull, the eagle, and man with such an intense adoration, that it will certainly prevent me from ever becoming an ambitious person.'

He was compelled to go ever closer, to approach and approach and approach. In *extremis* he approaches so close that the stars in the night sky became maelstroms of light, the cypress trees ganglions of living wood responding to the energy of wind and sun. There are canvases where reality dissolves him, the painter. But in hundreds of others he takes the spectator as close as any man can, while remaining intact, to that permanent process by which reality is being produced.

Once, long ago, paintings were compared with mirrors. Van Gogh's might be compared with lasers. They do not wait to receive, they go

out to meet, and what they traverse is not so much empty space as the act of production, the production of the world. Painting after painting is a way of saying, with awe but little comfort: Dare to come this close and see how it works.

<p style="text-align:center">ନ</p>

IS IT STILL POSSIBLE to write more words about him? I think of those already written, mine included, and the answer is 'No'. If I look at his paintings, the answer is again – for a different reason – 'No'; the canvases command silence. I almost said *plead for*, and that would have been false, for there is nothing pathetic about a single image he made – not even the old man with his head in his hands at the gates of eternity. All his life he hated blackmail and pathos.

Only when I look at his drawings does it seem worthwhile to add to the words. Maybe because his drawings resemble a kind of writing, and he often drew on his own letters. The ideal project would be to *draw* the process of his drawing, to borrow his drawing hand. Nevertheless I will try with words.

Vincent van Gogh, *Olive-Trees, Montmajour*, 1888

In front of a drawing, drawn in July 1888, of a landscape around the ruined abbey of Montmajour near Arles, I think I see the answer to the obvious question: Why did this man become the most popular painter in the world?

The myth, the films, the prices, the so-called martyrdom, the bright colours, have all played their part and amplified the global appeal of his work, but they are not at its origin. He is loved, I said to myself in front of the drawing of olive trees, because for him the act of drawing or painting was a way of discovering and demonstrating why *he* loved so intensely what he was looking at, and what he looked at during the eight years of his life as a painter (yes, only eight) belonged to everyday life.

I can think of no other European painter whose work expresses such a stripped respect for everyday things without elevating them, in some way, without referring to salvation by way of an ideal which the things embody or serve. Chardin, de la Tour, Courbet, Monet, de Staël, Miro, Jasper Johns – to name but a few – were all magisterially sustained by pictorial ideologies, whereas he, as soon as he abandoned his first vocation as a preacher, abandoned all ideology. He became strictly existential, ideologically naked. The chair is a chair, not a throne. The boots have been worn by walking. The sunflowers are plants, not constellations. The postman delivers letters. The irises will die. And from this nakedness of his, which his contemporaries saw as naivety or madness, came his capacity to love, suddenly and at any moment, what he saw in front of him. Picking up pen or brush, he then strove to realise, to *achieve* that love. Lover-painter affirming the toughness of an everyday tenderness we all dream of in our better moments and instantly recognise when it is framed . . .

Words, words. How is it visible in his practice? Return to the drawing. It's in ink, drawn with a reed-pen. He made many such drawings in a single day. Sometimes, like this one, direct from nature, sometimes from one of his own paintings, which he had hung on the wall of his room whilst the paint was drying.

Drawings like these were not so much preparatory studies as graphic hopes; they showed in a simpler way – without the complication of handling pigment – where the act of painting could hopefully lead him. They were maps of his love.

What do we see? Thyme, other shrubs, limestone rocks, olive trees on a hillside, in the distance a plain, in the sky birds. He dips the pen into brown ink, watches, and marks the paper. The gestures come from his hand, his wrist, arm, shoulder, perhaps even the muscles in his neck, yet the strokes he makes on the paper are following currents of energy which are not physically his and *which become visible only when he draws them*. Currents of energy? The energy of a tree's growth, of a plant's search for light, of a branch's need for accommodation with its neighbouring branches, of the roots of thistles and shrubs, of the weight of rocks lodged on a slope, of the sunlight, of the attraction of the shade for whatever is alive and suffers from the heat, of the Mistral from the north which has fashioned the rock strata. My list is arbitrary; what is not arbitrary is the pattern his strokes make on the paper. The pattern is like a fingerprint. Whose?

It is a drawing which values precision – every stroke is explicit and unambiguous – yet it has totally forgotten itself in its openness to what it has met. And the meeting is so close you can't tell whose trace is whose. A map of love indeed.

Two years later, three months before his death, he painted a small canvas of two peasants digging the earth. He did it from memory because it refers back to the peasants he painted five years earlier in Holland and to the many homages he paid throughout his life to Millet. It is also, however, a painting whose theme is the kind of fusion we find in the drawing.

The two men digging are painted in the same colours – potato brown, spade grey, and the faded blue of French work clothes – as the field, the sky, and the distant hills. The brushstrokes describing their limbs are identical to those which follow the dips and mounds of the field. The two men's raised elbows become two more crests, two more hillocks, against the horizon.

The painting is not of course declaring these men to be 'clods of earth', the term used by many citizens at that epoch to insult peasants. The fusion of the figures with the ground refers fiercely to the recipro-cal exchange of energy that constitutes agriculture, and which explains, in the long term, why agricultural production cannot be submitted to purely economic law. It may also refer – by way of his own love and respect for peasants – to his own practice as a painter.

During his whole short life he had to live and gamble with the risk of self-loss. The wager is visible in all the self-portraits. He looks at himself as a stranger, or as something he has stumbled upon. His portraits of others are more personal, their focus more close-up. When things went too far, and he lost himself utterly, the consequences, as the legend reminds us, were catastrophic. And this is evident too in the paintings and drawings he made at such moments. Fusion became fission. Everything crossed everything else out.

When he won his wager – which was most of the time – the lack of contours around his identity allowed him to be extraordinarily open, allowed him to become permeated by what he was looking at. Or is that wrong? Maybe the lack of contours allowed him to lend himself, to leave and enter and permeate the other. Perhaps both processes occurred – once again as in love.

Words. Words. Return to the drawing by the olive trees. The ruined abbey is, I think, behind us. It is a sinister place – or would be if it were not in ruins. The sun, the Mistral, lizards, cicadas, the occasional hoopoe bird, are still cleaning its walls (it was dismantled during the French Revolution), still obliterating the trivia of its one-time power and insisting upon the immediate.

As he sits with his back to the monastery looking at the trees, the olive grove seems to close the gap and to press itself against him. He recognises the sensation – he has often experienced it, indoors, outdoors, in the Borinage, in Paris, or here in Provence. To this pressing – which was perhaps the only sustained intimate love he knew in his lifetime – he responds with incredible speed and

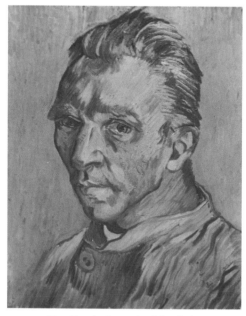

Van Gogh, *Portrait of the Artist Without His Beard*, 1889

273

the utmost attention. Everything his eye sees, he fingers. And the light falls on the touches on the vellum paper just as it falls on the pebbles at his feet – on one of which (on the paper) he will write 'Vincent'.

Within the drawing today there seems to be what I have to call a gratitude, which is hard to name. Is it the place's, his, or ours?

31.

Käthe Kollwitz
(1867–1945)

THE CENTRE OF the city of Dresden was still razed to the ground when I first met Erhard Frommhold there in the early 1950s. The Allied bombing of the city on 13 February 1945 had killed in a single night 100,000 civilians; most of them burnt to death in temperatures that reached 1800° Fahrenheit. In the 1950s Frommhold was working as an editor in the VEB Verlag der Kunst.

He was my first publisher. He published a book about the Italian painter Renato Guttuso, several years before any book of mine was published in Britain. Thanks to him I discovered that, despite my doubts, I was capable of finishing a book.

Erhard was lithe and had the physical presence of an athlete or football player. Perhaps more accurately the latter, for he came from a working-class family. His energy was striking, concentrated, and reticent – somewhat like the pulse at the pit of his neck.

Both his lean energy and the devastation of the city testified, at that time, to the force of history. It was history then, not brand-names, that began with a capital letter. What History signified or promised, however, was open to various interpretations. Was it better or not to let some of the sleeping dogs lie?

Erhard was two years younger than I, but I thought of him in

Dresden as being several years my senior. He was more experienced, he had lived more History. He was a kind of elected elder brother. Today, when the principles of Fraternity and Equality have been declared obsolete by every Bad Government in the world, this may sound sentimental, but it wasn't.

We were not intimate as natural brothers sometimes are. What was fraternal between us was a certain trust: an existential trust which ultimately derived from a marxist reading of history. Reading or perspective? I would say perspective, for what was essential was another sense of time, which could accommodate both the long term (centuries) and the urgent (half-past two tomorrow afternoon).

We seldom talked in detail about politics – in part because we didn't have a fluent common language, but also because both of us were covertly nonconformist and opposed to simplifications. Both of us listened hard to Bertolt Brecht, who was our elected uncle.

One of Brecht's *Herr K* stories is about Socrates. Socrates is listening to some Sophist philosophers endlessly pontificating, and so finally he steps forward and states: All I know is that I know nothing! This sentence is greeted with deafening applause. And Herr K wonders whether Socrates had something to add, or whether the applause had rendered what followed inaudible for the next two thousand years!

When we heard this, we smiled and glanced at one another. And somewhere behind our agreement was the tacit recognition that any original political initiative has to start off as being clandestine, not through a love of secrecy, but because of the innate paranoia of the politically powerful.

Everyone in the DDR was aware of history, its bequests, its indifference, its contradictions. Some resented it, some tried to use it to their own advantage, most concentrated on surviving beside it, and a few – a very few – tried to live with dignity whilst facing it night and day. And Erhard was among those few. This is why he was an example for me, a hero, who had a deep effect on what I wanted to try to become.

His example wasn't an intellectual but an ethical one. It was given to me by my observing and trying to respond to his daily behaviour, the precise way he encountered events and people.

Can I define it? I never formulated it for myself; it was an almost wordless example, like the quality of a particular silence.

He gave me a touchstone for distinguishing between the false and the genuine, between – in Spinoza's terms – the inadequate and the adequate.

Touchstones, however, indicate by way of a mineral reaction, not through a discursive debate. The original touchstone was a flint reacting to silver and gold.

Writing this, I think of the etching by Käthe Kollwitz entitled *Working-Class Woman (with Earring) 1910*.

Erhard and I both admired Kollwitz. Just as History was indifferent, she was caring. Yet her horizon was no narrower. Hence the pain she shared.

Erhard looked unflinchingly at History. He measured the catastrophes of the past and their scale, and accordingly he chose proposals for a future of greater justice and more compassion, whilst never forgetting that the pursuit of those proposals was likely to involve threats, accusations, and ceaseless struggle, for History, even when recognised, is eternally recalcitrant.

In the '70s, Erhard was sacked from the Verlag der Kunst, of which he was by then director, and was accused, on account of several of the books he had edited, of formalism, bourgeois decadence, and factionalism. Fortunately he was not jailed. He was simply condemned to performing socially useful work: as a gardener's assistant in a public park.

Look again at the etching by Kollwitz. The earring is a small but proud declaration of hope, yet it is totally outshone by the light of the face, which is inseparable from its nobility. Meanwhile the face has been drawn with black lines from the surrounding blackness. And this perhaps is why she chose to wear earrings!

Erhard's example offered a small, undemonstrative, persistent hope. It embodied endurance. An endurance that was not passive but active, an endurance that was the result of the taking on of History, an endurance that guaranteed a continuity despite History's recalcitrance.

A sense of belonging to what-has-been and to the yet-to-come is what distinguishes man from other animals. Yet to face History is to

face the tragic. Which is why many prefer to look away. To decide to engage oneself in History requires, even when the decision is a desperate one, hope. An earring of hope.

> All actions which follow from the emotions which are related to the mind, insofar as it understands, I refer to fortitude, which I distinguish into courage and generosity. For I understand by courage the desire by which each endeavours to preserve what is his own according to the dictate of reason alone. But by generosity I understand the desire by which each endeavours according to the dictate of reason alone to help and join to himself in friendship all other men. And so I refer those actions which aim at the advantage of the agent alone to courage, and those which aim at the advantage of others to generosity. Therefore temperance, sobriety, and presence of mind in danger, etc., are species of courage; but modesty, clemency, etc., are species of generosity. And thus I think I have explained and shown through their primary causes the principal emotions and waverings of the mind which arise from the composition of the three primary emotions, namely, pleasure, pain, and desire. And it is apparent from these propositions that we are driven about by external causes in many manners, and that we, like waves of the sea driven by contrary winds, waver, unaware of the issue and of our fate.
>
> (*Ethics*, Part III, Proposition LIX, Note)

> By body (*corpus*) I understand a mode which expresses in a certain and determinate manner the essence of God, insofar as he is considered as an extended thing.
>
> (*Ethics*, Part II, Definition I)

32.

Henri Matisse
(1869–1954)

MATISSE'S GREATNESS HAS been recognised but not altogether under-stood. In an ideological climate of anguish and nostalgia, an artist who frankly and supremely celebrated Pleasure, and whose works are an assurance that the best things in life are immediate and free, is likely to be thought not quite serious enough. And indeed, in Matisse's obit-uaries the word 'charming' appeared too frequently. 'I want people who feel worried, exhausted, overworked, to get a feeling of repose when looking at my painting.' That was Matisse's intention. And now, looking back over his long life's work, one can see that it represents a steady development towards his declared aim, his works of the last fifteen or twenty years coming nearest to his ideal.

Matisse's achievement rests on his use – or in the context of contem-porary Western art one could say his invention – of pure colour. The phrase, however, must be defined. Pure colour as Matisse understood it had nothing to do with abstract colour. He repeatedly declared that colour 'must serve expression'. What he wanted to express was 'the nearly religious feeling' he had towards sensuous life – towards the blessings of sunlight, flowers, women, fruit, sleep.

When colour is incorporated into a regular pattern – as in a Persian rug – it is a subsidiary element: the logic of the pattern must come first.

When colour is used in painting it usually serves either as a decorative embellishment of the forms – as, say, in Botticelli – or as a force charging them with extra emotion – as in Van Gogh. In Matisse's later works colour becomes the entirely dominant factor. His colours seem neither to embellish nor charge the forms, but to uplift and carry them on the very surface of the canvas. His reds, blacks, golds, ceruleans flow over the canvas with the strength and yet utter placidity of water above a weir, the forms carried along on their current.

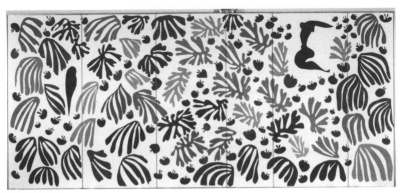

Henri Matisse, *The Parakeet and the Mermaid*, 1952

Obviously such a process implies some distortion. But the distortion is far more of people's preconceived ideas about art than of nature. The numerous drawings that Matisse always made before he arrived at his final colour-solution are evidence of the pains he took to preserve the essential character of his subject whilst at the same time making it 'buoyant' enough to sail on the tide of his colour scheme. Certainly the effect of these paintings is what he hoped. Their subjects invite, one embarks, and then the flow of their colour-areas holds one in such sure equilibrium that one has a sense of perpetual motion – a sense of movement with all friction removed.

Nobody who has not painted himself can fully appreciate what lies behind Matisse's mastery of colour. It is comparatively easy to achieve a certain unity in a picture either by allowing one colour to dominate or by muting all the colours. Matisse did neither. He clashed his colours together like cymbals and the effect was like a lullaby.

Perhaps the best way of defining Matisse's genius is to compare him

with some of his contemporaries who were also concerned with colour. Bonnard's colours dissolve, making his subjects unattainable, nostalgic. Matisse's colours could hardly be more present, more blatant, and yet achieve a peace which is without a trace of nostalgia. Braque has cultivated his sensibility until it has become precious. Matisse broadened his sensibility until it was as wide as his colour range, and said that he wanted his art to be 'something like a good armchair'. Dufy shared Matisse's sense of enjoyment and his colours were as gay as the fêtes he painted; but Matisse's colours, no less bright, go beyond gaiety to affirm contentment. The only man who possibly equals Matisse as a colourist is Léger. But their aims are so different that they can hardly be compared. Léger is essentially an epic, civic artist; Matisse essentially a lyrical and personal one.

I said that Matisse's paintings and designs of the last fifteen years were his greatest. Obviously he produced fine individual works before he was seventy. Yet not, I think, till then had he the complete control of his art that he needed. It was, as he himself said, a question of 'organising the brain'. Like most colourists he was an intuitive painter, but he realised that it was necessary to select rigorously from his many 'instincts' to make them objective in order to be able to build upon them rationally. In terms of the picture this control makes the all-important difference between recording a sensation and reconstructing an emotion. The Fauves, whom Matisse led, recorded sensations. Their paintings were (and are) fresh and stimulating, but they depended upon and evoke a forced intoxication. When Matisse painted red flashes against ultramarine and magenta stripes to describe the movement of goldfish in a bowl, he communicated a pleasurable shock; one is brought up short by the climax, but no solution follows. It was for this reason, I think, that Matisse finally abandoned Fauvism and returned to a more disciplined form of painting. Between 1914 and 1918 he produced paintings – mostly interiors – which are magnificently resonant in colour, but in which the colours seem *assembled* rather than dynamic – like the furnishings in a room. Then for the next ten years he painted his famous Odalisques. In these the colour is freer and more pervasive, but, being based on a heightening of the actual local colour of each object, it has a slightly exotic effect. This period, however, led him to his final great phase: the phase in which

he was able to combine the energy of his early Fauve days with a quite objective visual wisdom.

It is of course true that Matisse's standards of imagination and taste belonged to the world of the French *haute bourgeoisie*. No other class in the modern world enjoyed the kind of seclusion, fine taste, and luxury that are expressed in Matisse's work. It was Matisse's narrowness (I can think of no modern artist with less interest in either history or psychology) that saved him from the negative and destructive attitudes of the class-life to which his art belonged. It was his narrowness that allowed him to enjoy this milieu without being corrupted by it, or becoming critical of it. He retained throughout his whole career something of Veronese's naive sense of wonder that life could be so rich and luxurious. He thought and saw only in terms of silks, fabulous furnishings, the shuttered sunlight of the Côte d'Azur, women with nothing to do but lie on grass or rug for the delight of men's calm eyes, flower-beds, private aquaria, jewellery, couturiers, and perfect fruit, as though such joys and achievements, unspoilt by mention of the price, were still the desire, the ambition of the entire world. But from such a vision he distilled experiences of sensuous pleasure, which, disassociated from their circumstances, have something of the universal about them.

33.

Pablo Picasso
(1881–1973)

THE VERY LAST period of Picasso's life as a painter was dominated by the theme of sexuality. Looking at these late works, I yet again think of W. B. Yeats, writing in his old age:

> You think it horrible that lust and rage
> Should dance attention upon my old age;
> They were not such a plague when I was young;
> What else have I to spur me into song?

Yet why does such an obsession so suit the medium of painting? Why does painting make it so eloquent?

Before attempting an answer, let us clear the ground a little. Freudian analysis, whatever else it may offer in other circumstances, is of no great help here, because it is concerned primarily with symbolism and the unconscious. Whereas the question I'm asking addresses the immediately physical and the evidently conscious.

Nor, I think, do philosophers of the obscene – like the eminent Bataille – help a great deal because, again but in a different way, they tend to be too literary and psychological for the question. We have to think quite simply about pigment and the look of bodies.

The first images ever painted displayed the bodies of animals. Since then, most paintings in the world have showed bodies of one kind or another. This is not to belittle landscape or other later genres, nor is it to establish a hierarchy. Yet if one remembers that the first, the basic, purpose of painting is to conjure up the presence of something which is not there, it is not surprising that what is usually conjured up are bodies. It is their presence which we need in our collective or individual solitude to console, strengthen, encourage, or inspire us. Paintings keep our eyes company. And company usually involves bodies.

Let us now – at the risk of colossal simplification – consider the other arts. Narrative stories involve action: they have a beginning and an end in time. Poetry addresses the heart, the wound, the dead – everything which has its being within the realm of our inter-subjectivities. Music is about what is behind the given: the wordless, the invisible, the unconstrained. Theatre re-enacts the past. Painting is about the physical, the palpable, and the immediate. (The insurmountable problem facing abstract art was to overcome this.) The art closest to painting is dance. Both derive from the body, both evoke the body, both in the first sense of the word are physical. The important difference is that dance, like narration and theatre, has a beginning and an end and so exists in time, whereas painting is instantaneous. (Sculpture, because it is more obviously static than painting, often lacks colour, and is usually without a frame and therefore less intimate, is in a category by itself, which demands another essay.)

Painting, then, offers palpable, instantaneous, unswerving, continuous, physical presence. It is the most immediately sensuous of the arts. Body to body. One of them being the spectator's. This is not to say that the aim of every painting is sensuous; the aim of many paintings has been ascetic. Messages deriving from the sensuous change from century to century, according to ideology. Equally, the role of gender changes. For example, paintings can present women as a passive sex object, an active sexual partner, as somebody to be feared, as a goddess, as a loved human being. Yet, however the art of painting is used, its use begins with a deep sensuous charge which is then transmitted in one direction or another. Think of a painted skull, a painted lily, a carpet, a red curtain, a corpse – and in every case, whatever the conclusion may be, the beginning (if the painting is alive) is a sensuous shock.

He who says 'sensuous' – where the human body and the human imagination are concerned – is also saying 'sexual'. And it is here that the practice of painting begins to become more mysterious.

The visual plays an important part in the sexual life of many animals and insects. Colour, shape, and visual gesture alert and attract the opposite sex. For human beings the visual role is even more important, because the signals address not only reflexes but also the imagination. (The visual may play a more important role in the sexuality of men than women, but this is difficult to assess because of the extent of sexist traditions in modern image-making.)

The breast, the nipple, the pubis, and the belly are natural optical focii of desire, and their natural pigmentation enhances their attractive power. If this is often not said simply enough – if it is left to the domain of spontaneous graffiti on public walls – it is due to the weight of puritan moralising. The truth is, we are all made like that. Other cultures in other times have underlined the magnetism and centrality of these parts with the use of cosmetics. Cosmetics which add more colour to the natural pigmentation of the body.

Given that painting is the appropriate art of the body, and given that the body, to perform its basic function of reproduction, uses visual signals and stimuli of sexual attraction, we begin to see why painting is never very far from the erogenous.

David Douglas Duncan, *Fish-eye Picasso*, 1963

Tintoretto painted a canvas, *Woman with Bare Breasts*, which is now in the Prado. This image of a woman uncovering her breast so that it can be seen is equally a representation of the gift, the talent, of painting itself. At the simplest level, the painting (with all its art) is imitating nature (with all its cunning) in drawing attention to a nipple and its aureole. Two very different kinds of 'pigmentation' used for the same purpose.

Yet just as the nipple is only part of the body, so its disclosure is only part of the painting. The painting is also the woman's distant expression, the far-from-distant gesture of her hands, her diaphanous clothes, her pearls, her coiffure, her hair undone on the nape of her neck, the flesh-coloured wall or curtain behind her, and, everywhere, the play between greens and pinks so beloved of the Venetians. With all these elements, the *painted* woman seduces us with the visible means of the living one. The two are accomplices in the same visual coquetry.

Tintoretto was so called because his father was a dyer of cloth. The son, although at one degree removed and hence within the realm of art, was, like every painter, a 'colourer' of bodies, of skin, of limbs.

Let us imagine this Tintoretto beside a Giorgione painting, *An Old Woman*, painted about half a century earlier. The two paintings together show that the intimate and unique relation existing between pigment and flesh does not necessarily mean sexual provocation. On the contrary, the theme of the Giorgione is the loss of the power to provoke.

Perhaps no words could ever register like this painting does the sadness of the flesh of an old woman, whose right hand makes a gesture which is so similar and yet so different from that of the woman painted by Tintoretto. Why? Because the pigment has become that flesh? This is almost true but not quite. Rather, because the pigment has become the communication of that flesh, its lament.

Finally, I think of Titian's *Vanity of the World*, which is in Munich. There a woman has abandoned all her jewellery (except a wedding ring) and all adornment. The 'fripperies', which she has discarded as vanity, are reflected in the dark mirror she holds up. Yet, even here, in this least suitable of contexts, her painted head and shoulders cry out with desirability. And the pigment is the cry.

Such is the ancient mysterious contract between pigment and flesh. This contract permits the great paintings of the Madonna and Child to offer profound sensuous security and delight, just as it confers upon the great Pietàs the full weight of their mourning – the terrible weight of the hopeless desire that the flesh should live again. Paint belongs to the body.

The stuff of colours possesses a sexual charge. When Manet paints *Le Déjeuner sur l'Herbe* (a picture which Picasso copied many times during his last period), the flagrant paleness of the paint does not just imitate, but becomes the flagrant nakedness of the women on the grass. What the painting *shows* is the body *shown*.

The intimate relation (the interface) between painting and physical desire, which one has to extricate from the churches and the museums, the academies and the lawcourts, has little to do with the special mimetic texture of oil paint, as I discuss it in my book *Ways of Seeing*. The relation begins with the act of painting, not with the medium. The interface can be there too in fresco painting or watercolour. It is not the illusionist tangibility of the painted bodies which counts, but their visual signals, which have such an astounding complicity with those of real bodies.

Perhaps now we can understand a little better what Picasso did during the last twenty years of his life, what he was driven to do, and what – as one might expect of him – nobody had quite done before.

He was becoming an old man, he was as proud as ever, he loved women as much as he ever had and he faced the absurdity of his own relative impotence. One of the oldest jokes in the world became his pain and his obsession – as well as a challenge to his great pride.

At the same time, he was living in an uncommon isolation from the world – an isolation, as I point out in my book, which he had not altogether chosen himself, but which was the consequence of his monstrous fame. The solitude of this isolation gave him no relief from his obsession; on the contrary, it pushed him further and further away from any alternative interest or concern. He was condemned to a single-mindedness without escape, to a kind of mania, which took the form of a monologue. A monologue addressed to the practice of painting, and to all the dead painters of the past whom he admired or loved

or was jealous of. The monologue was about sex. Its mood changed from work to work but not its subject.

The last paintings of Rembrandt – and particularly the self-portraits – are proverbial for their questioning of everything the artist had done or painted before. Everything is seen in another light. Titian, who lived almost as long as Picasso, painted towards the end of his life *The Flaying of Marsyas* and *The Pietà* in Venice: two extraordinary last paintings in which the paint as flesh turns cold. For both Rembrandt and Titian the contrast between their late works and their earlier work is very marked. Yet also there is a continuity, whose basis it is difficult to define briefly. A continuity of pictorial language, of cultural reference, of religion, and of the role of art in social life. This continuity qualified and reconciled – to some degree – the despair of the old painters; the desolation they felt became a sad wisdom or an entreaty.

With Picasso this did not happen, perhaps because, for many reasons, there was no such continuity. In art he himself had done much to destroy it. Not because he was an iconoclast, nor because he was impatient with the past, but because he hated the inherited half-truths of the cultured classes. He broke in the name of truth. But what he broke did not have the time before his death to be reintegrated into tradition. His copying, during the last period, of old masters like Velázquez, Poussin, or Delacroix was an attempt to find company, to re-establish a broken continuity. And they allowed him to join them. But they could not join him.

And so he was alone – like the old always are. But he was unmitigatedly alone because he was cut off from the contemporary world as a historical person, and from a continuing pictorial tradition as a painter. Nothing spoke back to him, nothing constrained him, and so his obsession became a frenzy: the opposite of wisdom.

An old man's frenzy about the beauty of what he can no longer do. A farce. A fury. And how does the frenzy express itself? (If he had not been able to draw or paint every day, he would have gone mad or died – he needed the painter's gesture to prove to himself he was still a living man.) The frenzy expresses itself by going directly back to the mysterious link between pigment and flesh and the signs they share. It is the frenzy of paint as a boundless erogenous zone. Yet the shared signs, instead of indicating mutual desire, now display the sexual

mechanism. Crudely. With anger. With blasphemy. This is painting swearing at its own power and at its own mother. Painting insulting what it had once celebrated as sacred. Nobody before imagined how painting could be obscene about its own origin, as distinct from illustrating obscenities. Picasso discovered how it could be.

How to judge these late works? Those who pretend that they are the summit of Picasso's art are as absurd as the hagiographers around him have always been. Those who dismiss them as the repetitive rantings of an old man understand nothing about either love or the human plight.

Spaniards are proverbially proud of the way they can swear. They admire the ingenuity of their oaths and they know that swearing can be an attribute, even a proof, of dignity.

Nobody had ever sworn in paint before Picasso painted these canvases.

34.

Fernand Léger
(1881–1955)

SINCE THE MIDDLE of the last century all artists of any worth have been forced to consider the future because their works have been misunderstood in the present. The very concept of the avant-garde suggests this. The qualitative meaning that the word 'modern' has acquired suggests it too. *Modern Art*, for those who have produced it, has meant not the art of today, as opposed to yesterday: but the art of tomorrow as opposed to the conservative tastes of today. Every important painter since 1848 has had to rely upon his faith in the future. The fact that he has believed that the future will be different and better has been the result of his awareness (sometimes fully conscious and sometimes only dimly sensed) of living in a time of profound social change. *From the middle of the last century socialism has promised the alternative which has kept the future open, which has made the power (and the Philistinism) of the ruling classes seem finite.* It would be absurd to suggest that all the great painters of the last century were socialists; but what is certainly true is that all of them made innovations in the hope of serving a richer future.

Fernand Léger was unique in that he made his vision of this future the theme of his art.

Léger's subjects are cities, machinery, workers at work, cyclists, picnickers, swimmers, women in kitchens, the circus, acrobats, still

lifes – often of functional objects such as keys, umbrellas, pincers – and landscapes. A similar list of Picasso's recurring subjects might be as follows: bullfights, the minotaur, goddesses, women in armchairs, mandolins, skulls, owls, clowns, goats, fawns, other painters' paintings. In his preoccupations Picasso does not belong to the twentieth century. It is in the use to which he puts his temperament that Picasso is a modern man. The other major painters of the same generation – Braque, Matisse, Chagall, Rouault – have all been concerned with very specialised subjects. Braque, for instance, with the interior of his studio; Chagall with the Russian memories of his youth. No other painter of his generation except Léger has consistently included in his work the objects and materials with which everybody who now lives in a city is surrounded every day of his life. In the work of what other artist could you find cars, metal frames, templates, girders, electric wires, number plates, road signs, gas stoves, functional furniture, bicycles, tents, keys, locks, cheap cups and saucers?

Léger then is exceptional because his art is full of direct references to modern urban life. But this could not in itself make him an important painter. The function of painting is not that of a pictorial encyclopedia. We must go further and now ask: What do these

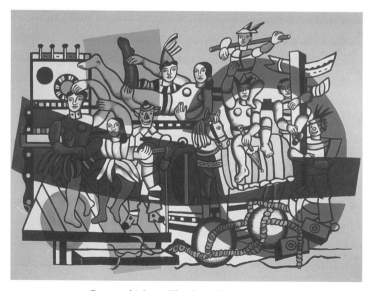

Fernand Léger, *The Great Parade*, 1955

references add up to? What is Léger's interest in the tools, artefacts, and ornaments of the twentieth-century city?

When one studies an artist's life work as a whole, one usually finds that he has an underlying, constant theme, a kind of hidden but *continuous* subject. For example, Géricault's continuous subject was endurance. Rembrandt's continuous subject was the process of ageing. The continuous subject reflects the bias of the artist's imagination; it reveals that area of experience to which his temperament forces him to return again and again, and from which he creates certain standards of interest with which to judge ordinary disparate subjects as they present themselves to him. There is hardly a painting by Rembrandt where the significance of growing older is not in some way emphasised. The continuous subject of Matisse is the balm of leisure. The continuous subject of Picasso is the cycle of creation and destruction. The continuous subject of Léger is mechanization. He cannot paint a landscape without including in it the base of a pylon or some telegraph wires. He cannot paint a tree without placing sawn planks or posts next to it. Whenever he paints a natural object, he juxtaposes it deliberately with a manufactured one – as though the comparison increased the value of each. Only when he paints a woman, naked, is he content to let her remain incomparable.

A number of twentieth-century artists have been interested by machines – although, surprising as it may seem, the majority have not. The Futurists in Italy, Mondrian and the de Stijl group in Holland, the Constructivists in Russia, Wyndham Lewis and the Vorticists in England, artists like Roger de la Fresnaye and Robert Delaunay in France, all constructed for themselves aesthetic theories based on the machine, but not one of them thought of the machine as a means of production, making inevitable revolutionary changes in the relations between men. Instead they saw it as a god, a 'symbol' of modern life, the means with which to satisfy a personal lust for power, a Frankenstein's monster, or a fascinating enigma. They treated the machine as though it were a new star in the sky, although they disagreed about interpreting its portents. Only Léger was different. Only Léger saw the machine for what it is – a tool: a tool both practically and historically in the hands of men.

This is perhaps the best place to examine the frequently made accusation that Léger sacrifices the human to the mechanical and that his figures are as 'cold' as robots. I have heard this argument in Bond Street – put forward by those who, if they pay their money, expect art to console them for the way the world is going; but I have also heard it in Moscow, put forward by art experts who want to judge Léger by the standards of Repin. The misunderstanding arises because Léger is something so rare in recent European art that we have almost forgotten the existence of the category of art to which he belongs. He is an *epic* painter. That is not to say that he paints illustrations to Homer. It is to say that he sees his constant subject of *mechanization* as a human epic, an unfolding adventure of which man is the hero. If the word was not discredited one could equally say that he was a 'monumental' painter. He is not concerned with individual psychology or with nuances of sensation: he is concerned with action and conquest. Because the standards by which we judge painting have been created since the Renaissance and because in general this has been the period of the bourgeois discovery of the individual, there have been very few epic painters. In an extraordinarily complex way Michelangelo was one, and if one compares Léger with Michelangelo, from whom he learnt a great deal, one sees how 'traditional' Léger suddenly becomes. But the best test of all is to place Léger beside the fifth-century Greek sculptors. Naturally there are enormous differences. But the quality of emotions implied and *the distance at which the artist stands from the personality of his subject* – these are very similar. The figures, for example, in *Les Perroquets* are no 'colder' or more impersonal than the Doryphorus of Polyclitus. It is absurd to apply the same standards to all categories of art, and it betrays an essential vulgarisation of taste to do so. The epic artist struggles to find an image for the whole of mankind. The lyric artist struggles to present the world in the image of his own individualised experience. They both face reality, but they stand back to back.

Léger's attitude to mechanization did not stay the same all his life. It changed and developed as his political and historical understanding increased. Very roughly his work can be divided into three periods. I will try briefly to put into words the attitude suggested by each period

so as to make it easier to grasp his *general* approach and the consistent direction of his thinking.

In his early work, up to about 1918, he was fascinated (it is worth remembering that he came from a family of Norman farmers) by the basic material of modern industry – steel. He became a Cubist, but for him, unlike most of the other Cubists, the attraction of Cubism was not in its intellectual system but in its use of essentially manufactured *metallic* shapes. The turning, the polishing, the grinding, the cutting of steel were all processes which fired the young Léger with a sense of modernity and a new kind of beauty. The cleanness and strength of the new material may also have suggested a symbolic contrast with the hypocrisy and corruption of the bourgeois world that plunged with self-congratulation and inane confidence into the 1914 war. I am of course simplifying and I don't want to mislead as a result. Léger did not paint pictures of steel. He painted and drew nudes, portraits, soldiers, guns, aeroplanes, trees, a wedding. But in all his work at this time he uses shapes (and often colours) which suggest metal and a new awareness of speed and mechanical strength. All the artists of that period were aware of living on the threshold of a new world. They knew they were heralds. But it was typical of Léger that the new was epitomised for him by a new *material*.

The second period in Léger's work lasted roughly from 1920 to 1930. His interest shifted from basic materials to finished, machine-made products. He began to paint still lifes, interiors, street scenes, workshops, all contributing to the same idea: the idea of the mechanised city. In many of the paintings, figures are introduced: women in modern kitchens with children, men with machines. The relationship of the figures to their environment is very important. It is this that prevents anyone suspecting that Léger is only celebrating commodity goods for their own sake. These modern kitchens are not advertisements for paints, linoleum, or up-to-date bungalows. They are an attempt to show (but in terms of painting and not lectures) how modern technology and modern means of production can enable men to build the environment they need, *so that nature and the material world can become fully humanised*. In these paintings it is as though Léger is saying: It is no longer necessary to separate man from what he makes, for he now has the power to make all that he

needs, so that what he has and what he makes will become an extension of himself. And this was based, in Léger's mind, on the fact that for the first time in history, we have the productive means to create a world of plenty.

The third period lasted roughly from 1930 to Léger's death in 1955. Here the centre of interest moved again; this time from the means of production to productive relations. During these twenty-five years he painted such subjects as cyclists, picnickers, acrobats, swimmers diving, building-workers. At first these subjects may seem mysteriously irrelevant to what I have just said. But let me explain further. All these subjects involve groups of people, and in every case these people are depicted in such a way that no one can doubt that they are modern workers. One could, more generally, say therefore that in this period Léger's recurring subjects were workers at work and at leisure. They are not of course documentary paintings. Further, they make no direct comment at all on working conditions at the time at which they were painted. Like almost every picture Léger painted, they are affirmative, gay, happy, and, by comparison with the works of most of his contemporaries, strangely carefree. You may ask: What is the significance of these paintings? Can they do nothing but smile?

I believe that their significance is really very obvious, and has been so little understood only because most people have not bothered to trace Léger's development even as sketchily as we are doing now. Léger knew that new means of production make new social relations inevitable; he knew that industrialization, which originally only capitalism could implement, had already created a working class which would eventually destroy capitalism and establish socialism. For Léger this process (which one describes in abstract language) became implicit in the very sight of a pair of pliers, an earphone, a reel of unused film. And in the paintings of his last period he was prophetically celebrating the liberation of man from the intolerable contradictions of the late capitalist world. I want to emphasise that this interpretation is not the result of special pleading. It is those who wish to deny it who must close their eyes to the facts. In painting after painting the same theme is stressed. Invariably there is a group of figures, invariably they are connected by easy movement one with another, invariably the meaning of this connection is emphasised by the very

tender and gentle gestures of their hands, invariably the modern equipment, the tackle they are using, is shown as a kind of confirmation of the century, and invariably the figures have moved into a new, freer environment. The campers are in the country, the divers are in the air, the acrobats are weightless, the building-workers are in the clouds. These are paintings about freedom: that freedom which is the result of the aggregate of human skills when the major contradictions in the relations between men have been removed.

To discuss an artist's style in words and to trace his stylistic development is always a clumsy process. Nevertheless I should like to make a few observations about the way Léger painted because, unless the form of his art is considered, any evaluation of its content becomes one-sided and distorted; also because Léger is a very clear example of how, when an artist is *certain* about what he wants to express, this *certainty* reveals itself as logically in his style as in his themes or content.

I have already referred to Léger's debt to Cubism and his very special (indeed unique) use of the language of the Cubists. Cubism was for him the only way in which he could demonstrate the quality of the new materials and machines which struck him so forcibly. Léger was a man who always preferred to begin with something tangible (I shall refer later to the effect of this on his style). He himself always referred to his subjects as 'objects'. During the Renaissance a number of painters were driven by a scientific passion. I think it would be true to say that Léger was the first artist to express the passion of the technologists. And this began with his seizing on the style of Cubism in order to communicate his excitement about the potentiality of new materials.

In the second period of his work, when his interest shifted to machine-made products, the style in which he painted is a proof of how thoroughly he was aware of what he was saying. He realised (in 1918!) that mass production was bound to create new aesthetic values. It is hard for us now, surrounded by unprecedented commercial vulgarity, not to confuse the new values of mass production with the gimmicks of the salesmen, but they are not of course the same thing. Mass production turns many old aesthetic values into purely snob values. (Every woman now can have a plastic handbag which is

in every way as good as a leather one: the qualities of a good leather one become therefore only the attributes of a status symbol.) The qualities of the mass-produced object are bound at first to be contrasted with the qualities of the hand-made object: their 'anonymity' will be contrasted with 'individuality', and their regularity with 'interesting' irregularity. (As pottery has become mass-produced, 'artistic' pottery, in order to emphasise and give a spurious value to its being hand-made, has become wobblier, rougher, and more and more irregular.)

Léger made it a cardinal point of his style at this time to celebrate the special aesthetic value of the mass-produced object in the actual way he painted. His colours are flat and hard. His shapes are regular and fixed. There is a minimum of gesture and a minimum of textural interest (texture in painting is the easiest way to evoke 'personality'). As one looks at these paintings one has the illusion that they too could exist in their hundreds of thousands. The whole idea of a painting being a jewel-like and unique private possession is destroyed. On the contrary, a painting, we are reminded, is an image made by a man for other men and can be judged by its efficiency. Such a view of art may be partisan and one-sided, but so is any view of art held by any practising artist. The important point is that in the way he painted these pictures Léger strove to prove the argument which was their content: the argument that modern means of production should be welcomed (and not regretted as vulgar, soulless, or cheap) because they offered men their first chance to create a civilisation not exclusive to a minority, not founded on scarcity.

There are three points worth making about the style of Léger's third period. He now has to deal with far more complex and variegated subjects – whole groups of figures, figures in landscapes, etc. It is essential to his purpose that these subjects appear unified: the cloud and the woman's shoulder, the leaf and the bird's wing, the rope and the arm, must all be seen in the same way, must all be thought to exist under the same conditions. Léger now introduced light into his painting to create this unity of condition. By light I do not mean anything mysterious; I mean simply light and shade. Until the third period Léger mostly used flat local colours and the forms were established by line and colour rather than by tone. Now the forms become much

more solid and sculptural because light and shade play upon them to reveal their receding and parallel planes, their rises and hollows. But the play of the light and shade does more than this: it also allows the artist to create an overall pattern, regardless of where one object or figure stops and another begins. Light passes into shade and shade into light, alternately, a little like the black and white squares of a chessboard. It is by this device that Léger is able to *equate* a cloud with a limb, a tree with a sprig, a stream with hair; and it is by the same device that he can bind a group of figures together, turning them into one *unit* in the same way as the whole chessboard can be considered one unit rather than each square. In his later work Léger used the element of light (which means nothing without shade) to suggest the essential *wholeness* of experience for which all men long and which they call freedom. The other artist to use light in a similar way was Michelangelo, and even a superficial comparison between the drawings of the two artists will reveal their closeness in this respect. The all-important difference is that for Michelangelo freedom meant lonely individuality and was therefore tragic, whereas for Léger it meant a classless society and was therefore triumphant.

The second point I want to make about Léger's style in his third period concerns the special use to which he discovered he could put colour. This did not happen until about the last ten years of his life. In a sense, it was a development which grew out of the use of light and shade which I have just described. He began to paint bands of colour across the features or figures of his subject. The result was a little like seeing the subject through a flag which, although quite transparent in places, imposed occasional strips or circles of colour on the scene behind. In fact it was not an arbitrary imposition: the colour strips were always designed in precise relation to the forms behind them. It is as though Léger now wanted to turn his paintings into emblems. He was no longer concerned with his subjects as they existed but with his subjects as they *could* exist. They are, if you like, paintings in the conditional mood. *La Grande Parade* represents what pleasure, entertainments, popular culture could mean. *Les Constructeurs* represents what work could mean. *Les Campeurs* represents what being at home in the world could mean. This might have led Léger to sentimental idealisation and utopian dreams. It did not because Léger understood

the historical process which has released and will increasingly release human potentiality. These last 'conditional mood' paintings of Léger's were not made to console and lull. They were made to remind men of what they are capable. *He did not deceive us by painting them as though the scenes already existed*. He painted them as hopes. And one of the ways in which he made this clear (he did not employ the same method in all his last pictures) was to use colour to make the pictures *emblematic*. Here I am using the word in its two senses, thinking of an emblem as both a sign and an allegory. In discussions on twentieth-century art, references are often made to *symbols*. It is usually forgotten that symbols must by definition be accessible. In art, a private symbol is a contradiction in terms. Léger's emblems are among the few true symbols created in our time.

The last point I want to make about Léger's later work has nothing to do, like the first two points, with any stylistic innovation, but with a tendency which, although inherent in all Léger's painting, became stronger and more obvious and conscious as time passed: the tendency to visualise everything he wanted to paint *in terms of its being able to be handled*. His world is literally *a substantial world*: the very opposite of the world of the Impressionists. I have already said that Léger allowed no special value to the hand-made as opposed to the machine-made product. But the human hand itself filled him with awe. He made many drawings of hands. One of his favourite juxtapositions was to put a hand in front of, or beside, a face; as though to convey that without the hand all that makes the human eye human would never have occurred. He believed that man could be manager of his world and he recognised the Latin root of the word 'manager'. *Manus*. Hand. He seized upon this truth as a metaphor, in his struggle against all cloudy mystification. Léger's clouds are in fact like pillows, his flowers are like egg-cups, his leaves are like spoons. And for the same reason he frequently introduces ladders and ropes into his pictures. He wanted to construct a world where the link between man's imagination and his ability to fashion and control with his hands was always emphasised. This, I am certain, is the principal explanation of why he simplified and stylised objects and landscapes in the way he did. He wanted to make everything he included in his art tangible and unmysterious: not because he was a mechanical nineteenth-century

rationalist, but because he was so impressed by the greater mystery: the mystery of man's insatiable desire to hold and understand.

This is perhaps the best place to refer to the artists who influenced Léger: the artists who helped him to develop the means with which to express his unusual vision. I have already mentioned Michelangelo: for Léger he was the example of an artist who created an heroic, epic art based exclusively on man. Picasso and Braque, who invented Cubism, were also indispensable examples. Cubism may have meant something different to its inventors (theirs was perhaps a more consciously art-historical approach and was more closely connected with an admiration for African art) but nevertheless Cubism supplied Léger with his twentieth-century visual language. The last important influence was that of the Douanier Rousseau: the naive Sunday painter who was treated as a joke or, later, thought to be 'delightful', but who believed himself to be a realist.

It would be foolish to exaggerate the realist element in Rousseau if one is using the word 'realist' in its usual sense. Rousseau was quite uninterested in social issues or politics. His realism, as he believed it to be, was in no sense a protest against a specific set of social or ideological lies. But nevertheless there are elements in Rousseau's art which in a long historical perspective can be seen to have extended the possibilities of painting certain aspects of reality, to use them and transform them for his own purpose.

I will try briefly to explain what these elements were – for the connection between Léger and Rousseau is not yet sufficiently recognised. Rousseau can be termed an amateur artist insofar as he was untrained and both his social and financial position precluded him from having any place at all in the official cultural hierarchy of France. Measured by official standards he was not only totally unqualified to be an artist but also pathetically uncultured. All that he inherited was the usual stale deposit of petit-bourgeois clichés. His imagination, his imaginative experience, was always in conflict with his received culture. (If I may add a personal parenthesis, I would suggest that such conflicts have not yet been properly understood or described; which is one of the reasons why I chose such a conflict as the theme of my novel *Corker's Freedom*.[1]) Every picture that Rousseau painted was a testimony to the existence of an alternative, unrecognised, indeed as

yet unformulated culture. This gave his work a curious, self-sufficient, and uninhibited conviction. (A little similar in this, though in nothing else, to some of the works of William Blake.) Rousseau had no method to rely on if his imagination failed him: he had no art with which to distract attention, if the *idea* he was trying to communicate was weak. The *idea* of any given picture was all that he had. (One begins to realise the intensity of these ideas by the story of how he became terrified in his little Parisian room when he was painting a tiger in the jungle.) One might say – exaggerating with a paradox – that Rousseau made all the other artists of his time look like mere virtuosos. And it was probably the strength of Rousseau's 'artlessness' which first appealed to Léger, for Léger also was an artist with surprisingly little facility, for whom the *ideas* of his art were also constant and primary, and whose work was designed to testify to the existence of an alternative, unrecognised culture.

There was, then, a moral affinity between Rousseau and Léger. There was also a certain affinity of method. Rousseau's style had very little to do with the fine arts as they were then recognised: as little to do with the fine arts as the circus has with the Comédie Française. Rousseau's models were postcards, cheap stage scenery, shop signs, posters, fairground and café decorations. When he paints a goddess, a nude, it has far more to do – iconographically but not of course emotionally – with the booth of any Fat Lady at a fair than with a Venus by Titian. He made an art of visual wonder out of the visual scraps sold to and foisted upon the petty bourgeoisie. It has always seemed over-romantic to me to call such scraps popular art: one might just as well call second-hand clothes popular *couture*! But the important point is that Rousseau showed that it was possible to make works of art using the visual vocabulary of the streets of the Parisian suburbs instead of that of the museums. Rousseau of course used such a vocabulary because he knew no other. Léger chose a similar vocabulary because of what he wanted to say. Rousseau's spirit was nostalgic (he looked back to a time when the world was as innocent as he) and his ambience was that of the nineteenth century. Léger's spirit was prophetic (he looked forward to the time when everyone would understand what he understood) and the atmosphere of his work belongs to this century. But nevertheless as painters they often both use similar

visual prototypes. The posed group photograph as taken by any small-town photographer; the placing of simple theatrical props to conjure up a whole scene – Rousseau makes a jungle out of plants in pots, Léger makes a countryside out of a few logs: the clear-cut poster where everything must be defined – so that it can be read from a distance – and mystery must never creep into the method of drawing: flags and banners to make a celebration; brightly coloured prints of uniforms or dresses – in the pictures of Rousseau and Léger all the clothes worn are easily identifiable and there is a suggested pride in the wearing of them which belongs essentially to the city street. There is also a similarity in the way both artists painted the human head itself. Both tend to enlarge and simplify the features, eyes, nose, mouth, and in doing this, because the mass of people think of a head as a face and a face as a sequence of features to be read like signs – 'shifty eyes', 'smiling mouth' – both come far nearer to the popular imagination of the story-teller, the clown, the singer, the actor, than to the 'ideal proportions' of the 'fine' artist.

Lastly, one further element in Rousseau's art which seems to have been important for Léger: its happiness. Rousseau's paintings are affirmative and certain; they reject and dispel all doubt and anxiety; they express none of the sense of alienation that haunted Degas, Lautrec, Seurat, Van Gogh, Gauguin, Picasso. The probable reason for this is simple but surprising: Rousseau was so innocent, so idealistic that it was the rest of the world and its standards which struck him as absurd, never his own unlikely vision. His confidence and credulity and good-naturedness survived, not because he was treated well – he was treated appallingly – but because he was able to dismiss the corruption of the world around him as an absurd accident. Léger also wanted to produce an art which was positive and hopeful. His reasoning was very different; it was based on the acceptance and understanding of facts rather than their rejection; but except for Rousseau, there was no other nineteenth- or twentieth-century artist to whom he could look for support and whose fundamental attitude was one of celebration.

In a certain sense Léger's art is extremely easy to appreciate, and all efforts to explain it therefore run the danger of becoming pretentious. There is less obscurity in Léger's work than in that of any of his famous

contemporaries. The difficulties are not intrinsic. They arise from our conditioned prejudices.

We inherit the Romantic myth of the genius and therefore find his work 'mechanical' and 'lacking in individuality'. We expect a popular artist to use the style of debased magazine illustration, and therefore find his work 'formalistic'. We expect socialist art to be a protest and so find his work 'lacking in contradiction'. (The contradiction is in fact between what he shows to be possible and what he knew existed.) We expect his work to be 'modern' and therefore fail to see that it is often tender in the simplest manner possible. We are used to thinking of art in an 'intimate' context and therefore find his epic, monumental style 'crude' and 'oversimplified'.

I would like to end with a quotation from Léger himself. Everything I have said is only a clumsy elaboration of this text.

> I am certain that we are not making woolly prophecies: our vision is very like the reality of tomorrow. We must create a society without frenzy, a society that is calm and ordered, that knows how to live naturally within the Beautiful, without protestations or romanticism, quite naturally. We are going towards it; we must bend our efforts towards that goal. It is a religion more universal than the others, made of tangible, definite, human joys, free from the troubled, disappointment-filled mysticism of the old ideals which are slowly disappearing every day, leaving the ground free for us to construct our religion of the Future.

35.

Ossip Zadkine
(1890–1967)

LAST NIGHT A man who was looking for a flat and asking me about rents told me that Zadkine was dead.

One day when I was particularly depressed Zadkine took us out to dinner to cheer me up. When we were sitting at the table and after we had ordered, he took my arm and said: 'Remember when a man falls over a cliff, he almost certainly smiles before he hits the ground, because that's what his own demon tells him to do.'
 I hope it was true for him.

I did not know him very well but I remember him vividly.

A small man with white hair, bright piercing eyes, wearing baggy grey flannel trousers. The first striking thing about him is how he keeps himself clean. Maybe a strange phrase to use – as though he were a cat or a squirrel. Yet the odd thing is that after a while in his company, you begin to realise that, in one way or another, many men don't keep themselves clean. He is a fastidious man; it is this which explains the unusual brightness of his eyes, the way that his crowded studio, full of

figureheads, looks somehow like the scrubbed deck of a ship, the fact that under and around the stove there are no ashes or coal-dust, his clean cuffs above his craftsman's hands. But it also explains some of his invisible characteristics: his certainty, the modest manner in which he is happy to live, the care with which he talks of his own 'destiny', the way that he talks of a tree as though it had a biography as distinct and significant as his own.

He talks almost continuously. His stories are about places, friends, adventures, the life he has lived: never, as with the pure egotist, about *his own opinion of himself.* When he talks, he watches what he is telling as though it were all there in front of his hands, as though it were a fire he was warming himself at.

Some of the stories he has told many times. The story of the first time he was in London, when he was about seventeen. His father had sent him to Sunderland to learn English and in the hope that he would give up the idea of wanting to be an artist. From Sunderland he made his own way to London and arrived there without job or money. At last he was taken on in a woodcarving studio for church furniture.

'Somewhere in an English church there is a lectern, with an eagle holding the Bible on the back of its outspread wings. One of those wings I carved. It is a Zadkine – unsigned. The man next to me in the workshop was a real English artisan – such as I'd never met before. He always had a pint of ale on his bench when he was working. And to work he wore glasses – perched on the end of his nose. One day this man said to me: "The trouble with you is that you're too small. No one will ever believe that you can do the job. Why don't you carve a rose to show them?" "What shall I carve it out of?" I asked. He rummaged under his bench and produced a block of apple wood – a lovely piece of wood, old and brown. And so from this I carved a rose with all its petals and several leaves. I carved it so finely that when you shook it, the petals moved. And the old man was right. As soon as the rush job was over, I had to leave that workshop. When I went to others, they looked at me sceptically. I was too young, too small, and my English was very approximate. But then I

would take the rose out of my pocket, and the rose proved eloquent. I'd get the job.'

We are standing by an early wood-carving of a nude in his studio.

'Sometimes I look at something I've made and I know it is good. Then I touch wood, or rather I touch my right hand.' As he says this, Zadkine touches the back of his small right hand, as though he were touching something infinitely fragile – an autumn leaf for example.

'I used to think that when I died and was buried all my wood carvings would be burnt with me. That was when they called me "the negro sculptor". But now all these carvings are in museums. And when I die, I shall go with some little terracottas in my pocket and a few bronzes strung on my belt – like a pedlar.'

Drinking a white wine of which he is very proud and which he brings to Paris from the country, sitting in a small bedroom off the studio, he reminisces.

'When I was about eight years old, I was at my uncle's in the country. My uncle was a barge-builder. They used to saw whole trees from top to bottom to make planks – saw them by hand. One man at the top end of the saw was high up and looked like an angel. But it was the man at the bottom who interested me. He got covered from head to foot in sawdust. New, resinous sawdust so that he smelt from head to foot of wood – and the sawdust collected even in his eyebrows. At my uncle's I used to go for walks by myself down by the river. One day I saw a young man towing a barge. On the barge was a young woman. They were shouting at each other in anger. Suddenly I heard the man use the word "cunt". You know how for children the very sound of certain forbidden words can become frightening? I was frightened like that. I remembered hearing the word once before – though God knows where I had learnt that it was forbidden – I was going along the passage between the kitchen and the dining-room and as I passed a door I saw a young man from the village with one of our maids on his knee, his hand was unbuttoning her and he used the same word.

'I started to run away from the river and the shouting couple by the

barge towards the forest. Suddenly, as I ran, I slipped and I found myself face-down on the earth.

'And it was there, after I had fallen flat on my face as I ran away from the river, that my demon first laid his finger on my sleeve. And so, instead of running on, I found myself saying – I will go back to see why I slipped. I went back and I found that I had slipped on some clay. And again for the second time my demon laid a finger on my sleeve. I bent down and I scooped up a handful of the clay. Then I walked to a fallen tree trunk, sat down on it and began to model a figure, the first in my life. I had forgotten my fear. The little figure was of a man. Later – at my father's house – I discovered that there was also clay in our back garden.'

It is about ten o'clock on a November morning seven years ago. The light in the studio is matter of fact. I have only called to collect or deliver something. It is a time for working rather than talking. Yet he insists that I sit down for a moment.

'I am very much occupied with time,' he says. 'You are young but you will feel it one day. Some days I see a little black spot high up in the corner of the studio and I wonder whether I will have the time to do all that I still have to do – to correct all my sculptures which are not finished. You see that figure there. It is all right up to the head. But the head needs doing again. All the time I am looking at them. In the end, if you're a sculptor, there's very little room left for yourself – your works crowd you out.'

Zadkine's masterpiece remains his monument to the razed and reborn city of Rotterdam. This is how he wrote about it:

Ossip Zadkine, *Destroyed City*, 1967

It is striving to embrace the inhuman pain inflicted on a city which had no other desire but to live by the grace of God and to grow naturally like a forest . . . It was also intended as a lesson to future generations.

36.

Henry Moore
(1898–1986)

THE DEVELOPMENT OF Henry Moore's sculpture is a tragic example of how the half-truths on which so much Modern Art has been based eventually lead to sterility and – in terms of appreciation – mass self-deception. Tragic because Moore is so obviously an honest-minded artist.

Thirty of his new, large and small bronzes are now at the Leicester Galleries. A life-size *King and Queen*, with crowns like jug handles to their heads, bodies that are scooped out, winded, and smacked flat like kippers, fairly life-like hands that rest on laps as boneless and lifeless as mattresses,

Henry Moore, *Mother and Child*, 1953

stare blindly (their eyes are holes to be threaded as the eyes of needles) at the crowds who admire them and talk of 'presences'. A mother with simplified legs but a wrench-spanner for a head holds back her child, who is trying to bite off her breast with his beak – he has presumably succeeded once, for her other breast is hollow! *Three Standing Figures* look like petrol pumps. A woman reclines, a conglomeration of bone-shapes that seem in places to be lagged with sacking. It is of course easy to be facetious about anything that is imaginative. But the invention, the oddness of these works is pointless. Their distortions do not interpret or clarify the structure of what they portray, but are arbitrary and inconsistent (a real arm and a set-square breast); their emotional impact is unreckoned and often so contradictory that it is comic; their symbolism is so vague that it doesn't deserve the name. Eventually one begins to realise that it is not their distortions that are arresting at all, but the fact that any parts have any reference to life whatsoever. And then, thinking about this, one begins to see what has gone wrong.

Moore has often been praised as a craftsman. And indeed he is a craftsman of extraordinary sensibility and feeling. His early figures and abstract pieces, worked according to the theory of 'truth to material', are very pleasing objects: satisfying to handle, interesting because they reveal so clearly the nature of the wood or stone in which they are carved, and admirable for the skill and sensitivity of their execution. But an artist must do more than create an *object*. A craftsman creates an object – usually one that can be used. An artist creates an image. An object is simply itself. An image connects and is a comment on something other than itself. A craftsman's primary concern is with the thing he is making; an artist's primary concern is with his vision, which the thing he is making must express. Moore has never consistently allowed for this basic distinction. He has always allowed the thing he is creating to dominate. As his imagination has demanded more stress and more drama, his 'objects' have become less pleasing, more tortured, more fantastic, but no nearer to being connecting, commenting images. They remain objects with merely curious resemblances: fabricated *objets trouvés*.

Many characteristics of Moore's work support this argument: the fact that they are most impressive when seen very close – so close that no comparison with anything else can be made, when they become

scaleless, a world unto themselves; the fact that Moore himself in his drawings so often places his sculptures on deserted planes; the frequently mentioned similarity of his work to natural *objects* – bones, tree trunks, driftwood; the point that Moore's drawings (in which of course he *is* concerned with 'outside' vision) have so little creative relationship to his sculpture.

Moore's great popularity can, I think, like Sutherland's, be largely explained by the present sentimental, highbrow fashion for projecting crises of conscience and introspection onto the timeless processes of nature. In some way it is a comfort to lose oneself in aeons, to hide oneself in the rock of ages – perhaps rather as it is a comfort to leave all the troubles of the world to 'Evolution'.

Finally, I recommend the reader most strongly to go to the Beaux Arts Gallery to look at the bas-reliefs and drawings of Raymond Mason, a sculptor of great talent who is concerned with men striving in their environment – instead of sinking back into it and emulating fossils.

℘

IN THE PAST I have severely criticised exhibitions by Henry Moore, and I still stand by these criticisms. Yet both critic and reader should always allow for the fact that the artist continues: that *his* perspective is his whole life's work. Moore has now produced a bronze which suggests that he has emerged from a difficult period and which reestablishes his obstinate power as an artist. The *Falling Warrior* (in an exceptionally good mixed show at the Marlborough Galleries) is not entirely successful, but it is impressive, well wrought, and tragically moving. The man, naked except for a round shield in his hand, falls like – like a man falling who will not stand up again. It is, in all senses of the word, the most vulnerable sculpture Moore has made; intentionally vulnerable in that the figure has been modelled sinuously and realistically – these are not legs that will endure like bones or hills, and the swellings across the torso are physical not aesthetic distortions, the result of injury; also vulnerable because, as a work of art, it is overtly and directly emotional. No one else will be so brash as to say it, but this, I am sure, is Moore's protest against Nuclear War. It is not entirely successful because the man's head – like

Moore's earlier, highly formalised heads of stone with holes right through them – is inconsistent with the rest of the figure. It is not difficult to understand Moore's dilemma here. He wanted the Man to be anonymous and he was acutely aware of the danger of sentimentality. Yet what he has done is not a solution of this problem, but an evasion of it. If Moore were a classical artist like Archipenko (who has a *Seated Nude* of marvellous beauty in the same exhibition), he could have achieved anonymity by generalising all the forms – although he would also have had to change the pose of the moment when the figure, still falling, first touches the ground and begins to roll. As it is, the only way to preserve the anonymity of this work would have been to search in a particular head for the typical – as Rodin did, or indeed as Moore himself has done in the rest of the body. However, this is an important and impressive work. As a practical suggestion, I wonder whether Moore's studies for it might not be exhibited under the auspices of the Campaign for Nuclear Disarmament?

☙

THE HANDS, APPARENTLY, of an old person. Perhaps a woman. Hands, one might guess, which have gardened, washed, cooked, ironed, consoled and dressed babies, fed children, washed many heads of hair.

These hands made a drawing, a copy of a detail from Giovanni Bellini's most famous Pietà. As in the original painting, the head of Mary is pivoted against the head of the dead Christ, as though the two

Moore, *Falling Warrior*, 1956–57

heads were hinged cheek to cheek, and the death on the one had printed the grief on the other. Mary is holding Christ's hand, her forefinger and thumb framing the hole driven through the flesh by the hammered nail.

The copy is faithful but free, intelligently drawn, and full of feeling for the hinged bond of agony between mother and son. It was drawn in 1975 by Henry Moore.

I want to try to liberate us from some of the stereotypes and critical clichés which surround Moore's work five years after his death. These clichés are partly the result of his prestige as Britain's most important twentieth-century international artist, partly the consequence of so many blind glossy colour photos showing reclining figures with holes through them on cultural sites throughout the world, and partly a product of the spite which characterises a great deal of post-modernist opinion-making.

Post-modernism has cut off the present from all futures. The daily media adds to this by cutting off the past. Which means that critical opinion is often orphaned in the present, incapable of seeing beyond shrill and opportunist prejudices.

I want to ask a difficult but fundamental and therefore simple question: What is Henry Moore's art about? What are people across the world likely, in the future, to find in his sculpture? The photograph of his hands may eventually help us.

In history the most common subject for sculpture has been the human body. The link is through the sense of touch. Touch is the most corporeal of the body's five senses and sculptures demand to be touched. In the long run, nothing can change this. It's inscribed in the human imagination that sculpture must push towards the body. (Perhaps Brancusi's work is one of the most beautiful plastic demonstrations of this inherent tendency of the sculptured form to long for breath, to become a body.)

Most of Henry Moore's sculpture concerns the feminine body. Fathers and warriors arrived later, but they were passing. At the beginning and end was woman. Seen how? Seen and dreamt as what? Serving (as all impressive art must) what obsession?

The early drawings from posed models already suggest a clue. With their search to define mass – as distinct from contour or gesture, with their striving for solidity, they are clearly the drawings

of a man who is determined to be a sculptor. But they indicate something more. This artist wants to *hold* the body he is drawing. He does not simply want to read and record it as, say, Raphael might have done. All his energy is directed to making marks on the paper in such a way that the body appears as graspable, as tangible. It is her existence, not her appearance, which obsesses him. Her presence, not her message. He wants her to be *there*, prior to the reading of any sign emanating from her.

His first stone carvings of the early thirties, in which critics found an Aztec influence due to his studying the Mexican collection in the British Museum, express the same hope and the same need. The young woman in *The Girl with Clasped Hands* (1931) is grasping herself as if seeking assurance from her own solidity as proof of existence. The marvellous head and shoulders, in Cumberland alabaster, shows two arms making a circle and the two breasts nosing each other for company. A kind of self-embrace, except that that suggests something too pathetic and too narcissistic. These sculptures cannot be pathetic because they precede the normal language of emotion. They are earlier than sentiment. The consistent underplaying of the features of the face (eyes, mouth, chin, etc.) emphasises this inarticulateness which we might term pre-verbal.

Moore's first geometric, non-figurative sculptures give a similar impression of unmistakable, reassuring, but mute presences. They have little or nothing to do with objects. All of them possess a kind of body warmth.

So where are we? We are before women whose physical presence, whose mass, whose warmth is all. If there is an eroticism about them, it is not addressed to men nor to sexuality as men usually feel it. (Moore's art has always escaped the puritan ban.) Rather his work addresses some vague memory of an experience in which everything was erotic and nothing was identifiable.

The theme of the Mother and Child came very soon. There is a drawing of 1933 in which a child lies curled in the lair of his mother's arms like a hibernating animal. There is a stone-carving of 1936 where the mother and child resemble the knuckles and thumb of a single clenched fist, their eyes as small and insignificant as worm holes in the sand. Works like these announce the principal subject of fifty years of

creativity still to come. Throughout his life, Moore searched – backwards – to find a way of expressing the child's experience of the mother's body.

Put like this, the project sounds simple enough, and yet it can easily be misunderstood. The originality of Moore's obsession and achievement makes it difficult to describe. Sometimes a thing is simpler done than said.

Psychoanalysis has had a considerable influence on our century's art, yet Moore, whose chosen subject was the primary pivotal relation between mother and child, had little or no interest in psychoanalytical theory. He was fascinated not by emotions but by touch: not by the deep unconscious but by surfaces and the tactile.

Imagine a baby carried, as in Africa, on the mother's back, its cheek between her shoulder blades, or, sometimes, lower down, against the small of her back. The surface of this back, like a pasture for the baby's sense of touch, is the creative field of hundreds of Moore's sculptures. Sleeping in the crook of the arm, cheek against the rounded shoulder, is another primary tactile experience of his art. As also the experience of knees, legs somewhat apart, across which the infant lies to be washed or changed. I leave the touched experience of the breast till last, for it is the most clear. In French the word for breast (*sein*) is also the word for womb. In drawings and in clay Moore often played with this duality which is so deeply embedded in our infancy but which adult perception may forget.

Now, however, we come to the most complex and, in a sense, paradoxical aspect of his art. To express these very old, mute, pre-verbal experiences, Moore did not choose (or invent) a primitive sculptural language, like, say, Dubuffet. On the contrary, he chose a classical language which maintained a continuity with Praxiteles or the Renaissance or the Benin bronzes. His extraordinary ability, when he was at his best, to capture the tension of a form (energy pushing outwards from within) and, at the same time, to keep this form always surprising, when the spectator walks around it to discover the always *other* side – this derived from a highly sophisticated and traditional mastery of the art. When he was in his eighties, he still made painstaking drawings of trees or sheep as Mantegna or Géricault might have done. He was both an innovator – because he imported a totally new

aspect of tactile experience into sculpture – and a traditionalist. And this was the only way to do what he wanted to do.

If he had invented a primitive language, the experiences expressed would have remained isolated in infancy. Some works might have prompted memories of things forgotten, but the refound memories could never have become universal. They would have remained local and infantile. What Moore wanted to do – or what the demon of his obsession obliged him to do – was to make space for the infantile within a classical view of the human body. To include the infantile not by way of anecdote or circumstance – with one exception the most deeply maternal of his figures are those where no child is present in the sculpture – but through an evocation of a special way of touching forms and being touched by them.

His figures, however small, all look like giants. Why? They have been perceived, imaginatively, by tiny hands. Their surfaces are like landscapes because they have been felt so close up. Their notorious hollows and holes are sites of a sensation of enclosure, cradling, nuzzling. Before Moore's art, as before nobody else's, we are reminded that we are mammals.

If the recurrent theme of his work is infancy, this is not of course to say that everything Moore did should only be considered in this light. Watteau's recurrent theme was mortality; Rodin's submission; Van Gogh's work; Toulouse-Lautrec's the breaking point between laughter and pity. We are talking about obsessions which determine the gestures and perceptions of artists throughout a life's work, even when their conscious attention is elsewhere. A kind of bias of the imagination. The way a life's work slips towards a theme which is home for that artist.

Moore's work was uneven. He produced, in my opinion, his weakest sculptures during the period when his work was most in demand and most critically unquestioned. I remember that towards the end of the fifties, when I had the temerity to write critically about his latest work, I very nearly lost my job on the *New Statesman*. I was considered a national traitor!

Because of its underlying theme of pre-verbal experience, his work lent itself to a special kind of cultural appropriation. It could easily be covered with words, and so become all things to all men. Its

universality became an alibi for very diverse uses. A Henry Moore became an emblem for Time-Life and, at the same time, for UNESCO!

It's not of course the first time such a thing had happened in the history of art. Fashion and the *beaux-arts* have a tendency to become dancing partners. Only in a work's second life, after its first death, can it insist upon its own terms.

During the fifties and sixties Moore was often distracted by ambition. Or rather – for in reality he remained a modest man – his art was distracted by other people's ambitions for it. It lost sight of its obsession and lent its obsessive language to rhetoric. No energy pushed out from within. *The King and Queen* of 1952–53 is for me a perfect example of this highly productive but comparatively barren period.

By contrast, the last period of Moore's working life – and notably the years when he was in his late seventies or over eighty – was of an incomparable richness. Here he joins the company of Titian or Matisse in the sense that his life's work becomes cumulative, his last works an apogee. At the end he found – magnificently – the way back to what he was always hoping to find.

Let us take the *Mother and Child: Block Seat* (1983–84). The mother is seated. One of her arms is like the arm of an upholstered chair, on which the child balances like a Mexican jumping bean. Her other arm is relaxed, its relatively naturalistic hand hovering above her lap. Both their faces are featureless. The two 'features' which the sculpture possesses are elsewhere. One is the nipple of her left breast, which does not stand up but is a hole like a mouth of a sentient bottle; and the other is a protuberance on the child's face which is like an eventual stopper for that hole, a stanch for that wound, a life for that nourishment.

Moore, *Mother and Child: Block Seat*, 1983–86

I don't like puns, but if I try to approach the emotions generated by this last or almost last sculpture by Henry Moore, I can't get round the

word 'mummy'. Except perhaps for the mother's hand over the lap, all the forms are encased, swathed, bound as were those of the Egyptian dead. Enveloped for eternal survival. There is the same urgent sense of what is within. The sculpture is not, of course, upright and rigid like a mummy in its case, and it includes not a single figure but two. Yet the limbs and bodies have been similarly bound, dressed, handled. Not this time so that they should be hidden and protected, but so that their new exterior surface resembles the close-up of the first body we ever touched.

The last rite of the Egyptian burying ceremony was the opening of the mouth. The son of the deceased, or a priest, solemnly opened the mouth, and this act allowed the dead person who was in the other world to speak, to hear, to move, to see. In Henry Moore's last great work the mouth has become the mother's nipple.

37.

Peter Lazslo Peri
(1899–1967)

I KNEW ABOUT PETER PERI from 1947 onwards. At that time he lived in Hampstead and I used to pass his garden, where he displayed his sculptures. I was an art student just out of the Army. The sculptures impressed me not so much because of their quality – at that time many other things interested me more than art – but because of their strangeness. They were foreign-looking. I remember arguing with my friends about them. They said they were crude and coarse. I defended them because I sensed that they were the work of somebody totally different from us.

Later, between about 1952 and 1958, I came to know Peter Peri quite well and became more interested in his work. But it was always the man who interested me most. By then he had moved from Hampstead and was living in considerable poverty in the old Camden Studios in Camden Town. There are certain aspects of London that I will always associate with him: the soot-black trunks of bare trees in winter, black railings set in concrete, the sky like grey stone, empty streets at dusk with the front doors of mean houses giving straight onto them, a sour grittiness in one's throat, and then the cold of his studio and the smallness of his supply of coffee with which nevertheless he was extremely generous. Many of his sculptures were about the same

aspects of the city. Thus even inside his studio there was little sense of refuge. The rough bed in the corner was not unlike a street bench – except that it had books on a rough shelf above it. His hands were ingrained with dirt as though he worked day and night in the streets. Only the stove gave off a little warmth, and on top of it, keeping warm, the tiny copper coffee saucepan.

Sometimes I suggested to him that we go to a restaurant for a meal. He nearly always refused. This was partly pride – he was proud to the point of arrogance – and partly perhaps it was good sense: he was used to his extremely meagre diet of soup made from vegetables and black bread, and he did not want to disorient himself by eating better. He knew that he had to continue to lead a foreign life.

His face. At the same time lugubrious and passionate. Broad, low forehead, enormous nose, thick lips, beard and moustache like an extra article of clothing to keep him warm, insistent eyes. The texture of his skin was coarse and the coarseness was made more evident by never being very clean. It was the face whose features and implied experience one can find in any ghetto – Jewish or otherwise.

The arrogance and the insistence of his eyes often appealed to women. He carried with him in his face a passport to an alternative world. In this world, which physically he had been forced to abandon but which metaphysically he carried with him – as though a micro-cosm of it was stuffed into a sack on his back – he was virile, wise, and masterful.

I often saw him at public political meetings. Sometimes, when I myself was a speaker, I would recognise him in the blur of faces by his black beret. He would ask questions, make interjections, mutter to himself – occasionally walk out. On occasions he and my friends would meet later in the evening and go on discussing the issues at stake. What he had to say or what he could explain was always incomplete. This was not so much a question of language (when he was excited he spoke in an almost incomprehensible English) as a question of his own estimate of us, his audience. He considered that our experience was inadequate. We had not been in Budapest at the time of the Soviet Revolution. We had not seen how Béla Kun had been – perhaps unnecessarily – defeated. We had not been in Berlin in 1920.

We did not understand how the possibility of a revolution in Germany had been betrayed. We had not witnessed the creeping advance and then the terrifying triumph of Nazism. We did not even know what it was like for an artist to have to abandon the work of the first thirty years of his life. Perhaps some of us might have been able to imagine all this, but in this field Peri did not believe in imagination. And so he always stopped before he had completed saying what he meant, long before he had disclosed the whole of the microcosm that he carried in his sack.

I asked him many questions. But now I have the feeling that I never asked him enough. Or at least that I never asked him the right questions. Anyway, I am not in a position to describe the major historical events which conditioned his life. Furthermore I know nobody in London who is. Perhaps in Budapest there is still a witness left: but most are dead, and of the dead most were killed. I can only speak of my incomplete impression of him. Yet though factually incomplete, this impression is a remarkably total one.

Peter Peri was an exile. Arrogantly, obstinately, sometimes cunningly, he preserved this role. Had he been offered recognition as an artist or as a man of integrity or as a militant anti-fascist, it is possible that he would have changed. But he was not. Even an artist like Kokoschka, with all his Continental reputation and personal following among important people, was ignored and slighted when he arrived in England as a refugee. Peri had far fewer advantages. He arrived with only the distant reputation of being a Constructivist, a militant Communist, and a penniless Jew. By the time I knew him, he was no longer either of the first two, but had become an eternal exile – because only in this way could he keep faith with what he had learned and with those who had taught him.

Something of the meaning of being such an exile I tried to put into my novel *A Painter of Our Time*. The hero of this novel is a Hungarian of exactly the same generation as Peri. In some respects the character resembles Peri closely. We discussed the novel together at length. He was enthusiastic about the idea of my writing it. What he thought of the finished article I do not know. He probably thought it inadequate. Even if he had thought otherwise, I think it would have been impossible for him to tell me. By that time the habit of suffering

inaccessibility, like the habit of eating meagre vegetable soup, had become too strong.

I should perhaps add that the character of James Lavin in this novel is in no sense a *portrait* of Peri. Certain aspects of Lavin derived from another Hungarian émigré, Frederick Antal, the art historian who, more than any other man, taught me how to write about art. Yet other aspects were purely imaginary. What Lavin and Peri share is the depth of their experience of exile.

Peri's work is very uneven. His obstinacy constructed a barrier against criticism, even against comment, and so in certain ways he failed to develop as an artist. He was a bad judge of his own work. He was capable of producing works of the utmost crudity and banality. But he was also capable of producing works vibrant with an idea of humanity. It does not seem to me to be important to catalogue which are which. The viewer should decide this for himself. The best of his works express what he believed in. This might seem to be a small achievement but in fact it is a rare one. Most works which are produced are either cynical or hypocritical – or so diffuse as to be meaningless.

Peter Peri. His presence is very strong in my mind as I write these words. A man I never knew well enough. A man, if the truth be told, who was always a little suspicious of me. I did my best to help and encourage him, but this did not allay his suspicions. I had not passed the tests which he and his true friends had had to pass in Budapest and Berlin. I was a relatively privileged being in a relatively privileged country. I upheld some of the political opinions which he had abandoned, but I upheld them without ever having to face a fraction of the consequences which he and his friends had experienced and suffered. It was not that he distrusted me: it was simply that he reserved the right to doubt. It was an unspoken doubt that I could only read in his knowing, almost closed eyes. Perhaps he was right. Yet if I had to face the kind of tests Peter Peri faced, his example would, I think, be a help to me. The effect of his example may have made his doubts a little less necessary.

Peri suffered considerably. Much of this suffering was the direct consequence of his own attitude and actions. What befell him was not entirely arbitrary. He was seldom a passive victim. Some would say

that he suffered unnecessarily – because he could have avoided much of his suffering. But Peri lived according to the laws of his own necessity. He believed that to have sound reasons for despising himself would be the worst that could befall him. This belief, which was not an illusion, was the measure of his nobility.

38.

Alberto Giacometti
(1901–66)

THE WEEK AFTER Giacometti's death *Paris Match* published a remarkable photograph of him which had been taken nine months earlier. It shows him alone in the rain, crossing the street near his studio in Montparnasse. Although his arms are through the sleeves, his raincoat is hoiked up to cover his head. Invisibly, underneath the raincoat, his shoulders are hunched.

The immediate effect of the photograph, published when it was, depended upon it showing the image of a man curiously casual about his own well-being. A man with crumpled trousers and old shoes, ill-equipped for the rain. A man whose preoccupations took no note of the seasons.

But what makes the photograph remarkable is that is suggests more than that about Giacometti's character. The coat looks as though it has been borrowed. He looks as though underneath the coat he is wearing nothing except his trousers. He has the air of a survivor. But not in the tragic sense. He has become quite used to his position. I am tempted to say 'like a monk', especially since the coat over his head suggests a cowl. But the simile is not accurate enough. He wore his symbolic poverty far more naturally than most monks.

Every artist's work changes when he dies. And finally no one remembers what his work was like when he was alive. Sometimes one can read what his contemporaries had to say about it. The difference of emphasis and interpretation is largely a question of historical development. But the death of the artist is also a dividing line.

It seems to me now that no artist's work could ever have been more changed by his death than Giacometti's. In twenty years no one will understand this change. His work will seem to have reverted to normal – although in fact it will have become something different: it will have become evidence from the past, instead of being, as it has been for the last forty years, a possible preparation for something to come.

The reason Giacometti's death seems to have changed his work so radically is that his work had so much to do with an awareness of death. It is as though his death confirms his work: as though one could now arrange his works in a line leading to his death, which would constitute far more than the interruption or termination of that line – which would, on the contrary, constitute the starting point for reading back along that line, for appreciating his life's work.

You might argue that after all nobody ever believed that Giacometti was immortal. His death could always be deduced. Yet it is the

Henri Cartier-Bresson, *Alberto Giacometti, Paris,* 1961

325

fact which makes the difference. While he was alive, his loneliness, his conviction that everybody was unknowable, was no more than a chosen point of view which implied a comment on the society he was living in. Now by his death the point was proved for him.

This may sound extreme, but despite the relative traditionalism of his actual methods, Giacometti was a most extreme artist. The neo-Dadaists and other so-called iconoclasts of today are conventional window-dressers by comparison.

The extreme proposition on which Giacometti based all his mature work was that no reality – and he was concerned with nothing else except the contemplation of reality – could ever be shared. This is why he believed it impossible for a work to be finished. This is why the content of any work is not the nature of the figure or head portrayed but the incomplete history of *his* staring at it. The act of looking was like a form of prayer for him – it became a way of approaching but never being able to grasp an absolute. It was the act of looking which kept him aware of being constantly suspended between being and the truth.

If he had been born in an earlier period, Giacometti would have been a religious artist. As it was, born in a period of profound and widespread alienation, he refused to escape though religion, which would have been an escape into the past. He was obstinately faithful to his own time, which must have seemed to him rather like his own skin: the sack into which he was born. In that sack he simply could not in all honesty overcome his conviction that he had always been and always would be totally alone.

To hold such a view of life requires a certain kind of temperament. It is beyond me to define that temperament precisely. It was visible in Giacometti's face. A kind of endurance lightened by cunning. If man was purely animal and not a social being, all old men would have this expression. One can glimpse something similar in Samuel Beckett's expression. Its antithesis was what you could see in Le Corbusier's face.

But it is by no means only a question of temperament: it is even more a question of the surrounding social reality. Nothing during Giacometti's lifetime broke through his isolation. Those whom he liked or loved were invited to share it temporarily with him. His basic

situation – in the sack into which he was born – remained unchanged. (It is interesting that part of the legend about him tells of how almost nothing changed or was moved in his studio for the forty years he lived there. And during the last twenty years he continually recommenced the same five or six subjects.) Yet the nature of man as an essentially social being – although it is objectively proved by the very existence of language, science, culture – can only be felt subjectively through the experience of the force of change as result of common action.

Insofar as Giacometti's view could not have been held during any preceding historical period, one can say that it reflects the social fragmentation and manic individualism of the late bourgeois intelligentsia. He was no longer even the artist in retreat. He was the artist who considered society as irrelevant. If it inherited his works it was by default.

But having said all this, the works remain and are unforgettable. His lucidity and total honesty about the consequences of his situation and outlook were such that he could still save and express a truth. It was an austere truth at the final limit of human interest; but his expressing of it transcends the social despair of cynicism which gave rise to it.

Giacometti's proposition that reality is unshareable is true in death. He was not morbidly concerned with the process of death; but he was exclusively concerned with the process of life as seen by a man whose own mortality supplied the only perspective in which he could trust. None of us is in a position to reject this perspective, even though simultaneously we may try to retain others.

I said that his work had been changed by his death. By dying he has emphasised and even clarified the content of his work. But the change – anyway as it seems to me at this moment – is more precise and specific than that.

Imagine one of the portrait heads confronting you as you stand and look. Or one of the nudes standing there to be inspected, hands at her side, touchable only through the thickness of two sacks – hers and yours – so that the question of nakedness does not arise and all talk of nakedness becomes as trivial as the talk of bourgeois women deciding what clothes to wear for a wedding: nakedness is a detail for an occasion that passes.

Imagine one of the sculptures, thin, irreducible, still and yet not

rigid, impossible to dismiss, possible only to inspect, to stare at. If you stare, the figure stares back. This is also true of the most banal portrait. What is different now is how you become conscious of the track of your stare and hers: the narrow corridor of looking between you: perhaps this is like the track of a prayer, if such a thing could be visualised. Either side of the corridor nothing counts. There is only one way to reach her – to stand still and stare. That is why she is so thin. All other possibilities and functions have been stripped away. Her entire reality is reduced to the fact of being seen.

When Giacometti was alive you were standing, as it were, in his place. You put yourself at the beginning of the track of his gaze and the figure reflected his gaze back to you like a mirror. Now that he is dead, or now that you know that he is dead, you take his place rather than put yourself in it. And then it seems that what first moves along the track comes from the figure. It stares, and you intercept the stare. Yet however far back you move along the narrow path, the gaze passes through you.

It appears now that Giacometti made these figures during his lifetime for himself, as observers of his future absence, his death, his becoming unknowable.

39.

Mark Rothko
(1903–70)

It seems to me, after going to Bâle, that Rothko's life's work makes a story, one which is a little like a fable. The story doesn't of course tell the whole truth – what story does? – but perhaps it makes the *essential* truth of his achievement a little clearer.

Marcus is born on 25 September (sign of Balance) 1903, in Drinsk, Russia. Six years later his father emigrates to Portland, Oregon, where he works in the rag trade. In 1913 the whole Rothkowitz family join him, including Marcus. Next year the father dies. At the age of eleven Marcus sells newspapers, but he is brilliant at school and at the age of seventeen he wins a scholarship to Yale. He is interested in philosophy and, more than anything else, in the theatre and music. He does not become seriously interested in painting until his early twenties. He anglicises his name to Mark Rothko in 1940, when he is thirty-seven.

There were how many Jewish emigrant artists of his generation? The number helped to define the twentieth century, which has just ended. Yet Rothko's art is unique in the way it treats emigration – and not only Jewish emigration. Other artists were more nostalgic, more personal, more adventurous, more agonised, but nobody else – or so it seems to

me – saw how the drama of emigration could turn the language of painting inside out. Let me try to explain.

The first commission he ever received – it was in 1927 – was to draw the maps and illustrations for a book, published in New York, entitled *The Graphic Bible: From Genesis to Revelation in Animated Maps and Charts*. (I have never seen it, but its title was perhaps prophetic.)

From the early '30s to 1948 he worked and developed as a painter, and what he produced was sensitive, serious, and avant-garde, but it was not outstanding. Looking back at it now, in the light of his later achievement, this may seen surprising, but it was like that. Even when he began painting his rectangles, what he later called his 'things', he borrowed, I suspect, the first idea for them from either his friend Barnett Newman or his friend Clyfford Still. The colossal originality of what he was about to find was like a Visitation, and it occurred during the following year, 1949, when he was forty-six years old! After that, until his death twenty years later, he never looked back. Or, to be more precise, he did nothing else but look back in a way such as no painter before had ever done!

All previous painting – from the paleolithic caves to modern abstraction – was a reflection upon, or a game with, the visible as found in the existent visible world. The painted forms and colours were often invented, not simply reproduced, yet they all referred, in some way, to what might be imagined after the experience of looking at the world, the visible world. This applies to Rublev or de Kooning. It would also apply to Barnett Newman's colour constructions. Rothko's paintings do, or propose, the opposite. They are about colours or light *awaiting* the creation of the visible world. Their expression is of an intense premonition, as might have occurred in the flash of the Big Bang! (The phrase is rhetorical, and I do not understand how the paintings produce the effect they have; nevertheless I'm sure these painted canvases appear to be *awaiting* the visible world. Not post-factum, but ante-factum.)

Another way of putting this would be to ask whether they do not refer to the very first act of Creation? Whether they are not a quest on canvas for the Beginning, the Origin?

Rothko turned painting inside out because the colours he so laboriously created are waiting to depict things which do not yet exist. And his art is an emigrant art, seeking, as only emigrants do, the unfindable place of origin, the moment before everything began.

In one of his lectures, George Steiner mentions certain rare languages, used I think by nomads, in which the future is thought of as being something *behind* the speaker because it is unknowable and the past is thought of as being in front, because it is traceable and evident. It is in this sense that Rothko looks *ahead* at the one-time beginning.

No one can consider seeing without also thinking about blindness. Rothko's work is very close to blindness. A tragic coloured blindness. The greatest of his canvases are not about going blind, but about trying to take off the blindfolds of colour from which the visible world was (or is again) about to be made!

Am I crazy?

All my love, John

CR

Haute Savoie
6 May 2001

Kut,

Just on a postcard a quotation I found from him:

'If I must place my trust somewhere, I would invest it in the psyche of sensitive observers who are free of the conventions of understanding. I would have no apprehension about the use they would make of these pictures for the needs of their own spirits. For if there is both need and spirit there is bound to be a real transaction.'

Not sure about sensitive, but transaction, yes.

XXX. John

40.

Robert Medley
(1905–94)

ROBERT MEDLEY'S PAINTINGS were deeply admired and esteemed by many of his contemporary painters, and often by those younger than himself, of the next generation. At the same time his work was consistently underestimated or passed over by public institutions, critics, and dealers. Maybe the phenomenon could now be explained, but the explanation would involve analysing neither his work nor his person, but, rather, the pertaining cultural climate of London during the period 1950–80. And interesting though this might be (there was an intrinsic suspicion of Pleasure), his surviving paintings – such as can be seen here – are far *more* interesting. Let's consider them.

What makes Medley's work so rewarding and unusual is its dexterity. Dexterity in its strict sense refers to an inborn or acquired skill in dealing with, or being at home with, the tangible. Something close to the fingertips. (His hands were as important to him as his eyes.) All Medley's work is about touch. Not about caressing – that's another story. Touch, the fifth sense.

Dexterity also implies panache, a quality of gesture. One can think of the cast of a master fly-fisherman. The stance of a prodigious

violinist. The aim from the shoulder of a champion billiards player. Medley's paintings have the concentration and elegance of such performances. Yet their gestures are never self-regarding or manoeuvred. They interact with the world; they do not withdraw from it. They have the modesty to forget themselves. Which is precisely what allows them to possess true elegance.

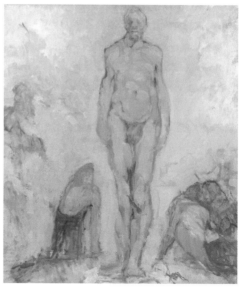

Robert Medley, *Self Portrait after Watteau*, 1980

Today the quality of elegance is usually associated, in some manner, with fashion, success, winning. (About such things he was sardonic.) Yet there are other kinds of elegance. The one, for instance, to which mathematicians refer when talking of solutions. Or the elegance to which the wandering, solitary, haiku writers over three centuries dedicated their extraordinary sensibility and great art.

Lines like these:

> If it were not for their cries
> One wouldn't see the white herons
> Morning of snow
>
> (Chiyo-ni, 1701–75)

Or these:

> She landed on my shoulder
> She's seeking company
> the red dragonfly
>
> (Soseki, 1865–1915)

Such haiku make me think of Robert Medley's paintings. There's the same delight in the tangible world, the same distance from it, and above all, the same knack of getting hold of some horizon and using it as a skipping rope to gig with.

41.

Frida Kahlo
(1907–54)

THEY WERE KNOWN as the Elephant and the Butterfly – although her father called her the Dove. When she died, more than forty years ago, she left behind 150 small paintings, a third of which are classified as self-portraits. He was Diego Rivera and she was Frida Kahlo.

Frida Kahlo! Like all legendary names, it sounds like an invented one, but wasn't. During her lifetime she was a legend, both in Mexico and – amongst a small circle of artists – in Paris. Today she is a world legend. Her story has been told and retold very well – by herself, by Diego, and later by many others. Victim of polio as a child, horribly crippled again in a bus accident, introduced to painting and communism by Diego, their passion, marriage, divorce, remarriage, her love affair with Trotsky, her hatred of the gringos, the amputation of her leg, her probable suicide to escape the pain, her beauty, her sensuality, her humour, her loneliness.

There's an excellent Mexican film about her, directed by Paul Leduc Rosenzweig. There's a beautiful novel by Le Clézio called *Diego and Frida*. There's a fascinating essay by Carlos Fuentes which introduces her Intimate Diary. And there are numerous art-historical texts placing her work in relation to Mexican popular art, surrealism, communism, feminism. Yet I have just seen something – something

you can really see only if you look at the paintings rather than the reproductions. Maybe this thing is so simple, so obvious, that people have taken it for granted. Anyway they don't talk about it. And so here I am, writing.

A few of her paintings are on canvas, the vast majority are either on metal or Masonite, which is as smooth as metal. However fine the grain of a canvas, it resisted and diverted her vision, making her brush-strokes and the contours she drew too painterly, too plastic, too public, too epic, too much like (although still so different from) the Elephant's work. For her vision to remain intact, she needed to paint on a surface as smooth as skin.

Even on days when pain or illness forced her to stay in bed, she spent hours every morning dressing and making her toilette. Every morning, she said, I dress for paradise! Easy to imagine her face in the mirror with her dark eyebrows which naturally joined, and which with her kohl crayon she emphasised and transformed into a black bracket for her two indescribable eyes. (Eyes you remember only if you shut your own!)

In a comparable way, when she painted her pictures, it was *as if* she were drawing, painting, or writing words on her own skin. If this were to happen there would be a double sensitivity, because the surface would also feel what the hand was tracing – the nerves of both leading to the same cerebral cortex. When Frida painted a self-portrait with a little portrait of Diego painted on the skin of her own forehead and on his forehead a painted eye, she was surely confessing – amongst other things – to this dream. With her small brushes, fine as eyelashes, and with her meticulous strokes, every image she made, as soon as she fully became the painter Frida Kahlo, aspired to the sensibility of her own skin. A sensibility sharpened by her desire and exacerbated by her pain.

The corporeal symbolism she used when painting body parts like the heart, uterus, mammary glands, spine, to express her feelings and ontological longing, has been noticed and commented upon many times. She did this as only a woman could, and as nobody else had done before. (Although Diego in his own way sometimes used a similar symbolism.) Yet it is essential to add here that, without her special method of painting, these symbols would have remained

336

surrealist curiosities. And her special method of painting was to do with the sense of touch, with the *double* touch of hand and of surface as skin.

Look at the way she paints hairs, either those on the arms of her pet monkeys or her own along the hair-line of her forehead and temples. Each brush mark grows like a hair from a pore of the body's skin. Gesture and substance are one. In other paintings drops of milk being expressed from a nipple, or drops of blood dripping from a wound, or tears flowing from her eyes, have the same corporeal identity – that is to say the drop of paint does not describe the body liquid but seems to be its double. In a picture called *Broken Column* her body is pierced by nails and the spectator has the impression that she was holding the nails between her teeth and taking them one by one to tap in with a hammer. Such is the acute sense of touch which makes her painting unique.

And so we come to her paradox. How is it that a painter so concentrated on her own image is never narcissistic? People have tried to explain this by quoting Van Gogh or Rembrandt, who both painted numerous self-portraits. But the comparison is facile and false.

It is necessary to return to pain and the perspective in which Frida placed it, whenever it allowed her a little respite. The capacity to feel pain is, her art laments, the first condition of being sentient. The sensitivity of her own mutilated body made her aware of the skin of everything alive – trees, fruit, water, birds, and, naturally, other women and men. And so, in painting her own image, as if on her skin, she speaks of the whole sentient world.

Critics say that Francis Bacon's work was concerned with pain. In his art, however, pain is being watched through a screen, like soiled linen being watched through the round window of a washing machine. Frida Kahlo's work is the opposite of Francis Bacon's. There is no screen; she is close up, proceeding with her delicate fingers, stitch by stitch, making not a dress, but closing a wound. Her art talks to pain, mouth pressed to the skin of pain, and

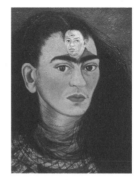

Frida Kahlo, *Diego and I*, 1949

it talks about sentience and its desire and its cruelty and its intimate nicknames.

One finds a comparable intimacy with pain in the poetry of the great living Argentinian poet Juan Gelman.

> that woman begs for alms in a twilight of pots and pans
> that she's washing furiously / with blood / with oblivion /
> to ignite her is like putting a gardel record on the phonograph /
> streets of fire fall from her unbreakable barrio /
>
> and a man and a woman walking tied
> to the apron of pain we put on to wash /
> like my mother washing the floors every day /
> that the day would have a little pearl at its feet.[1]

Much of Gelman's poetry has been written in exile during the 1970s and '80s, and much of it is about the *compañeros* – including his son and daughter-in-law – whom the Junta made *disappear*. It is a poetry in which the martyred come back to share the pain of those bereaving them. Its time is outside time, in a place where pains meet and dance and those suffering grief make their assignations with their losses. Future and past are excluded there as absurd; there is only the present, only the immense modesty of the present which claims everything ever, except lies.

Often the lines of Gelman's poems are punctuated by strokes, which somewhat resemble the beat of the tango – the music of Buenos Aires, his city. But the strokes are also silences which refuse entry to any lie. (They are the visible antithesis to censorship, which is invariably imposed in order to defend a system of lies.) They are a reminder of what pain discovers and what even pain cannot say.

> did you hear me / heart? / we're taking
> defeat someplace else /
> we're taking this animal elsewhere
> our dead / somewhere else /

1 From 'Cherries (to Elizabeth)'. Juan Gelman, *Unthinkable Tenderness*, translated from the Spanish by Joan Lindgren (University of California Press, 1997).

let them make no noise / quiet as they can be / not
even the silence of their bones should be heard /
their bones, little blue-eyed animals /
who sit like good children at table /

who touch pain without meaning to /
saying not a word about their bullet wounds /
with a little gold star and a moon in their mouths /
appearing in the mouths of those they loved[2]

This poetry helps us see something else about Kahlo's paintings, some-
thing that separates them distinctly from Rivera's, or any of her
Mexican contemporaries. Rivera placed his figures in a space which
he had mastered and which belonged to the future; he placed them
there like monuments: they were painted for the future. And the future
(although not the one he imagined) has come and gone and the
figures have been left behind alone. In Kahlo's paintings there was no
future, only an immensely modest present which claimed everything
and to which the things painted momentarily return whilst we look,
things which were already memories before they were painted, memo-
ries of the skin.

So we return to the simple act of Frida putting pigment on the
smooth surfaces she chose to paint on. Lying in bed or cramped in her
chair, a minute brush in her hand, which had a ring on every finger,
she remembered what she had touched, what was there when the pain
wasn't. She painted, for example, the feel of polished wood on a
parquet floor, the texture of rubber on the tyre of her wheelchair, the
fluff of a chick's feathers, or the crystalline surface of a stone, like
nobody else. And this discreet capacity – for it was very discreet – came
from what I have called the sense of double touch: the consequence of
imagining she was painting her own skin.

There's a self-portrait (1943) where she lies on a rocky landscape
and a plant grows out of her body, her veins joining with the veins of
its leaves. Behind her, flattish rocks extend to the horizon, a little like
the waves of a petrified sea. Yet what the rocks are *exactly* like is what

2 From 'Somewhere Else'. Juan Gelman, ibid.

she would have felt on the skin of her back and legs if she had been lying on those rocks. Frida Kahlo lay cheek to cheek with everything she depicted.

That she became a world legend is in part due to the fact that in the dark age in which we are living under the new world order, the sharing of pain is one of the essential preconditions for a refinding of dignity and hope. Much pain is unshareable. But the will to share pain is shareable. And from that inevitably inadequate sharing comes a resistance.

Listen again to Gelman:

> hope fails us often
> grief, never.
> that's why some think
> that known grief is better
> than unknown grief.
> they believe that hope is illusion.
> they are deluded by grief.[3]

Kahlo was not deluded. Across her last painting, just before she died, she wrote, 'Viva La Vida'.

3 From 'The Deluded'. Juan Gelman, ibid.

42.

Francis Bacon
(1909–92)

IT HAS ALWAYS been Francis Bacon's very considerable reputation – not his work – which has puzzled me. Now, having thought a good deal about his six new paintings at the Hanover Gallery, I think that I begin to see the matter a little more clearly.

Three of these paintings are of a Pope (Innocent X from the Velázquez portrait) sitting on his throne, inside a glass case in a black box-like room. (In two of them the features of the Pope's face 'dissolve' into a scream.) The fourth painting is a portrait of Mr Lucien Freud – also in a glass case and box; the fifth is of a paleo-lithic man doubled up in front of a grey curtain; and the sixth – smaller than the other, large ones – is of a human doing something to an ape in the zoo.

The really impressive thing about these pictures is that they *exist*. Nor is that such a stupid statement as it sounds. Many contemporary paintings are fragmentary and inconclusive so that, like overheard conversations, their power depends on their context. They barely exist in their own right. These paintings by Bacon do exist in their own right, and indeed have a uniquely convincing presence which their startling, unlikely subject matter somehow makes even more convinc-ing. One watches them, hypnotised as an agnostic might be hypnotised

by some ectoplasmic manifestation at a séance – and, in fact, the way that the greyish figures materialise out of the dark, detailed in some places and almost lost in others, is reminiscent of such an affair.

Yet the reasons for the power of their presence are, when combined, the very reasons why in my opinion Bacon is a very remarkable but not finally important painter – why he is really outside the main tradition. These paintings are haunting because Bacon is a brilliant stage manager, rather than an original visual artist; and because their emotion is concentratedly and desperately private.

I say that Bacon is a brilliant stage manager rather than an original artist because there is no evidence in his work of any visual discovery, but only of imaginative and skillful arrangement. The objects in his pictures are chosen for the meaning they already have and this meaning is then given a twist by their odd juxtaposition. No new meaning is added in the actual process of painting them. Looking at the painting of the Pope one is not made aware, in some newly vivid way, of the construction of the human head or of the possible vibration of two colours; instead, one is fascinated by a particular dramatic focus; one's eye travels across open areas of black paint on unprimed canvas and is then held by an intensely staring head, painted with grey paint mixed with sand so that it has the acrid quality of cigarette ash. One notices the folds in the curtains and robe, not because they really qualify the form underneath, but because their shadows are startlingly and sometimes fearfully suggestive. All this, however, is necessary if the paintings are to exercise their immediate hypnotic power. If, for example, the edges of the glass case emphasised too originally the space they contained, one would forget the usual associations of glass cases and the spell would be broken.

Everything then depends upon the content of the pictures and, since most of them are horrific, on the meaning of horror, disgust, and loneliness. Here it is impossible to be dogmatic, but for myself I believe that Bacon's interpretation of such suffering and disintegration is too egocentric, that he describes horror with connivance – that his descriptions lack not only the huge perspective of compassion but even the smaller perspective of indignation. I feel myself that the Pope screams not because of the state of his conscience or the state of the world but, puppet-like, simply because he has been put into

Bacon's glass case. And again, if this is true, it explains the hypnotic power of the paintings. The spectator watches as at the Grand Guignol, fascinated because, in a sense, made cosy – the horror is stimulating because it is remote, because it belongs to a life removed from the normal world.

If Bacon's paintings began to deal with any of the real tragedy of our time, they would shriek less, they would be less jealous of their horror, and they would never hypnotise us, because we, with all conscience stirred, would be too much involved to afford that luxury.

<p style="text-align:center">☙</p>

A BLOOD-STAINED FIGURE on a bed. A carcass with splints on it. A man on a chair smoking. One walks past his paintings as if through some gigantic institution. A man on a chair turning. A man holding a razor. A man shitting.

What is the meaning of the events we see? The painted figures are all quite indifferent to one another's presence or plight. Are we, as we walk past them, the same? A photograph of Bacon with his sleeves rolled up shows that his forearms closely resemble those of many of the men he paints. A woman crawls along a rail like a child. In 1971, according to the magazine *Connaissance des Arts,* Bacon became the first of the top ten most important living artists. A man sits naked with torn newspaper around his feet. A man stares at a blind cord. A man reclines in a vest on a stained red couch. There are many faces which move, and as they move they give an impression of pain. There has never been painting quite like this. It relates to the world we live in. But how?

To begin with a few facts:

1. Francis Bacon is the only British painter this century to have gained an international influence.

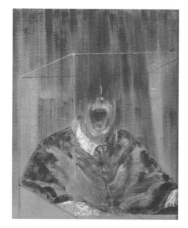

Francis Bacon, *Head VI*, 1949

2. His work is remarkably consistent, from the first paintings to the most recent. One is confronted by a fully articulated worldview.

3. Bacon is a painter of extraordinary skill, a master. Nobody who is familiar with the problems of figurative oil-painting can remain unimpressed by his solutions. Such mastery, which is rare, is the result of great dedication and extreme lucidity about the medium.

4. Bacon's work has been unusually well written about. Writers such as David Sylvester, Michel Leiris, and Lawrence Gowing have discussed its internal implications with great eloquence. By 'internal' I mean the implications of its own propositions within its own terms.

Bacon's work is centred on the human body. The body is usually distorted, whereas what clothes or surrounds it is relatively undistorted. Compare the raincoat with the torso, the umbrella with the arm, the cigarette stub with the mouth. According to Bacon himself, the distortions undergone by face or body are the consequence of his searching for a way of making the paint 'come across directly on to the nervous system'. Again and again, he refers to the nervous system of painter and spectator. The nervous system for him is independent of the brain. The kind of figurative painting which appeals to the brain he finds illustrational and boring.

'I've always hoped to put over things as directly and rawly as I possibly can, and perhaps if a thing comes across directly, they feel that it is horrific.'

To arrive at this rawness which speaks directly to the nervous system, Bacon relies heavily on what he calls 'the accident'. 'In my case, I feel that anything I've ever liked at all has been the result of an accident on which I've been able to work.'

The 'accident' occurs in his painting when he makes 'involuntary marks' upon the canvas. His 'instinct' then finds in these marks a way of developing the image. A developed image is one that is both factual and suggestive to the nervous system.

'Isn't it that one wants a thing to be as factual as possible, and yet at the same time as deeply suggestive or deeply unlocking of areas of

sensation other than simple illustrating of the object that you set out to do? Isn't that what art is all about?'

For Bacon the 'unlocking' object is always the human body. Other things in his painting (chairs, shoes, blinds, lamp switches, newspapers) are merely illustrated.

'What I want to do is to distort the thing far beyond appearance, but in the distortion to bring it back to recording of the appearance.'

Interpreted as process, we now see that this means the following. The appearance of a body suffers the accident of involuntary marks being made upon it. Its distorted image then comes across directly on to the nervous system of the viewer (or painter), who rediscovers the appearance of the body through or beneath the marks it bears.

Apart from the inflicted marks of the painting-accident there are also sometimes *painted marks* on a body or a mattress. These are, more or less obviously, traces of body fluids – blood, semen, perhaps shit. When they occur, the stains on the canvas are like stains on a surface which has actually touched the body.

The double-meaning of the words which Bacon has always used when talking about his painting ('accident', 'rawness', 'marks'), and perhaps even the double-meaning of his own name, seem to be part of the vocabulary of an obsession, an experience which probably dates back to the beginning of his self-consciousness. There are no alternatives offered in Bacon's world, no ways out. Consciousness of time or change does not exist. Bacon often starts working on a painting from an image taken from a photograph. A photograph records for a moment. In the process of painting, Bacon seeks the accident which will turn that moment into all moments. In life, the moment which ousts all preceding and following moments is most commonly a moment of physical pain. And pain may be the ideal to which Bacon's obsession aspires. Nevertheless, the content of his paintings, the content which constitutes their appeal, has little to do with pain. As often, the obsession is a distraction and the real content lies elsewhere.

Bacon's work is said to be an expression of the anguished loneliness of Western man. His figures are isolated in glass cases, in arenas of pure colour, in anonymous rooms, or even just within themselves. Their isolation does not preclude their being watched. (The triptych

form, in which each figure is isolated within his own canvas and yet is visible to the others, is symptomatic.) His figures are alone, but they are utterly without privacy. The marks they bear, their wounds, look self-inflicted. But self-inflicted in a highly special sense. Not by an individual but by the species, Man – because, under conditions of such universal solitude, the distinction between individual and species becomes meaningless.

Bacon is the opposite of an apocalyptic painter who envisages the worst is likely. For Bacon, the worst has already happened. The worst that has happened has nothing to do with the blood, the stains, the viscera. The worst is that man has come to be seen as mindless.

The worst had already happened in the *Crucifixion* of 1944. The bandages and the screams are already in place – as also is the aspiration towards ideal pain. But the necks end in mouths. The top half of the face does not exist. The skull is missing.

Later, the worst is evoked more subtly. The anatomy is left intact, and man's inability to reflect is suggested by what happens around him and by his expression – or lack of it. The glass cases, which contain friends or a Pope, are reminiscent of those in which animal behaviour patterns can be studied. The props, the trapeze chairs, the railings, the cords are like those with which cages are fitted. Man is an unhappy ape. But if he knows it, he isn't. And so it is necessary to show that man cannot know. Man is an unhappy ape without knowing it. It is not a brain but a perception which separates the two species. This is the axiom on which Bacon's art is based.

During the early 1950s, Bacon appeared to be interested in facial expressions. But not, as he admits, for what they expressed.

'In fact, I wanted to paint the scream more than the horror. And I think if I had really thought about what causes somebody to scream – the horror that produces a scream – it would have made the screams that I tried to paint more successful. In fact, they were too abstract. They originally started through my always having been very moved by movements of the mouth and the shape of the mouth and the teeth. I like, you may say, the glitter and colour that comes from the mouth, and I've always hoped in a sense to be able to paint the mouth like Monet painted a sunset.'

346

In the portraits of friends like Isabel Rawsthorne, or in some of the new self-portraits, one is confronted with the expression of an eye, sometimes two eyes. But study these expressions; read them. Not one is self-reflective. The eyes look out from their condition, dumbly, onto what surrounds them. They do not know what has happened to them, and their poignancy lies in their ignorance. Yet what has happened to them? The rest of their faces have been contorted with expressions which are not their own – which, indeed, are not expressions at all (because there is nothing behind them to be expressed), but are events created by accident in collusion with the painter.

Not altogether by accident, however. Likeness remains – and in this Bacon uses all his mastery. Normally, likeness defines character, and character in man is inseparable from mind. Hence the reason why some of these portraits, unprecedented in the history of art, although never tragic, are very haunting. We see character as the empty cast of a consciousness that is absent. Once again, the worst has happened. Living man has become his own mindless spectre.

In the larger figure-compositions, where there is more than one personage, the lack of expression is matched by the total unreceptivity of the other figures. They are all proving to each other, all the time, that they can have no expression. Only grimaces remain.

Bacon's view of the absurd has nothing in common with existentialism, or with the work of an artist like Samuel Beckett. Beckett approaches despair as a result of questioning, as a result of trying to unravel the language of the conventionally given answers. Bacon questions nothing, unravels nothing. He accepts the worst has happened.

His lack of alternatives, within his view of the human condition, is reflected in the lack of any thematic development in his life's work. His progress, during thirty years, is a technical one of getting the worst into sharper focus. He succeeds, but at the same time the reiteration makes the worst less credible. That is his paradox. As you walk through room after room it becomes clear that you can live with the worst, that you can go on painting it again and again, that you can turn it into more and more elegant art, that you can put velvet and gold frames round it, that other people will buy it to hang on the walls of

the rooms where they eat. It begins to seem that Bacon may be a charlatan. Yet he is not. And his fidelity to his own obsession ensures that the paradox of his art yields a consistent truth, though it may not be the truth he intends.

Bacon's art is, in effect, conformist. It is not with Goya or the early Eisenstein that he should be compared, but with Walt Disney. Both men make propositions about the alienated behaviour of our societies, and both, in a different way, persuade the viewer to accept what is. Disney makes alienated behaviour look funny and sentimental and, therefore, acceptable. Bacon interprets such behaviour in terms of the worst possible having already happened, and so proposes that both refusal and hope are pointless. The surprising formal similarities of their work – the way limbs are distorted, the overall shapes of bodies, the relation of figures to background and to one another, the use of neat tailor's clothes, the gesture of hands, the range of colours used – are the result of both men having complementary attitudes to the same crisis.

Disney's world is also charged with vain violence. The ultimate catastrophe is always in the offing. His creatures have both personality and nervous reactions; what they lack (almost) is mind. If, before a cartoon sequence by Disney, one read and believed the caption *There is nothing else*, the film would strike us as horrifically as a painting by Bacon.

Bacon's paintings do not comment, as is often said, on any actual experience of loneliness, anguish, or metaphysical doubt; nor do they comment on social relations, bureaucracy, industrial society, or the history of the twentieth century. To do any of these things they would have to be concerned with consciousness. What they do is to demonstrate how alienation may provoke a longing for its own absolute form – which is mindlessness. This is the consistent truth demonstrated, rather than expressed, in Bacon's work.

☙

VISIT THE FRANCIS BACON exhibition at the Maillol Museum in Paris. Read Susan Sontag's book *Regarding the Pain of Others*. The exhibition represents succinctly a long life's work. The book is a remarkably probing meditation about war, physical mutilation, and

the effect of war photographs. Somewhere in my mind the book and exhibition refer to one another. I'm not yet sure how.

As a figurative painter, Bacon had the cunning of a Fragonard. (The comparison would have amused him, and both were accomplished painters of physical sensation – one of pleasure and the other of pain.) Bacon's cunning has understandably intrigued and challenged at least two generations of painters. If during fifty years I have been critical of Bacon's work, it is because I was convinced he painted in order to shock, both himself and others. And such a motive, I believed, would wear thin with time. Last week, as I walked backwards and forwards before the paintings in the rue de Grenelle, I perceived something I'd not understood before, and I felt a sudden gratitude to a painter whose work I'd questioned for such a long while.

Bacon's vision from the late 1930s to his death in 1992 was of a pitiless world. He repeatedly painted the human body or parts of the body in discomfort or want or agony. Sometimes the pain involved looks as if it has been inflicted, more often it seems to originate from within, from the guts of the body itself, from the misfortune of being physical. Bacon consciously played with his name to create a myth and he succeeded in this. He claimed descent from his namesake, the sixteenth-century English empiricist philosopher, and he painted human flesh as if it were a rasher of bacon.

Yet it is not this which makes his world more pitiless than any painted before. European art is full of assassinations, executions, and martyrs. In Goya, the first artist of the twentieth century (twentieth, yes), one listens to the artist's own outrage. What is different in Bacon's vision is that there are no witnesses and there is no grief. Nobody painted by him notices what is happening to somebody else painted by him. Such ubiquitous indifference is crueller than any mutilation.

In addition there is the muteness of the settings in which he places his figures. This muteness is like the coldness of a freezer, which remains constant whatever is deposited in it. Bacon's theatre, unlike Artaud's, has little to do with ritual, because no space around his figures receives their gestures. Every enacted calamity is presented as a mere collateral accident.

349

During his lifetime such a vision was nourished and haunted by the melodramas of a very provincial bohemian circle, within which nobody gave a fuck about what was happening elsewhere. And yet . . . and yet the pitiless world Bacon conjured up and tried to exorcise has turned out to be prophetic. It can happen that the personal drama of an artist reflects within half a century the crisis of an entire civilisation. How? Mysteriously.

Has not the world always been pitiless? Today's pitilessness is perhaps more unremitting, pervasive, and continuous. It spares neither the planet itself nor anyone living on it anywhere. Abstract because deriving from the sole logic of the pursuit of profit (as cold as the freezer), it threatens to make obsolete all other sets of belief, along with their traditions of facing the cruelty of life with dignity and some flashes of hope.

Return to Bacon and what his work reveals. He obsessively used the pictorial language and thematic references of some earlier painters – such as Velázquez, Michelangelo, Ingrès, or Van Gogh. This 'continuity' makes the devastation of his vision more complete.

The Renaissance idealisation of the naked human body, the Church's promise of redemption, the classical notion of heroism, or Van Gogh's ardent nineteenth-century belief in democracy are revealed within his vision to be in tatters, powerless before the pitilessness. Bacon picks up the shreds and uses them as swabs. This is what I had not taken in before. Here was the revelation.

A revelation which confirms an insight: to engage today with the traditional vocabulary, as employed by the powerful and their media, only adds to the surrounding murkiness and devastation. This does not necessarily mean silence. It means choosing the voices one wishes to join.

The present period of history is one of the Wall. When the Berlin one fell, the prepared plans to build walls everywhere were unrolled. Concrete, bureaucratic, surveillance, security, racist walls. Everywhere the walls separate the desperate poor from those who hope against hope to stay relatively rich. The walls cross every sphere, from crop cultivation to health care. They exist too in the richest metropolises of the world. The Wall is the front line of what, long ago, was called the Class War.

On the one side: every armament conceivable, the dream of no-body-bag wars, the media, plenty, hygiene, many passwords to glamour. On the other: stones, short supplies, feuds, the violence of revenge, rampant illness, an acceptance of death, and an ongoing preoccupation with surviving one more night – or perhaps one more week – together.

The choice of meaning in the world today is here between the two sides of the wall. The wall is also inside each one of us. Whatever our circumstances, we can choose within ourselves which side of the wall we are attuned to. It is not a wall between good and evil. Both exist on both sides. The choice is between self-respect and self-chaos.

On the side of the powerful there is a conformism of fear – they never forget the Wall – and the mouthing of words which no longer mean anything. Such muteness is what Bacon painted.

On the other side there are multitudinous, disparate, sometimes disappearing, languages, with whose vocabularies a sense can be made of life, even if, particularly if, that sense is tragic.

When my words were wheat
I was earth.
When my words were anger
I was storm.

Francis Bacon, *Two Figures in a Room*, 1959

When my words were rock
I was river.
When my words turned honey
Flies covered my lips.

<div align="right">Mahmoud Darwish</div>

Bacon painted the muteness fearlessly, and in this was he not closer to those on the other side, for whom the walls are one more obstacle to get around? It could be . . .

43.

Renato Guttuso
(1911–87)

Renato Guttuso, *The Battle of Ponte dell'Ammiraglio*, 1955

'ONE CAN ONLY grow through obligations.' This remark of Saint-Exupéry's sums up the argument for Renato Guttuso's large painting of Garibaldi and his Thousand fighting their way to Palermo. First seen in this year's Biennale at Venice, this picture was outstanding among many more suave works, because it so obviously implied an ambitious and compelling sense of obligation. The unprejudiced visitor was forced to admit that it had been painted to serve something beyond the artist's own reputation, and that his aesthetic sensibility

was a talent properly used – not the *raison d'être* of the work itself. The same could of course be said of any good recruiting poster, but it is also true that no tradition or single masterpiece has ever been produced without such a sense of service. It is significant, for example, that Picasso has never surpassed *Guernica*, nor Henry Moore produced such profound drawings as those he did in the tube shelters during the war. In periods less revolutionary than our own, the artist has simply been able to serve a general, diffused way of life, but today, if his attitude (intuitive or conscious) is vital enough to admit the necessary interaction between art and life, it is almost inevitable that he will see his cause as an urgent one. Even as sheltered a painter as Bonnard has had to express his faith in sensuous domesticity in a way which, for all its marvellous subtleties, is strident compared to that of Chardin or Velázquez.

I emphasise this point because in the present climate of the arts, in which only aesthetic considerations are above suspicion, it is liable to be forgotten; because it counters the superficial and over-sophisticated charge that Guttuso's painting is merely a propaganda affair of toy-soldier heroics; and also because it explains the actual strength and weakness of the picture itself.

Guttuso, who was born in Palermo in 1911, has always been aware of the inherent connection between art and politics: politics being used in the broadest sense of the word to describe that struggle of social forces which underlies any particular social order. In 1931, when working in Rome, he reacted strongly against the neo-classicism being encouraged by the Fascists. (It is perhaps worth restating here that the various aesthetic theories of formalisation and abstraction – such as are implied in Guttuso's earlier work – were all, in their own time, necessary, socially significant reactions against sterile, reaction-ary formulae. It is only within the last ten or fifteen years that the once avant-garde movements have lost their revolutionary vitality and become the new academic.)

In 1942 he painted a notorious anti-clerical crucifixion, and later, having fought in the Resistance movement, produced a series of works in protest against the Nazi massacres in Italy. In 1944 these were published in book form under the title *Gott mit uns*. After the war the example of his own work and his newspaper articles made

354

him one of the acknowledged leaders of the Italian Social Realist movement. There is no space here to discuss the movement in detail, but this painting, which is its latest culmination, may suggest its essential character. The choice of subject indicates the popular but contemporarily relevant appeal at which the movement aims, while the obvious influences of Caravaggio, Courbet, and (in the simplification of various forms) Picasso give some idea of its more immediate historical basis.

The reproduction of the *Garibaldi* painting is somewhat deceptive. One loses the sense of scale – all the foreground figures are life-size – and, even more important, one loses the main rhythm of the composition. This is based on the violent conflict of red and blue uniforms against a brown-green background. But because this contrast is in terms of colour rather than tone, it is lost in a black-and-white reproduction, and, instead, the light tones of the sabres, distant sea, and foreground garments become over-insistent and confusing. One also misses the impressive vigour and directness with which the pigment itself has been applied. These shortcomings, however, need not confuse the main argument: the argument that it was the painter's overwhelming sense of purpose which made this picture the outstanding contemporary work of the Biennale.

Firstly, there is the complexity of the painting: the confidence and ambition which has inspired Guttuso, despite the contemporary fashion for single poses, and for the exquisite placing of the minimum number of objects, to tackle thirty-five figures, five horses, and the ground-plan of an elaborate landscape; also, to welcome problems of acute foreshortening, violent movement, and the whole organisation of action – not on a single plane, like a frieze, but in full three-dimensional space.

Secondly, there is its vigour – its broad, generous, unsuperstitious energy. This can be seen in formal terms, if one observes how in any passage the disposition of the large forms, however complicated spatially or logically, is never cramped or mean but always sturdily, easily, balanced. It can also be seen in the way in which the interest remains constant and even. There are no obsessive details, no special little passages of virtuoso. Everything is related (without being evasively formalised) to the unity of the whole conception.

Lastly, there is the human attitude. Guttuso has sufficiently identified himself with his subject never to be sentimental. The facts of hand-to-hand fighting are faced up to. The dead are neither peaceful nor glorious. He recognises that only the inevitability of sacrifice can make it heroic.

But just as these qualities are directly related to the artist's sense of purpose, so are the serious failures. Because as yet Guttuso's conviction has not been entirely translated into terms of paint, his enthusiasm – as a man, not a painter – allows him to ignore many weak details of drawing and structure. For someone who is able to articulate a figure as subtly as Guttuso it can only be impatience, not a lack of talent, which causes him to leave uncorrected a figure as crude, for example, as that of the man with arms raised above him on the bridge. Until Guttuso's convictions as man and painter are fully integrated, similar crudities will always impair his work and such passages be justifiably reminiscent of the recruiting poster. But even a recruiting poster can lead to greater achievement, in every sense, than an *objet d'art*.

<div align="center">∞</div>

BENEDICT NICOLSON: *Many people have been to see the twenty recent oil paintings – some of them large – by Guttuso at the Leicester Galleries. Whether the reaction to them has been favourable or unfavourable, everyone must have felt that here was something new. Here is a welcome change from the now monotonous exhibitions of formalist clichés.*

JOHN BERGER: I agree; but this exhibition isn't, of course, just a novelty. It demonstrates in practice long-standing socialist theories of art, and is also linked with the whole tradition of European humanism. But you are right insofar as Guttuso's work sets a new example. And this, I believe, is one of his conscious intentions. He paints as Corbusier builds – in order to teach, to challenge other artists.

Apart from his desire to teach, he has also surely the desire to communicate to a mass audience. I believe he has this audience constantly in mind and that this conditions the nature of his work. This is important, because the same cannot be said of the best art of the last seventy years

or so, when artists have been grateful for recognition but have never modified their style in order to obtain it.

Certainly it is true that those most concerned with mass communication have been those dealing in commercial 'culture'. And what I find of revolutionary importance in Guttuso's work is that his desire to communicate with a popular audience is combined with his acceptance of the discoveries of the modern Masters.

I would go further and suggest he could never have become a serious artist at all without having assimilated the modern movements. I think you are quite correct to stress in the preface to the catalogue that he stems from the two most productive styles of our time: Cubism and Expressionism – not from just one.

Obviously modern forms are needed to express contemporary reality. But what makes his work significant is his grasp of that reality – not just his style. It is Guttuso's understanding of our historical and social position which finally enables his anger, his compassion, his sense of human dignity, to be applied to subjects which can fully justify them.

I see that you have a different idea from myself of what constitutes significant human subjects. You insist on confining these to the heroic actions of the working class. Surely their struggles are no more stirring as a subject for art than the struggle of other classes.

There is no other class struggle, only resistance to that of the working class. The social crisis in which we live is the result of the crumbling of the position and the values of the upper and middle classes. And I think the obscurity and remoteness of so much contemporary art, to which you referred, is closely bound up with this. I believe that only those who identify themselves with the vigour of the class which will take their place can have the confidence and perspective to allow their full human feelings to develop. These can then be applied to absolutely any subject.

But this is precisely what Guttuso fails to do. Take his picture Boogie-Woogie in Rome. A nightclub of bourgeois students jiving. You would have thought he would have shown some sympathy towards ebullient teenagers. But not at all. He paints their frustration, their

corruption. He satirises American infiltration by a Mondrian on the wall. I submit that it is because they were unfortunate enough not to belong to the correct class that he treated them with such dismal lack of sympathy.

Nonsense. If you look at the faces of the adolescents – the girl who hasn't got a boy, for example – you will find considerable sympathy for their predicaments and a recognition of the vitality of their youth. What he satirises is the cult that misleads and, as you rightly say, frustrates them.

Yes, but Guttuso would never depict corruption among the workers.

Here one must consider the pattern of the facts. Arbitrarily isolated facts can only lead to triviality in art. When one talks of an artist expressing his time one means that he has seized upon what is typical, not incidental. Of course, there are individual corrupt workers. Of course, there are decent bourgeois. But the fact remains that it is the peasants in Italy who remain undernourished, the working class who, in their struggle for their rights, get shot, and the bourgeoisie who connive.

I think you exaggerate. We must disagree here. Simply because I attach more importance than you do to individual morality. But I do agree – and this is the vital point – that the nobility and grandeur of Guttuso's pictures are the direct outcome of his political and social convictions. Look at the Dead Worker; *he lies stretched out on his bed like Mantegna's* Dead Christ. *It is an intensely moving picture, precisely because of the artist's identification with the man's suffering.*

One can only yield oneself to something which one has entirely assimilated. The fact that Guttuso can identify himself so completely with a dead worker is proof of how personally and how individually he embraces his morality. But this identification is only the means of his and our being moved. What is finally moving is the truth of the scene – the limp white sheets that covered so much pain, the grief of the man's comrades and family. A work of art is moving in direct ratio to the degree to which it extends our experience of significant, objective facts.

Guttuso, *Death of a Hero*, 1953

Come now! Some facts which are not 'significant' in your sense, and some purely personal sensations, are rich material for art. All that matters is that the artist should believe them and convince us of the authenticity of his sensations. It would be foolish to argue that Van Gogh was less significant as an artist when expressing intensely personal emotions than when gearing his sensations to some social ideal.

I entirely disagree. The most moving Van Goghs are precisely those in which his intense emotions are applied to objective reality. It was because his own over-personal sensations finally smothered his vision that he killed himself. One day his work will be reassessed in the light of this fact. When, however, Van Gogh said that he wanted to paint a landscape as it would strike the postman walking across it, his attitude was very similar to Guttuso's, who views the world objectively and is only romantic in the fervour of his expression. It is the everyday life of Italy, the carrying in of the weight of the harvest, the determination of the miner, the setting up of telegraph poles through a landscape, the terracing of the hills, that Guttuso celebrates.

But what about the quality of the celebration? There seems at times to be a crudity in both draughtmanship and colour which is difficult to explain in so accomplished an artist. I accept the harshness of his Heroine of the Fight for the Land *as I would accept a Soutine. But compare his miner with the equivalent Géricaults from which it partly*

359

derives, or his cactus landscape with a Fauve Derain. Is there any reason besides incompetence why they should be clumsier?

Certain passages may be clumsy and insufficiently worked out. But there are plenty of reasons for this. It is easy to be sensitive and illegible. The problem of bringing the tradition of modern art out of the museum almost single-handed; the problem of interpreting contemporary events with all their haste and urgency, in a way which adds up to something far more profound than rapportage and makes them legendary; the problem of painting with an insistent clarity that is not the result of over-simplification – look at the seizing arm of the Magnani-like woman on a ladder in *The Flood* – these problems are formidable. Compare the Guttusos with the Moynihans in the next room. Simply in terms of drawing, the difference is that between blowing smoke-rings and struggling like a wainwright to fashion a wheel that will turn.

However much we may differ in our interpretation, we seem to agree that the exhibition is an encouraging indication that art is being re-born.

44.

Jackson Pollock
(1912–56)

IN A PERIOD of cultural disintegration – such as ours in the West today –
it is hard to assess the value of an individual talent. Some artists are
clearly more gifted than others, and people who profoundly under-
stand their particular media ought to be able to distinguish between
those who are more and those who are less gifted. Most contemporary
criticism is exclusively concerned with making this distinction; on the
whole, the critic today accepts the artist's aims (so long as they do not
challenge his own function) and concentrates on the flair or lack of it
with which they have been pursued. Yet this leaves the major question
begging: How far can talent exempt an artist if he does not think beyond
or question the decadence of the cultural situation to which he belongs?

Perhaps our obsession with genius, as opposed to talent, is an
instinctive reaction to this problem, for the genius is by definition a
man who is in some way or another larger than the situation he inher-
its. For the artist himself the problem is often deeply tragic; this was
the question, I believe, which haunted men like Dylan Thomas and
John Minton. Possibly it also haunted Jackson Pollock and may partly
explain why in the last years of his life he virtually stopped painting.

Pollock was highly talented. Some may be surprised by this. We have
seen the consequences of Pollock's now famous innovations – thousands

of Tachiste and Action canvases crudely and arbitrarily covered and 'attacked' with paint. We have heard the legend of Pollock's way of working: the canvas on the floor, the paint dripped and flung onto it from tins; the delirium of the artist's voyage into the unknown, etc. We have read the pretentious incantations written around the kind of painting he fathered. How surprising it is then to see that he was, in fact, a most fastidious, sensitive, and 'charming' craftsman, with more affinities with an artist like Beardsley than with a raging iconoclast.

His best canvases are large. One stands in front of them and they fill one's field of vision: great walls of silver, pink, new gold, pale blue nebulae seen through dense skeins of swift dark or light lines. It is true that these pictures are not composed in the Renaissance sense of the term; they have no focal centre for the eye to travel towards or away from. They are designed as continuous surface patterns which are perfectly unified without the use of any obvious repeating motif. Nevertheless their colour, their consistency of gesture, the balance of their tonal weights all testify to a natural painter's talent. The same qualities also reveal that Pollock's method of working allowed him, in relation to what he wanted to do, as much control as, say, the Impressionist method allowed the Impressionists.

Pollock, then, was unusually talented and his paintings can delight the sophisticated eye. If they were turned into textile design or wallpapers they might also delight the unsophisticated eye. (It is only the sophisticated who can enjoy an isolated, single quality removed from any normal context and pursued for its own sake – in this case the quality of abstract decoration.) But can one leave the matter there?

It is impossible. Partly because his influence as a figure standing for something more than this is now too pressing a fact to ignore, and partly because his paintings must also be seen – and were probably intended – as images. What is their content, their meaning? A well-known museum curator, whom I saw in the gallery, said, 'They're *so* meaningful.' But this, of course, was an example of the way in which qualitative words are now foolishly and constantly stood on their heads as everybody commandeers the common vocabulary for their unique and personal usage. These pictures are meaningless. But the way in which they are so is significant.

362

Imagine a man brought up from birth in a white cell so that he has never seen anything except the growth of his own body. And then imagine that suddenly he is given some sticks and bright paints. If he were a man with an innate sense of balance and colour harmony, he would then, I think, cover the white walls of his cell as Pollock has painted his canvases. He would want to express his ideas and feelings about growth, time, energy, death, but he would lack any vocabulary of seen or remembered visual images with which to do so. He would have nothing more than the gestures he could discover through the act of applying his coloured marks to his white walls. These gestures might be passionate and frenzied but to us they could mean no more than the tragic spectacle of a deaf mute trying to talk.

I believe that Pollock imaginatively, subjectively, isolated himself almost to that extent. His paintings are like pictures painted on the inside walls of his mind. And the appeal of his work, especially to other painters, is of the same character. His work amounts to an invitation: Forget all, sever all, inhabit your white cell and – most ironic paradox of all – discover the universal in your self, for in a one-man world you are universal!

The constant problem for the Western artist is to find themes for his art which can connect him with his public. (And by a theme I do not mean a subject as such but the developing significance found in a subject.) At first Pollock was influenced by the Mexicans and by Picasso. He borrowed stylistically from them and was sustained by their fervour, but try as he might he could not take over their themes because they were simply not applicable to his own view of his own social and cultural situation. Finally in desperation he made his theme the impossibility of finding a theme. Having the ability to speak, he acted dumb. (Here a little like James Dean.) Given freedom and contacts, he condemned himself to solitary confinement in the white cell. Possessing memories and countless references to the outside world, he tried to lose them. And having jettisoned everything he could, he tried to preserve only his consciousness of what happened at the moment of the act of painting.

If he had not been talented this would not be clear; instead one would simply dismiss his work as incompetent, bogus, irrelevant. As it is, Jackson Pollock's talent did make his work relevant. Through it one

can see the disintegration of our culture, for naturally what I have described was not a fully conscious and deliberate personal policy; it was the consequence of his living by and subscribing to all our profound illusions about such things as the role of the individual, the nature of history, the function of morality.

And perhaps here we have come to something like an answer to my original question. If a talented artist cannot see or think beyond the decadence of the culture to which he belongs, if the situation is as extreme as ours, his talent will only reveal negatively but unusually vividly the nature and extent of that decadence. His talent will reveal, in other words, how it itself has been wasted.

45.

Jackson Pollock and Lee Krasner (1908–84)

THE SUICIDE OF an art is a strange idea. Yet I am bound to start with it, if I'm to talk about the story of Jackson Pollock and his wife, the painter Lee Krasner. Krasner outlived her husband by nearly thirty years and went on working as a considerable painter in her own right until 1984. Now, however, I want to concentrate on the fifteen years during which the two of them lived and worked together and Pollock made a bid to change the course of what was then thought of as modern art.

Pollock died thirty-five years ago in a car accident near his house in Springs on Long Island, New York. This wasn't the suicide. He was forty-four years old and he had already been acclaimed as the first great American painter. The tragedy of his death, even if foreseeable, obscured for most the suicide of the art.

Born in 1912, Pollock was the youngest of five children of a poorish Irish-Scots Presbyterian family, living mostly in Arizona. He revealed a clumsy but passionate talent early on. Talent doesn't necessarily mean facility. It's a kind of motor activity within a temperament – a form of energy. Pollock's talent was immediately recognised by his teacher, Thomas Hart Benton, the country folk painter.

Pollock was slim, handsome, aggressive, brooding: deeply ambitious to prove he was not a failure and perhaps to earn, at last, his stern mother's approval. In everything he did there was a touch of charisma and, following everything he did, a nagging doubt. He was more or less an alcoholic before he was twenty.

As a teenager he dropped his first name, Paul, and used only his second name, Jackson. The change says a lot about the persona he was already being driven into. Jackson Pollock was a name for fighting in the ring. A champ's name.

His later fame as a painter produced the legend that at heart Pollock was a cowboy. Compared to his first collector, Peggy Guggenheim, or to his first apologist, Clement Greenberg, or to the art critic Harold Rosenberg, who invented the term 'action painter' for him, he was indeed a goy and a redneck. He hated verbal theories, he didn't read much, he'd never travelled outside the States, he punched people up, and when he was drunk at parties, he pissed into the fireplace. But whatever miracles cowboys may achieve with lassos, no cowboy could dream of controlling paint as Pollock did. This needs repeating several times, because with his notorious drip paintings he came to be thought of by some as a dripster, a drooler, a mere pourer. Nothing could be further from the truth. The suicide was committed with mastery, and the desperation was very precise.

Pollock found himself as a painter during the 1940s. At that time most avant-garde painters in the United States were interested in Picasso, Surrealism, the Jungian unconscious, the inner self, abstraction. Direct painted references to the objective visible world were usually dismissed as 'illustrative'. The trip was inwards, an uneasy quest for the soul.

In 1943 the well-known painter Hans Hofmann asked the young Pollock how important nature was for his art. 'I am nature,' replied Pollock. The older painter was shocked by the arrogance of the reply and Pollock, sensing this, rubbed salt into the wound by adding: 'Your theories don't interest me! Put up or shut up! Let's see your work!' The reply may or may not have been arrogant, but, more significantly, it carried within itself the fatality to come.

Six years later Harold Rosenberg, thinking of Pollock and praising

him, wrote: 'The modern painter begins with nothingness. That is the only thing he copies. The rest he invents.'

At this moment, what was happening in the outside world? For a cultural climate is never separate from events. The United States had emerged from the war as the most powerful nation in the world. The first atom bomb had been dropped. The apocalypse of the Cold War had been placed on the agenda. McCarthy was inventing his traitors. The mood in the country that had suffered least from the war was defiant, violent, haunted. The play most apt to the period would have been *Macbeth*, and the ghosts were from Hiroshima.

The word 'freedom' was being bandied about a lot at the time and meant many different things. It's worth considering three different kinds of freedom, for, put together, they may conjure up something of the stridency of the period. Time was short in the US. There was very little patience. The stakes were down. There was an inarticulate sense of loss, often expressed with anger or violence. Vietnam was one of the historical tragedies which would eventually follow from this insecurity.

Freedom of the market. The New York artists were working, more crudely than ever before, for an expanding free market. They painted exactly what they wanted, the size they wanted, with the materials they wanted. Their finished works, scarcely dry, were then put up for sale, promoted, sometimes bought. Bought by collectors and – for the first time whilst, as it were, still wet – by museums. The competition, however, was ruthless and aggressive. The latest was always at a premium. Gallery fashions changed quickly. Recognition (being featured in *Life*) was dramatic but short-lived. The risks were high and the casualties many. Gorky and Rothko killed themselves. Kline, Reinhardt, and Newman died young. Nearly all the painters drank heavily to protect their nerves, for finally their works, transformed into extraordinary property investments, benefited from far more security measures than their working lives. They lived on success and despair.

Next, the freedom the artists were seeking within themselves. As a mixed-show catalogue statement put it: 'The past decade in America

has been a period of great creative activity in painting. Only now has there been a concerted effort to abandon the tyranny of the object and the sickness of naturalism to enter within consciousness.' Entering into consciousness – an obscure phrase – meant trying to be oneself on the canvas, without the props of a single familiar reference, and thus to be free of rhetoric, history, convention, other people, safety, the past. Perhaps in a foul world these men were seeking purity.

Then there was the freedom of the Voice of America, the freedom of the Free World. By 1948 the United States needed an international cultural prestige to offset its military and political power: it needed a sophisticated reply to the slogans of 'Yankee Go Home!' This is why the CIA during the fifties and sixties covertly supported a multitude of initiatives whose aim was to present the new American art across the world as a promise for the future. Since the works (De Kooning apart) were abstract, they lent themselves to diverse interpretations.

In this way a mostly desperate body of art, which had at first shocked the American public, was transformed by speeches, articles, and the context in which it was displayed, into an ideological weapon for the defence of individualism and the right to express oneself. Pollock, I'm sure, was unaware of this programme – he died too soon; nevertheless, the propaganda apparatus helped to create the confusion surrounding his art after his death. A cry of despair was turned into a declaration for democracy.

<center>℺</center>

In 1950 Hans Namuth made a film of Pollock painting. Pollock puts on his paint-spattered boots – which appear as a kind of homage to Van Gogh – and then he starts to walk around the unprimed canvas laid out on the earth. With a stick he flicks paint onto it from a can. Threads of paint. Different colours. Making a net. Making knots. His gestures are slow but follow one another swiftly. Next he uses the same technique but this time onto a sheet of transparent glass placed on trestles, which allows the photographer to film the act through the glass, so that we see the paint falling around the pebbles and wires already placed on the glass. We look towards the painter from the painting's point of view. We look out from behind to the front where everything is happening. The way he moves his arms and shoulders

suggests something between a marksman and a beekeeper putting a swarm into a hive. It is a star performance.

It was probably this film which prompted the phrase 'action painting'. The canvas, according to this definition, becomes an arena for the artist's free actions, which the spectator relives through the traces they leave. Art is no longer mediation but act. No longer pursuit but arrival.

What we are slowly making our way towards are the pictorial consequences of Rosenberg's *nothingness* and the fatality.

<div align="center">જ</div>

Photos of Lee Krasner and Jackson Pollock together somehow indicate how much theirs was a marriage of two painters. It's on their clothes. You can smell the paint. Lee Krasner's first love was a Russian painter called Igor Pantuhoff. She lived with him for eleven years. When she first met Pollock, she was thirty-four and better known as an artist than he was. 'I had a comet by the tail,' she said afterwards. What called out to her was, surely, what she felt to be Pollock's destiny as an artist. He was inspired, probably more inspired than anybody she had ever met. And for Jackson Pollock the champion, always fearful of losing, Lee was at last the judge he could trust. If she told him that something he had painted worked, he believed it – at least at the beginning of their marriage. Between them the ultimate in praise was 'It works.' A phrase between professionals.

From 1943 till 1952 – the period when Pollock produced all his most surprising work – the two of them were, in part, painting for each other: to see each other's surprise. It was a way of communicating, of touching or being touched. (Maybe there were not many ways of communicating with Pollock.) During these years Lee Krasner painted less than she did before or afterwards. Pollock took the studio on the property they bought in Springs, and she worked in a bedroom. Yet the argument that she sacrificed her art for his is as stupid as the argument about who influenced whom. (In 1953 Pollock produced a canvas called *Easter and the Totem* which anybody might mistake for a Krasner.) The truth is that as painters and as a man and a woman, they were engaged, during these years, in the same adventure which turned out to be more fatal than either of them realised at the time. And today their canvases speak of it.

Lee Krasner's paintings were, by nature, sensuous and ordered. Their colours and gestures frequently suggested flesh, the body; their order, a garden. Abstract as they are, one enters them to find, behind the colours or collage, a kind of welcome.

By contrast, Pollock's paintings were metaphysical in aim and violent. The body, the flesh, had been rejected and they were the consequence of this rejection. One can feel the painter, at first with gestures that are almost childish, and later like a strong, fully grown man, emptying his body of energy and liquids so as to leave traces to prove that he had physically existed. On one occasion he put his hand prints on the painting as if beseeching the canvas to acknowledge the exiled body. There is an order in these works, but it is like that at the centre of an explosion, and all over their surfaces there is a terrible indifference to everything that is sentient.

When their paintings are hung together, the dialogue between them is very clear. He paints an explosion; she, using almost identical pictorial elements, constructs a kind of consolation. (Perhaps their paintings said things to one another during these years that they could never say in person.) Yet it would be wrong to give the impression that Krasner's paintings were primarily consolatory. Between the two of them there was a fundamental issue at stake. Time and again her paintings demonstrated an alternative to the brink which they sensed his were heading for. Time and again her paintings protested against the art's threat of suicide. And I think they did this as paintings whilst Lee Krasner as a person was being dazzled by the brilliance of his recklessness.

An obvious example would be a painting called *Bald Eagle*, made in 1955, one year before the car accident. Here Lee Krasner took a canvas Jackson Pollock had abandoned – a bare hessian canvas with flicked black lines across it – and incorporated pieces of this canvas into a large colourful collage, a little suggestive of autumn and a bird soaring. Thus her picture saved the lost gestures of his. The example, however, is not typical, for it occurred after the suicide.

Before, he would splatter; and she would take the same pigment, the same colours, and assemble. He would thrash; and she would make the same wound and stitch it. He would paint flames; and she would paint fire in a brazier. He would throw paint imitating a comet;

and she would paint a part of the Milky Way. Every time the pictorial elements – as distinct from the purpose – were similar, if not almost identical. He would lend himself to a deluge; she would imagine water gushing into a basin.

But the messages of her paintings to his paintings were not about domestication. They were about continuity, they were about the desire of painting to go on living.

Unfortunately, it was already too late.

Pollock had stood the art of painting on its head, reversed it, negated it.

The negation had nothing to do with technique or abstraction. It was inherent in his purpose – in the *will* which his canvases expressed.

On these canvases the visible is no longer an opening but something which has been abandoned and left behind. The drama depicted is something that once happened *in front of* the canvas – where the painter claimed to be nature! Within or beyond them there is nothing. Only the visual equivalent of total silence.

Painting throughout its history has served many different purposes, has been flat and has used perspective, has been framed and has been left borderless, has been explicit and has been mysterious. But one act of faith has remained a constant from paleolithic times to cubism, from Tintoretto (who also loved comets) to Rothko. The act of faith consisted of believing that the visible contained hidden secrets, that to study the visible was to learn something more than could be seen in a glance. Thus paintings were there to reveal a presence *behind* an appearance – be it that of a Madonna, a tree, or, simply, the light that soaks through a red.

Jackson Pollock was driven, by a despair which was partly his and partly that of the times which nourished him, to refuse this act of faith: to insist, with all his brilliance as a painter, that there was nothing behind, that there was only *that which was done to the canvas on the side facing us*. This simple, terrible reversal, born of an individualism which was frenetic, constituted the suicide.

46.

Abidin Dino
(1913–93)

SOMETIMES IT SEEMS that, like an ancient Greek, I write mostly about the dead and death. If this is so, I can only add that it is done with a sense of urgency which belongs uniquely to life.

Abidin Dino lived with his beloved Guzine on the ninth floor of an HLM in one of those artists' studios built, at a certain period, by the city of Paris for painters. They were happy there, but if you added all the space of the studio and its closets together, it would come to no more than the space available for the passengers in a long-distance bus. Translations, poems, letters, sculptures, drawings, mathematical models, raki, almonds covered with cocoa, cassettes of Guzine's radio programmes in Turkish, elegant clothes (both of them in their different ways dressed as impeccable stylists), newspapers, pebbles, canvases, watercolours, photos – everything was packed in. And whenever I visited, I came away with my head full of the space of vast landscapes, even of Greater Anatolia – in such a way did Abidin and Guzine drive the coach in which they lived.

This week Abidin Dino died in the Paris hospital of Villejuif. He died three days after he lost his voice and could speak no more.

A week ago almost the last thing Abidin told me was: Don't exaggerate in your new book. You don't need extravagance. Stay realist.

He was a realist about his cancer. He knew how grave it was. But the adjective he used about his state of health was the adjective you might use about a shoe that pinched and which you had to walk a long way in.

Any image which comes to me about him when alive inevitably includes roads, caravanserai, voyages. He had a traveller's vigilance. As Saadi the Persian wrote:

> He who sleeps on the Road will lose either
> his hat or his head.

In the small book-alcove of the studio, or before the portable easel which he folded up at night, Abidin continually travelled. He painted women who became planets. He drew the pain of hospital patients as with the recording needle of a seismograph. Not long ago he gave me photocopies of some drawings he had made about the tortured. (Like many of his friends he had been in prison in Turkey.) Look at them, he said, as he accompanied me to the lift on the ninth floor, and one day some words from far away may come to you. Perhaps just one word or two. That will be enough. He painted flowers – their throats, their Bosporus passages to love. This summer, at the age of eighty, whilst staying in a *yali*, a house on the real Bosporus, he painted a white door with a mysterious sign on it. A white door which was not in the *yali* but elsewhere.

On the night of his death, I woke up in the small hours of the morning. I woke up to the knowledge that he had died, and I prayed for him. I tried to become a lens in a kind of telescope so that an angel somewhere might see Abidin a little better as he accompanied him. Maybe not better. Simply a little more. Then I found myself face to face with a sheet of white paper, so full of light there was no place there for any orphaned colour.

Later I fell asleep, in no way anguished. Early next morning Selcuk, our mutual friend, telephoned to tell me we had lost Abidin. (He had died in the hospital about two hours before I woke up.)

This time I wept, choking with the grief of a dog. Grief is animal. The ancient Greeks knew that.

Men often say, referring to a noble man's death, that a light has gone out. It is a cliché, yet how better to describe the dusk afterwards?

The white paper I saw became charcoal – black, and charcoal is the colour of absence.

Absence? The sign Abidin painted on the white door this summer reminded me of another series of drawings and paintings he made during the last months. They were of crowds. Images of countless faces, each person distinct, but together in their energy similar to molecules. The images, however, were neither sinister nor symbolic. When he first showed them to me I thought this multitude of faces were like the letters of an undeciphered writing. They were mysteriously fluent and beautiful. Now I ask myself whether Abidin had not travelled again, whether these were not already pictures of the dead?

And at this moment he answers the questions, for suddenly I remember him quoting Ibn al-Arabi: 'I see and note the faces of all who have lived and will one day live, from Adam until the end of time . . .'

47.

Nicolas de Staël
(1914–55)

I READ TODAY of the suicide of de Staël. He was a better painter than he knew. Any suicide is the result of a lack of recognition. The man believes there is no sense in this world because there is no comprehension. If he happens to be an artist, the missing recognition will be, at least partly, connected with the attitude of other people to his work. De Staël had been successful and was acclaimed. Ponder on this. Capitalist society is incapable of rewarding the artist, incapable of granting true success. The social salute has the same ring to it as the last shot of Vincent's revolver. 'Even the highest intellectual productions are only recognised and accepted by the bourgeois because they are presented as direct producers of material wealth and wrongly shown to be such.' I marked that passage long ago.

Cubism is to us what Anatomy was to Michelangelo.

ᖇ

I WOULD LIKE TO write with the same fluency as one of your brushstrokes, but I cannot. I hesitate and become inarticulate before the certitude and the doubts of your painting. Almost everything you did is recognisable as being by you, like a familiar voice in the next room. At the same time many of the later

paintings represent Absence. Like the blue reclining nude painted without a model in 1955. A woman on the other side of the mountains and you before the glacier. A couple of months later you killed yourself. You locked your studio, climbed up to the terrace on the roof, and threw yourself off.

However clumsily, I want to describe to you what it's like today looking at your work fifty years afterwards. It has taken me all that time to see what you were doing and what you achieved. Yet what I'm going to tell, you must have known yourself at moments when working. I have the strange feeling of writing down a few thoughts which could only belong to this moment now, and, at the same time, of visiting you half a century ago. Maybe such a simultaneity is what destiny is about.

All his short life he struggled to paint the sky and its lights. No wonder he admired Philips de Koninck, for whom the sky was more important than anything he painted below it in seventeenth-century Holland. He admired Vermeer too. De Staël's struggle with the sky was heroic.

Skies change not only from hour to hour, and from season to season, but also from century to century. They change according to weather, and according to history. And this is because the sky is like a window and a mirror, a window onto the rest of the universe, and a mirror to the earthly events taking place below it. El Greco's skies

Nicolas de Staël, *Landscape Noon*, 1953

reflect the conspiracies of the Counter-Reformation and the Spanish Inquisition, as much as Turner's reflect the turmoil of the Industrial Revolution.

Nobody looks up at a real sky for more than a minute without making a wish related to some current fear or hope.

Between 1945 and 1948 you painted the ruins of Europe more profoundly, more closely, than any other artist did then, or has done since. These works were considered abstract at the time, although you contested this. Today – perhaps because we are living amongst ruins of another order, amongst the havoc being wrought by the new global and corporate tyranny – it's clear that these paintings and drawings are about human survival, about continuing to live, with extraordinary stamina and a few slivers of hope, in the craters and hecatombs.

What does this continuing to live imply? It implies adapting, learning new spatial habits, believing that lying low can be an act of resistance, discovering what is still friendly in the surrounding desolation and cherishing it.

These works are not finally about exploded walls, smashed roofs, and shattered masonry, but about how a person with soul and imagination and memory searches for a path through the ruins, and comes to terms with the damage to such a point that she or he invents their own gestures to accord with those of the wreckage and so find a way through the debris. The invented gestures are traceable in the visible gestures of paint. In each painting there are slivers of light, and between the wrecked gestures there is a passage to follow so as to emerge. They are paintings about crawling towards the light of the sky, and they are magnificent.

They remind me of three lines by the poet René Char, who was de Staël's close friend.

> One finds true clarity
> only at the foot of the stairs
> near the draught of the door.

Between 1948 and 1952 de Staël's gestures and forms become more geometric, brick-like, rectangular, calm. Likewise his colours become less sombre. Europe was being rebuilt. This period of his work culminates with the famous image of the roofs of Paris, above which, taking up two-thirds of the large canvas, extends a Parisian sky, whose lilac grey is like that of a pigeon's feather. After seven years of crawling towards the sky, he had reached it.

Three things then began to change. First, his work became, nominally, more figurative. He painted football players, landscapes, coastlines, ships at sea, a desired woman's body, the interior of his studio. Second, his palette changed. He made his colours more and more competitive, performing for and against one another, like instruments in a jazz quartet. And third, despair lurked now round every corner.

The sky he had at last reached proved to be very different from what he had expected.

By 1952 the Third World War (the Cold War) was being fought. The USA was contemplating a preventative nuclear attack on the USSR, and had exploded their first H-bomb. The KGB's reign of terror was at its worst since 1937. The historic disappointment during the decade which followed the victory of 1945 in Europe was very deep. No one imagined in 1944 the sky of 1952.

De Staël was not a political artist. Even the artistic political controversies of the time – notably that between abstraction and figuration – interested him only marginally. Nothing except the *practice* of painting counted for him.

His presence as a painter. He steps back after making one of his decisive swift gestures, steps back just to examine the exact tone and placing of the colour applied, his presence is like an athlete's, he is prancing on his toes, ready to lunge forward again.

Yet the period's mood – that's to say its relation to the political hopes which preceded it and its own projected fears concerning the future – infiltrated the sky for those who were passionate and had eyes to see. And de Staël's sensibility to the condition of the world had been heightened by his early experiences.

When he was born in St Petersburg in 1914, his father was a

tsarist general, and probably a much feared one, for he was in command of the fortress where political prisoners were held. After the Revolution and during the Civil War his mother organised, in 1921, the family's escape to Poland, where his father promptly died of a heart attack, followed by his mother a month later, after she had arranged for the three children to be smuggled into France. Nicolas lived in Belgium as a homeless person without papers until he was in his twenties. It seems he never spoke of what he saw or felt as an orphan during that childhood exodus. He assumed it, however, as an integral part of his destiny.

After 1952 begins the struggle to find the hope which was missing from the sky. He cannot return to crawling through the dark. Instead, he seeks the sheerest colours, colours which are indomitable and seem almost bullet-proof, colours which are defiant against grey. He finds them in the shirts and shorts of the French soccer team, as they play at night under the banked arc lights of the stadium of Le Parc des Princes. (It was the match of 26 March 1952 against Sweden. France lost 1–0.)

These paintings of footballers contain perfectly timed reflexes – as if the painter himself is controlling the ball or shooting goals. Yet they are like Polaroids (which did not yet exist), insofar as they promise no future and have been peeled off an instant which has gone forever. When the match is over the stadium will be in pitch-darkness.

Soon afterwards, he abandoned indomitable colours and returned to landscapes, the coastlines of the grey North Sea and the skies above them. With hallucinating precision he painted the distance between things, a lighthouse, a ship, a road to the cliff edge. But the paintings give the impression that what they are showing is on the brink of a vast sea-change which risks to be catastrophic. This is the result of what I can only call the pain, the abrupt pain of the paint marks. The colours were celestial, the gestures were measured, but the speed of application betrayed the fact that what was being painted, including the distance between things, was perhaps being painted at a last moment.

Nothing, you once said, is more violent than tenderness.

This proximity of pain metamorphosed – as not even Ovid

foresaw – painted sea mists and white clouds into dressings and bandages! You were now painting wounded sky after wounded sky.

And he did this without a trace of expressive self-indulgence, on the contrary remaining faithful to his inordinate respect for Hercules Seghers's engravings of ruins, in which each displaced stone is carefully cherished for its own sake.

Fine lines traced on a retina before the coins are placed on closed eyes.

Few noticed the proximity of the pain. You were at the height of your success. Already being destroyed by dealers and collectors – in 1954 you were obliged to make 280 paintings. The search for alternatives was desperate, and you already knew it.

Finally the paintings in Sicily – particularly at Agrigente. The strings of the colours so taut they almost snap. The space between things rendered to a metre's accuracy. But the things themselves gone. No substance but dust. No distinction any more between sky and earth. Sky has been banished. All that remains is an absence, with deeply dyed colours stuffed into its mouth to stop it crying out.

Beside these hopeless paintings (hopeless in a descriptive, not a critical, term) his small drawings, done at the same time, with their lines like pine needles. Drawings which recall the ruins he crawled through when the sky contained hope.

Let me tell you the rest. I looked again and again at the life-size standing nudes you did in charcoal about a month before your death. I don't want to talk about Jeanne, who didn't pose for them. Nobody posed. Hofmannsthal said somewhere: 'When somebody dies, he takes with him the secret which allowed him and only him to live a life of the spirit.' Your secret is a secret. I've never seen drawings, however, of such a precise absence. As if the woman you imagined standing there had left behind – to touch repeatedly your imagination – only the shadows which were once on her body. Drawings of a disappearance. Perfectly controlled smudges on a retina before the coins are placed on closed eyes.

And then I found out something else about them. If one tilts one's head sideways so they become horizontal instead of being vertical, even the shadows on the woman's body vanish, and they become

drawings of darkish clouds and an almost dazzling light in the sky, a light that opens. Nothing else but that.

Nicolas de Staël was a painter who never stopped searching for the sky. Today he encourages us who are in the circle, the ever renewable circle, of those struggling to find a way out of the present darkness, and who, despite everything, will do so. He encourages us by his courage, and by the unique maps he left behind about crawling towards the light.

During the war, before he met de Staël, René Char had written: You put a match to your lamp and what's lit gives no light. It's far, very far from you, that the circle is lit.

48.

Prunella Clough
(1919–99)

IT WAS CALLED the Broad Street line. A little suburban electric train running from the City of London to Kew Gardens. Many flower lovers and gardeners took the train to visit and marvel at the flowers in the botanical gardens, founded in the nineteenth century for the study of all the exotic plants being found in the far flung British Empire. In the early 1950s I took this train several times a week to go to a college in Richmond where I was a part-time teacher of painting. At one point the Broad Street line skirts the immense mainline marshalling yards of Willesden. It was here that all the traffic to and from Scotland and the North-west was sorted, assembled, and prepared. Rolling stock for passengers, first- and second-class, for goods, merchandise, coal, plying between Leighton Buzzard, Crewe, Preston, Carlisle, Glasgow, and London. On each journey in the little train, I awaited the moment when we approached and stopped at the Junction and I could look down on the yards. I would sit glued to the window. I have heard people say that they first felt small when they gazed through a telescope at the night sky. For me it happened when I looked across Willesden Junction. In the early morning, at twilight, through rain in the dark, under snow, in the summer heat and day after ordinary day. Five years previously the railways in Britain had been nationalised.

The London Midland and Scottish Railway, which had owned these yards and overseen their continuous, haphazard, chaotic expansion, was now part of British Rail, which was said to belong to the people. As a consequence of nationalisation, the new coal freight trucks had double the capacity of the old ones. In the post-war dereliction there was somewhere a grandeur.

One morning I took the little train and got down at Willesden. I discovered Atlas Road, Common Lane, and the North Pole Depot. And I began to draw the marshalling yards. I drew them again and again – as one might draw evening after evening the same woman, head inclined, sewing under the same lamp. Sometimes I drew them as if they were Bathsheba. Sometimes as if they were a Descent from the Cross. I exaggerate? Yes and no. It was a place of exaggeration. Coupling one truck to another and another. Making one train out of the wagons of two. Uncoupling a long train into fifty separate freight cars. Work of precision and exaggeration by day and night, under the arc lights and in daylight. Precision and exaggeration.

From the drawings I wanted to make etchings. I remember printing some with Pru, and once or twice she came with me to Willesden. We walked along the Hythe Road and somehow got down onto an almost deserted stretch of the Permanent Way. To draw lines on copper into which acid ate had something in common with the rails. Pru spotted and picked up a pair of canvas gloves which had been dropped

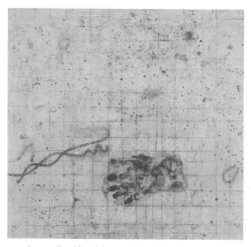

Prunella Clough, *Mesh with Glove*, 1980

by a platelayer. She tried them on, laughing. They were huge and her wrists, like her legs, were very thin. She was the best painter of her generation. She might have been a Soviet constructivist. She died in the 1990s. Now she's helping me to remember as, once, my cheek on her shoulder, my nose in her armpit, she helped me forget. We put the gloves on a turnout lever so they were conspicuous. When a plate had been inked, Pru could wipe it with the side of her palm cleaner than I ever could.

The etchings made one want to paint. At that time my studio was a maid's room on the top floor of the house of Dr Winnicott, who is now known throughout the world because of his deep insight into the psychology of infants. He would often be on his hands and knees in the drawing room on the ground floor playing with and observing a baby, and I would be on the top floor with Willesden. Four days out of five it seemed hopeless – life was too big. And we would both console one another at the foot of the stairs. The sharpness of the colours. The depth of the panic. Next morning the same infant and the same canvas would prompt us to try to advance further. In my paintings of the Junction it was summer, almost dusk, a few minutes before the arc-lights. Lines joining, separating, receding, the colour of the stringy ribs of cut sticks of rhubarb, placed side by side, pointing to the horizon, where they stewed. Some of these paintings were sold, others I gave away to people I loved. None is left. And there's one I'd give a lot to see again. A small canvas, horizontal, 60cm × 50cm. It came quickly after weeks of struggle with more ambitious canvases. At the end of the afternoon I gave a painter's prayer of thanks. I saw what it was. This was in '53, when I was twenty-seven years old.

The paint hurtles towards the horizon. Welts of fading light scar the shoulders of the yard. An invisible controller taps the wheels of a wagon to check for flaws. Everything is flawed, everything is checked, everything will survive another night, and the next working day, which will come up in the east, beyond the Grand Union Canal. Amen. Rust, the taste of steel on the tongue, the lunge to release the hand brake, the sound of boots walking on the hard clinker between the rails, the green eyes of a woman in another city, lying between fresh sheets, fresh streets . . .

Even the pigments on this small canvas were political. Nobody noticed this at the time, least of all myself.

Politics was the National Union of Railwaymen. The NUR. The three letters, like tracks leading towards the horizon, without illusion, but with force and pride. The trailing points, the facing points, the gradients, the trebly checked signals, the sheds, the turntables – with their regular routines, instructions, and orders – give every few minutes a nod to the sky, so that it might acknowledge the confidence history had allotted us: that the hundreds of trains assembled here each week, with seven working days, would leave safely and on time, and along with the shit they had to carry and the unavoidable human doubts they had to transport, would deliver to the future beyond the horizon something which would induce in that future – I shan't live to see it – a little more justice to the Junction and the world around it.

Only tonight, when the small painting is unfindable, do I realise that its very pigments are political. Naples Yellow, half a dozen tones pretending to be black and cunningly never being so, rose, yes rose, burnt umber, raw sienna, the palest cerulean blue of a gas flame, the grey colour of the platelayer's thumb at the end of his shift, snot titanium white, a vein of red. Colours that nobody can deceive, colours that remain themselves and insist.

49.

Sven Blomberg
(1920–2003)

IT WAS CALLED the Hotel du Printemps and was in the 14th arrondissement. The entrance with a reception desk was no wider than a corridor. Room number 19 was on the third floor. A steep staircase with no lift. Sven and I climbed slowly up to his room. He had arrived in Paris the day before and we had been friends for forty years.

Room 19 was small, with a window which gave on to a deep narrow yard. The light's better in the toilet, said Sven. Beside the window was a wardrobe, and the toilet alcove on the other side of the bed, which took up most of the floor space, was the size of the wardrobe.

On the pinkish fluffy bed cover lay a large portfolio tied up with tapes, two of which had broken. The walls were papered with a yellowish wallpaper that was both bleak and friendly – like a vest which the room slept in and never took off.

At our age and with our past, it was normal that Sven and I had artist friends who had become successful, who were invited as guests of honour to Venice and stayed in the Hotel Danieli, and about whom monographs with many colour plates were written. They were good friends, and when we met, we laughed a lot with them. We, however, each in his own fashion, were chronically unfashionable, or – to put it more baldly – we didn't sell much.

When together, Sven and I, we saw this as an honour, almost as part of a conspiracy. Not a conspiracy against us. God forbid. The conspiracy was ours: it was in our nature to resist, he in painting, I in writing. We weren't somewhere between success and failure, we were elsewhere.

A year or two ago, Sven began suffering from Parkinson's disease. When not holding a brush, his hand trembled considerably. I had cricked my back that summer bringing in hay and was suffering from sciatica.

So, there we were, two elderly men in rather crumpled clothes and with not very clean hands, edging our way crab-like along the narrow path around the bed in Room 19.

The lampshade on the fitted wall light which had only a 25-watt bulb in it was melon-coloured. Thirty years before at this time of year – the end of August – we used to walk through the melon fields of the Vaucluse, Sven with his paintbox and I with a camera, a Voejtlander. It's hot, his peasant friends would say to us, they quench the thirst, pick one whenever you want to.

He pulled back the window curtain to let in a little more light and air and I untied and opened the portfolio. In it was a pile of unstretched canvas which Sven had just painted in tempera. Open, the portfolio took up almost the whole double bed. I picked up a canvas and arranged it somehow to lean against the back of the chair at the foot of the bed. Sven remained standing. Then I went back to where the pillows were and sat down cautiously.

It's the left side, Sven asked, the sciatica?

Yes.

Is this the first? I asked him, nodding at the painting of sea and rocks.

No it's one of the last; they're not in any order.

He had an unanxious but curious expression. Curious not, I believe, about my opinion, but about exactly what had happened when he painted the canvas.

Then we looked. It was very hot in the room and we were sweating, our shirts like the wallpaper. After a long while – but time had stopped – I got to my feet. Mind your back! Sven said. I went to examine more closely the canvas against the chair, then returned to the pillows and gazed.

What we were doing in Room 19, we had done several hundred times before in his studio, or on beaches, or outside the tent we slept in with our families, or against the windscreen of a Citroën 2CV or under cherry trees. And what we were doing was looking together, intently, critically, silently, at something he had brought back. I say *silently* but often on these occasions there was music in the air. The colours and lights and darks on the canvas and the traces of the stubby gestures of the brush – gestures which made it unmistakably a painting by Sven – made a kind of music. We could hear it now in the hotel bedroom.

Over the years piles of canvases, taken off their stretchers, had grown higher and higher in the lofts and basements of the houses through which he had passed. The pile on the bed was less than five centimetres high. The ones I'm thinking of were two metres high. Once finished, his paintings were discarded. Maybe they kept each other company in their piles.

Anyway there had never been time to bring them out and offer them to the world. There were a few exceptions – sometimes he gave a painting to a friend. Sometimes a maverick collector bought one. I remember a man who manufactured paints and lived in Marseille. All the other canvases were forgotten. And this seemed right, because finally they belonged to the field or the oil tanker or the street of traffic or the dog which had been their starting point.

After forty years we both accepted this fatality which was also a happiness. When the canvases were put aside, they were carefree. No frames, no dealers, no museums, no literature, no worries. Only the very distant music.

Although we knew this, each time we examined a newly painted canvas we nevertheless did so with the critical concentration of judges selecting a painting for a permanent collection. We couldn't be bought and we couldn't be influenced.

The second canvas was on the chair. I got up to go closer. Careful of your back! warned Sven.

Wet rocks seen from above.

I recognise something today which I didn't before. Sven is the last painter who looks at what is out there, as Cézanne and Pissarro did. He doesn't paint like them. He doesn't try to. But he *stands* there,

brush in hand like them, his eyes open in the same way, observing thoughtlessly. Thoughtlessly? Yes, following without asking why. This is what makes these men a little like saints and this is why their modesty is so unassumed.

The light from where the sun touched the wet rocks comes through several layers of paint as if, impossibly, the light was the first thing painted.

We scrutinised canvas after canvas. We drank tepid mineral water as we sweated. Perhaps Room 19 of the Hotel du Printemps had never been filled with such an intensity of looking before. The unstretched canvases, with their ragged margins of white, carrying weeks of looking in Belle Île, where they had been painted, and the two of us, studying each scribble of paint to ensure that nothing false should pass. And maybe this would still be true for Room 19 even if once or twice we were mistaken in our assessment.

Sven never sat down. Once he went into the toilet to splash some water on his face.

A canvas on which the pile of a green hill slid like the blade of a plough under a pale-orange sky at exactly the right angle to turn the landscape into a furrow.

I carry a spare egg with me always, Sven mused, in case I need to mix more colour.

50.

Friso Ten Holt
(1921–97)

FRISO TEN HOLT is about thirty-eight. He has been a painter all his life. He is also an etcher and engraver. His prints are recognised in Holland as being imaginatively better worked than those of any other Dutch artist. Further, he has designed and made some large stained-glass windows. I believe that these windows are more successfully modern than any others I have seen. 'Modern'? The greatness of Ten Holt as an artist could be said to lie in the fact that by considering his work one arrives at an answer to the question, at a valid definition of the word 'modern'.

Eight years ago his work was very highly formalised, so that some of it appeared even abstract, mainly influenced by late Cubist Braques and Picassos. He had previously been taught to draw from childhood onwards by his painter father. His drawing masters then were Rembrandt for landscapes and Cézanne for figures. In his highly formalised works of eight years ago Ten Holt was learning to organise and build across the surface of a large canvas. It was like the apprenticeship of a fitter. His eye was already trained, but he had to learn how to put a vehicle together so that it could go as fast as the Cubists and Mondrian had made possible.

His next step was to paint a canvas (approximately sixteen by ten feet) of Jacob wrestling with the Angel. In this all the previous

'structural' lessons he had learnt were used, in relation to a subject that was, as it were, already travelling in its own right because of its own emotional power. (In the same way Picasso was able to use Cubism when he came to paint *Guernica*.) Ten Holt, however, was not yet capable of being original, and for his vocabulary of forms he went to that great sculptor Lipchitz. When I hear people talk about there being no epic art today and no artists who can interpret great themes, I think of this large canvas. It is an epic picture, in the tradition of Delacroix's *Liberty Leading the People* – though the museums would never see the connection because they are obsessed with stylistic cataloguing. And it is successful. Jacob wrestles with the Angel like Don Quixote with the sails of the windmill; yet at the same time it looks as still and calm as a catherine-wheel when it is revolving. One would think it the work of an older man: it suggests the austerity of a mature artist who will not step outside his art. He will affect you if he can by his performance. But he will not smile at you or insinuate round the edges of that performance. As I have said, however, it is not yet an original work. But from its foreshortened flying angel, originality came. (Originality! It is claimed so often, and is so rare, that the very word has become wry.) From the angel in the air flying towards the ground came the idea of a figure entering one element and leaving another. And from that came a series of paintings on the theme of swimmers. Looking at these you realise how unstartling originality can appear. For certainly these swimmers are original. I know of no sensible references to apply to them. In spirit – something of Veronese. In colour – certain Van Goghs. In touch – something of Cézanne. Yet they could not have been painted before the fifties. An impossible-sounding pedigree! Bastards. Originals.

I have given this compressed history of Ten Holt's development in order to show the nature of his apprenticeship. This apprenticeship has only just ended and he is nearly forty. It takes a long time to become a painter such as he has become. Naturally he has painted many pictures which I haven't mentioned. But he works slowly and his output is small, because the path he has chosen is one of the most difficult an artist can choose today. (De Staël chose a similar path, but got less far along it.) It is the path which leads from a complete understanding of the laboratory experiments of twentieth-century art

forwards towards their application to life. It avoids romanticism. Its aim is objectivity, but not naturalism. Its spirit is rational. Its faith is in art itself and yet it is entirely opposed to art for art's sake. There is another kind of artist whose genius is a by-product of his passion. In our time Guttuso is such an artist. But for Ten Holt everything must be produced with direct intention.

His attitude is in fact admirably demonstrated by this very painting of *The Swimmers*. It represents two nude figures, a man and a woman, in the sea. Like all images that are the result of profound searching, it has many meanings. (The great illusion of current non-art lies in the belief that numerous meanings can be expressed without searching.) They swim in the sea. They turn in their dreams. They twist in sex, all lights and weights, the embodiment of caresses and invisible responses. (George Barker: 'O whirlwinds catching up the sea / And folding islands in its shawls / Give him to me, give him to me, / And I will wrap him in my shallows.') They fly like Icarus. They play like children – their speed their *joie de vivre*.

But the painting as a whole also has another significance. The water, the air, and the figures are indivisible. It is impossible to define either the form of the limbs or the colour of the water or the strength of the light *separately*. Without the figures in it, this sea would be another ocean. Without water to bear them, these lovers would be a different pair. Flesh, water, air, each element possesses the other, because all are subordinate to the element of painting.

When I said that the idea behind the series of pictures was that of a figure leaving one element and entering another, I did not only mean it literally in relation to two swimmers entering the sea; these pictures also demonstrate how two figures enter the element of painting itself. Ten Holt believes that painting is an independent element with its own laws and demands. If an image enters this element and does not satisfy its demands he believes that it will have neither the necessary power nor conviction with which to comment on the different demands which life makes. Art, in other words, is neither a replica nor an extension of life. It is independent. But it is independent only because it is a parallel phenomenon, just as water is a parallel element to air.

One could sum all this up – but without the foregoing explanation it wouldn't mean much – by saying that Ten Holt is a classical artist.

(The Romantic believes that the connection between art and life is not the result of their parallel laws, but of his own personality free to inhabit both worlds as it chooses.) It has been easy to be a classical artist. Today it is immensely difficult. And immensely necessary. Personalities are destroying art. The great modern discoveries lie unused. The responsibilities of the day pull one way; cowardice and manias pull the other way. Incommunicability is thought to be the theme of our time. How difficult to remain confident and dutiful as it becomes an artist to be dutiful, in the midst of such a din! And how difficult to accept being abused as old-fashioned and academic! Yet this is the fate of the original artist today. The function of the original artist is to renew the tradition to which he belongs. In the nineteenth century most people had a nostalgic view of their tradition and so considered originality outrageous. Today our cultured have gone beyond nostalgia; in their despair they hate all but the violently primitive, and so originality becomes an act of faith which offends them because it questions their illusion of freedom from all traditions.

One day, with the advent of new visual media and a society not based on alienation, the modern tradition will be continued. Then artists like Ten Holt (perhaps there are half a dozen in Europe) will be seen to have been heroes. Not because they were politically conscious heralds of that new society – that is another way of living; but because they obstinately believed in *the continuity of art* at a time when most, doubting the continuity of their own way of life, wanted to destroy all continuity. And to believe in continuity is to be modern, is to be – for us who can respect nothing else – revolutionary.

51.

Peter de Francia
(1921–2012)

Peter de Francia, *Eric Hobsbawm*, 1955

THE SOMEWHAT UNHUMOROUSLY entitled exhibition *The Dying Art*, at
Roland, Browse and Delbanco, is a show of modern portraits ranging
from about 1910 to the present day. The Foreword explains that
portraiture is dying because 'Man is slowly renouncing belief in his
supreme position in the universe . . . the change from nineteenth-
century liberalism to twentieth-century conformism . . .' etc. The
apocalyptic wail! In fact – as the best paintings on show prove – only
official portraiture has died: for the simple reason that the ruling class
can no longer glory in any aspect of the truth about themselves.

If, however, the Foreword is hot air, the exhibition is a most inter-
esting one. It reveals (and I weigh my words) that we have in this
country a portrait painter comparable with Kokoschka: Peter de

Francia is a more extrovert artist, but he submits himself to the same exacting discipline of draughtsmanship and he has the same, very rare, imaginative openness or generosity towards the character of his sitter.

<center>◌◑</center>

OUR CRITICS, WHO pick up their titbits of opinion like cocktail cherries, have glanced at Peter de Francia's six-by-twelve-foot canvas *The Bombardment of Sakiet* (Waddington Gallery) and murmured 'Guernica'. This is about as silly as murmuring 'Goya' in front of the Picasso. But finally this comparison is only made possible by the fact that so few such pictures have been painted.

The Sakiet canvas represents the debris of one home in the Tunisian village just after one of the French bombs has fallen: splintered planks, torn clothes, broken wicker, a fallen sewing machine, a collapsed roof, the dead, and the living whose lives have now been irrevocably broken. The composition is roughly that of a diagonal cross of violent movement, almost as though the diagonals were the paths of the blast. The havoc caused is not merely evident in the facts just described (if that were so the painting would be no more than a gruesome illustration), but also in the actual painting itself. The forms themselves are splintered and fly like chips of wood from an axe. By a boy, dead on the ground, there is a crumpled piece of red-and-green striped drapery, and these clashing stripes ricocheting off each other are as expressive of the violence done as the boy's still, clutching hand. The brushstrokes are swift and when they describe a body their looseness emphasises physical human vulnerability: rendering a foot, a wrist, a head, they become, for all their accuracy of drawing, like straws in the wind. Before you are aware of the subject, you see a world of form split open and rent, with only the blue sky unharmed. Then, as you begin to read the incidents in the painting, the full enormity of what has happened strikes you.

This is a work of political protest. But it is also a painting in the European tradition. Like Delacroix's *Massacre at Scio* (and the sketches recall Delacroix vividly) or like Géricault's *Raft*, it deals with an actual event. It has been painted on the assumption that painting can hold its own with the other arts without becoming literary or theatrical. And the assumption is justified.

The picture has weak passages. It was not painted at Sakiet, nor could it have been. It was painted in a quiet studio two thousand miles away. The blast had to shrill its way through a man's conscience and imagination and there, becoming a symbol for all modern inhumanity in a way which Delacroix and Géricault never had to contend with, it occasionally buffets a form and inflates it or knocks it sideways exaggeratedly. The stomach of the pregnant woman or parts of the fleeing child – these are over-wrenched details, where the artist's imagination has been blackmailed by the news, where his emotion has become sharper than his power to visualise. Even such passages, however, are very well integrated into the organisation of the picture as a whole – their failure is in their relation to reality. And this power to organise reveals one of de Francia's great virtues as an artist: his intelligence.

It is his intelligence which makes him a professional in an age of amateurs. Look at the other works in this show – the portraits, the quarry landscapes, the drawings – to see what this professionalism means. He has trained himself. He can draw, he can handle paint, he can compose, he can paint a picture which won't fall to bits. He can do what a well-trained apprentice used to be able to do after ten years with a master. That doesn't sound remarkable? One must remember that this is a time when artists are encouraged to make a virtue of their inabilities, and when there is no master-apprentice system, so that for a man to train himself requires the wisest and most dedicated study (de Francia's masters are Rubens, Hals, Delacroix, Courbet, Picasso, Léger) and also a belief in the dignity of painting.

It is also de Francia's intelligence which gives his work a yet rarer quality. Through his intelligence he is aware of what is happening in the world. His art deals with events. Sakiet is bombed. Men work in the sun. An Indian painter comes to London with his wife. An African girl sits thinking, her back to a reproduction of *Guernica*. The subjects of all pictures might, of course, be called events. But through all de Francia's paintings a wind blows, less violently than the blast in the Sakiet picture but no less certainly, and this wind brings with it a promise of time and distance and news.

In the portraits (one of which the Tate should buy if it takes note of anything apart from the small talk of the cocktail-cherry men) this

sense of eventfulness is there in the swift Hals-like brush marks in the colours that dart from passage to passage like light on the sea, but primarily in the intensity and clarity with which the faces are drawn and seen – as though being scrutinised like messengers. These are not in the usual sense of the word psychological portraits: they are paintings of men and women who wear the expression of our time as others wear a smile. In the quarry landscapes the sense of eventfulness is there in the most straightforwardly visual way of all. These are paintings about the way the meridional light strikes blocks of white rock. This light appears to recut and reshape the stone along the same edges as the quarry workers themselves. And so here the labour of men appears to turn sunshine into an event.

Much of de Francia's work is disturbed and disturbing. It is always clamorous. There is no quiet. He is the opposite of a classical painter. A romantic? No, because he belongs to the mid twentieth century, and romanticism, in the usual sense of the word, cannot. It is not his own emotions which are supreme for him, but the new world he sees emerging, and which, by painting, he helps to bring about.

<div align="center">◌ઢ</div>

PETER DIDN'T FIT in easily, did he? Why?

My answer would be because he was so large, he embodied largeness in a very distinct and unique way. He was physically large, but what I'm thinking of goes far beyond that.

Consider the way he draws, the energy, the speed, of his drawn lines – they display and express a largeness, even if the drawing itself is a small one. He's the opposite of a nature-morte painter; he's an horizon-painter. When he's observing a chair or a foot his gaze and scrutiny are still panoramic. In his vision there are no shelters from space. He has the vision of a helmsman navigating an open sailing boat. Alone.

If I search for a fellow artist to compare Peter with, I think of Ambrogio Lorenzetti, in the town hall of Sienna painting the frescoes of *Good* and *Bad Government*. Six centuries separate them, and their painterly idioms and iconography are very different. What they nevertheless share is the largeness. Both set out to create images for people

under the immense vault of a sky which is, in part, firmament and, in part, History. The immense vault of the sky.

Something similar applied to Peter's opinions, judgements, and questions concerning the ongoing struggles in the world today and the role of art in those struggles. He came on and spoke like a newly arrived messenger from elsewhere, always from another front. And so his company was provocative, disconcerting, illuminating, funny, often very funny. He was never local.

Peter de Francia is an horizon-painter.

52.

Francis Newton Souza
(1924–2002)

IN THE HISTORY of art one of the most important developments of the twentieth century may be the emergence of a new humanist Asian art. Or will it be the opposite that is remarkable? Will the desperately practical needs of Asia preclude art for the first half-century of their independent power? What will their art, when it is established, owe to their own traditions, and what to Europe? Such questions can only begin to be answered by those who have lived in Asia. And it is for that reason that the exhibition of painting by the Indian artist Souza, at Gallery One, Litchfield Street, is both so interesting and so puzzling. Analysis breaks down and intuition takes over. If one enjoys these pictures, one must simply accept that pleasure; what we accept may or may not be what the artist intended.

Souza, who is a comparatively young artist, now in London, was born in the Indian Portuguese state of Goa. He was brought up a Catholic but is now hardly an orthodox one. In Bombay he is well known as both a painter and a writer. How much his pictures derive from Western art and how much from the hieratic temple traditions of his country, I cannot say. It is obvious that he is an excellent designer and a good draughtsman. His subjects are landscapes, nudes, and figures of priest-like men. The colours he

uses are dark and rich and his forms are usually bound by heavy outlines.

I find it quite impossible to assess his work comparatively. Because he straddles several traditions but serves none, his work lacks grace and has to make up for a lack of certainty with a clumsy, individual power. But at the same time it seems to me to contain an imaginative vision which is truly moving. One can of course avoid the whole problem of what his work means by explaining its entire appeal in formal terms. His use of engraved lines, graffitto-like, to enrich the surface of his paint, his sense of pattern tending towards the effect of dark brocaded silks, his method of modelling a figure solid by apparently burnishing the pigment and its tones until the result is reminiscent of a smooth, very simplified but full bronze statue, his occasional use of acid colour, quick and aerial as small flames, his awareness of the weight of the human body – belly keeping it to the ground: all this contributes to the impact of his work.

But what about the arrows that stick so ungorily into the necks of his men, what about the sex of his women, triumphant and yet entirely uncultivated, what about his Byzantine-looking towns and his Cubist analysis of objects? Ignorant before the meaning of these phenomena we can only react intuitively. Or are all these considerations fabricated? Are these twenty-one rather clumsy canvases only the expression of a man hopelessly muddled and meaninglessly pushed hither and thither? Are their few qualities only the result of the tag-end of a broken, used-up tradition? I do not know. I can only say that this exhibition draws, fascinates, and gives me pleasure. If I try to define what moves me, I come to the conclusion that it is the yielding in the works of the hieratic to the banal, and vice versa. The bearded man in front of the landscape is both arch priest and gimcrack tramp. The nude is a greedy, undeniable goddess and yet common as any fruit in a market. The couple are Abraham and Sarah or Bombay shopkeepers. Indeed, the nearest parallel is the Old Testament. A shout can break down a city wall.

53.

Yvonne Barlow
(1924–)

TO DRESS A wound. A medical term with a clear meaning. Yet something about it – perhaps on account of the word 'dress' – also suggests the theatre and theatrical practice. Dressing up. Dress rehearsals. The connection, however, is deeper. Theatre began with the need to make some sense out of the mystery and pain and passion of life. And in doing this it offers *catharsis* for those participating and watching. And the first meaning of catharsis is *cleansing*, which is part of the traditional practice of dressing a wound.

Looking at Yvonne Barlow's oeuvre these thoughts come to mind. Her paintings – covering a period of sixty years – are never repetitive, but they are remarkably consistent in their approach. Their approach is very painterly and, at the same time, theatrical. The incidents they observe in life, invent with imagination, and then depict, these incidents all have the profile of actions being enacted on a stage.

Her paintings function like this calmly, in a sure-fingered manner; they never fall into melodrama. At a certain moment in her teens Yvonne Barlow wondered whether she should devote herself to painting or to the piano as a pianist. She decided to continue painting. Her sense of composition as a painter is, however, more musical than

Yvonne Barlow, *Friend or Foe?*, 1987

geometric. There's something Chopinesque about it. Her composi-
tions are not concerned with the timeless (as were Braque's or Piero
della Francesco's) – they involve the ongoing performance of the
whole painting which includes duration and timing. This musical
sense of composition then fills the space of a stage. (As it does, differ-
ently, in the work Watteau or Courbet.)

The spectators of Yvonne Barlow's paintings await and expect as
much as they examine. Dreams, memories, fears will help to take
them to the places she paints. But no GPS can.

I met and fell in love with Yvonne in 1942. We were students at
the Central School of Art, London. The Blitz was over, but London
was still being bombed at night by the first pilotless drones, called
Doodle Bugs. We lived by our wits and with the Old Masters. I'm not
sure exactly how but a painting from the National Gallery, first spot-
ted by Yvonne and then adopted my me, became our private ikon,
our secret logo. It was *A Satyr Mourning Over a Nymph* (its present
title) by Piero di Cosimo. The dog is also mourning and I think I
identified with the dog.

402

Yvonne Barlow (1924–)

I tell the story here, for it looks as if this small exquisite painting can also serve us as a series of chapter-headings for all of Yvonne Barlow's eloquent, diverse, and mysterious works.

There is the animal as independent witness, there are flying birds as messengers, there is the beach and coastline for arrivals and departure, there are frail boats to be sailed, there are the countless gestures of human bodies, hands, fingers, shoulders, feet, which are both eloquent and wordless, there is the aerial everlasting question: What exactly has happened? There is the precision of each profile and the mystery of each event, there are flowers, there is blood, there is catharsis.

Often in Yvonne Barlow's forest of encounters, a figure is wearing a white shirt that gleams like a bandage. To dress a wound. . . .

A life's work.

54.

Ernst Neizvestny
(1925–)

IT HAPPENED LIKE this. The Moscow Union of Artists planned to organise an exhibition of work done by members during the previous thirty years. The exhibition was to be 'liberal' in emphasis and was intended to draw attention to the narrowness of the Academy. Neizvestny was invited to participate because on this occasion his own record against the Academy might add weight to the Union's argument.

Neizvestny refused to participate unless some other experimental young artists were also invited. The Union refused. But the idea of having an exhibition of experimental, unofficial art was then taken up by a man called Bilyutin, who was at that time running a teaching studio. Somehow he managed to arrange the exhibition under the auspices of the Moscow City Council. The exhibition was to include the work of Bilyutin's students, Neizvestny, and some other younger artists whom Neizvestny suggested. It is difficult to discover exactly why and how the exhibition was ever allowed to take place. It is possible that the Academy wanted a provocation in order to persuade the government that it must act to prevent the further spread of 'nihilism' – the revived label now attached to the non-conformists. It is equally possible that, owing to bureaucratic inefficiencies and lack of

liaison between departments, nobody realised what the exhibition meant until it was too late.

The exhibition opened[1] and caused a sensation. Partly as a result of the works exhibited, which were unlike any works seen in public for at least twenty years: even more as a result of the enthusiasm with which the younger generation greeted them. The crowds and queues were beyond anybody's expectations. After a few days the exhibition was officially closed down and the artists were told that they must bring their works to the Manège building, by the side of the Kremlin, so that all the problems raised by their work should be considered by the government and the Central Committee.

This official reaction, with its half-promise of a discussion and conclusions not already prejudged, represented a considerable advance from the days of absolute Stalinist orthodoxy. But at the same time there had been no declared change of policy. No one knew how far the apparent new tolerance would extend. None of the artists knew how gravely they might be condemned. Both the risks and the opportunities remained unknown. Everything depended on how Khrushchev might be personally persuaded. The enigma of personality was still the crucial factor.

Bilyutin suggested to the artists that they should leave their more extreme works behind and take only the more conventional ones. Neizvestny opposed this on the grounds that it would deceive nobody; also because here was an opportunity for having at least the existence of their work officially recognised.

The artists hung their own works in the Manège building. Several of them worked throughout the night. Then they waited. The building was cordoned off by security men. The gallery was searched. Windows and curtains were checked.

The entourage of about seventy men entered the building. Khrushchev had no sooner reached the top of the stairs than he began to shout: 'Dog shit! Filth! Disgrace! Who is responsible for this? Who is the leader?'

A man stepped forward.

'Who are you?'

The voice of the man was scarcely audible. 'Bilyutin,' he said.

1 In 1962.

Inge Morath, *Portrait of Ernst Neizvestny*, 1967

'Who?' shouted Khrushchev.

Somebody in the government ranks said: 'He's not the real leader. We don't want him. That's the real leader!' and pointed at Neizvestny.

Khrushchev began to shout again. But this time Neizvestny shouted back: 'You may be premier and chairman but not here in front of my works. Here I am Premier and we shall discuss as equals.'

To many of his friends this reply of Neizvestny's seemed more dangerous than Khrushchev's anger.

A minister by the side of Khrushchev: 'Who are you talking to? This is the Prime Minister. As for you, we are going to have you sent to the uranium mines.'

Two security men seized Neizvestny's arms. He ignored the minister and spoke straight to Khrushchev. They are both short men of about equal height.

'You are talking to a man who is perfectly capable of killing himself at any moment. Your threats mean nothing to me.'

The formality of the statement made it entirely convincing.

At a sign from the same person in the entourage who had instructed the security men to seize Neizvestny's arms, they now released them.

Feeling his arms freed, Neizvestny slowly turned his back and began to walk towards his works. For a moment nobody moved. He knew that for the second time in his life he was very near to being lost. What happened next would be decisive. He continued walking, straining his

ears. The artists and onlookers were absolutely silent. At last he heard heavy, slow breathing behind him. Khrushchev was following.

The two men began to argue about the works on view, often raising their voices. Neizvestny was frequently interrupted by those who had by now re-assembled around the Prime Minister.

The head of the Security Police: 'Look at the coat you're wearing – it's a beatnik coat.'

NEIZVESTNY: 'I have been working all night preparing this exhibition. Your men wouldn't allow my wife in this morning to bring me a clean shirt. You should be ashamed of yourself, in a society which honours labour, to make such a remark.'

When Neizvestny referred to the work of his artist friends, he was accused of being a homosexual. He replied by again speaking directly to Khrushchev.

'In such matters, Nikita Sergeyevich, it is awkward to bear testimony on one's own behalf. But if you could find a girl here and now – I think I should be able to show you.'

Khrushchev laughed. Then, on the next occasion when Neizvestny contradicted him, he suddenly demanded: 'Where do you get your bronze from?'

NEIZVESTNY: 'I steal it.'

A MINISTER: 'He's mixed up in the black market and other rackets too.'

NEIZVESTNY: 'Those are very grave charges made by a government head and I demand the fullest possible investigation. Pending the results of this investigation I should like to say that I do not steal in the way that has been implied. The material I use is scrap. But, in order to go on working at all, I have to come by it illegally.'

Gradually the talk between the two men became less tense. And the subject was no longer exclusively the work on view.

KHRUSHCHEV: 'What do you think of the art produced under Stalin?'

407

NEIZVESTNY: 'I think it was rotten, and the same kind of artists are still deceiving you.'

KHRUSHCHEV: 'The methods Stalin used were wrong, but the art itself was not.'

NEIZVESTNY: 'I do not know how, as Marxists, we can think like that. The methods Stalin used served the cult of personality and this became the content of the art he allowed. Therefore the art was rotten too.'

So it went on for about an hour. The room was very hot. Everyone had to remain standing. The tension was high. One or two people had fainted. Yet nobody dared to interrupt Khrushchev. The dialogue could be brought to a close only via Neizvestny. 'Better wind it up now,' he heard somebody in the government ranks say from behind his ear. Obediently he held out his hand to Khrushchev and said he thought that perhaps they should stop now.

The entourage moved across to the doorway onto the staircase. Khrushchev turned round: 'You are the kind of man I like. But there's

Ernst Neizvestny, Tomb of Nikita Khrushchev

an angel and a devil in you,' he said. 'If the angel wins, we can get along together. If it's the devil who wins, we shall destroy you.'

Neizvestny left the building expecting to be arrested before he reached the corner of Gorky Street. He was not arrested.

Later the investigation took place which Neizvestny had demanded. The minister withdrew his charges and declared that there was no serious evidence that Neizvestny was not an honourable man. The investigation included Neizvestny's being examined to see whether he was mad.

Before this examination but after the encounter in the Manège, Khrushchev, who had several long conversations with Neizvestny, asked him how it was that he could withstand for so long the pressure of the State.

55.

Leon Kossoff
(1926–)

LEON KOSSOFF WAS born in London in 1926 and is undoubtedly far above our general level of chic mediocrity. He may even, eventually, become much better than that rather safe pronouncement suggests.

He paints landscapes of London and single figures. His colours are earth colours. And the pigment itself is shockingly thick, rising in places to 2½ inches above the original picture surface. (I say shockingly because such an innovation is bound to shock at first, whether justified or not.) The way he paints his forms depends partly upon colour and tone, but also upon his digging into this mass of paint and so making indented lines, as in a relief. Texturally his pictures look as if they were made of coloured, solidified engine grease as put into a grease gun. His drawings are in their own way equally heavily worked, and very black. His idiom is Expressionist, but at the same time more analytical of spatial structure than, say, Rouault or Soutine. Probably his studies with Bomberg taught him to be analytical in this way. Kossoff is another painter who bears out my contention that Bomberg is the most constructive influence today amongst the young in this country. The general mood of Kossoff's work is profoundly pessimistic and might be compared to Beckett's: the same hatred of any sensuous

pleasure, the same modesty, the same belief in the equality of hope-lessness – which in a ruthless, self-seeking society looks like compassion, but in fact isn't.

Nevertheless I was impressed. Forget about the thickness of the paint, the unpleasantness of the material, and stand where you can best see these paintings, undistracted by the means the artist has chosen to use. You'll then see that he has created images which may be bare and joyless but which have authority. Why? Because of their considerable strength of drawing and composition. Despite the churned-up medium, there is nothing sloppy or broken about the way the essential masses and planes are rendered. His brooding, hunched-up figures fit into their panels as tensely, as properly, as medi-eval figures into their niches. His heads are as solid as their stone ones and the clotted disfigurations of the pigment are as superficial as disfig-urations caused by time and weather. It is not because the panels are big that they can be called monumental, but for this reason – which is confirmed again by the drawings. In these the receding plane of a table top or the turning surface of a head is established as an absolutely primary fact – as in Masaccio or Mantegna, both of whom, I'm sure, Kossoff particularly admires. Or look at his drawings of building sites seen from above. Anyone who can create and control space like

Leon Kossoff, *Building Site, Oxford Street,* 1952

that – unaided by any comparative scale or confirming detail – is a true draughtsman.

Kossoff's predicament is, I think, in the broad sense of the word, an ideological one. He paints to emphasise the primacy of matter – hence his monumentality, his emphasis of mass, and his use of the medium. Yet, at the same time, he is overwhelmed by the powerlessness of man in face of the material world – hence his profound pessimism. He is too honest to resort to religion, and yet can find no explanation for the crushing weight of suffering. Other critics have been made uncomfortable by his sense of tragedy. I am not. I sympathise. But to turn a sense of tragedy into a tragic work of art one must believe in the possibility of the happy alternative. And so – paradoxically – if Kossoff's understanding can make him rise above his own pessimism, he could become a tragic artist of real significance.

<div align="center">∞</div>

DEAR LEON,

I still remember clearly the first time I visited you in your studio, or the room you were then using as a studio. It was some forty years ago. I remember the debris and the omnipresent hope. The hope was strange because it's nature was that of a bone, buried in the earth by a dog.

Now the bone is unburied and the hope has become an impressive achievement. Except that the last word is wrong, don't you think? To hell with achievement and its recognition, which always comes too late. But a hope of redemption has been realised. You have saved much of what you love.

All this is best not said in words. It's like trying to describe the flavour of garlic or the smell of mussels. What I want to ask you about is the studio.

The first thing painters ask about a studio-space usually concerns the light. And so one might think of a studio as a kind of conservatory or observatory or even lighthouse. And of course light is important. But it seems to me that a studio, when being used, is much more like a stomach. A place of digestion, transformation, and excretion. Where images change form. Where everything is both regular and

unpredictable. Where there's no apparent order and from where a well-being comes. A full stomach is, unhappily, one of the oldest dreams in the world. No?

Perhaps I say this to provoke you, because I'd like to know what images a studio (where images are made) suggests to you – you who have spent years alone in a studio. When we enter one, we go blind in order to see. Tell me . . .

With affection and a respect bordering on veneration – John

CR

Dear John,

Thank you for your letter. Almost forty years ago you wrote a very generous piece on my work 'The Weight'. It was the first and, for many years, the only constructive and positive response to the work, and I never thanked you. But I have never forgotten it, and, in the strange time I am living through now, of having to gather my work (and my life I suppose) together for a first retrospective, I am frequently reminded of it.

All the things you say about the studio are true and the place I work in is much the same as it has always been. A room in a house – a much larger house. There is mess and paint everywhere on the walls – on the floor.

Brushes are drying by the radiator, unfinished paintings are on the walls with drawings of current subjects. There is a place for the model to sit in a corner and a few reproductions on the wall that I've had most of my painting life. I don't worry much about the light, sometimes it can be awkward as the room faces due south, then I turn the painting round or start a new version. I seem engaged in an endless cycle of activities. For the best part of 40 years I have been left alone, but recently, owing to extra exposure and studio visits, the place has become like a deserted ship.

Do you remember when we first saw the revealing and moving photographs of Brancusi's and Giacometti's studios in the 1950s? It was a special time. Now every book on every artist includes a photograph of the studio. It has become a familiar stage-set for the artist's work. Has the activity become more important than the resulting image, or does the image need the confirmation of the

studio and the myth of the artist because it's not strong enough to be on its own?

I don't know what the work will look like when it finally appears on the walls of the Tate. The main thing that has kept me going all these years is my obsession that I need to teach myself to draw. I have never felt that I can draw and as time has passed this feeling has not changed. So my work has been an experiment in self-education.

Now, after all this drawing, standing before a vast Veronese I experience the painting as an exciting exploratory drawing in paint. Or, looking at Velázquez's *Pope Innocent X*, at present in the National Gallery, I wonder, after moving to the nearby early *Christ after Flagellation*, at the transformation of his capacity to draw with paint. Recently I saw a book of Fayum portraits [the Egyptian mummy paintings] and, thinking about their closeness to Cézanne and the best Picasso, I am reminded of the importance of drawing to all art since the beginning of time. I know this is all familiar to you – even simplistic – but it's where I begin and end.

The exhibition will commence with the thick painting you wrote about. Will the later, relatively lighter and thinner work be seen to have emerged out of my need to relate to the outside world by teaching myself to draw?

Yours,
Leon

ᚼ

Dear Leon,

I don't, of course, find your thought about drawing 'simplistic'. I too have been looking at that extraordinary book of Fayum portraits. And what first strikes me, as it must strike everybody, is their thereness. They are there in front of us, here and now. And that's why they were painted – to remain here, after their departure.

This quality depends on the drawing and the complicity, the inter-penetrations, between the head and the space immediately around it. (Perhaps this is partly why we think of Cézanne.) But isn't

it also to do with something else – which perhaps approaches the secret of this so mysterious process which we call drawing – isn't it also to do with the collaboration of the sitter? Sometimes the sitter was alive, sometimes dead, but one always senses a participation, a will to be seen, or, maybe, a waiting-to-be-seen.

It seems to me that even in the work of a great master, the difference between his astounding works and the rest, always comes down to this question of a collaboration with the painted, or its absence.

The romantic notion of the artist as creator eclipsed – and today the notion of the artist as a star still eclipses – the role of receptivity, of openness in the artist. This is the pre-condition for any such collaboration.

So-called good draughtsmanship always supplies an answer. It may be a brilliant answer (Picasso sometimes), or it may be a dull one (any number of academics). Real drawing is a constant question, is a clumsiness, which is a form of hospitality towards what is being drawn. And, such hospitality once offered, the collaborations can sometimes begin.

When you say: 'I need to teach myself to draw', I think I can recognise the obstinacy and the doubt from which that comes. But the only reply I can give is: I hope you never learn to draw! (There would be no more collaboration. There would only be an answer.)

Your brother Chaim (in the larger 1993 portrait) is there like one of the ancient Egyptians. His spirit is different, he has lived a different life, he is awaiting something different. (No! That's wrong, he's awaiting the same thing but in a different way.) But he is equally there. When somebody or something is there, the painting method seems to be a detail. It is like the self-effacement of a good host.

Pilar (1994) is there to a degree that makes us forget every detail. Through her body, her life was waiting to be seen, and it collaborated with you, and your drawing in paint allowed that life to enter.

You don't draw in paint in the same way as Velázquez – not only because times have changed, but also because time has changed, your openness is not the same either (he with his open

scepticism, you with your fervent need for closeness), but the riddle of collaboration is still similar.

Maybe when I say *your* 'openness' I'm simplifying and being too personal. Yes, it comes from you, but it passes into other things. In your painting of Pilar, the surface of pigment, those gestures one upon another like the household gestures of a mother during a lifetime, the space of the room – all these are *open* to Pilar and her body waiting-to-be-seen. Or is it, rather, waiting-to-be-recognised?

In your landscapes the receptivity of the air to what it surrounds is even more evident. The sky opens to what is under it and in *Christchurch Spitalfields, Morning 1990*, it bends down to surround it. In *Christchurch Stormy Day, Summer 1994*, the church is equally open to the sky. The fact that you go on painting the same motif allows these collaborations to become closer and closer. Perhaps in painting this is what intimacy means? And you push it very far, in your own unmistakable way. For the sky to 'receive' a steeple or a column is not simple, but it's something clear. (It's what, during centuries, steeples and columns were made for.) But you succeed in making an early summer suburban landscape 'receive', be open to, a diesel engine!

And there I don't know how you do it! I can only see that you've done it. The afternoon heat has something to do with it? But how does that heat become drawing? How does such heat draw in paint? It does, but I don't know how. What I'm saying sounds complex. In fact all I'm saying is already there in your marvellous and very simple title: *Here Comes the Diesel*.

You say that on the walls of your painting room there are some reproductions which have been pinned there for years. I wonder what? Last night I dreamt I saw at least one. But this morning I've forgotten it.

I suppose that soon you'll be hanging the paintings at the Tate. I've never done it but I guess it's a very hard moment. It's difficult to hang paintings well because their *therenesses* compete. But apart from this difficulty, what I guess is hard is being forced to see them as exhibits. For Beuys it was OK because his collaboration was with the spectator. But for iconic works like yours it may seem, I imagine, like

a dislocation, and therefore a violence. Yet don't worry – they will hold their own. They are coming from their own place, like the train between Kilburn and Willesden Green.

With affection and respect
John

<div align="center">ʒ</div>

Dear John,

No one has written about the work of drawing and painting with such directness and selfless insight as you have in your last letter to me. That it's 'my' work you are writing about is less important than the fact that, through your words, you acknowledge the separateness and independence of the images.

'Thereness' follows nothingness. It is impossible to pre-meditate. It is to do with the collaboration of the sitter, as you say, but also to do with the disappearance of the sitter the moment the image emerges. Is this what you mean by 'the self-effacement of the good host'? The Fayum portraits of course emerge out of an attitude to life and death quite different from our own. In the pyramids there was life after death and the life was in the 'thereness' of the portraits. If there is something of this quality in the painting of Pilar it has more to do with the processes I am involved with than trying to paint a certain picture.

Pilar came to sit for me some years ago. She comes two mornings a week. For the first two or three years I drew from her. Then I started to paint her. Painting consists of working over the whole board quickly, trying to relate what was happening on the board to what I thought I was seeing. The paint is mixed before starting – there is always more than one board around to start another version. The process goes on a long time, sometimes a year or two. Though other things are happening in my life which affect me, the image that I might leave appears moments after scraping, as a response to a slight change of movement or light. Similarly with the landscape paintings. The subject is visited many times and lots of drawings are made, mostly very quickly. The work is begun in the studio where each new drawing means a new start until one day a drawing appears which opens up the subject in a new way, so I work from

the drawing as I do from the sitter. It's the process I am engaged in that is important.

I'm not too worried about the hanging of the paintings. The Tate are very good at this. The experience will be very strange. I haven't seen many of the pictures for a very long time and as the event draws closer I become more aware that the work will represent an experiment in living which has been exciting, interesting, and extending, so I'm not so concerned about success or failure as I am about holding myself together to keep the experiment going. This is rather difficult.

The reproductions I have had on my wall since my student days are the Rembrandt *Bathsheba*, a late Michelangelo drawing, the Philadelphia Cézanne, *Achille Empaire* by Cézanne, and a photograph of some early works by Frank Auerbach. About 20 years ago I added a head by Velázquez (Aesop) and a portrait by Delacroix. I don't look at them much but they are there.

Yours Leon

The portrait by Delacroix is of Apasie. I almost forgot the *Judgement of Solomon* by Poussin.

છ

Dear Leon,

Yes, the disappearance of the sitter at a certain moment. And you're right, I left that out. The image takes over. And in your case the image comes through all the vicissitudes of paint, board, plastering on, drawing, and scraping off: vicissitudes which produce something so movingly close to the wear and tear of life. So the image unpremeditatedly, as you say, takes over. And the slow process of discovering what is there, without disturbing it, begins. Sometimes of destroying what's there, without disturbing it. (Eavesdroppers may consider us mad, but it's true.) Then after all that, or during all that, isn't there something else happening? The sitter – who may be a train, a church, a swimming pool – comes back through the canvas! It's as if she disappears, vanishes, merges with everything else – takes a long journey on a kind of Inner Circle (which may last months or a year) and then re-emerges in

418

the stuff with which all this time you've been struggling. Or am I again being too simple?

The 'sitter' is at first here and now. Then she disappears and (sometimes) comes back there, inseparable from every mark on the painting.

After she has 'disappeared' a drawing or two are the only clues about where she may have gone. And of course sometimes they're not enough, and she never comes back . . .

Yes, at our age, the most important thing is to 'hold things together', to 'keep the experiment going.' And it's (most of the time) rather difficult.

I guess the Bathsheba is the one where she's holding a letter? And on her forearm she's wearing a bracelet which, in a way I can't understand but probably you can, is the keystone of the whole painting? And that marvellous rear leg in shadow, and everything tentative except her body.

My friend the Spanish painter Barceló has made a whole book of reliefs with a text in Braille to be felt with the fingers by those who are blind. And this makes me see that if a blind person felt Bathsheba's body and then felt Pilar's or Cathy's, they would have the sensation of touching similar flesh. And this similarity is not to do with a similar way of painting but with a comparable respect for flesh, paint, and their vicissitudes, their endless vicissitudes. The *Aesop* of Velázquez I too have lived with for years. A strange coincidence, Leon, no?

And again, at a level which has nothing to do with method, I see something in common between *Aesop* and your brother *Chaim* (1993). Something said by their presence. 'He observes, watches, recognises, listens to what surrounds him and is exterior to him, and at the same time he ponders within, ceaselessly arranging what he has perceived, trying to find a sense which goes beyond the five senses with which he was born. The sense found in what he sees, however precarious and ambiguous it may be, in *his only* real possession.'

Last week I was looking at *Aesop* in Madrid, in the same room as the head of a deer, in the same life as Willesden and a children's swimming pool.

Tell me how you are.

I salute you! (Incorrigible Latin that I am in my exuberance, blackness notwithstanding.)

John

PS: What sort of music do you like?

<p style="text-align:center">℘</p>

Dear John,

Thank you for your letter. I am still thinking about 'thereness' and the Velázquez portrait of *Aesop*. Referring to a book on the artist I noticed that the author writes 'the picture is by no means a portrait but rather an amalgam of literary and visual sources successfully disguised under a veneer of realism'. Art historians can get away with anything! So I went back to Pacheco, the painter and father-in-law of Velázquez – who wrote – 'I keep to nature for everything and in the case of my son-in-law who follows this course one can see how he differs from all the rest because he always works from life,' and later 'those who have excelled as draughtsmen will excel in this field' (portraits).

Reading Pacheco, one realises that Velázquez must have been drawing continuously, and it becomes possible to begin to understand how the image of Aesop might have emerged in a few moments at the end of a long day's painting, as the artist turned away from the work he was engaged upon to encounter this extraordinary person who had entered the studio. Velázquez was the ultimate example of the artist working at speed, turning drawing into painting like Degas and Manet after him. Drawing from life in paint becomes 'thereness'.

And there's something else – the effort of your friend Barceló on behalf of the blind reminds me that recently I heard a blind man talking on the radio about his experience of light. He said: 'Reassuring, encouraging, people make a kind of light.' (I know this is not what you are saying but doesn't 'touch' produce a kind of light also?) This blind man knew somehow that light would occur through the deepening of his relationship with the outside world. And so it is with painting. It is impossible to set out to paint light. Light in a painting makes its own appearance. It occurs as a result of a

420

resolution of the relationships within the work. The painter might be driven by anxiety, but the light in final work (I'm thinking of Cézanne) is as much a surprise to him as it is a delight to us. In a sense, before the work is resolved, the painter is, in a certain way, blind.

It is possible we become more 'Latin' as we grow older. In my case I wish it was the other way round. Perhaps not. These days I feel I should have been born nearer the Mediterranean in the first place.

Yours,

Leon

56.

Anthony Fry
(1927–)

LOOKING THROUGH A WALL. Oil on canvas. 44.5 x 46 inches. A wall of what? Stone? Brick? Cement? Wattle-and-daub? Or is it a wall of heat? The doorway and the exterior with the walking figure could almost be on *this* side of the wall, as if they were a reflection in a mirror leaning against the wall.

If one reads it like this, the wall dissolves and becomes something like a sky or the fragment of a sunset. Something similar happens in another painting by Fry. For example, the nude lying on the afternoon bed and the painter with his easel seen through a window. Is she lying in the blue shade of a room, or on a wrinkled blue sky? Where is the blue in space? Or, in the first painting, where is the red? With a painter of Fry's skill and experience, there can be no question that this ambiguity is the consequence of clumsiness, indecision or error; it is intentional.

It seems to me that he intends to show in these paintings that there is no division between earth and firmament, that the distant is continually making deals with the near to swap sensations, and that all this is so because the experience of a certain kind of heat places you in a sphere rather than on a plane.

Here the heat changes the surface of everything it touches and the touch provokes, strangely and simultaneously, both desire and satiety.

Or perhaps the wall in question is nothing less than that particular *day* being touched by the heat. That particular day which is scarcely distinguishable from the day before or the day after – until the season abruptly changes. Maybe the wall is a calendar date within a season? Maybe it is what keeps out eternity – where perhaps there are no colours.

Because there has been, in our time, so much talk (almost all of it balls) about artistic freedom, and so little talk about the limits which any viable art imposes, people have come to think of art as an open field. In fact, art is far more like a fenced-in reserve. It is not, by its very nature, open to the rest of life; on the contrary, it builds walls, high walls, to shelter the equilibrium it maintains. The constant risk art runs is that of complacency. (Today's fashion for shocks changes nothing.) Art is always shutting out – it has to do so in order to create the quiet in which its own voice can be heard. Yet its shuttings-out, its exclusions, can easily lead to a complacency which, in turn, leads to diminishing energy. Hence art's cyclic need for invigoration.

Art is regularly invigorated, not, as is lazily thought today, by stylistic 'revolutions', but by the introduction *into* the reserve of a previously shut-out aspect of human experience. Such introductions are never of course simple, because new artistic means have to be found to accommodate the newly admitted experience. For example, Brancusi's formative experience of a certain kind of peasant spirituality obliged him to find or rediscover a totally other way of carving and polishing stone and wood in Paris. For example, in *Ulysses*, Joyce's bringing into the art of literature the unmentionable heroic fantasies of so-called ordinary people obliged him to invent a totally other form of narration. This is how the true stylistic revolutions occur.

I have noticed for many years that when some new body of work by an artist impresses me so that I cannot forget it, the paintings, the videos, the poems, or whatever contain something new in the sense which I have just described. Maybe I can't name what it is. Yet I sense a new admission. Maybe it's something quite small, a very small detail of human experience. (The sensation, for example, of the inside of a thigh touching the inside of the other thigh: this is in Bonnard.) Fortunately, in the realm of art, there is no hierarchy of experiences.

I am asking myself now: why do I find Anthony Fry's South Indian paintings unforgettable? Why under certain circumstances does life, will life, suddenly and abruptly, remind me of them? What have these paintings smuggled, for the first time, into the reserve of European art?

Anthony Fry, *The Man Who Loved Volcanoes*, 2008–09

Their secret has to do with living within a certain climate, of living within a certain tradition of heat. They are emphatically not paintings about the weather (in no sense Impressionist); they are paintings about a culture, imbued with the timeless, daily human experience of a certain climate. I am tempted to say that all the pigments used here have been mixed with perspiration and then varnished with it. I reject the word 'sweat', not through gentility, but because it is a word which implies effort, and these paintings are about an aspect of a culture which cultivates patience and effortlessness.

We are nevertheless in front of paintings, not arguments. Fry's pictures – like all good visual art – defy words. With words we cannot get nearer to them than a map can get to a landscape. We can enter them only with our eyes. Once within them, the eyes may tell the skin something. Once within, the eyes may see even with eyelids shut.

In such a tradition of heat appearances becomes stains. The heat becomes a screen against which every body is pressed. In such heat everything touches everything else. In this heat the words 'alone' and 'together' mean the same thing. In this heat the stain of each colour seems to be played by Pablo Casals.

Try another map. The last one was too rhetorical. Comparing one map with another, we begin to doubt. And, in such affairs, doubt is a better guide to where one wants to go than certitude.

In such a heat the whole world is a tent. The thickest walls undulate. The sky is touchable. Daylight is an entrance held open by two tapes. Night is any chosen corner. A piece of silk is a tent within a tent. The temperature of everything, except certain metals, is more or less

424

the same. Swimming fish, fruit on a plate, a dhoti thrown on a divan, are equally warm or cool. Maybe it is the common (or almost common) temperature which makes the visible colours equal, despite their different intensities. Equal as if each was saying the same word. What word? The word which fingertips whisper when they reassure and say: Wait . . . wait. A word which is neither tender nor cruel, but infinitely knowing. The password of the heat.

57.

Cy Twombly
(1928–2011)

IT HAS BEEN SAID that Cy Twombly's paintings resemble writing, or
are a kind of *écriture*. Certain critics have seen parallels between
his canvases and wall graffiti. This makes sense. In my experience,
however, his paintings refer to more than all the walls I pass in
cities and gaze at, or the walls on which I too once scrawled names
and drew diagrams; his paintings, as I see them, touch upon some-
thing fundamental to a writer's relationship with her or his
language.

A writer continually struggles for clarity *against* the language he's
using, or, more accurately, against the common usage of that
language. He doesn't see language with the readability and clarity of
something printed out. He sees it, rather, as a terrain full of illegibil-
ities, hidden paths, impasses, surprises, and obscurities. Its map is
not a dictionary but the whole of literature and perhaps everything
ever said. Its obscurities, its lost senses, its self-effacements come
about for many reasons – because of the way words modify each
other, write themselves over each other, cancel one another out,
because the unsaid always counts for as much, or more, as the said,
and because language can never cover what it signifies. Language is
always an abbreviation.

It was Proust who once remarked that all true poetry consists of words written in a foreign language. Everyone of us is born with a mother tongue. Yet poetry is motherless.

I'll try to make what I'm saying simpler. From time to time I exchange letters and drawings with a Spanish friend. I do not (unhappily) speak Spanish. I know a few words, and I can use a dictionary. Often in the letters I receive there are quotations in Spanish from poets – Borges, Juarroz, Neruda, Lorca. And I reply with other quotations of poems in Spanish, which I have sought out. The letters are hand-written, and, as I carefully trace the letters of strange words in what is to me a foreign tongue, I have the sense, as at no other time, of walking in the furrows of a poem, across the terrain of poetry.

Cy Twombly's paintings are for me *landscapes* of this foreign and yet familiar terrain. Some of them appear to be laid out under a blinding noon sun, others have been found by touch at night. In neither case can any dictionary of words be referred to, for the light does not allow it. Here in these mysterious paintings we have to rely upon other accuracies: accuracies of tact, of longing, of loss, of expectation.

I know of no other visual Western artist who has created an oeuvre that visualises with living colours the silent space that exists between and around words. Cy Twombly is the painterly master of verbal silence!

58.

Frank Auerbach
(1931–)

WHATEVER ELSE YOU don't do, do go and see Frank Auerbach's fifteen new paintings at the Beaux Arts Gallery. Six of them are of a woman lying naked on a bed; another six are of London building sites; and three are of Primrose Hill. All of them have been much worked on, so that the paint is thick, uneven, turgid. Obvious influences are, indirectly Rembrandt, directly Bomberg. Many may be tempted to dismiss these original works as muddy, churned-up failures. Such people, however, will be those who are unaware of the nature of painting, familiar only with styles as they are filed in the sales catalogues of modern art.

All these works have an extraordinary physical presence. That's why I said naked instead of nude. She is there on her bed. You, by looking and not disturbing her, cease to be a stranger. The building sites are damp. The mud clings. The tarpaulins are heavy with moisture. The light in the sky is far less comforting than a cup of tea. Do I make the paintings sound literal? Of course I do. It is the curse of words in this context. They are not literal. They are physically real partly because Auerbach has learnt to search by drawing, partly because he understands the intimidating limitations of painting. Let me explain what I mean by that, for it concerns the heart of the problem with which

every true painter now has to struggle, and with which we've seen Auerbach struggling for several years.

His earlier works were mud-coloured, inches thick. They looked as if they had been painted in the dark with a candle and a stick. When I first saw them, I recognised the strength of the drawings that accompanied them, but I was unconvinced by the paintings themselves. I now see, in the light of this new exhibition, that they were an essential step in Auerbach's development. Every painter now has to settle for himself the genesis point of his own art. Some choose geometry, for instance. Auerbach chose the density of his pigment. He began with the nearest that a painter can get to substance. Whatever the artist chooses for his genesis will seem inadequate. It will always be like trying to build a house with matchsticks. But it is this inadequacy that he then pushes against. Maybe for years. Always aware of the richness of life and the poorness of art. And then suddenly the inadequacy becomes an advantage. He has turned it to his purpose. The inert deadness of the mud in Auerbach's earlier paintings becomes eloquent now about the weather and the depth dug in the building sites, just as in the nudes it becomes eloquent about the substance of flesh. If an artist inherits a tradition, his development is made much easier. Here and now no artist inherits a tradition. Consequently he faces two dangers, with only his own obstinacy to help him. He can be misled into trying to imitate life. Imitation amounts to no more than a salesman's gimmick: it merely stimulates one's appetite for the real thing. Or else he can be misled into subjectivity. As far as I am concerned the matches are logs, he says to himself, and so happily plays with them and tells himself stories. What he must do, if he is to break through, is to create from discontent. A portentous term. But what it means is that he must accept the limitations of his art. Only from these can he create. His struggle can then be seen as the equivalent of life. And his shock of recognition when he at last achieves something will communicate itself to us – as vividly as a shock received from life. This exhibition contains many such shocks.

59.

Vija Celmins
(1938–)

YOU HAVE TO SEE them. Words can't get round them. And reproduction sends them back to where they came from. (Most of her works originate in photographs.) You have to be within touching distance of them.

It has been said that Velázquez was (is) very important for her. I can believe it. One or two of the things I want to say about her might also refer to him, but to few other painters I can think of. The precondition for their common stance is a certain form of anonymity, a stepping aside.

Vija Celmins is sixty-three years old. She was born in Riga. Her parents emigrated to the US. For thirty years she lived in Venice, California. Now she is in New York.

My bet is that when she was in the Prado, discovering Velázquez, one painting went straight to her heart – the *Tapestry Weavers*.

She both paints and draws, paints in oils, draws with graphite. The work is highly finished and shows what things look like – an electric fire, for example, a TV set, a hotplate, a pistol. These are not from photos; they are life-size, and painted like the Rokeby Venus. I don't say this to compare genius, but to convey the kind of observation, in which tonal precision is so important, working within a patient and very tactful technique of searching.

Her other subjects are motorways, Second World War planes in the sky, the surface of the moon, Hiroshima after the bomb, the surface of deserts, the mid-ocean, and the night sky with stars. Only it's perhaps misleading to call these her subjects. Rather they are the places from which news came via photographs. (Sometimes, as with the ocean, via photographs she herself took.)

I picture her in her studio shutting her eyes in order to see – because what she wants to see, or has to see, is always far away. She opens them to look only at her drawing. What she does with her shut eyes is like what we do when we put a sea shell to our ear to listen to the sea.

She draws galactic space, she never goes out, and she does not let her considerable imagination run free. To imagine is too easy and too consuming. She knows that she has to stay at her post for years. Doing what? I'd say: waiting.

And this is where Velázquez's *Tapestry Weavers* offers us a clue. Vija Celmins is the artist as Penelope. Far away the pitiless Trojan War continues. Hiroshima is razed. A man on fire runs away. A roof burns. Meanwhile the sea which separates and the sky which looks down are utterly indifferent. And here, where she is, nothing is meaningful except her unlikely and possibly absurd fidelity.

For thirty years she ignored trends, fashion, and artistic hyperbole. Her commitment was to the far away. Such fidelity was sustainable

Vija Celmins, *Night Sky #4*, 1992

431

because of two things: a deep pictorial scepticism and a highly disciplined patience.

Celmins's scepticism tells her that painting can never get the better of appearances. Painting is always behind. But the difference is that, once finished, the image remains fixed. This is why the image has to be *full* – not of resemblance but of searching. All tricks wear thin. Only what comes unasked has a hope.

She plays a game called *To Fix the Image in Memory*. She takes eleven pebbles from the beach to look at (like everybody does when idle) and she makes casts of them in bronze and paints them. Can you tell which is which? You can? Are you sure? Then how? This is a close-up exercise in scepticism. (And it's a way of giving value to the original pebbles.)

Unlike the first Penelope, she does not undo every night what she has woven during the day – in order to keep her worldly suitors at bay. Yet it comes to the same thing, for next day she will continue to move slowly with her graphite across the shimmering water which never stops and when at last she finishes one sheet of paper, she takes another. Or, if it's the night sky she's doing, she moves from galaxy to galaxy. Her patience comes from an awareness of the distance to be covered.

'I think there's something profound', she once said, 'about working in material that is stronger than words, and is about some other place which is a little more mysterious.'

None of this would, in itself, be interesting unless you happened to know her and like her. (I myself do not know her.) Her contribution is not to argument. It is tangible and lies in the mysterious images which are framed behind glass: the images you have to be in touching distance of.

I explain her to myself as Penelope because these images are so hand-made (staying at home, head bent, working for years and years) whilst the news they bring – of war, unbearable distances, disappearances, a wisp of smoke from a gun just fired – is bad or threatening.

And this strange marriage leads to a strange transformation. She squares up, square centimetre by square centimetre, the photo of the sea, and she transcribes devotedly, forgetting herself. She is too intelligent and too sceptical to copy; she transcribes with all the fidelity she knows. And when at last it is finished, there is an image of the cruel

sea, or the cruel sea photographed in a killing instant, and everywhere all over it, you see the touch of a loving hand. It is visibly and infinitely hand-made.

It is the same with all her paintings and drawings. They look unflinchingly at what is, and at what man does, and at the dimensions of solitude, and they are systematically touched with love.

What Homer did with his dactylic hexameters (long-short-short) Celmins does with the pressure of her fingers – a kind of Morse code of the pencil. And so, thanks to this constant measure, her chilling images of distance are warmed, and this gives us pause, makes us wonder.

60.

Michael Quanne
(1941–)

HE WAS BORN FORTY-THREE years ago in Surrey, south of the river, but when he was one year old the family moved to Bethnal Green in the East End. It was in those post-war streets, as typical of London as was Dickens, that he learnt to dream, to run, to watch: the same streets and tenements that thirty years later he was going to paint. He failed the eleven-plus. 'The educational system is grounded in words and at home words were in short supply. I was verbally inarticulate.'

> You're like book ends, the pair of you, *she'd say*,
> Hog that grate, say nothing, sit, sleep, stare . . .
>
> Tony Harrison

'At school I liked drawing maps and colouring in the countries. The only thing I liked. I didn't know the capitals, it was the outlines that got me.' The painter was already there in embryo. Also the indefatigable questioner – but at that stage the questions were not formulated, they were simply impulses to get around what *was*, to leave this side in order to see the other, the obverse, to *be* (the word 'play' cannot apply) truant.

Last month in the Paris Metro he asked me: 'You, do you believe in Free Will?' I mumbled something equivocal. 'I read a book by Sartre,' he said, 'and whenever he spoke of free choice I got out a magnifying glass to make sure it was really there, and I never found it.'

At the age of sixteen he was arrested for the first time on a charge of attempted larceny. Since then the longest period he has been out of prison is three years. Most of his adult life he has been inside. *Inside* might be another title for this book. Only in one painting (the one at the seaside) are there no walls, no windows, no railings. All the others concern incarceration of one kind or another. How many faces peer out of windows! I have counted thirty.

'Remember in *War and Peace*,' he asked me, 'when Pierre is arrested and is about to be executed? He's spared at the last moment and then he watches the soldiers burying the ones they've already killed.'

Pale frightened figures busied themselves around the body of the last one shot. An old soldier with a handsome moustache untied the rope and, as he did so, his jaw was trembling. The corpse fell to the ground. Others made haste to drag the body behind the firing stake and to dump it in a trench. It was clear they knew they were assassins and they wanted to cover up their crime as quickly as possible.

'That passage', he said, 'came to my mind years ago, when a judge gave me seven years. He hurried through the sentence and he didn't want to look at me. He knew he was doing wrong.'

Authority dreams with its eyes shut of the efficacy of its punishments (no authority dreams of justice), just like the woman in a blue dress with her eyelids closed, the woman who once punished kids by making them dance in front of the class, and who still appears in his nightmares.

To enter the world as lived by Michael Quanne, it is necessary to abandon the idea that justice exists on this earth, the idea that people mostly deserve what they get, that money is usually a reward for effort and skill, that everyone has a more or less equal chance to make up their minds and come to decisions, that the good and brave are finally

honoured, that the 'social good' is something to be debated about so that the best argument may triumph, to abandon the expansive space of such complacency where all horizons are moral, and, by contrast, to enter a crowded corner of a sprawling edifice, where nine out of ten doors are locked, where there are no perspectives, no horizons, but only deteriorations (downhill), where nearly everything which happens in your corner is chancy and arbitrary, where there are no appeals because there have never been addresses to which to deliver them, nor incumbents to read them, and where the only thing that is straight is what you tell yourself. It is to leave the privileged and to join the excluded.

> Through tatter'd clothes small vices do appear;
> Robes and furr'd gowns hide all. Plate sin with gold,
> And the strong lance of justice hurtless breaks;
> Arm it in rags, a pigmy's straw does pierce it.
>
> *King Lear*, Act IV, Scene 6

The word 'primitive' when applied to a painter like Michael Quanne is doubly confusing. Quanne is a highly self-conscious and skilful artist. (Talking with him about art reminds me of conversations with L. S. Lowry, who was about as primitive as a Zen Buddhist monk.) Furthermore, there is a confusion lurking in the label itself and this we need to understand if we are to come to terms with Quanne's achievement.

Any professional painter learns a given language of painting, and this language – when seen from far away – is always limited because it has been developed to express and satisfy certain experiences and not others. Every art-form is intimately related to a type of life experience. The difference between chamber music and jazz is not one of quality, finesse, or virtuosity but of two ways of life, which the people involved did not choose but were born into. The professional skill learnt by an apprentice in Gainsborough's studio was ideal for painting feathers and satin and useless for painting a Pietà.

Every style in art cherishes certain experiences and excludes others. When somebody tries to introduce into painting a life experience which the current style or traditional styles exclude, he is always

dubbed by the professionals *crude, clumsy, grotesque, naive, primitive.* (It happened to, amongst others, Courbet, Van Gogh, Käthe Kollwitz, and earlier to Rembrandt.)

It would be wrong to explain this phenomenon by the bad faith of the professionals for, in a sense, the epithets are correct. The intruding experience cannot share the culture of the cherished ones. It has its own culture, a culture of exclusion. Its very nature demands, in relation to prevailing taste, an apparently disjointed, distorted, or clumsy expression. How can it preserve its memories of exclusion and at the same time be suave?

This said, Michael Quanne's paintings are very remarkable because of the richness and subtleties of the experience they relate. Each figure, however minor, is a portrait; there are no stereotypes. (Undoubtedly Quanne is a storyteller because he has that kind of observation: when he looks at a face, he senses a destiny.) Every painted gesture derives from active experience – look at the figures climbing the wall in *Mass Escape,* or the boy lifting the pails in *Breakfast Time,* or the couple walking towards us in *Umbrellas.* I say 'couple' because, although they are children, they are already elderly.

This ambiguity in his art about age (he turns those who are adults in life into children in his paintings) is rooted, I believe, in his experience and is perhaps related to three insights: that kids who live on the street mature early, that prisoners are treated like punished children, and that, among those whom the law finds guilty, many might claim a never-to-be-formulated innocence. About this innocence there is nothing soulful or poetic; it is simply the *affair and its circumstances seen from the other side,* from the side where little is ever formulated, yet where the appetite for love – and if not love, respect – is undiminished.

Lastly, I would like to point out a dimension in his art which does not derive from a specific milieu but which is universal: the felt presence of what is not visible. Each of his paintings is like something closely studied through a window – an outside seen from inside, or an interior seen from outside. One can, of course, approach all paintings in this way. But in his, you are made conscious that the 'window' is set into a wall which hides. In what we see there is a haunting sense of what lies beyond the frame. The bottom of the hill to which the

roller-skaters are heading. The worst – that which Quanne says he'd rather not paint – the prison gates, the dock, the Scrubs. The mysterious place from where the animals have come. The sky in which the kite will fly. The immanence behind (or within?) each brick. The garden outside for which the trikes in the room were made . . . This is a book made up of images of incarceration – and dreams of freedom.

Michael Quanne,
Free Will, 1993

438

61.

Maggi Hambling
(1945–)

Poets – unlike other people – are loyal only in misfortune
and they abandon those who are doing well.

Ivo Andric, *Disquiet*, 1917

HERE I AM at the beginning, where I agreed to be, and I don't know
what to do. The drawings which follow tell their own story and speak
for themselves in a breathtakingly direct and naked way. To add
words would be to dress them, and distract from their nakedness. I'd
go further: to add words – any words – risks to be a form of censor-
ship.

The loved one is indescribable to any third person. This is not because
love is blind, but because the lover has discovered and has been shown
something which is habitually hidden. Lovers undress one another
with passion, and part of the promise in physical passion is the chance
of also baring a soul: a promise sometimes realised, often not. Yet,
when it is, the lovers reveal to each other something hidden from the
rest of the world. The revelation may be brief or may be almost
instantly covered over or denied, but revelation it was, and revelations
are, by their nature, incommunicable in any of the world's everyday
languages. Hence the solitude of love.

To be loved is to be unmasked. The verb 'to unmask', in normal usage, suggests that what lies behind the mask is ignoble, that the mask is being worn to put a better face on something which, if disclosed, would be undesirable. When love unmasks, the sense is reversed, and the conclusion is the opposite: what lies behind the mask is found to be more lovable (perhaps even sometimes nobler) than what the mask is pretending. No love without nakedness.

What constitutes a mask? A reputation with its exaggerations. A face with its expressions. A life-style with its acquisitions. A pair of eyes with their arranged signals. A body with its poses. Nearly everything personal presented to the world functions as mask. Social life demands this. In certain cultures the theatricality of the mask has been openly acknowledged, in others (like our own) it is deeply confused, but, either way, masks are necessary. Love's unmasking goes beyond necessity. Hence love's subversion.

I remember Henrietta from the early '50s in Soho. I didn't know her personally. If I ever spoke to her, it couldn't have been more than a couple of words. Yet I often watched her, fascinated. She wore her masks carelessly, so that even a stranger like me at the far end of the bar, or sunk in an armchair in the distant corner of the same room, would catch a glimpse of what stretched behind them. I use the word 'stretch' because whatever it was that lay behind her masks was like an open landscape, whilst she, at the same time, perched on her stool or striding towards the door, was like a horse to be ridden bareback.

OK. But of what interest is this here and now? My vivid memories of Henrietta don't quite concur with her hearsay legend or anyway the press versions of it. The legend proposes that Henrietta, fabulous model and muse of a circle of painters, Ikon Queen of Soho in the 1950s, lived it up for as long as she could and then, as a result of drink, LSD, and extravagance, skidded to the bottom, eventually dying at the age of sixty-seven, from cirrhosis of the liver.

The facts are correct. The only thing I question is the 'timing' of the rise and fall. Henrietta held court, held sway like a Queen, was imperious and magnificent, and then a decline set in. Nevertheless

people are not empires, and her fatality was of a different kind, subject to a more mysterious law. I'll try to explain.

Francis Bacon was fascinated by Henrietta and painted her many times. There was not so much a close friendship between them – he never gave her a single painting – but rather a certain complicity. They confirmed each other, and my guess is that this was because they both accepted the same proposition, namely that the worst had already happened!

For Bacon this was the basis of his ideological world view as an artist, and it led to a curious and (in my opinion) criticisable complacency. For Henrietta it was the subjective basis for finding her own incandescent form of courage.

It is about this incandescence that I want to say a few words. When Henrietta arrived in Soho, called Audrey, not yet Henrietta, aged eighteen, the worst possible had already happened. Which was what? I don't know. I doubt whether she could have named it herself. Yet it was not a fancy or adolescent exaggeration. She had come through some kind of furnace and had been recast. Nothing, her experience told her, would be as bad again – and, probably, right up to her death nothing was.

I have no right to be writing this. I didn't know her. I just watched her across rooms full of people. What I saw wasn't despair, but rather an impatience, protected by a fearlessness, to go further and further and faster and faster. Such impatience is often egotistical and obsessive. Whereas, in her case, the fearlessness which accompanied the impatience was something she offered to others and wanted to share. And it was this which created her incandescence. Call it charisma, glamour, sex-appeal, beauty. Such terms, however, are too general for what I observed. Very precisely, her incandescence was generated by a fearlessness on offer to others.

The offer, however, was not gratuitous; it was linked, if only loosely and tacitly, to a contract which said: whatever we do together, we'll do it in such a way as to cheat life again and delay for another moment its cruelty; we'll search together not for pleasure, but for consolation. Evidently there were people who found this contract outrageous, particularly the simple pleasure-seekers. Others lacked the stamina to hold to it for long. But Henrietta, I believe, held to it.

When Maggi Hambling met Henrietta face to face in February 1998 (it was not the first time they had met, but it was the decisive meeting), Fate put three cards face down on the table. The first showed Maggi drawing Henrietta day after day until her death. The second foresaw Henrietta asking Maggi to hug her a few seconds before she died. And the third predicted that the two of them would fall in love with one another.

Maggi Hambling, *Study of Henrietta Moraes*, 1998

All this happened. And the story of how and why it happened is told by the immortal drawings which survived. Told *by*, not told *in*, for the story is inherent in every line drawn, every hesitation of the charcoal, every correction, every tentative mark of love left on the paper.

Drawing a face is one way of noting down a biography. Good portraits are both prophetic and retrospective. (When they are drawn rather than painted, this is clearer, for colour, which tends to insist upon an eternal present, can be a distraction.) The passage across time is not something consciously sought after by the artist; it emerges naturally from the act of drawing.

Look at the formation of a mouth, how it protrudes, overhangs, recedes, hides its corner, opens for its tongue or clamps shut – try tracing

such things and one is led back, stage by stage, to the birth of that mouth; just as looking at the grin of its teeth and the way in which it draws away from the nose, leads one forward to the death of that mouth. Every trait on a face is in a state of suspension between memory and expectation. Nothing else in the world quivers with such complexity as the living human face, and its quivers are like waves crossing the sea of a lifetime, so that the one drawing becomes an observer, at the water's edge, on all the shores of the life of that face. And the more the waves enter the drawing, the less the face will remain a mask. Indeed there are draw- ings – like some by Maggi or some by Rembrandt – which unmask. You don't regret that comparison? No, I don't.

Sometimes when drawing I have the feeling that my fingers are brighter or more subtle than my eyes, and certainly brighter than my intelligence. If one says finger, one says hand, if one says hand one says arm, if one says arm one says shoulder. At the best moments one draws with the whole body – genitals included. Nevertheless return down the arm to the fingers.

Her fingers touching the paper with a stick of charcoal or graphite pencil or a rubber. Yet is that all they are doing? Are they not touching the face too, the face, the nose, the hair, the eyes – so that they shut a little, the corners of the mouth? What is the relation between tracing and stroking, between an erasure and a caress?

I don't know the exact answer, but I recognise the mystery. And it is connected with another, the mystery lying behind the fact that this series of drawings, recording the last days of a bohemian drunk, makes me think, despite myself, of angels. In the Prado there is a painting by Antonello da Messina. A Pietá. The slumped body of a dead Christ in the arms of a frail angel. The angel holds the body as these drawings hold Henrietta. This said, let us immediately note the difference in the two situations. In most of Maggi's drawings, Henrietta is not dead, and in some she is very actively participating, giving of herself, demanding promises, seeking and offering consolation. The drawings are part of a love affair. (One could think of them as love letters – written by both.) Yet what are love affairs really about? Don't ask the soap operas, ask deep in the self. Each affair is different, but all have to do, in some way or another, with desire and with pity. What is called attraction always

has written within it a secret clause about consolation: consolation offered and given. I am not thinking here of the emotion of pity, closely connected with the idea of mercy: I am thinking of pity as an ingredient in, or perhaps the ground of, other emotions and passions. Or to put it more simply, there is no love without pity, and this becomes clearer the older one is. Maggi and Henrietta knew it.

These drawings remind us that in sex and in pity, touch is as primordial as in drawing.

A final observation: the ten drawings made by Maggi in the morgue or drawn looking down into Henrietta's coffin are the only ones where nothing has been rubbed out. We touch the dead differently. In the last drawings, drawn from memory, the caresses begin again.

62.

Liane Birnberg
(1948–)

LIANE, I DON'T WANT to interpret your paintings for a third person, because they are independent and free, and to interpret them for somebody else would be to limit them. By this I don't mean they are vague, being all things to all men. They are precise, and in a moment I want to try to say something about their precision. Furthermore, the word 'interpret' is wrong, for it suggests that the paintings are in a foreign language and they are not. Their language is familiar – even if they sometimes speak of what is nameless, as does music.

I like it that they are untitled, because, like this, each spectator can find names for her or himself: nicknames for the sake of identification. Their real names have been folded in the act of painting.

These are images which demand to be looked at – despite their discretion and secretiveness. They demand to be looked at because one immediately recognises that the light, the painted light *in* them, is falling on something real, something existent. The light in them authenticates the rest. This is why, for all their mystery, they celebrate substance.

You have watched light touching things all your life, and that experience of watching is palpably here in these canvases. You have listened to the noises light makes as it crosses or settles on surfaces – many

different surfaces. You know how light is sometimes like a comb, sometimes like a metal file, or a hammer, or a pair of lips, everything depends upon the source of light and the surface being touched.

The first authenticity of these paintings is proved by the way the painted light touches what is painted. This is what makes them incontestable.

And what is being painted, what is there? They are images from the past; they evoke the past, as do certain Watteaus – with whose palette they have something in common. Yet your paintings are not about performances, nor about players who have left; they are about what remains. And it is here that they tell something new about memory.

The past is usually thought of as a temporal category: linear time consists of past, present, and future. Nobody thinks much about the space of the past, or the past as a *spatial* category. This is not of course the same thing as thinking about past space – as one can find it in a Gothic cathedral or on an archeological site.

What you show is that the past has its own space *now*, which is quite unlike present space, and you offer us examples of the past's space, each canvas being a variant. You show us how we wear the past, as if it were a garment, or, more accurately, how the present wears the past next to its skin. It seems to me your starting point is always those two surfaces touching: the skin of the present and the garment of the past.

The word 'linen' comes to me – with all its associations of washing, ironing, bleaching, folding, and with its smell which is quite unlike that of cotton or wool or silk. Linen never clings and it invariably lets breathe. There is always air between it and the body touching it – even if the body is lying on it.

Thanks to this air, the past which impregnates the linen whispers to the skin. (Perhaps it is not surprising that the best canvases for painting on always have linen in the weave.) You, the painter, follow where those whispers lead, and, if we follow you, we too begin to discover the space, the topography of the past: a topography wherein distance is replaced by layers which are more or less transparent, where there is no horizon, only Origin, where roads and paths are repeatedly folded, like linen, to become palimpsests.

Your paintings are wordless stories. The term may sound strange.

How can there by any narrative without words? Dogs know better, and as a storyteller, I know that new stories begin wordlessly. Their shape, their colour, their smell, their temperature, their short hairs, their eyes, and above all their fingers with which they touch are there, distinct and unique, before a single word has been found. Words finish stories rather than engender them.

In the past's space (of which you are mistress as a painter) colours often float like sounds, and the secret of this space is close, no?, to the mystery of acoustics? In any case, I cannot look at your paintings without listening to them.

63.

Peter Kennard
(1949–)

MOST GUARDIAN READERS
are familiar with Peter
Kennard's work, for it has
often appeared in these
pages, and is haunting.
Eschewing words, it insists
upon not being forgotten.
Two exhibitions and a book,
which collect Kennard's
photomontages from over a
period of twenty years, give
us a chance of reflecting on
why his art cannot be
ignored. I put it negatively
(instead of writing 'Why his
art is so impressive' – which
would be equally true)
because what he has to say is
unfashionable, disturbing,
obsessive. I would say his

Peter Kennard, *Thatcher
Cuts Healthcare*, 1985

work was pure – if the word hadn't become dirty. Like salt water on wounds.

He has two themes. The development of nuclear weapons since Hiroshima, and modern poverty, the two connected by way of the world's defence budgets. At one level Kennard is announcing nothing new. Every schoolkid knows the score – just as every schoolkid has to learn to live in a dirty world. The threat to the planet. Millions dying of malnutrition. What can a single man with a pile of photos, a pair of scissors, and paste do in face of all this? It's after such a question that we get a little closer to seeing what Kennard's project really is. It's much nearer home.

His first theme isn't really about nuclear weapons, but about the readiness of political power to *envisage their use*. Likewise, his second theme isn't really about starvation, but about the *indifference* of political and economic policy in face of the facts. His terrain is that of the human conscience. This is why all debates about deterrents, electoral programmes, or the realities of the world market leave his work, which is wordless, intact. His arguments are not about tactics *or* strategy. He addresses all the while a single question: How do we live with it? And the answer is: Very badly.

His imagination is not that of an avowed moralist. Moralists try to list permanently what is good or bad: an act, a custom, a person, a desire, a system, even a people. Yet neither evil nor good can be commonly defined within a moral typology – because they are forces whose tendencies are present everywhere in every type of action or decision. If absolute evil exists it only exists in the consequences of a specific act (such as nuking a city) not in any moral generalisation.

To say this is not to relativise the question of evil, but on the contrary to face it in its full extent. The same goes for the good. Moralists, however, like to arrange such questions in cupboards (or prisons) so they can be free of them and go out to dine! With their list of moral definitions they hope to create an area of innocence. But no such area exists, and this is what Peter Kennard knows.

His terrain of the human conscience contains guilts, suppressed fears, and the longing for good; it is the terrain of our nightmares and dreams, consequent upon the fact that we elect governments who

envisage the use of atomic weapons, and that we contribute to an economy which ruins the lives of half the people in the world.

This is why Kennard's images are often, at the same time, highly original and deeply familiar. The island of Britain burning like waste paper. A funnel, a hollow utensil with a wide mouth tapering to a small hole, stuffed with money, dripping war-heads. The globe as the face of a hungry child. The world padlocked. The mushroom cloud vaporising a face.

His images are impossible to convey with words because, first, there is their unmistakable visual texture, suggesting a strange amalgam of X-ray, satellite image, and slag. Secondly, there is their visual configuration which, while art-historically owing a lot to surrealism, insists, in the sleeping life of our nation, upon many common nightmares: some dating from the First World War, when the trauma of being commanded by generals who did not know what they were doing began; some taking up the diabolic torch of 6 August 1945 (Hiroshima); others scrutinising the future, pleading that it may be different.

The subtitle of the book *Images for the End of the Century* is 'Photomontage Equations'. The book is divided into fourteen sequences, each one an equation. There are no captions, but between the images there is often a plus, minus, or equals sign. And this word-less device renders accurately the ineluctable flow of a dream from which one wakes up protesting.

Yet there is another less explicit equation, which defines both the driving force, the will, of Peter Kennard as an artist, and our need of his work. This is the equation between what we know and (often) suppress, and what those who wield power lie about. Kennard is involved – and this is why he has chosen the medium of photo-montage – in making the invisible visible. Or in disclosing what is being both deliberately and unconsciously hidden. Such disclosures look indecent and are noble.

They are noble, among other reasons, because they invoke the future. The last image in the book is of a foetus in the womb of the globe.

We live, at the moment, in a culture which is so obsessed with

short-term advantages that it has already forgotten the future. The instant chatter of the media. The instant promise of plastic money. Politicians who want us to be blind so that we vote for them.

The future – which for so long was a mine of gory rhetoric for those holding power – today depends upon those who insist upon looking beyond their lifetime. And to do this we have to scrutinise, like Peter Kennard, our nightmares and suppressed hopes.

64.

Andres Serrano
(1950–)

TODAY IS GOOD Friday, the day nominated by Christian churches for recalling Christ's agony and death on the cross.

Six days ago in Avignon the local bishop, supported by several Catholic fundamentalist groups and by the National Front (who gained 27 percent of the votes in the last election in Avignon), forced a museum in the city to shut because it was exhibiting a photographic work by the New York artist Andres Serrano entitled *Piss Christ*. The work, made more than twenty years ago, shows a crucifix immersed in a bottle said to contain blood and urine.

The following day a small group breaks into the museum and smashes this work. The minister of culture then speaks out against an attack on the fundamental principle of Freedom of Expression and Creativity. And all the media refer to the little incident as an act of wanton barbarism.

And I wonder. It seems to me that what's involved is more painful and more complex and is also symptomatic of a much wider and ongoing tendency in the bad naming of things. Yes.

Serrano explains that he made this and other comparable works during the first epidemic of AIDS. Blood tests suddenly became alarming; many big firms forced their employees to have urine tests.

Christ is immersed in these two liquids. The image was also conceived as an attack against the Roman Catholic Church, whose doctrines, persecutions, and inquisitions have often contradicted the impulse of pity that Christ demonstrated and preached. Faced with the scourge of AIDS, Christ would surely have stood by its victims.

Serrano's polemical error (the aesthetic of the work is altogether another question) concerns its title. If he had named it *Urine, Blood, and Christ* or *Christ Immersed in Urine and Blood*, the point would have been made.

In fact he calls it *Piss Christ*. And this expletive is an aggression, a violent provocation. (Its taunt is asking for a counterattack and a scandal.) The provocation of the title is also blasphemous, for it insults the sacred.

The fact that the bishop in question has pronounced the photograph *blasphemous* need in no way deter us from considering the term. The Church should be allowed the monopoly of no words. (Every form of fanaticism begins with the exclusive ownership of words.) A figure like the Abbé Regis de Cacquercy of Avignon reminds me of several of the ecclesiastics whom Tolstoy portrayed with such magnificent anger in his last book, *Resurrection*. (After its publication the Orthodox Church excommunicated Tolstoy.)

Christ's example is seen and felt by numerous millions of people, who live outside the ministry of the churches, as a guide, or as a revelation of the possible. It offers hope and it offers Pietàs. It is such faith, not the symbols or edicts of the churches, which demands to be considered as sacred, and therefore spared gratuitous insults. The two words 'Piss Christ' (not the image) constitute such an insult.

Why do I retell this trivial story whose significance has already been exaggerated by its pompous press coverage? Because it is a telling example of how a smart use of words may stand in for a colossal ignorance about how things work out on the ground. Serrano with his jibe title forgot about the extent and complexity of the faith I refer to. Forgot? Or has become ignorant of?

Today in the Communication deluge, word-play and attitudinising often pre-empt the reality of countless other lives being lived. And this

leads to the paradox that *ignorance* so often accompanies the latest *information*.

Last week on TV a neo-liberal economist was asked what investment signifies across the world. His reply was: To invest is to hope for gain.

It is Good Friday and almost midnight.

65.

Juan Muñoz
(1953–2001)

Friday

Nazim, I'm in mourning and I want to share it with you, as you shared so many hopes and so many mournings with us.

> The telegram came at night,
> only three syllables:
> 'He is dead'.

I'm mourning my friend Juan Muñoz, a wonderful artist, who makes sculptures and installations and who died yesterday on a beach in Spain, aged forty-eight.

I want to ask you about something which puzzles me. After a natural death, as distinct from victimisation, killing, or dying from hunger, there is first the shock, unless the person has been ailing for a long while, then there is the monstrous sense of loss, particularly when the person is young –

> The day is breaking
> but my room
> is composed of a long night.

and there follows the pain, which says of itself that it will never end. Yet with this pain there comes, surreptitiously, something else which approaches a joke but is not one. (Juan was a good joker.) Something which hallucinates, a little similar to the gesture of a conjuror's handkerchief after a trick, a kind of lightness, totally opposed to what one is feeling. You recognise what I mean? Is this lightness a frivolity or a new instruction?

Five minutes after my asking you this, I received a fax from my son Yves, with some lines he had just written for Juan:

> You always appeared
> with a laugh
> and a new trick.
>
> You always disappeared
> leaving your hands
> on our table.
> You disappeared
> leaving your cards

Juan Muñoz, *Towards the Corner*, 1998

in our hands.
You will re-appear
with a new laugh
which will be a trick.

Saturday

I'm not sure whether I ever saw Nazim Hikmet. I would swear to it
that I did, but I can't find the circumstantial evidence. I believe it
was in London in 1954. Four years after he had been released from
prison, nine years before his death. He was speaking at a political
meeting held in Red Lion Square. He said a few words and then he
read some poems. Some in English, others in Turkish. His voice was
strong, calm, highly personal, and very musical. But it did not seem
to come from his throat – or not from his throat at that moment. It
was as though he had a radio in his breast, which he switched on and
off with one of his large, slightly trembling hands. I'm describing it
badly because his presence and sincerity were very obvious. In one
of his long poems he describes six people in Turkey listening in the
early 1940s to a symphony by Shostakovich on the radio. Three of
the six people are (like him) in prison. The broadcast is live; the
symphony is being played at that same moment in Moscow, several
thousand kilometres away. Hearing him read his poems in Red Lion
Square, I had the impression that the words he was saying were also
coming from the other side of the world. Not because they were
difficult to understand (they were not), nor because they were
blurred or weary (they were full of the capacity of endurance), but
because they were being said to somehow triumph over distances
and to transcend endless separations. The *here* of all his poems is
elsewhere.

In Prague a cart –
a one-horse wagon
passes the Old Jewish Cemetery.
The cart is full of longing for another city,
I am the driver.

Even when he was sitting on the platform before he got up to speak, you could see he was an unusually large and tall man. It was not for nothing that he was nicknamed 'The tree with blue eyes'. When he did stand up, you had the impression he was also very light, so light that he risked to become airborne.

Perhaps I never did see him, for it would seem unlikely that, at a meeting organised in London by the international peace movement, Hikmet would have been tethered to the platform by several guy-ropes so that he should remain earthbound. Yet that is my clear memory. His words after he pronounced them rose into the sky – it was a meeting outdoors – and his body made as if to follow the words he had written, as they drifted higher and higher above the square and above the sparks of the one-time trams which had been suppressed three or four years before along Theobald's Road.

> You're a mountain village
> in Anatolia,
> you're my city,
> most beautiful and most unhappy.
> You're a cry for help – I mean, you're my country;
> the footsteps running towards you are mine.

Monday morning

Nearly all the contemporary poets who have counted most for me during my long life I have read in translation, seldom in their original language. I think it would have been impossible for anyone to say this before the twentieth century. Arguments about poetry being or not being translatable went on for centuries – but they were chamber arguments, like chamber music. During the twentieth century most of the chambers were reduced to rubble. New means of communication, global politics, imperialisms, world markets, etc., threw millions of people together and took millions of people apart in an indiscriminate and quite unprecedented way. And as a result the expectations of poetry changed; more and more the best poetry counted on readers who were further and further away.

458

Juan Muñoz (1953–2001)

> Our poems
> like milestones
> must line the road.

During the twentieth century, many naked lines of poetry were strung between different continents, between forsaken villages and distant capitals. You all know it, all of you: Hikmet, Brecht, Vallejo, Atilla Jósef, Adonis, Juan Gelman . . .

Monday afternoon

When I first read some poems by Nazim Hikmet I was in my late teens. They were published in an obscure international literary review in London, which was published under the aegis of the British Communist Party. I was a regular reader. The Party line on poetry was crap, but the poems and stories published were often inspiring.

By that time, Meyerhold had already been executed in Moscow. If I think particularly now of Meyerhold, it is because Hikmet admired him, and was much influenced by him when he first visited Moscow in the early 1920s . . .

'I owe very much to the theatre of Meyerhold. In 1925 I was back in Turkey and I organised the first Workers' Theatre in one of the industrial districts of Istanbul. Working in this theatre as director and writer, I felt that it was Meyerhold who had opened to us new possibilities of working for and with the audience.'

After 1937, those new possibilities had cost Meyerhold his life, but in London readers of the *Review* did not yet know this.

What struck me about Hikmet's poems when I first discovered them was their space; they contained more space than any poetry I had until then read. They didn't describe space; they came through it, they crossed mountains. They were also about action. They related doubts, solitude, bereavement, sadness, but these feelings followed actions rather than being a substitute for action. Space and actions go together. Their antithesis is prison, and it was in Turkish prisons that Hikmet, as a political prisoner, wrote half his life's work.

Wednesday

Nazim, I want to describe to you the table on which I'm writing. A white metal garden table, such as one might come across today in the grounds of a *yali* on the Bosporus. This one is on the covered verandah of a small house in a south-east Paris suburb. This house was built in 1938, one of many houses built here at that time for artisans, tradesmen, skilled workers. In 1938 you were in prison. A watch was hanging on a nail above your bed. In the ward above yours three bandits in chains were awaiting their death sentence.

There are always too many papers on this table. Each morning the first thing I do, whilst sipping coffee, is to try to put them back into order. To the right of me there is a plant in a pot, which I know you would like. It has very dark leaves. Their undersurface is the colour of damsons; on top the light has *stained* them dark brown. The leaves are grouped in threes, as if they were night butterflies – and they are the same size as butterflies – feeding from the same flower. The plant's own flowers are very small, pink, and as innocent as the voices of kids learning a song in a primary school. It's a kind of giant clover. This particular one came from Poland, where the plant's name is Koniczyna. It was given to me by the mother of a friend who grew it in her garden near the Ukrainian border. She has striking blue eyes and can't stop touching her plants as she walks through the garden or moves around her house, just as some grandmothers can't stop touching their young grandchildren's heads.

> My love, my rose,
> my journey across the Polish plain has begun:
> I'm a small boy happy and amazed
> a small boy
> looking at his first picture book
> of people
> animals
> objects, plants.

In storytelling everything depends upon what follows what. And the truest order is seldom obvious. Trial and error. Often many times.

This is why a pair of scissors and a reel of scotch tape are also on the table. The tape is not fitted into one of those gadgets which makes it easy to tear off a length. I have to cut the tape with the scissors. What is hard is finding where the tape ends on the roll, and then unrolling it. I search impatiently, irritably with my fingernails. Consequently, when once I do find the end, I stick it onto the edge of the table, and I let the tape unroll until it touches the floor, then I leave it hanging there.

At times I walk out of the verandah into the adjoining room where I chat or eat or read a newspaper. A few days ago, I was sitting in this room and something caught my eye because it was moving. A minute cascade of twinkling water was falling, rippling, towards the verandah floor near the legs of my empty chair in front of the table. Streams in the Alps begin with no more than a trickle like this.

A reel of scotch tape stirred by a draught from a window is sometimes enough to move mountains.

Thursday evening

Ten years ago I was standing in front of a building in Istanbul near the Haydar-Pasha Station, where suspects were interrogated by the police. Political prisoners were held and cross-examined, sometimes for weeks, on the top floor. Hikmet was cross-examined there in 1938.

The building was not planned as a jail but as a massive administrative fortress. It appears indestructible and is built of bricks and silence. Prisons, constructed as such, have a sinister, but often, also, a nervous, makeshift air about them. For example, the prison in Bursa where Hikmet spent ten years was nicknamed 'the stone aeroplane', because of its irregular layout. The staid fortress I was looking at by the station in Istanbul had by contrast the confidence and tranquility of a monument to silence.

Whoever is inside here and whatever happens inside here – the building announced in measured tones – will be forgotten, removed from the record, buried in a crevice between Europe and Asia.

It was then that I understood something about his poetry's unique and inevitable strategy: it had to continually overreach its own

confinement! Prisoners everywhere have always dreamt of the Great Escape, but Hikmet's poetry did not. His poetry, before it began, placed the prison as a small dot on the map of the world.

> The most beautiful sea
> hasn't been crossed yet.
> The most beautiful child
> hasn't grown up yet.
> Our most beautiful days
> we haven't seen yet.
> And the most beautiful words I wanted to tell you
> I haven't said yet.
>
> They've taken us prisoner,
> they've locked us up:
> me inside the walls,
> you outside.
> But that's nothing.
> The worst
> is when people – knowingly or not –
> carry prison inside themselves . . .
> Most people have been forced to do this,
>
> honest, hard-working, good people
> who deserve to be loved as much as I love you.

His poetry, like a geometry compass, traced circles, sometimes intimate, sometimes wide and global, with only its sharp point inserted in the prison cell.

Friday morning

Once I was waiting for Juan Muñoz in an hotel in Madrid, and he was late because, as I explained, when he was working hard at night he was like a mechanic under a car, and he forgot about time. When he eventually turned up, I teased him about lying on his back under cars. And later he sent me a joke fax which I want to quote to you, Nazim.

I'm not sure why. Maybe the why isn't my business. I'm simply acting as a postman between two dead men.

'I would like to introduce myself to you – I am a Spanish mechanic (cars only, not motorcycles) who spends most of his time lying on his back underneath an engine looking for it! But – and this is the important issue – I make the occasional art work. Not that I am an artist. No. But I would like to stop this nonsense of crawling in and under greasy cars, and become the Keith Richard of the art world. And if this is not possible, to work like the priests, half an hour only, and with wine.

'I'm writing to you because two friends (one in Porto and one in Rotterdam) want to invite you and me to the basement of the Boyman's Car Museum and to other cellars (hopefully more alcoholic) in the old town of Porto.

'They also mentioned something about landscape which I did not understand. Landscape! I think maybe it was something about driving and looking around, or looking around whilst driving around . . .

'Sorry, sir, another client just came in. Whoa! A Triumph Spitfire!'

I hear Juan's laughter, echoing in the studio where he is alone with his silent figures.

Friday evening

Sometimes it seems to me that many of the greatest poems of the twentieth century – written by women as well as men – may be the most fraternal ever written. If so, this has nothing to do with political slogans. It applies to Rilke, who was apolitical; to Borges, who was a reactionary; and to Hikmet, who was a life-long Communist. Our century was one of unprecedented massacres, yet the future it imagined (and sometimes fought for) proposed fraternity. Very few earlier centuries made such a proposal.

> These men, Dino,
> who hold tattered shreds of light
> where are they going
> in this gloom, Dino?
> You, me too:

we are with them, Dino.
We too Dino
have glimpsed the blue sky.

Saturday

Maybe, Nazim, I'm not seeing you this time either. Yet I would swear
to it that I am. You are sitting across the table from me on the veran-
dah. Have you ever noticed how the shape of a head often suggests the
mode of thinking which habitually goes on inside it?

There are heads which relentlessly indicate speed of calculation.
Others which reveal the determined pursuit of old ideas. Many these
days betray the incomprehension of continuous loss. Your head – its
size and your screwed-up blue eyes – suggests to me the coexistence of
many worlds with different skies, one within another, inside it; not
intimidating, calm, but used to overcrowding.

I want to ask you about the period we're living today. Much of what
you believed was happening in history, or believed should happen, has
turned out to be illusory. Socialism, as you imagined it, is being built
nowhere. Corporate capitalism advances unimpeded – although
increasingly contested – and the twin World Trade Towers have been
blown up. The overcrowded world grows poorer every year. Where is
the blue sky today that you saw with Dino?

Yes, those hopes, you reply, are in tatters, yet what does this
really change? Justice is still a one-word prayer, as Ziggy Marley
sings in your time now. The whole of history is about hopes being
sustained, lost, renewed. And with new hopes come new theories.
But for the overcrowded, for those who have little or nothing
except, sometimes, courage and love, hope works differently. Hope
is then something to bite on, to put between the teeth. Don't forget
this. Be a realist. With hope between the teeth comes the strength
to carry on even when fatigue never lets up, comes the strength,
when necessary, to choose not to shout at the wrong moment,
comes the strength above all not to howl. A person with hope
between her or his teeth is a brother or sister who commands
respect. Those without hope in the real world are condemned to be
alone. The best they can offer is only pity. And whether these hopes
between the teeth are fresh or tattered makes little difference when

it comes to surviving the nights and imagining a new day. Do you have any coffee?

I'll make some.

I leave the verandah. When I come back from the kitchen with two cups – and the coffee is Turkish – you have left. On the table, very near where the scotch tape is stuck, there is a book, open at a poem you wrote in 1962.

If I was a plane tree I would rest in its shade
If I was a book
I'd read without being bored on sleepless nights
Pencil I would not want to be even between my own fingers
If I was a door
I would open for the good and shut for the wicked
If I was a window a wide open window without curtains
I would bring the city into my room
If I was a word
I'd call out for the beautiful the just the true
If I was a word
I would softly tell my love.

66.

Rostia Kunovsky
(1954–)

I HAVE A friend called Rostia Kunovsky. He's Czech in origin, he lives in Paris, and he is a painter. I have known him and have followed his work for over twenty-five years. Both his vision and practice as a painter are original and sustained. There are one or two people who sometimes buy a painting from him, but his work has never been taken up and promoted. It survives incognito.

Journalists in the world press occasionally refer to me as one of the most influential voices writing about the visual arts. Yet I've never been able to influence any gallery or exhibition curator to do anything about Kunovsky's work. For the investment and promotion circuits I have no voice. So be it.

I'm going to write now about an imaginary exhibition of his latest existing work. You can choose the city. It opened last Wednesday. I invited Tom Waits to the opening and he came and he sang 'Talking at the Same Time'. Ben Jaffe played the trombone and there were several guitars. They played in front of one of the large paintings measuring about two metres by two metres. Unframed.

get a job, save your money, listen to Jane
everybody knows umbrellas cost more in the rain and all the news is bad
is there any other kind?

Rostia calls his latest series of canvases *Fenêtres Lettres.*

Rostia Kunovsky, *Untitled, Series: Fenêtres Lettres, Figure 1,* 2011

The Letters in question are not mail but letters of the alphabet. They don't spell out words; rather they are stencilled acronyms for terms whose original meaning has now escaped or been forgotten.

> *everybody's talking at the same time*
> *well it's hard times for some*
> *for others it's sweet*
> *someone makes money when there's blood in the street*

The Windows in question in these recent paintings are square holes pierced in the walls of many, many rectangular buildings crammed together on a waste terrain. We imagine a settlement with thousands of people living or squatting there, but we don't see them. The vibrant colours, however, allow us to feel something of the pulse of their lives.

> *everybody's talking at the same time.*

467

The density of the settlement makes it look like a dump, but its colours are like those of flowers in a bouquet arranged with care.

Perhaps many of the buildings with their empty windows are only shells, yet are they ruins or are they construction sites? Or are they both alternately?

The Letters of the acronyms are about the same size as the buildings. Many are upside down. Some are in mirror writing. Others run vertically, helter-skelter.

Kunovsky, *Untitled, Series: Fenêtres Lettres, Figure 2*, 2011

These images, despite their unexpectedness, rhyme with something we've already seen. They are playing with the stereotype of countless media pictures accompanying a reportage about some incident – invariably violent – which has occurred the day before in the outskirts of some distant city which we have never been to.

We see the favela, the suburb, the camp, where lives were risked and lost, and where now the faceless façades, the kerb stones, the

empty parking lot are for this moment the only visible memorial to what happened.

The paintings evoke such settings, but whereas the media images are dominated by a forlorn, hopeless sense of distance, Kunovsky's images are, by contrast, intimate, vivid close-ups. And what makes them close-up and intimate is their rhythm: they have a rhythm as insistent as rap. Four paintings were sold on the first day of the imaginary exhibition. These are paintings which speak specifically to the period we are living through. About twenty years ago something began to change concerning language and therefore about the way we see the world. Before that, the words used for describing or naming ideas or things contained a promise of continuity and therefore of a certain kind of survival; there was some kind of companionship between words and the social and physical world. Of course there were lies, exaggerations, illusions. But between words and what they stood for there was an affinity; between signifier and signified there was an old, complicated but continuous family history.

Then came globalisation and the dictatorship of financial speculative capitalism. And the words used by the trading navigators of

Kunovsky, *Untitled, Series: Fenêtres Lettres, Figure 3,* 2011

so-called market forces, by their communication experts and the medias they have annexed, by hypnotised national politicians with their globalised prophesies which have no fixed address, these words have no relation to any lived experience. Imagine a history or a story pieced together only from what surveillance cameras record – a drone account of the human condition – this is what the ruling language, which now surrounds us, is like. And Kunovsky's alphabet Letters are a comment on this meaningless language. By contrast, his Windows are convivial, and as animated as any street talk you can come across. They observe and they tell each other what they are seeing. At the end of the opening I asked Tom to sing 'Tell Me'. Dawn Harms played the violin.

Kunovsky, *Untitled, Series: Fenêtres Lettres, Figure 4*, 2011

470

tell me so I'll know why does a bird build its nest so high why hold
the baby when the baby cries so the river will not drown it and the
highway won't take it and the dust will not cover it and the sun will
not blind it and the wind won't blow it away

Prose today can't relate to what we are living; songs can.

Look at *Fenêtres Lettres* once more before the gallery closes. There
is that drawn-out gasp of surprise which looking at paintings can some-
times induce. How come that a martyrdom or a death or a battle can
offer an occasion for creating beauty? How come that these paintings,
nominally about dereliction, have the promise of flowers?

67.

Jaume Plensa
(1955–)

Sculpture, my sculpture at least, has a tendency towards fossilised footprints rather than to fresh footprints.

Jaume Plensa

THERE IS NO QUESTION that the living crowd out the dead. And where the density of the living population is high, the dead cede. By contrast there are other areas in the world, very thinly populated, where the dead assemble.

Often these areas are arid or poor and it is for this reason that they cannot support the living. The desert or the polar regions are the most extreme examples. Perhaps those who know most about the dead are Bedouins and Eskimos.

Many poor areas are nomadic. They prompted – indeed insisted upon – a nomadic way of life. Further, as any shepherd or hunter will tell you, when you are wandering through certain lands, the paths themselves come towards you. You do not cross such a land like a railway line, you pursue, or are pursued by, its own paths. And this is the second way in which certain areas are nomadic. They go on and on. There are obstacles but no final barriers.

The Western Highlands of Scotland are an area like this. Everything is in transit, because there is nowhere to stop. The crofters' cottages crouch like animals sheltering on the ground for the night. There are

encampments but no permanent assemblies. Everything moves on, the larches, the bracken, the Caledonian pines, the heather, the juniper bushes, the scrub grass. And then moving into the land is the water: the rivers going to the sea, the sea with its tides coming into the lochs. And across both land and water, the wind, above all the northwest wind. Sometimes in the wind there are wild geese, and their honking, as they fly, is like a fleeting measure, a counting in another algebra, of all the land's movement.

This movement no more respects boundaries than did the fighting clans who once lived here; it mixes and confuses all. This is why herrings can be fished from water surrounded by brackened hills. This is why on some days the sky appears to have more flesh on it, to be more hospitable, than the land.

Time does not begin to be counted until there are settlements; between land and sky here it is like a shore. And as sea shores smell of seaweed, so this shore smells of uncounted time.

When the Highlands are crossed going westwards into the wind, you arrive at the Hebrides. Among the very first islands is a small one, no more than six miles long, called Gigha. It is thought that Gigha may mean 'Of the Gods'.

The straits around it are treacherous. Five hundred years ago, near the southern tip of the island, the islanders built a chapel. It stood for three centuries and then fell into ruin. But around the chapel was a cemetery, and in this cemetery the dead were still buried and continue to be buried today.

Many tombstones record the deaths of several generations, the names, the year of her or his birth, the day of death, and the place of the death, if it was not on the island. The only cause of death cited is that of drowning at sea. (Other causes are passed over.)

A name and the two dates, the last one precise to the very day. This is what is recorded. About what happened between, apart from the bare fact of survival, not a word is written. Even for the shortest life no imaginable stone would be large enough; the largest quarry face would be too small to record the life of a one-year-old child.

Then why the name and the two dates? Salt, rain, lichen, and wind efface the deepest-cut letters within a century or two. The question might be asked in any cemetery where names are inscribed. But on

Gigha the answer is more evident. The inscriptions are not for the living. (Those who will remember the dead have no need of a reminder.) The inscriptions are a naming, and this naming is addressed to all the other dead whom the mourned one has now joined.

The inscriptions on the stones are letters of recommendation. Into the ears of the rain the cut letters and numerals whisper: before the eyes of the wind they make signs. This is not poeticizing; on Gigha it is simply a report about what is happening.

From Gigha you look across to the straits, to the sea, to the sky above the sea, or, in the opposite direction, to the brackened mountains beginning their next migration eastwards. The sparsely inhabited coast of the continent here is shaped like the passage for a birth outwards, a uterus leading towards the western horizon. And to this birthplace, the nomadic dead have travelled. They are now within speaking distance in the cemetery.

Yet we did not know how to speak to them. So we had to use the carved stones as go-betweens: go-betweens who supplied the names of those who had left us. Like this the dead did not have to *re-name* them, and like this we were a little reassured.

68.

Cristina Iglesias
(1956–)

HOW TO PERSUADE you to go to the first-ever exhibition in Britain of the incomparable Spanish installation artist Cristina Iglesias? By citing her renown and success in other countries? To do so would be to contradict the modesty of her practice. She is an artist, not of palaces and office-blocks, but of the souk and back alleys.

Her works are impossible to reproduce because a camera cannot walk, hesitate, go back, doubt, or poke a finger behind. Describing them in words makes them sound far more cerebral and portentous than they are, and, anyway, her works beg for silence, because each piece is about listening – listening to a fugitive space or an arriving light. Just as statues, when exhibited, were once placed on plinths of wood or stone, her installations are left in invisible tents of silence.

Perhaps I should start by saying where I believe her works have come from – rather than what's in them. They come from a sense of the inexplicable, and from the disappointment, confusion, loss, as well as wonder, which often accompany that sense. This is not what the works express, it is what they seek a way out of, without resorting to rhetoric or sentimentality. They come from – and address – the human need to find a way out of meaninglessness. A shared but secret way out.

We are living at a moment when meaninglessness is particularly dense. The criminal and absurd war taking place today accentuates this, but the obscurity has been gathering for a decade or more. The New World Order of corporations and B-52s constructs not roads or railways or airstrips but blind walls. Walls for physically separating the rich from the poor, walls of misinformation, walls of exclusion, walls of virtual ignorance. And all these walls insinuate together a global non-sense.

Iglesias is not a didactic artist. She is a silent singer who transports the listener to an elsewhere, which is hidden but familiar, and which encourages a personal quest for meaning. Her songs are the places she makes. Sometimes they are laments. Often they refer to fear. But folded secretly into each one is a sign like a hand held out in solidarity from behind what is there. The medium of these signs is infiltrating light.

She invents street corners and alleyways – such as abound behind the blind walls for keeping the poor out. She dismantles small cardboard boxes and turns them into lodgings with doors and passages. Then she photographs the model and silk-screens the photo onto a huge copper plate, which makes the place life-size. Absurd, makeshift living quarters, bathed in a coppery light suggestive of human warmth. A suggestion that reinforces the absurdity and is, simultaneously, a reminder of a small, possible consolation.

She constructs meandering cages of latticework tracery, which you enter like a caged bird. Or which you wear as if it were a gigantic mantilla. The tracery includes letters that almost succeed in making sentences but finally don't. A language that can no longer explain what matters. Yet in the gaps and spaces another imaginary alphabet of a nameless desire. Perhaps the desire to be enclosed, to be inside. Not innocently as in the mother's womb, but with experience, with everything one has lived and suffered included. To be enclosed by a horizon of your own, on the far side of the usual horizons.

She makes labyrinths of resin panels on which the densest vegetation tells a suffocating story of death, decay, and proliferation. Yet in the same story there is the evolution of the human fingertip with its countless nerve-ends, whose sensitivity is such that the finger can trace exactly the outline of any leaf, or can caress in such a way that

476

the caressed one feels for the duration of the caress that the whole of life is a gift.

She wonders how places are impregnated by what has happened in them. If walls could speak . . . they can't. Their memories are silent. Against the wall of the gallery she builds another at a slight tangent, as if the second wall was waiting to be peeled off the first. And between the two of them – on their hidden interface – the compressed memory of a garden, conveyed by a tapestry.

She designs raffia carpets, and instead of placing them on the floor, she hangs them, interweaving one over the other, from the ceiling, and through the lace-like holes light shines, so that on the floor, when the carpets stir in the air, there is a dappled pattern of shifting light and shade, a pattern which, in the silence, you long to see and feel on your own skin. A silent invitation, from the flimsiest domestic furnishing that exists, proposes the dimensions of a home in a hostile world.

Ways out of meaninglessness, varied and artful, discovered in silence.

After visiting the exhibition in Whitechapel I went to the National Gallery in Trafalgar Square and made my way to Room 32, where there hangs a self-portrait by Salvator Rosa. Just after Cristina Iglesias's husband, Juan Muñoz, died unexpectedly in August 2001, I was walking through Room 32, and suddenly this painting caught my eye and then transfixed me, for it reminded me intensely of Juan.

Not a close facial resemblance but an almost identical stance, intransigence, and way of both facing and defying life. I went this time because I wanted to check this out. It was still true, but what I had altogether forgotten was the Stoic inscription at the bottom of the painting: 'Be silent, unless what you have to say is better than silence.'

69.

Martin Noel
(1956–2008)

ALL GENUINE ART approaches something which is eloquent but which we cannot altogether understand. Eloquent because it touches something fundamental. How do we know? We do not know. We simply recognise.

Art cannot be used to *explain* the mysterious. What art does is to make it easier to notice. Art uncovers the mysterious. And when noticed and uncovered, it becomes more mysterious.

I suspect writing about art is a vanity, leading to sentences like the above. When words are applied to visual art, both lose precision. Impasse.

Try to proceed in another way. I have a hunch about where the mystery, which Martin Noel's art approaches, is situated. Forget what it is, consider only its whereabouts. (The last word makes me think of how he likes painting on postcards of places, and drawing over maps! His lines are always leading somewhere else, and in this they are the opposite of geometric lines, which assemble together everything which is theoretically existent.)

Try to situate the mystery which Martin Noel's work approaches, and to place it on the right continent of knowledge. For example, it's

not on the Continent of Metaphysics – where one might place Rothko. Nor is it on the Continent of Psychology, where one might place Balthus, or, very differently, Warhol.

It is on the Continent of the Physical, in the bodily sense of the term, almost in the anatomical sense. I would guess he admires Leonardo, who, besides making anatomical research, was fascinated by the *prophesies* contained in anatomy.

Yet if I claim that Martin Noel's secret is somewhere on the Continent of the Physical, it is not by art-historical reasoning. It is because of what is immediately visible in his paintings and woodcuts, whether they are the size of postcards or very large. It is because of the way he draws.

Every line he makes is tense, as it meets resistance, as it searches for a way through, as it battles with friction, or as it finds itself face to face with Necessity, without which the physical world cannot exist.

His manner of drawing searches for the opposite of the virtual, or, to be plainer, the opposite of the slippery. When you look at his drawing in paint, you often have the sensation of looking at a portrait – that's to say at the rendering of a unique, one-time-only, physical presence. The fact that he gives names (not 'titles') to his images seems to confirm this. Yet in fact there is nobody – no normal body – there! Or, anyway, not at any scale we are used to recognising.

Why do these squiggles and cuts and slashes have the authority of a physical presence? Where does their authority come from on the Continent of the Physical?

One can't explain it by resemblance or any theory of re-presentation. Certainly there are clusters of lines which recall a flower, a stalk, a tree, the limb of a body, or the feature of a face. Yet these weak coincidences cannot explain their authority.

Perhaps the word 'articulation' offers a clue. It comes etymologically from the same root '*ar*' as the word 'art'. To put together, to join, to fit. (*Artus* in Latin means limb. *Arsis* in Greek means lifting.) 'Articulation' refers, first of all, to an anatomical joint and, then, to the production of speech or any other language system. Articulation implies both the act of joining and the act of changing direction.

Look again at his drawing. Doesn't its authority come from the

Martin Noel, *Croy,* 1996

accuracy with which it records the energy (and of course the diffi-culty) of constant articulation?

The articulation of a tree represents both the history and future of its growth, of its branching, its rooting, its adaptation, and its search for light and water. The fact that wood is Martin Noel's first and favourite material may be significant here.

The visible grain in sawn wood is made up of traces left by the tree's own growth and articulation. On this background of old events he draws a new event belonging to the same order of Branching Out.

I slept for many years in a mountain room whose walls and ceiling were made of pine planks. Many nights before falling asleep, and often in the morning before getting out of bed, my gaze would idly follow the meanders and starts and stops of their grain, and I had the impres-sion that all of them had echoes in the body beside me and my own body. A question of a comparable flow of connections.

Articulation, when referring to the production of a language, is today closer to certain forms of anatomical articulation than it was in the time of Leonardo; if tree branches somewhat resemble knee-joints, the nervous system of neurone cells (*neurone* in Greek meant sinew or cord), communicating across synapses, may be said to resemble a language. As do DNA codes.

On the Continent of the Physical, messages and sensations are

480

being continually articulated, to offer a sense of direction around obstacles. Without this, life could not develop. Such a sense of direction (of survival) implies some kind of memory. Plants, we know, are sentient. It would seem that water may have memory.

Martin Noel's art is situated close to the field where nature itself might be said to *draw*. Draw because what is alive has the capacity either to steer or be steered. His drawing is close to such steering. The rest is mysterious.

70.

Jean-Michel Basquiat (1960–88)

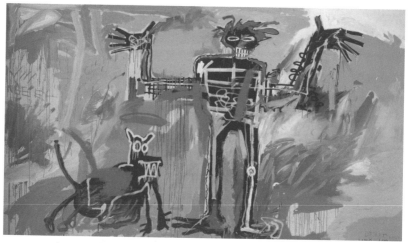

Jean-Michel Basquiat, *Boy and Dog in a Johnnypump*, 1982

BEFORE YOU GET to him, you have to walk through a lot of hot air, because he became a local and then a global legend, and you have to ignore the screeches of the vultures who deal his work. Had he turned up for the opening of the recent show nominally celebrating his fiftieth birthday (he in fact died in 1988, at the age of twenty-seven), he would surely have turned up several days late.

When you find yourself, however, face-to-face with what Jean-Michel Basquiat made, it's a revelation, as the many thousands of Parisians, queuing for an hour recently to get into the show at the Musée d'Art Moderne, had sussed out for themselves. They were of all ages, but the majority were young.

Confronting his work, or being confronted by it, has little to do with High Culture or VIPs but a lot to do with seeing through the lies (visual, verbal, and acoustic) that are imposed on us every minute. Seeing those lies dismembered and undone is the revelation.

Basquiat's legendary *curriculum vitae* evokes something of his existential experience: a Haitian–Puerto Rican black kid living on the streets of New York who tags walls and later starts making paintings that get shown and sold all over the world by the vulture dealers; a kid who collaborates with Andy Warhol, painting in a daring and very pure way on the same canvases; a kid who over a decade produces thousands of images and then dies of a heroin overdose. This story and the many photos taken of him conjure up something of what Basquiat's life was like, but they reveal little about the secret of his art.

Normally when women or men want to contest the lies they are living among and under, they put forward as counter-assertions the truths that are being hidden. James Baldwin and Angela Davis are examples from an earlier period both of them, being black, fought against of the same lies.

Basquiat chose a different strategy. He sensed that hidden truths cannot be described in any of the languages commonly employed for the promotion of lies; he saw every official language as a code of conveying false messages. His strategy as a painter was to discredit and split open such codes and to let in some vibrant, invisible, clandestine truths – like a saboteur. His ploy as a painter was to spell out the world in a language that is deliberately broken – ontologically broken.

Let's consider for a moment the blind. (Basquiat had sharp eyes, yet the comparison can help us.) Observe a blind person travelling somewhere in public – walking along a street, crossing a road, taking an escalator, riding in an underground train, stepping onto a platform, climbing stairs. The blind negotiate their way by asking questions and receiving answers with all the senses except that of sight. They receive information and perspectives offered by sounds, by the air and its draughts and temperatures, by the touch of their probing sticks, their feet and hands. Each sense has for them its own language with which it recognises and defines the world. What distinguishes the blind, however, from those who have sight is that the blind accept that a large part of

what exists is indescribable. Familiar, sustaining, hateful, or lovable, essential, but nevertheless indescribable because, to them, invisible.

As a painter, facing the world he faced, Basquiat was intensely aware, like a blind person, that a large part of the real is indescribable. For him the hoped-for purpose, the sacred task, of painting was to tune in to the invisible – rather in the same manner an anatomical diagram tunes in to the invisible functioning of a living body. And why did he want to do this? Because the invisible cannot be lied about.

One of his self-portraits, *Autoportrait* (1983), is like an assembly diagram for fitting together a shirt, a pair of arms, two kneecaps, a skull, and some boots. The space for him as a man is intensely there; but he, within it, is invisible and so cannot be captured by any official lie or cliché.

His painting *Boy and Dog in a Johnnypump* (1982) is a screen of splashes spelling out the excitement, the fury, the fun of a boy and dog on a stifling summer day in Brooklyn dousing themselves with jets of cold water from a fire hydrant. But neither dog nor boy can be identified. They have very strong and precise features, but none of these features can be accommodated on an identity card. And all the features demanded by IDs have been scratched out or painted over. This doesn't mean that the dog and the boy are being evasive; it simply means they are free.

How did Basquiat put his strategy into practice? How did he proceed visually, graphically? He invented his own alphabet, which consists not of twenty-six signs but of hundreds of signs. It includes the Roman alphabet, numerals, geometric shapes, graffiti emblems, logos, map symbols, pictograms, outlines, diagrams, drawings – and with them all he spells out the world. Often the signs confirm one another. Thus the four Roman letters N O S E find themselves beside a drawn protuberance with two nostrils. Thus the three letters P A W find themselves on the back of a left hand in a painting called *Hollywood Africans* (1983).

With this vivid, amusing, furious, and diverse alphabet, he spells out what he has seen happening around him or within him, or he spells out what he knows in his blood once happened but has never been fully acknowledged. For example, in a large painting, ten feet long and seven feet high, entitled *Slave Auction* (1982) are stuck, as collage, fourteen sheets of paper. On these sheets are crudely drawn

variations of a male comic face. These collages are the slaves. In front of them is the auctioneer, a silhouette in dark blue. His arms are raised, and he is anonymous. He functions like a derrick or a crane. On the left, against the same dark blue, is a skull, and above it, drawn in the same colours as the skull, the symbol of a halo. It could be a reference to Christ.

With his extensive alphabet, he gives everything a name that belongs to no official language and therefore can enter no official record. The events that inspired him answer to the names he gives them, and the names collude with the events. There is a mutual recognition. The paintings are very expressive and, at the same time, absolutely unpronounceable. They can be read silently or they can be remembered wordlessly or they can be replied to by another painting or by another direct action, but they cannot be pronounced in official discourse. And their illegality is intimately connected to the fact that the vivid images celebrate the invisible. Thus no lie can net them; they are free. Indeed they are an exemplary demonstration of freedom! An incitement to freedom.

Each painted figure or animal or object imagined by Jean-Michel Basquiat has borrowed a T-shirt from Death in order to become impossible to arrest, invisible and free. Hence the exhilaration.

The seven letters M A N D I E S find themselves repeated on several of the last canvases, beside a crow's claw – evidence, too, of Basquiat's immense solitude.

71.

Marisa Camino
(1962–)

I AM SITTING in a stationary car thinking about Marisa Camino's strange exhibition which took place earlier this month in the forest of Söhrewald, near Kassel, in Germany. Although the artist has been working for fifteen years in Spain, particularly in Galicia, she seldom exhibits. Indeed she seldom puts what she draws and paints into a frame of any kind.

This reticence, I think, has nothing to do with personal modesty; rather it comes from a rare assurance and is an essential part of her strategy as an artist. She could not make the images she does without such a reticence. As I am thinking this, a single petal from a chestnut candle-flower falls and is blown by a slight breeze onto the car's windscreen, where it sticks. I stare at it.

Camino's drawings and paintings are closer to this petal than they are to most of the works at present being shown in the Venice Biennale. They give the impression of having come from somewhere else, instead of having been fabricated to be exhibited. They hear no trace of the vanities which currently accompany the notion of artistic Creation – be it a modernist or post-modernist one. Her works claim nothing for themselves and everything for what has brushed against them, for what may be glimpsed through them.

At the same time they are neither naive nor simplistic. Each drawing (they vary in size from two metres to twenty centimetres) has been patiently worked, corrected, erased, hesitated over, re-worked. The artist has quoted from the Chinese master Shitao (1641–1717): 'To me the mountains are the sea and the sea the mountains, and the mountains and sea know that I know.' One cannot talk to international juries and to the mountain. One has to choose. And Camino has evidently chosen.

What has brushed against these works? What do they depict? Most of them have no title. On one small drawing is written: 'I am fish, bird, man between sun and moon'. They depict no single thing.

They are irregular in every sense of the term. What they do is to demonstrate graphically how things in nature withstand the forces which threaten them – and so survive. And in demonstrating this, they come upon what the survival of a mountain may have in common with the survival of a seed, or of a tongue in a mouth. Looking at these drawings, you start remembering that survival is not so much a grand plan as a slyness. A cunning. Cunning often suggests swiftness – as with the cardsharper or the fox. These works are about a cunning which is as slow (or as instantaneous) as the double helix of DNA. The cunning, for instance, in the survival of the hermit crab.

In each drawing different survivals meet and compare the adaptabilities which have allowed their survival. A mountain addresses a feather about endurance and the experience of winds. And vica versa. A crayfish interrogates a tree about branches and the experience of articulation. A stone confronts a skull and they discuss crevices. An animal is shoved sideways by a change in climate and accommodates to the hills being eroded by the same climatic change.

The 'conversations' depicted in these drawings are, thank God, without any symbolism or surrealist promotion: they consist simply of the interweaving, overlapping, and juxtaposition of traces as discovered by the artist's sense of touch and her openness to the ceaseless yet hidden parallels to be found in natural appearances. They do not begin with ideas, but with the tangible. Often she uses paper which she herself has made from straw. There are already traces within this paper. The way she then tears a piece and sticks it onto a different paper becomes another kind of trace. To these she adds marks of oil or

pigment, rubbings of graphite, charcoal, blacks, pen-lines, and, occasionally, real feathers or plant fibres.

What is mysterious and what I do not altogether understand is the fact that these drawings never appear arbitrary. On the contrary, they insist upon a precision which seems as credible as that found in a botanical or anatomical engraving. Yet a precision in face of what?

It is as if, through some process of symbiosis, the artist lends her fingers – with all the exactitude a human finger possesses – to the fossil traces she uncovers, and that they re-animate – this is where the precision comes in – the life which the fossilisation has fixed and made static. Her touch, no longer her own, marks the limits of the life she is depicting. Within each drawing she becomes not author but the trace of a breath which once existed.

Many other artists, and most profoundly Joseph Beuys, have been fascinated by the eloquence of traces. What makes Marisa Camino's work so extraordinary is its total fidelity to what lies beyond the traces on their far side, and its tough refusal of promotion in any form on this side. In other words, what is extraordinary is its purity. As a consequence, the body of her work confirms with authority what Jorge Luis Borges proposes in the line

> One thing alone does not exist – oblivion.
> [Sólo una cosa no hay. Es el olvido.]

72.

Christoph Hänsli
(1963–)

FIRST, THE PROJECT, the event. Second, the creator. Third, the surprise. The project. Take a smallish mortadella sausage – about sixteen centimetres in diameter and twenty-two centimetres long. The mortadella sausage was invented in Bologna at the beginning of the seventeenth century. Its name comes from the fact that origi-nally it was minced in a mortar and seasoned with myrtle berries.

Christoph Hänsli, *Mortadella*, 2007–08

The meat should be pure pork, and other seasonings always include coriander and white wine.

Cut the mortadella into 166 slices, each slice about 1.5 mm thick. Number the slices, and study each slice from both sides. The two sides are never the same, for, during the 1.5 mm, the parts of lean and fat and the particles of grains have evolved, with their shapes marginally changing. Take a colour photo of each side of each slice: 332 photos. The project is to make life-size paintings (using the photos as an *aide-mémoire*) on stiff white cards of each side of each slice of the given mortadella. One could suppose that the sides of two slices, which were once contiguous, would be mirror images of one another when opened out. Yet this is not the case. The descent of the blade has slightly differentiated them. And the painter has to decide to take even this into account. The paintings are begun with coats of acrylic, continued with coats of oil paint, and finished with coats of varnish. Each painting demands nearly a dozen distinct sessions of work.

The surface of the painted slice must always appear to be exactly on the surface of the card – never on top of it or behind it. Consequently the surface of each whitish card has to be separately painted and coaxed so that it meets the particular mortadella slice in perfect equanimity. The whole project takes fifteen months. The paintings are then filed – in the order of cutting – in wooden cabinets. The project is a comic, a bureaucratic, and a fantastic one.

Second. Christoph Hänsli, the creator. During Hänsli's working life as an artist he has used various techniques and procedures to treat different themes. And his choice of procedure is never arbitrary. It is always to do with patience and stealth, with taking the particular theme by surprise. His work deserves and, I'm sure, will provoke an overall study; here I am concentrating on the Hänsli who created *Mortadella*.

If I try to picture this creator at work, I see the famous painting by Jusepe de Ribera entitled the *Allegory of Sight* (Museo Franz Mayer, Mexico City). The painting shows a man with deeply intelligent eyes and rough working hands, holding a telescope. He is standing before a window through which we see nature, land, sea, sky, and the scale of the universe. On the shelf in front of him there is a portable mirror, a pair of

spectacles (pince-nez) for reading closely, the case for carrying them in so their lenses are not scratched, and a plume-pen for making notes.

The whole image reminds us, because of its calm and its intensity, that the sense of sight in man is inseparable from the desire (or the need) to examine closely, to compare, and to find what is visible yet hidden.

The *Mortadella* painter could paint, if he so chose, masterly fakes. (A Fragonard, a Delacroix, a Corot might be amongst his specialities.) He has extreme patience and the manual dexterity that accompanies it. He has a visual sense of tonal matching which makes one think of a singer who has a sense of perfect pitch. Every minute touch accords with the others. He has a phenomenal knowledge of painterly materials – surfaces, media, pigments, diluents, varnishes, glazes . . . Above all, he has an instinct for congruity – a nervous warning system about what risks to be out of place, and this instinct becomes more and more precise the longer he works.

He chooses, however, not to be a forger, because the optical, the manual, and the market are not, in themselves, what interest him. What does is mystery. The mystery in visibility itself. Did it precede the first eye? And the enigma of painted images. No painted image pretends to be a counterfeit! Skin, as painted by Velázquez, defies the categories of any dermatologist, but relates only to the way earth or sky or cloth or pewter have also been painted.

Hänsli, *Mortadella*, 2007–08

Hänsli's painted slices of mortadella are not, in any way, facsimiles of the original cut slices. He could have painted such a facsimile, which would have deceived the eye until you touched it, but this did not interest him. It would have been a kind of fake. What obsessed him (fifteen months working every day) is what painted mortadella (every painted slice remaining, nevertheless, faithful to its particular meat model), what painted mortadella becomes when it is painted on painted whitish cards! It is transformed, unforeseeably transformed.

Third. The surprise. This is what one both feels and sees when looking at the finished paintings. The surprise of the transformation. To approach the kind of surprise involved, I will quote from Italo Calvino's magical book *Invisible Cities*. Here he is writing about the city of Andria.

> 'Our city and the sky correspond so perfectly', they answered, 'that any change in Andria involves some novelty among the stars.' The astronomers, after each change takes place in Andria, peer into their telescopes and report a nova's explosion, or a remote point in the firmament's change of colour from orange to yellow, the expansion of a nebula, the bending of a spiral of the Milky Way. Each change implies a sequence of other changes, in Andria as among the stars: the city and the sky never remain the same.

We are now looking at something like celestial bodies. This is how the mortadella sausage, whilst being painted, has been patiently and systematically transformed. The creator has used his telescope. What was once pork has become a firmament!

The transformation has occurred thanks to the act of painting day after day until every edge, where two different substances touch and meet, appears ordained and inevitable. Consequently, the painted surface is unlike any in nature, for it contains memory. As Hugo von Hofmannsthal put it: 'Depth must be hidden. Where? On the surface.' This is the difference between the pink of the meat and the painted pink, between the white of the fat and the painted white. In the painted ones there is depth and memory.

Furthermore, the paintings are now presented as a sequence. As a

result, the 166 slices and the 332 different sides allow our gaze to penetrate a normally opaque mortadella. And our attention is fixed on what changes between each slice. We are examining processes of growth and diminishment which are otherwise invisible.

We are watching what is waxing and what is waning and what is in continual movement. We are surprised by the infinity of the possible variations and, simultaneously, by the certainty and precision of each actual variation.

Like this, our imaginations, our questions, are enmeshed in the metaphysical mystery of any event! Then suddenly – boom! – we are back with a smallish mortadella!

Here – and without further comment – I'd like to quote five propositions from Spinoza.

Existence appertains to the nature of substance.

Every substance is necessarily infinite.

The more reality or being a thing has, the more attributes belong to it.

Each attribute of one substance must be conceived through itself.

God or a substance consisting of infinite attributes each of which expresses eternal and infinite essence, necessarily exists.

We are now close to the surprise the work offers us. And behind the surprise, there is the comic, there is a joke, for the painstaking painter has also transformed himself, he has made himself anonymous! Caught as we are, between the Bologna sausage and the celestial bodies, we forget about him. And he, now wearing his pince-nez, notices this and reads it as a thank-you.

73.

Michael Broughton
(1977–)

THE BODY OF work here, consisting of paintings made during the last three or four years by Michael Broughton, impresses me deeply because of its originality. True originality in art is never an aim but a reward. These heavily worked paintings – mostly on hardboard rather than canvas – achieve something such as I have never before seen. I want to describe what this 'something' is. Inevitably I will fail, because painterly achievements are not describable in words.

Let's begin with the Dutch seventeenth-century architectural painter Pieter Saendredam. His speciality was church interiors. These interiors are filled with light in a striking and unusual way. The light does not enter from the outside, it resides there. The light is the inhabitant of the place. Something comparable and different occurs in Broughton's paintings.

Broughton paints not churches but his own studio in Falmouth and a dilapidated room for playing snooker in. In local Dutch art history Saendredam belonged to the generation just before Vermeer; in recent English art history Broughton stems from Kossoff and Auerbach. So the correspondence between Broughton and Saendredam is neither stylistic nor iconographic; a snooker table is a long way from an altar. What they share is a fascination

for the way light can bed down and make a home for itself in an interior.

In the studio and snooker room, within their walls and on their floorboards, there are objects, furniture – chairs, a desk, a snooker table (often with a white dust-sheet over it), a desk, an easel, a stack of paintings, doors, a window frame, bric-a-brac, a garment, and the habitual detritus of everyday life. And in the paintings the light (like the dust-sheet) cherishes these things; it recognises their identity. Not by outlining them or re-presenting them, but by becoming intimately familiar with the space around them, and by discovering their biographies. Yes, household objects have biographies.

Perhaps this becomes clearer if we consider how Broughton works, how these paintings have been made, how they have come into being.

The paintings are made not by looking at the interior but by following a fresh drawing made of the whole interior at the beginning of that day's painting session.

For example, the large painting of the studio is the result of sixty such drawings and sixty such painting sessions. And during each session Broughton worked and reworked on the space of the whole scene being painted.

This means that the things he is painting have already been, as it were, dismantled through the act of drawing. Their conventional appearances have been cross-questioned, interrogated so that what is surprising and unique about each object has begun to reveal itself.

In the painted wooden chair there is a reminder of how it was when being fitted together on a carpenter's bench. The painted metal light shade above the snooker table takes account of the electrician's calculations when fixing its wires to the ceiling. The sweeping extent of the white dust-cloth placed over the table conjures up the inexorability of the course of a billiard ball across the green felt once it has been cued.

The painted light in these works is not the light of Reason, nor is it the light of astrophysics; it is the light of intimacy. And intimacy has its own time-scale, distinct from the time of clocks or calendars; an irregular time-scale which slows down to make some moments big, and accelerates to make other movements irrelevant. This is why such light can play with the notion of the eternal. The eternal with a small e.

There is nothing trivial about these paintings, yet there is not a trace of rhetoric.

They don't capture an outside light, they await light. And slowly, dimly, the act of waiting becomes itself light, and interior light.

Here the due meaning of the word interior spells out the riddle. We are looking at paintings of interiors whose intimate space is inhabited by an interior light.

There is a small self-portrait in the show. Its pictorial elements – its colours, tonalities, gestures – are exactly the same as those in the large painting of the studio. The two are made of exactly the same stuff. A meditative man's head and the place where the same man practices his craft as a painter. Both invite us discreetly to enter . . .

74.

Randa Mdah
(1983–)

A FEW DAYS after our return from what was thought of, until recently, as the future state of Palestine, and which is now the world's largest prison (Gaza) and the world's largest waiting room (Cis-Jordan), I had a dream.

I was alone, standing, stripped to the waist, in a sandstone desert. Eventually somebody else's hand scooped up some dusty soil from the ground and threw it at my chest. It was a considerate rather than an aggressive act. The soil or gravel changed, before it touched me, into torn pieces of cloth, probably cotton, which wrapped themselves around my torso. Then these tattered rags changed again and became words, phrases. Written not by me but by the place.

Remembering this dream, the invented word 'landswept' came to my mind. Repeatedly. Landswept describes a place or places where everything, both material and immaterial, has been brushed aside, purloined, swept away, blown down, irrigated off, everything except the touchable earth.

There's a small hill called Al Rabweh on the western outskirts of Ramallah; it's at the end of Tokyo Street. Near the top of the hill the poet Mahmoud Darwish is buried. It's not a cemetery.

The street is named Tokyo because it leads to the city's Cultural

Centre, which is at the foot of the hill, and was built thanks to Japanese funding.

It was in this Centre that Darwish read some of his poems for the last time, though no one then supposed it would be the last. What does the word 'last' mean in moments of desolation?

We went to visit the grave. There's a headstone. The dug earth is still bare, and mourners have left on it little sheaves of green wheat – as he suggested in one of his poems. There are also red anemones, scraps of paper, photos.

He wanted to be buried in Galilee, where he was born and where his mother still lives, but the Israelis forbade it.

At the funeral tens of thousands of people assembled here, at Al Rabweh. His mother, ninety-six years old, addressed them. 'He is the son of you all', she said.

In exactly what arena do we speak when we speak of loved ones who have just died or been killed? Our words seem to us to resonate in a present moment more present than those we normally live. Comparable with moments of making love, of facing imminent danger, of taking an irrevocable decision, of dancing a tango. It's not in the arena of the eternal that our words of mourning resonate, but it could be that they are in some small gallery of that arena.

On the now deserted hill I tried to recall Darwish's voice. He had the calm voice of a beekeeper:

> A box of stone
> where the living and dead move in the dry clay
> like bees captive in a honeycomb in a hive
> and each time the siege tightens
> they go on a flower hunger strike
> and ask the sea to indicate the emergency exit.

Recalling his voice, I felt the need to sit down on the touchable earth, on the green grass. I did so.

Al Rabweh means in Arabic 'the hill with green grass on it'. His words have returned to where they came from. And there is nothing else. A nothing shared by four million people.

The next hill, five hundred metres away, is a refuse dump. Crows are circling it. Some kids are scavenging.

When I sat down in the grass by the edge of his newly dug grave, something unexpected happened. To define it, I have to describe another event.

This was a few days ago. My son Yves was driving, and we were on our way to the local town of Cluses in the French Alps. It had been snowing. Hillsides, fields, and trees were white, and the whiteness of the first snow often disorients birds, disturbing their sense of distance and direction.

Suddenly a bird struck the windscreen. Yves, watching it in the rearview mirror, saw it fall to the roadside. He braked and reversed. It was a small bird, a robin, stunned but still alive, eyes blinking. I picked him up out of the snow; he was warm in my hand, very warm – birds have a higher blood temperature than we do – and we drove on.

From time to time I examined him. Within half an hour he had died. I lifted him up to put him on the back seat of the car. What surprised me was his weight. He weighed less than when I had picked him up from the snow. I moved him from hand to hand to check this. It was as if his energy when alive, his struggle to survive, had added to his weight. He was now almost weightless.

After I sat on the grass on the hill of Al Rabweh, something comparable happened. Mahmoud's death had lost its weight. What had remained were his words.

Months have passed, each one filled with foreboding and silence. Now disasters are flowing together into a delta that has no name, and will only be given one by geographers, who will come later, much later. Nothing to do today but to try to walk on the bitter waters of this nameless delta.

Gaza, the largest prison in the world, is being transformed into an abattoir. The word 'Strip' (from Gaza Strip) is being drenched with blood, as happened sixty-five years ago to the word 'ghetto'.

Day and night, bombs, shells, GBU39 radioactive arms, and machine-gun rounds are being fired by the Israeli Defense Forces from air, sea, and land against a civilian population of one and a half million. The estimated number of mutilated and dead increases with each news report from international journalists, all of whom are

forbidden by Israel to enter the Strip. Yet the crucial figure is that for a single Israeli casualty, there are one hundred Palestinian casualties. One Israeli life is worth a hundred Palestinian lives. The implications of this assumption are constantly reiterated by Israeli spokesmen in order to make them acceptable and normal. The massacre will soon be followed by pestilence; most lodgings have neither water nor electricity, the hospitals lack doctors, medicines, and generators. The massacre follows a blockage and siege.

More and more voices across the world are raised in protest. But the governments of the rich, with their world media and their proud possession of nuclear weapons, reassure Israel that a blind eye will be cast on what its defence forces are perpetrating.

'A place weeping enters our sleep,' wrote the Kurdish poet Bejan Matur, 'a place weeping enters our sleep and never leaves.'

Nothing but landswept earth.

I am back, a few months ago, in Ramallah, in an abandoned underground parking lot, which has been taken over as a work-space by a small group of Palestinian visual artists, among whom there's a sculptor named Randa Mdah. I'm looking at an installation conceived and made by her entitled *Puppet Theater*.

It consists of a large bas-relief measuring three metres by two, which stands upright like a wall. In front of it on the floor there are three fully sculpted figures.

The bas-relief of shoulders, faces, hands is made on an armature of wire, of polyester, fibreglass, and clay. Its surfaces are coloured: darkish greens, browns, reds. The depth of its relief is about the same as in one of Ghiberti's bronze doors for the Baptistry in Firenze, and the foreshortening and distorted perspectives have been dealt with with almost the same mastery. (I would never have guessed that the artist is so young. She's twenty-nine.) The wall of the bas-relief is like 'the hedge' that an audience in a theatre resembles when it's seen from the stage.

On the floor of the stage in front are the life-size figures, two women and one man. They are made of the same materials, but with more faded colours.

One is within touching distance of the audience, another is two metres away and the third twice as far away again. They are wearing their everyday clothes, the ones they chose to put on this morning.

500

Randah Mdah, *Puppet Theater*, 2008

Their bodies are attached to cords hanging from three horizontal sticks which in turn hang from the ceiling. They are the puppets; their sticks are the control bars for the absent or invisible puppeteers.

The multitude of figures on the bas-relief are all looking at what they see in front of their eyes and wringing their hands. Their hands are like flocks of poultry. They are powerless. They are wringing them because they cannot intervene. They are bas-relief, they are not three-dimensional, and so they cannot enter or intervene in the solid real world. They represent silence.

The three solid, palpitating figures attached to the invisible puppeteers' cords are being hurled to the ground, head first, feet in the air. Again and again until their heads split. Their hands, torsos, faces are convulsed in agony. One that doesn't reach its end. You see it in their feet. Again and again.

I could walk between the impotent spectators of the bas-relief and the sprawling victims on the ground. But I don't. There is a power in this work such as I have seen in no other. It has claimed the ground on which it is standing. It has made the killing field between the aghast spectators and the agonising victims sacred. It has changed the floor of a parking lot into something landswept.

This work prophesied the Gaza Strip.

Mahmoud Darwish's grave on the hill of Al Rabweh has now, following decisions made by the Palestinian Authority, been fenced off, and a glass pyramid has been constructed over it. It's no longer

possible to squat beside him. His words, however, are audible to our ears and we can repeat them and go on doing so.

> I have work to do on the geography of volcanoes
> From desolation to ruin
> from the time of Lott to Hiroshima
> As if I'd never yet lived
> with a lust I've still to know
> Perhaps Now has gone further away
> and yesterday come closer
> So I take Now's hand to walk along the hem of history
> and avoid cyclic time
> with its chaos of mountain goats
> How can my tomorrow be saved?
> By the velocity of electronic time
> or by my desert caravan slowness?
> I have work till my end
> as if I won't see tomorrow
> and I have work for today who isn't here
> So I listen
> softly softly
> To the ant beat of my heart . . .

Acknowledgements

All the writing in this book has appeared previously in other publications, with chapters often comprising articles from more than one source. Verso would like to thank the following.

1. **The Chauvet Cave Painters (c. 30,000 years BC)**
 'The Chauvet Caves' (1996), *The Shape of a Pocket* [2001] (London: Bloomsbury, 2002), pp. 35–42.
2. **The Fayum Portrait Painters (1st–3rd century)**
 'The Fayum Portraits' (1988), *The Shape of a Pocket*, pp. 53–60.
3. **Piero della Francesca (c. 1415–92)**
 'The Calculations of Piero' (1959), *Permanent Red: Essays in Seeing* (London: Methuen, 1960), pp. 157–62.
4. **Antonello da Messina (c. 1430–79)**
 'Resistance Is Fertile', *New Statesman* (9 April 2009).
5. **Andrea Mantegna (1430/1–1506)**
 From *Lying Down to Sleep*, with Katya Andreadakis Berger (Mantua: Edizioni Corraini, 2010).
6. **Hieronymous Bosch (c. 1450–1516)**
 'Against the Great Defeat of the World', *The Shape of a Pocket*, pp. 209–15.

7. **Pieter Bruegel the Elder (c. 1525–69)**
 'The Case Against Us', *Observer* (7 October 1962).

8. **Giovanni Bellini (active about 1459, died 1516)**
 'John Berger on Four Bellini Madonnas', *Monitor: An Anthology*, ed. Huw Wheldon, (London: Macdonald, 1962), pp. 174–78.

9. **Matthias Grünewald (c. 1470–1528)**
 'Between Two Colmars' (1976 – not 1973 as listed in some places), *About Looking* (London: Readers and Writers Publishing Cooperative, 1980), pp. 134–40.

10. **Albrecht Dürer (1471–1528)**
 'Dürer: A Portrait of the Artist' (1971), *The White Bird: Writings*, ed. Lloyd Spencer (London: Chatto & Windus, 1985), pp. 33–40.

11. **Michelangelo (1475–1564)**
 'Michelangelo' (1995), *The Shape of a Pocket*, pp. 97–101.

12. **Titian (?1485/90–1576)**
 With Katya Berger Andreadakis, *Titian: Nymph and Shepherd* (London: Bloomsbury, 2003), as extracted in 'Titian as Dog', *The Threepenny Review* 54 (1 July 1993): 6–9.

13. **Hans Holbein the Younger (1497/8–1543)**
 'A Professional Secret' (1979), *Keeping a Rendezvous* [1992] (London: Granta Books, 1993), pp. 124–31.

14. **Caravaggio (1571–1610)**
 From *And Our Faces, My Heart, Brief as Photos* [1984] (London: Bloomsbury, 2005), pp. 79–86.

15. **Frans Hals (1582/3–1666)**
 'Frans Hals' (1966), *The Moment of Cubism and Other Essays* (New York: Pantheon, 1969), pp. 124–32; 'The Hals Mystery' (1979), *The White Bird*, pp. 106–17.

16. **Diego Velázquez (1599–1660)**
 'A Story for Aesop' (1992), *Keeping a Rendezvous*, pp. 53–81; 'Through the Peephole of Eternity' (2010), *The Drawbridge* 17 (also in *Bento's Sketchbook*).

17. **Rembrandt (1606–69)**
 'Three Dutchmen' [review, Wilhelm Reinhold Valentiner, *Rembrandt and Spinoza*, and David Lewis, *Mondrian*], *Spectator* 6729 (1957): 788; from John Berger, Mike Dibb, Sven Blomberg, Chris Fox and Richard Hollis, *Way of Seeing* (London: BBC, 1972), pp. 109–12;

'Once in Amsterdam' (1984) from *And Our Faces, My Heart, Brief as Photos*, pp. 23–5; 'Rembrandt and the Body' (1992), *The Shape of a Pocket*, pp. 103–11; 'A Cloth Over the Mirror' (2000), *The Shape of a Pocket*, pp. 115–19 (pp. 115–16); 'On *The Polish Rider*' (2005), from *Here Is Where We Meet* (London: Bloomsbury, 2006), pp. 165–72.

18. **Willem Drost (1633)**
From *Bento's Sketchbook* (London: Verso, 2011), pp. 24–32.

19. **Jean-Antoine Watteau (1684–1721)**
'Drawings by Watteau' (1975), *The Look of Things*, pp. 103–6.

20. **Francisco de Goya (1746–1828)**
Extract from *A Painter of Our Time* [1958] (London: Verso, 2010, p. 13; 'The Honesty of Goya', *Permanent Red* (1960), pp. 180–84; 'The Maja Dressed and the Maja Undressed' (1964), *The Moment of Cubism*, pp. 86–91; extract from *Corker's Freedom* [1964] (London: Verso, 2010), p. 127–8; from John Berger and Nella Bielski, *Goya's Last Portrait: The Painter Played Today* (London: Faber, 1989), pp. 31–4, 93–104.

21. **Honoré Daumier (1808–79)**
'The Painter Inside the Cartoonist: Daumier's Silver Screen', *Observer* (11 June 1961): 37; paragraph in *Daumier: Visions of Paris* (London: Royal Academy, 2013).

22. **J. M. V. Turner (1775–1851)**
'Turner and the Barber's Shop' (1972), *About Looking*, pp. 149–55.

23. **Jean-Louis-André-Théodore Géricault (1791–1824)**
'A Man with Tousled Hair', *The Shape of a Pocket*, pp. 173–80.

24. **Jean-François Millet (1814–75)**
'Millet and Labour' (1956), *Permanent Red*, pp. 189–91; 'Millet and the Peasant' (1976), *About Looking*, pp. 76–85.

25. **Gustave Courbet (1819–77)**
'The Politics of Courbet' (1953), *Permanent Red*, pp. 196–98; 'Courbet and the Jura' (1978), *About Looking*, pp. 141–48.

26. **Edgar Degas (1834–1917)**
'On a Degas Bronze of a Dancer' (1969), *Permanent Red*, pp. 11–12; 'Degas', *Die Weltwoche*, 18 April 1997, in *The Shape of a Pocket*, pp. 63–68; 'The Dark Side of Degas's Ballet Dancers', *Guardian* (15 November 2011).

27. Le Facteur Cheval (1836–1924)

'The Ideal Palace' (c. 1977), *Keeping a Rendezvous*, pp. 82–91.

28. Paul Cézanne (1839–1906)

'Cézanne: Paint It Black', *Guardian* (12 December 2011).

29. Claude Monet (1840–1926)

'The Eyes of Claude Monet' (1980), *The White Bird*, pp. 189–96; 'The Enveloping Air: Light and Moment in Monet', *Harper's* (January 2011): 45–49.

30. Vincent van Gogh (1853–90)

'Vincent', *Aftonbladet*, 20 August 2000, in *The Shape of a Pocket*, pp. 87–92.

31. Käthe Kollwitz (1867–1945)

From *Bento's Sketchbook*, pp. 41–47.

32. Henri Matisse (1869–1954)

'Henri Matisse' (1954), *Permanent Red*, pp. 132–36.

33. Pablo Picasso (1881–1973)

'Erogenous Zone' (1988), in *El Pais*, 8 April 1988, in *Keeping a Rendezvous*, pp. 203–11.

34. Fernand Léger (1881–1955)

'Fernand Léger' (1963), *Selected Essays and Articles: The Look of Things*, ed. Nikos Stangos (London: Penguin, 1972), pp. 107–21.

35. Ossip Zadkine (1890–1967)

'Zadkine' (1967), *The Look of Things*, pp. 66–70.

36. Henry Moore (1898–1986)

'Piltdown Sculpture', *New Statesman and Nation* 48, no. 1199 (27 February 1954): 250; extract on Moore from 'Round London', *New Statesman* 56, no. 1245 (5 July 1958): 15; 'Infancy' (1989), from *Keeping a Rendezvous*, pp. 154–61.

37. Peter Lazslo Peri (1899–1967)

'Impressions of Peter Peri' (1968), *The Look of Things*, pp. 61–64.

38. Alberto Giacometti (1906–66)

'Alberto Giacometti', from *The Moment of Cubism*, pp. 112–16.

39. Mark Rothko (1903–70)

From a correspondence with Katya Andreadakis Berger, *Tages Anzeiger* (1 June 2001).

40. Robert Medley (1905–94)

From *Robert Medley: A Centenary Tribute* (London: James Hyman Fine Art, 2005).

41. **Frida Kahlo (1907–54)**
 'Frida Kahlo' (1998), *The Shape of a Pocket*, pp. 157–64.

42. **Francis Bacon (1909–92)**
 'Francis Bacon', *New Statesman* (5 January 1952): 10–11; 'Francis Bacon and Walt Disney' (1972), *About Looking*, pp. 118–25; 'A Master of Pitilessness?' (2004), *Hold Everything Dear: Dispatches on Survival and Resistance* (London: Verso, 2008), pp. 85–89.

43. **Renato Guttuso (1911–87)**
 John Berger, 'A Social Realist Painting at the Biennale', *Burlington Magazine* 94 (1952): 294–97; with Benedict Nicolson, 'Guttuso: A Conversation', *New Statesman* (19 March 1955): 384.

44. **Jackson Pollock (1912–56)**
 From *Permanent Red* (1958), pp. 66–70.

45. **Jackson Pollock and Lee Krasner (1908–84)**
 'A Kind of Sharing' (1989), *Keeping a Rendezvous*, pp. 105–16.

46. **Abidin Dino (1913–93)**
 'A Friend Talking (for Guzine)', *Photocopies* (London: Bloomsbury, 1996), pp. 127–30.

47. **Nicolas de Staël (1914–55)**
 From *A Painter of Our Time* (1958), pp. 126–27; *The Secret Life of the Painted Sky'*, *Le Monde Diplomatique*, June 2003.

48. **Prunella Clough (1919–99)**
 From John Berger and Anne Michaels, *Railtracks*, with photography by Teresa Stehlikova (London: Go Together Press, 2012), pp. 28–31.

49. **Sven Blomberg (1920–2003)**
 'Room 19' (1997), from *Photocopies*, pp. 165–70.

50. **Friso Ten Holt (1921–97)**
 From *Permanent Red*, pp. 100–105.

51. **Peter de Francia (1921–2012)**
 From 'Brill and De Francia', *New Statesman and Nation* 58, no. 1250 (21 June 1958): 804–5 ; 'News from the World', *New Statesman* 57, no. 1451 (24 January 1959): 105–6.

52. **F. N. Souza (1924–2002)**
 'An Indian Painter', *New Statesman and Nation* 49, no. 1251 (26 February 1954): 277–78.

53. **Yvonne Barlow (1924–)**

'To Dress a Wound', cattalogue text for an exhibition in London c. 2000, provided by the Berger family.

54. **Ernst Neizvestny (1925–)**

Extracts from *Art and Revolution: Ernst Neizvestny and the Role of The Artist in the U.S.S.R.* (New York: Pantheon Books, 1969), pp. 81–85.

55. **Leon Kossoff (1926–)**

'The Weight', *New Statesman* 58, no. 1488 (19 September 1959): 352, 354; with Leon Kossoff, 'A Marathon Swim through Thick and Thin', *Guardian* (1 June 1996): 29.

56. **Anthony Fry (1927–)**

'Some Notes Played for Tony', *Anthony Fry* [exh. cat.] (London: Turnaround, 2002).

57. **Cy Twombly (1928–2011)**

'Post Scriptum' in *Audible Silence: Cy Twombly at Daros*, ed. Eva Keller and Regula Malin (Zürich: Scalo Publishers, 2002).

58. **Frank Auerbach (1931–)**

'A Stick in the Dark', *New Statesman* 58, no. 1498 (28 November 1959): 745–46.

59. **Vija Celmins (1938–)**

'Penelope', in *Tages Anzeiger*, 18 April 1997, reprinted in *Keeping a Rendezvous*, pp. 43–48.

60. **Michael Quanne (1941–)**

'The Cherished and the Excluded', in *Michael Quanne: Prison Paintings* (London: Murray, 1985).

61. **Maggi Hambling (1945–)**

Preface to *Maggi and Henrietta: Drawings of Henrietta Moraes*, by Maggi Hambling (London: Bloomsbury, 2001).

62. **Liane Birnberg (1948–)**

Catalogue text for exhibition in Berlin, supplied by the Berger family (1998).

63. **Peter Kennard (1949–)**

'Global Warning', *Guardian* (15 June 1990): 36.

64. **Andres Serrano (1950–)**

'Vocabulary of Ignorance', *Le Monde* and *Clarin*, 27 April 2011; *Internazionale*, 6–12 May 2011.

65. **Juan Muñoz (1953–2001)**
'I Would Softly Tell My Love (January, 2002)', *Hold Everything Dear*, pp. 21–34.

66. **Rostia Kunovsky (1954–)**
'Rostia Kunovsky: Fenêtres Lettres', *OpenDemocracy*, 27 September 2013.

67. **Jaume Plensa (1955–)**
'Une lieu pour une sculpture de Jaume Plensa', in *Jaume Plensa*, ed. Françoise Bonnefoy, Sarah Clément, and Isabelle Sauvage (Paris: Éditions du Jeu de Paume, 1997), pp. 21–2. English version provided by the Berger Family.

68. **Cristina Iglesias (1956–)**
'Shh, This Is the Sound of Silence', *Observer*, 6 April 2003.

69. **Martin Noel (1956–2008)**
'Branching Out', in *Martin Noël: Blau und andere Farben*, ed. Peter Dering (Ostfildern-Ruit, Germany: Hatje Cantz, 2003), pp. 45–51.

70. **Jean-Michel Basquiat (1960–88)**
'Seeing Through Lies. Jean-Michel Basquiat: Saboteur', *Harper's* (April 2011): 45–50.

71. **Marisa Camino (1962–)**
'Sola una cosa no hay', *El Pais*, 20 June 2001, to mark an exhibition in the Forest of Söhrewald, Germany.

72. **Christoph Hänsli (1963–)**
'Mortadella', from *Mortadella* (Zürich: Edition Patrick Frey, 2008).

73. **Michael Broughton (1977–)**
'Big Moments', catalogue essay, Art Space Gallery, 2012.

74. **Randa Mdah (1983–)**
'A Place Weeping', *The Threepenny Review* 118 (Summer 2009): 31.

Illustration Credits

The publisher gratefully acknowledges the permission granted to reproduce the images in this book. Every effort has been made to trace copyright holders and obtain their permission for the use of copyright material. The publisher apologizes for any omissions and would be grateful if notified of any corrections to be incorporated in future editions.

Page 3. Painting in Chauvet Cave, c. 30,000 BC. © Stephen Alvarez/ National Geographic Creative.

Page 18. From *Bento's Sketchbook*. © John Berger 2011.

Page 46. Workshop of Giovanni Bellini, *The Virgin and Child*, 1480–90. © The National Gallery, London.

Page 47. Giovanni Bellini, *The Virgin and Child*, 1480–1500. © The National Gallery, London. Mond Bequest 1924.

Page 66. Sebastião Salgado, *Mussel Harvest*. © Sebastião Salgado/ Amazonas/nbpictures 1988.

Page 166. *From a Woman's Portrait by Willem Drost*, from *Bento's Sketchbook*. © John Berger 2011.

Page 280. Henri Matisse, *The Parakeet and the Mermaid* (*La Perruche et la Sirene*), 1952–53. Stedelijk Museum, Amsterdam, acquired with the generous support of the Vereniging Rembrandt and the Prins Bernhard Cultuurfonds 1967. © Succession H. Matisse/DACS 2015.

510

Page 285. David Douglas Duncan, *Fish-eye Picasso*, 1963. © Photography Collection, Harry Ransom Center, the University of Texas at Austin.

Page 291. Fernand Léger, *The Great Parade (Definitive State)*, 1955. © ADAGP, Paris and DACS, London 2015.

Page 310. Henry Moore, *Mother and Child*, 1953. Reproduced by permission of the Henry Moore Foundation.

Page 312. Henry Moore, *Falling Warrior*, 1956–57. Reproduced by permission of the Henry Moore Foundation.

Page 317. Henry Moore, *Mother and Child: Block Seat*, 1983–84. Reproduced by permission of the Henry Moore Foundation.

Page 325. Henri Cartier-Bresson, *Alberto Giacometti, Paris*, 1961. © Henri Cartier-Bresson/Magnum Photos.

Page 333. Robert Medley, *Self Portrait after Watteau*, 1980. © The Estate of Robert Medley, courtesy James Hyman Gallery, London.

Page 337. Frida Kahlo, *Diego and I*, 1949. © INBA Instituto Nacional de Bellas Artes/Banco de México/Fideicomiso Museos Diego Rivera y Frida Kahlo.

Page 343. Francis Bacon, *Head VI*, 1949. © The Estate of Francis Bacon. All rights reserved. DACS 2015.

Page 351. Francis Bacon, *Two Figures in a Room*, 1959. © The Estate of Francis Bacon. All rights reserved. DACS 2015.

Page 353. Renato Guttuso, *The Battle of Ponte dell'Ammiraglio*, 1955. © Guttuso/DACS 2015.

Page 359. Renato Guttuso, *Death of a Hero*, 1953. © Guttuso/DACS 2015 Bridgeman Images.

Page 376. Nicolas de Staël, *Landscape Noon*, 1953 © ADAGP, Paris and DACS, London 2015.

Page 383. Prunella Clough, *Mesh with Glove*, 1980. © Estate of Prunella Clough 2015. All Rights Reserved DACS.

Page 395. Peter de Francia, *Eric Hobsbawm*, 1955. © The Estate of Peter de Francia, courtesy James Hyman Gallery, London.

Page 402. Yvonne Barlow, *Friend or Foe?*, 1987. © Yvonne Barlow.

Page 407. Inge Morath, *Portrait of Ernst Neizvestny*, 1967. © Inge Morath /the Inge Morath Foundation/Magnum Photos.

Page 412. *Building Site, Oxford Street*, 1952. Leon Kossoff, b. 1926, purchased 1996, Tate. www.tate.org.uk/art/artworks/kossoff-building-site-oxford-street-t07199

Page 424. Anthony Fry, *The Man Who Loved Volcanoes*. © Anthony Fry c/o Browse and Darby.

Page 431. Vija Celmins, *Night Sky #4*, 1992. Oil on canvas mounted on wood panel, 78.1 × 95.9 × 3.81 cm. Courtesy The Museum of Contemporary Art, Los Angeles. Gift of Lannan Foundation.

Page 438. Michael Quanne, *Free Will*, 1993 (oil on canvas). Michael Quanne (b.1941)/Private Collection/Photo © Christie's Images/ Bridgeman Images.

Page 442. Maggi Hambling, *Study of Henrietta Moraes*, 1998. © Maggi Hambling.

Page 448. Peter Kennard, *Thatcher Cuts Healthcare*, 1985. © Peter Kennard.

Page 456. Juan Muñoz, *Towards the Corner*, 1998. © Munoz/DACS 2015

Page 467. Rostia Kunovsky, *Untitled, Series: Fenêtres Lettres, Figure 1*, 2011. © Rostia Kunovsky. kunovsky.com/Galerie Jorge Alyskewycz, Paris.

Page 468. Rostia Kunovsky, *Untitled, Series: Fenêtres Lettres, Figure 2*, 2011. © Rostia Kunovsky. kunovsky.com/Galerie Jorge Alyskewycz, Paris.

Page 469. Rostia Kunovsky, *Untitled, Series: Fenêtres Lettres, Figure 3*, 2011. © Rostia Kunovsky. kunovsky.com/Galerie Jorge Alyskewycz, Paris.

Page 470. Rostia Kunovsky, *Untitled, Series: Fenêtres Lettres, Figure 4*, 2011. © Rostia Kunovsky. kunovsky.com/Galerie Jorge Alyskewycz, Paris.

Page 480. Martin Noel, *Croy*, 1996 © Noel/DACS 2015.

Page 482. Jean-Michel Basquiat, *Boy and Dog in a Johnnypump*, 1982. © The Estate of Jean-Michel Basquiat/ADAGP, Paris and DACS, London 2015.

Page 489. Christoph Hänsli, *Mortadella*, 2007–08. © Christoph Hänsli. Mortadella is published as an art book: *Mortadella*, Edition Patrick Frey, Zurich, 2008.

Page 491. Christoph Hänsli, *Mortadella*, 2007–08. © Christoph Hänsli. Mortadella is published as an art book: *Mortadella*, Edition Patrick Frey, Zurich, 2008.

Page 501. Randah Mdah, *Puppet Theater*, 2008. © Randa Mdah.

All other images are held in the public domain or under a Creative Commons licence.